Unnatural Selection

Unnatural Selection

Katrina van Grouw

Princeton University Press ~ Princeton & Oxford

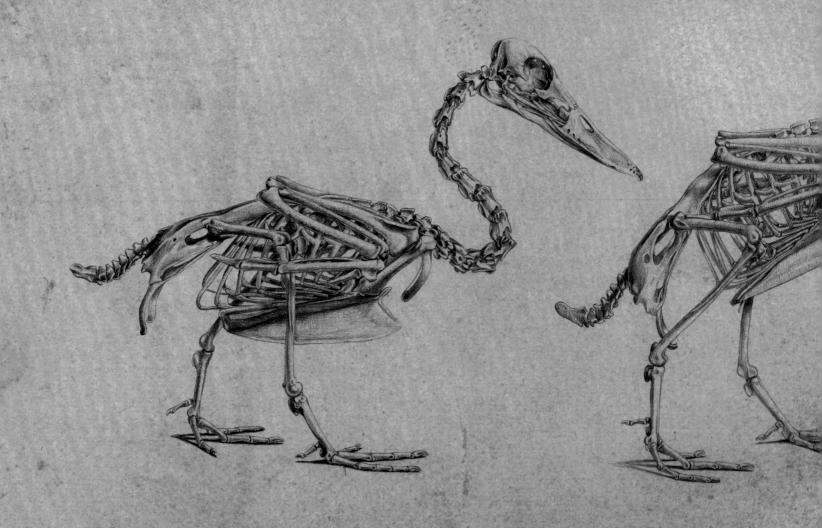

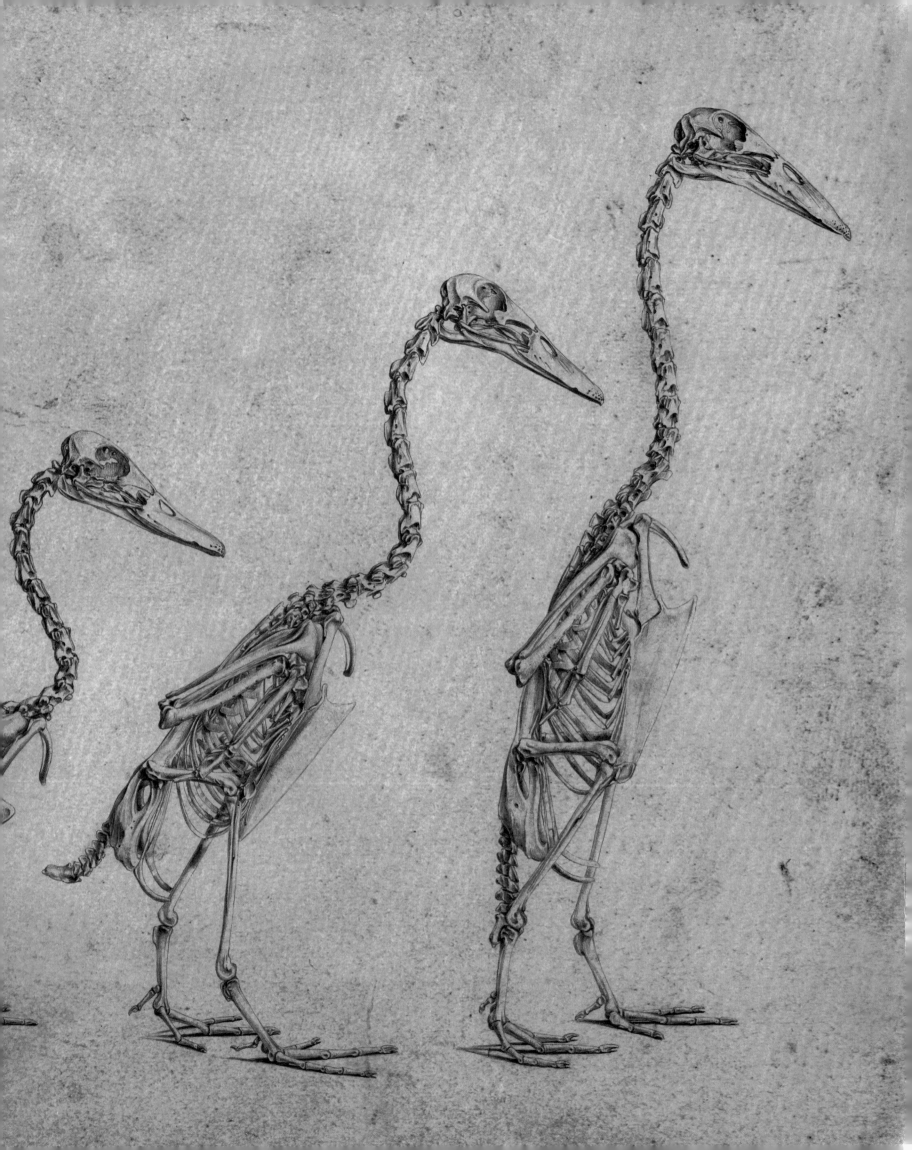

Copyright © 2018 by Katrina van Grouw

Requests for permission to reproduce material from this work
should be sent to Permissions, Princeton University Press

Published by Princeton University Press,
41 William Street, Princeton, New Jersey 08540

In the United Kingdom: Princeton University Press,
6 Oxford Street, Woodstock, Oxfordshire OX20 1TW

press.princeton.edu

Jacket art and design by Katrina van Grouw

All Rights Reserved

Library of Congress Cataloging-in-Publication Data

Names: Van Grouw, Katrina, 1965– author.

Title: Unnatural selection / Katrina van Grouw.

Description: Princeton : Princeton University Press, [2018] | Includes bibliographical references and index.

Identifiers: LCCN 2017031666 | ISBN 9780691157061 (hardback : alk. paper)

Subjects: LCSH: Animal breeding—Evolution. | Animal genetics. | Evolution (Biology)

Classification: LCC SF105 .V24 2018 | DDC 636.08/2—dc23 LC record available at https://lccn.loc.gov/2017031666

British Library Cataloging-in-Publication Data is available

This book has been composed in Cormorant with Serlio for display

Printed on acid-free paper. ∞

Printed in China

1 3 5 7 9 10 8 6 4 2

 "The Ascent of Mallard" by gradual artificial selection, to become the domesticated Indian runner duck. The possible reasons for this radical transformation are discussed in chapter 10.

To Husband,
naturally

~ Contents ~

Preface viii

Acknowledgments ix

Introduction xiii

Part 1: *Origin*

Chapter 1 ~ Problems with Pigeonholes 4

Chapter 2 ~ Plastic Animals 26

Chapter 3 ~ Darwin's Universal Law 56

Part 2: *Inheritance*

Chapter 4 ~ Colored Liquid; Colored Glass 72

Chapter 5 ~ A Question of Dominance 88

Chapter 6 ~ "Natura non Facit Saltus" 106

Part 3: *Variation*

Chapter 7 ~ The "M" Word 134

Chapter 8 ~ Common Threads 162

Chapter 9 ~ Terms & Conditions Apply 198

Part 4: *Selection*

Chapter 10 ~ Facets of Fitness 220

Chapter 11 ~ Islands of All Kinds 244

Chapter 12 ~ Between Dog & Wolf 266

Selected Reading 280

Index 282

~ Preface ~

Biology was my first love. It began when I was younger than I can remember and was effectively beaten out of me by my schoolteachers when they saw how well I could draw. I had a "God-given" talent. Therefore it was proper that I should follow a career in art, whether I wanted to or not.

It's a sad fact that many of the people in the privileged position of nurturing young minds begin their task by compartmentalizing, forcing polygonal pegs into round holes and snipping off any sprouting tendrils that dare snake their way toward square pegs next door. Pigeonholing continues all the way through life, of course, but right at the beginning, like the basic division between plant and animal in a taxonomic key, is the elementary segregation of science from art.

A few years can make a big difference during school education. My passion resurfaced, as passions always will, but regrettably too late to follow any course of formal study. Somewhere I still have the very kind letter from Professor Dawkins in response to my application to read zoology at Oxford: "I've never wanted so badly to accept an applicant based on enthusiasm alone, but sadly I feel that Katrina would struggle without a science background." It wasn't open for discussion.

What I missed through formal education I've gained the hard, slow way, without the benefit of tutors or peers. It's been tough. But a lack of mentors isn't wholly a bad thing. It can also force open new avenues of resourcefulness: a reliance on personal observation, intense thought, and reasoned questioning. And having to wrestle to gain an understanding of certain principles brings an appreciation of the pitfalls and hurdles, making it easier to explain the same principles to others. One of my previous book reviews began with the words, "Sometimes it takes an artist to create a masterpiece of scientific communication." While I'm obviously very flattered by this, I firmly believe it to be true.

Toward the completion of my last book I'd been looking forward to returning to the sort of artwork I'd been doing before—large dramatic drawings of towering sea cliffs spattered with teeming seabird colonies. But I discovered that its time had passed. Several of my artist colleagues have mourned my apparent abandonment of picture making as though I've died suddenly, leaving my masterpiece unfinished. I have not died, however. Neither have I ceased to be an artist. I've simply moved on.

The fact is that, for me at this time, producing my own unique, very beautiful books about evolution, which communicate this most profound and exciting field in all biology, is the ultimate expression of creativity. It ticks all the boxes and taps all my interests and skills—every facet of that polygonal peg. The artistic bit is not simply producing the illustrations; it's the entire creative and intellectual process. For me, right now, there is nothing finer, nothing more rewarding.

Art and science are not at opposite poles; they're not mutually exclusive, and pursuing both needn't be a compromise. In fact the two are better in combination. Pity the dry scientist or the airy-fairy artist with their narrow perception of the world! Together art and science add up to a richness and depth that far exceed the sum of their parts. It's the difference between looking at the world through one eye or two. And if, like me, you're good at one and passionate about the other, so much the better.

Passion should always be nurtured, even if it appears to be heading toward a dead end. My own path has been a dark one, yet, looking back, its meandering course seems perfectly obvious. The sorry tale of my botched though colorful career deserves to be told in a book of its own someday. Suffice to say, *this* book, *Unnatural Selection*, marks for me the journey back, full circle, to where I originally wanted to be, though richer from my years spent in other pastures. I'm more proud of it than of anything I've done before.

Although this unusual aberration is known as a "split" feather, it's not actually split, in a damaged sense, at all. Look carefully and you'll see that the two halves develop into perfectly formed feathers, each with a central shaft and two complete feather vanes.

~ Acknowledgments ~

This book began as a gesture of thanks. If you read the acknowledgments section of *The Unfeathered Bird* you'll know that while I was drawing, reading, researching, and writing, Husband meanwhile was slaving over a hot and foul-smelling stove boiling dead things, cleaning bones, and articulating skeletons in whatever posture I desired. You might also remember that it was he who persuaded me to include a few domesticated bird varieties. If you didn't know it already, Husband—Hein van Grouw—is a domesticated animal nerd, so I figured that the perfect way of rewarding him for his efforts was to produce a book about the things he loves best. Perhaps if he'd known how much extra work this would entail he'd have told me not to bother.

I wouldn't be exaggerating to say that 99 percent of the thanks I owe to others are due exclusively to him. I used his encyclopedic knowledge of domesticated animals as any researcher uses a library. He sourced the majority of my specimens. He cleaned, prepared, and mounted skeletons in postures accurate for each breed at the correct period. He pointed me in directions I'd find useful and piled my outstretched arms high with stacks of scientific papers. He patiently explained (on more than one occasion) the practical applications of Mendelian genetics and conducted breeding experiments with his own birds to test hypotheses. He took over housework duties (he insisted I mention that). He gave freely of his expertise on everything from the correct posture of a 1970s fantail to his newest unpublished research on color aberrations.

In addition to all this he did what every other long-suffering spouse-of-author does: he read every word several times over, discussed the book, listened to me talking about the book, listened to my accounts of my dreams about the book, my doubts and fears and worries about the book, until he was sick of hearing about the darned book—seven days a week for five long years. I could easily go on, but there are other people to mention.

It was actually surprisingly difficult to obtain the help I needed, even for apparently inoffensive requests like asking permission to photograph pedigree dogs or fancy goldfish varieties, and I'm sorry to say that most resistance came from fanciers in my own country. I managed to source everything I needed in the end, but a lot of precious time and energy were wasted. My only message in response is that they needn't have worried. I hope they read and enjoy the book and see that it is, as I had said, an objective analysis of their accomplishments in evolutionary terms, not a condemnation in any way. I strongly suspect that their reticence to help was a reflection not of their own practices but of their fear of the attitudes of the general public, often too quick to condemn based on a foundation of emotive sensationalism and insufficient knowledge. I hope this book goes partway toward balancing this prejudice.

Notwithstanding, "nothing pleaseth but rare accidents." It's time now to heap glory upon the individuals and institutions that did offer to help.

First, and most appreciated of all, were those who trusted and believed in me enough to donate the bodies of their beloved pet animals that had passed away. I can well understand how difficult this must have been and I'm not at all sure whether I would have the courage to do the same. To Mirjam Riekert, Anita van 't Klooster, and Julia Davies, then, our sincerest thanks for Alice, Amber, and Rosie.

Of immense value to the success of my task were the many bird and small animal fanciers (especially Husband's numerous friends and colleagues in the European pigeon and poultry fancy) who took the trouble to donate corpses of their deceased breeding and exhibition stock: ducks, pigeons, poultry, geese, canaries, and rabbits. Without them, this book would simply not have been possible. To Roy Aplin, Ian Hornsby, Alex Beylemans, Richard Hedges, Alan Wheal, Richie Brown, Dennis and Han van Doorn, Nico van Wijk, Hans Bulte, Graham Bates, Denise Moss, Aad and Ineke Rijs, Henry Verhees, Cees de Boer, Sjaak Hinke, Edgar de Poel, Jacob Janssen, Sytze de Bruine, Ad Boks, Rolinka Snijders, Rolf de Ruiter, Alois van Mingeroet, Arie van Roon, Kenneth Broekman, Hans Diehl, Bill Howard, Tony Jeffrey, and John Ross (whose excellent website *Darwin's Pigeons* is well worth a look)—your help is deeply appreciated. Special thanks in this category are due to Colin Ronald, one of the stalwarts of the British pigeon fancy and a close personal friend, and to the excellent Theo Jeukens, both of whom contributed above and beyond the call of duty.

To move up a step to larger animals, we owe an enormous debt of gratitude to our dear taxidermist friend Bas Perdijk. The many ways he's helped us and the many specimens he's provided for this book (including the zebu skeleton we still have in our living room) would fill more space than I have here.

Other preparators, too, have very kindly loaned or allowed access to prepared specimens in their private collections and workshops. We very much appreciate the help and hospitality of Will Higgs, Steven Porwol, Luke Williams, and especially horse-skeleton-preparator Walter Varcoe and his daughter Melissa. It's not every day that someone offers to put a horse skeleton together especially for you.

Access to museum research collections has also been vitally important, especially for a book that deals with historical specimens, extinct animals, and anatomical changes over time. Regrettably many museums treat requests from authors and, especially, illustrators as commercial inquiries, presumably without realizing the extreme level of penury the profession entails. Hefty bench fees (rarely covered by publishers of self-initiated book projects) are simply beyond our means.

Thankfully the majority of the museums I approached were highly civilized institutions whose curators appreciated the educational and research value of what I was doing and were only too pleased to help. I only wish there were more like them. These enlightened people were: the very charming and accommodating Marc Nussbaumer at the Albert Heim Foundation, part of the Natural History Museum of Bern, Switzerland; Renate Schafberg, tremendously helpful curator of the Julius Kühn Museum of Domesticated Animals at the University of Halle, Germany, and our former colleague Frank Steinheimer, the museum's director; Michael Schefzik, who allowed me to photograph the stunning Aurochs skeleton cast at the Halle State Museum of Prehistory—without a doubt one of the finest museums I've ever visited. Then there was Husband's successor, Steven van der Mije, at the Dutch national natural history museum, Naturalis; Mary Parrish, Kristen Quarles, and Chip Clark at the Smithsonian Museum of Natural History, who together enabled me to produce the drawing of the skeletons of Grover Krantz and his wolfhound, Clyde; and Brett Thorn, the archaeology curator at the Buckinghamshire County Museum, in my home town of Aylesbury. In addition, there was my friend Paolo Viscardi, former curator at the Grant Museum of Zoology, part of University College London; Andrew Crook and John Hutchinson at the Royal Veterinary College; the very gracious Malcolm Pearch at the small but excellent Harrison Institute in Kent, and his volunteer Isobel Chandler, who kindly helped me select the specimens I needed; my good friend Gina Allnatt, former curatorial assistant at the Oxford University Museum of Natural History, who helped me with my silkmoth drawing; Sally Davis and all her colleagues at the Abergavenny Museum, with grateful thanks for their permission to photograph and include the illustration of little Whiskey; Mark Omura at the Harvard Museum of Comparative Zoology—one of the most helpful curators I've ever had the pleasure to meet (and the lovely librarian there whose name I forgot to write down).

Thanks too to the Kennel Club of Great Britain for regular access to their excellent library; to Renate Lücht and Juan Valqui at the University of Kiel, Germany; to Richard Thomas at the University of Leicester's "Bone Laboratory"; and to Sarah Pearson, who allowed me to view the Lord Merton collection of Quagga and horse paintings at the Royal College of Surgeons.

Moving now to my correspondences, I'm very grateful to Barbara Narendra and Kristof Zyskowski at the Yale Peabody Museum, who helped in my search for "baboon dog" skeleton specimens, along with Jackie McCarthy from Harper Adams University, who assisted me in my unsuccessful quest for wingless chickens. Likewise, to Roberto Portela Miguez for his help with the Niata cow skull. Beekeepers Andrew Tyzack and Rebecca Bruce-Youles helped me with information about bees, and Sarah Robertson with Camargue horses. Dog breeder David Leavitt kindly sent photos of a skull from one of his superb Leavitt bulldogs. Andy Kahan and especially Carol Tashjian went to enormous personal trouble to photograph a particular specimen for me on exhibition in Philadelphia. Steve Bodio likewise spent a lot of effort in getting his pal Mark Cortner to send photos of his Mulefoot pigs' feet. (Incidentally it was Steve who helped me realize what this book was really about, before I even knew it myself.) Nathaniel "Nate"

A plaster bust of Charles Darwin (a wedding present from a friend) in situ on our living room bookcase—a daily reminder of the man, and his theory, that is the cornerstone of this book. *Unnatural Selection* was timed to commemorate 150 years since the publication of Darwin's *Variation of Animals and Plants under Domestication*.

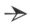

Marseglia—proud owner of Boris—was the winner of my Facebook "tabby cat photo competition" to select a cat for my illustrations in chapter 8, and Claudia Classon of Princeton University Press sent photos of her late beloved Cavalier King Charles spaniel, Corky, who appears in chapter 2.

My thanks also to Alison Foster, Thor Hanson (if you haven't read his book *Feathers* you really should), Alan Brush, Stephen Hall, Tom Whiting, and Hannah O'Regan—all of whom generously gave their time and expertise to help me in my research and provided me with scientific papers and other material.

We visited a vast number of farms, pigeon lofts, bird rooms, and smallholdings, some of which were already known to Husband; others were new to us both. We played with short-legged Munchkin kittens and admired magnificent Friesian stallions. Arno ten Have allowed us to examine and photograph his flock of Crested ducks; later the same day I was photographing the Pygmy pouters of Piet van Paridon. Wanda Swart and Berta van der Meer, among the few European breeders of longtail chickens, both provided us with valuable information, and Husband was able to visit Berta on one of his trips to Europe to learn firsthand about the molt patterns of different feather groups. Chris Leyland gave me a behind-the-scenes excursion through the Chillingham wild cattle herd, and Raf Bombeek (with thanks to Pierre Mallieu), at the opposite extreme, did the same with Belgian blues.

The nature of long-term projects of this sort is that they evolve and change direction. Thus there was a huge amount of material that never made the final cut, but all of it was necessary and the help very much appreciated. Brenda Dalton and Elizabeth Webster were genuinely interested in my project and made every attempt to procure a skeleton of a Caspian horse. I'm rather relieved that they didn't manage it, as I eventually came to realize that I didn't need one after all. Illness and ill luck prevented Richard McKown from preparing the fish specimens we'd discussed, and he felt truly awful that he wasn't able to get them done in time. Evolutionary geneticist John "Trey" Fondon wrote to me out of the blue (by amazing coincidence, at the very moment I was reading one of his papers) to offer access to his department's dog skull collection in Texas. At that time I was already busy with the canine skull collection in Bern, but his offer was no less appreciated. And my good friend Samuel Barnett eagerly helped with a multitude of things, none of which were eventually used; sorry, Sam!

There are a handful of people who will never see this formal acknowledgment of my gratitude but who nevertheless deserve to be included here. In particular, the artist and pigeon fancier Jan de Jong, a close and deeply missed friend of Husband, arranged exclusive VIP photographic rights for us over all exhibition livestock at the international championship pigeon and poultry show. Another pigeon man, Dave Willis, provided us with many specimens. Respected academic expert on domestication Juliet Clutton-Brock tragically succumbed to cancer before we had a chance to meet. Her daughter, Rebecca Jewell, a long-term associate of mine, read out my e-mailed questions to her in her final days, but she was unable to answer. My friend Steve Kacir met an untimely death through a heart attack, aged only forty-three. Although we knew each other for only a very short time, we connected in a special way, and I'd been looking forward to receiving his input at the molecular end of genetics. I wish he could have seen the finished book. And finally Robert Walker who, in the early days of this book, stepped in to help me when I was at my lowest ebb but, when his own turn came, was tragically unable to save himself.

To return to the living, I'm indebted to Mark Clementz for allowing me to share the poignant story at the close of chapter 2. Likewise to Marc Vincent, and the brilliant Darren Naish, for reading through my text and responding in such an agreeable way. And I'm especially grateful to Natee Puttapipat, whose stunningly beautiful handwritten annotations grace many of these pages. Darren, Marc, and Natee are also at the heart of my circle of new friends in the paleo-/tetrapod zoology world that has welcomed and supported my endeavors with open arms. Thanks, too, to my generous Patreon patrons; I only wish such excellent schemes as Patreon had been in existence long before now, enabling creators like me, who slip through conventional nets, to be able to continue to work without compromise.

Those who share my taste in music might recognize the names *Unnatural Selection* and *Between Dog and Wolf*. It's unlikely that either Muse or New Model Army will ever know that I "borrowed" their song/album titles, but if they do, I hope they'll take it as the tribute intended.

There are simply too many people instrumental in bringing a book into existence—not to mention publicizing and marketing it—for me to mention them all individually, and it's very likely that there are some whose names I don't even know. So last, but definitely not least, I'd like to thank *everyone* at Princeton University Press for their kindness, enthusiasm, and unwavering faith in me and my books.

~ Introduction ~

This is a book about selective breeding.

Although that's something that happens to captive animals, including domesticated ones, it's not the same as domestication. Domestication is what happens first—the transition of wild animals to self-sustaining populations of tame ones. This book is about what happens after that: the continuous metamorphosis of those tame populations into more beautiful, more useful, more productive, more efficient, or simply different versions of their former selves. Most of all, this book is about selective breeding on a much, much bigger scale, a scale that includes transformations in all wild animals (and plants too). We'd call it evolution.

While there are a lot of people nowadays making a big scientific fuss about domestication, selective breeding—a poor, humble Cinderella of a subject—has been virtually ignored. To say that this book is entirely unique, however, wouldn't be strictly true. There was another. It was published in 1868, exactly 150 years ago. The author was Charles Darwin.

The Variation of Animals and Plants under Domestication (usually referred to simply as *Variation under Domestication* or even just *Variation*) wasn't, I'm sorry to say, Darwin's finest accomplishment. It wasn't anywhere near as lucid or as focused as even the first chapter of *On the Origin of Species* (also called "Variation under Domestication") where he'd first made his eloquent analogy between selective breeding and his theory of evolution by natural selection. (Don't worry if you don't already know the historical background to this, it's all explained in chapter 3.) *Variation* (the book) was intended to expand on *Origin* and, most of all, to put forward a way in which the subtle variations between individuals might be inherited. Unfortunately, Darwin didn't have the answer.

The first thing I'd like to make clear is that I haven't always been an authority on selective breeding. That's Husband's field, and, until he came into my life about a decade ago, I was as biased against the achievements of animal fanciers as the majority of other modern naturalists. That is to say, I was ignorant, and proud of it.

We met and fell in love during the European Bird Curators' Conference in Vienna in 2007. At that time I was a curator of the bird collections at the British Natural History Museum and Hein van Grouw was the collections manager of birds and mammals at the national natural history museum of the Netherlands. Imagine the scene if you will: a candlelit dinner in the spectacular museum rotunda; admiring the view from the oculus under the stars with all the lights of Vienna stretching beneath us reflected in the dark waters of the Danube. The unspoken chemistry pulled us together by invisible threads, alone in that beautiful, romantic space oblivious to the people around us. It was roughly at this point that the man who was to become Husband shattered the illusion by telling me he kept pigeons.

Pigeon fanciers, at least in my country, wore flat caps and white coats with club badges sewn on. They were at least sixty, in attitude if not in actual years. They were not, generally, hot. I found the idea hilarious, and slightly disconcerting.

How foolish I was not to take fanciers more seriously. Oblivious was I to the fact that many of these men (and women too), in their own way, know at least as much about birds as any museum ornithologist or field birder. In their highly skilled hands pigeons are but putty that can, within a few generations, be molded into any shape and remade in virtually any color. Fanciers can fast-forward evolution like an H. G. Wells time machine. They can transfer a single trait from one variety to another without introducing unwanted traits; change a posture from horizontal to vertical; lengthen feathers in one body part and not another; or produce new combinations of colors and patterns. Animal fanciers were the masters of genetics long, long before Bateson first used the word, before Mendel's experiments with peas and before Darwin as a young man even set foot on the *Beagle*. They've produced greater diversity in individual species under domestication than exists, or has ever existed, anywhere in the natural world. And yet many modern advocates of biodiversity, from professional biologists to armchair naturalists, so readily dismiss and even revile their accomplishments.

Skeleton of an English short-faced tumbler, one of the oldest recognized fancy pigeon breeds and a special favorite of Charles Darwin. It's particularly associated with the almond pattern described in chapter 5, which has presented a challenge to breeders for many centuries.

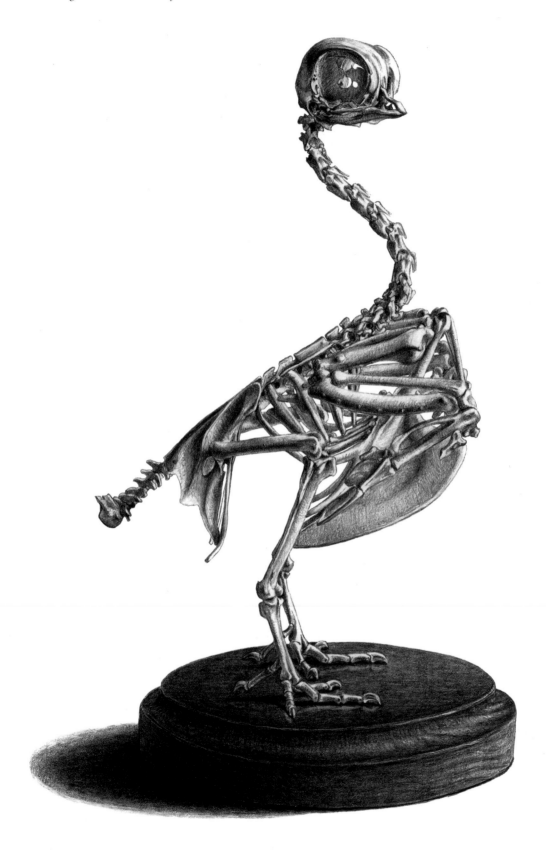

Husband, it turns out, has spent his life breeding fancy (exhibition) pigeon varieties—but not for exhibition. He's also bred chickens, gerbils, canaries, budgerigars, and barbary doves and made an extensive lifetime's study of the variant traits (particularly color aberrations) shared by species throughout the animal kingdom. He's spent decades experimenting in a way that would have delighted Darwin: for example, breeding the silkie mutation into Frillback pigeons to find out whether feather barbs play a part in feather curls; using the pointing mutation to decipher whether silkie-feathered birds are more susceptible to the cold than normal-feathered ones; producing a hybrid between a white chicken and a white pheasant to see if leucism shares the same inheritance in both species. The list goes on.

Darwin too was happiest when he was observing living things and carrying out his own experiments. They ranged from testing the effects of seawater on seeds in an effort to understand the colonization of oceanic islands to studying the senses of earthworms by observing their responses to different musical instruments. One of my favorites is his method to test the correlation between eyesight and hearing in very young kittens. Darwin had observed that kittens appear to be unresponsive to sound until their eyes have opened at around nine days. This was Darwin's method: (1) creep up to a nest of kittens, carrying brass poker and shovel, being careful not to make any sudden vibrations; then (2) bash poker and shovel together to make as much noise as possible! The kittens slept on, unfazed.

We recently watched our little troupe of bantams foraging in the garden. (Being Husband's birds, they're not recognized breeds but a motley collection of interesting genetic traits.) There were obviously a lot of good things to eat under the woodpile, but only the birds with the trait for shortened limbs could squeeze into the small gap—the others had to remain on the outside and listen to them feasting. Darwin's conclusion would have been the same as ours: if food had been scarce, the short-legged individuals would have a better chance of survival than the normal ones.

I've divided this book into four parts of three chapters each: "Origin," "Inheritance," "Variation," and "Selection." The first, "Origin," lays the foundation for the rest.

The book begins with a look at our system of classification, devised by Linnaeus long before the evolutionary relationship between living things was accepted by science. While the system works well for the most part—with the majority of animal and plant species appearing to be static and unchanging—it is, after all, an artificial structure entirely at odds with the gradual nature of evolution. Nowhere are the cracks more obvious than in how the system deals, or fails to deal, with domesticated animals.

Animals are plastic, ever-morphing things. Their appearance undergoes seamless transformations from one geographical location to the next and steadily over time; sometimes branching into two or more forms when before there was one. While the changes in wild animals tend to take place over unobservable eons, in domesticated animals they can be recorded within a single human lifetime. This branching plasticity is the subject of chapter 2.

The third chapter introduces Darwin's theory of natural selection, which, like any natural law, works on an elegantly simple formula of component elements. There are two ingredients: selection and variation. But in order for natural selection to work, the variation has to be heritable. This was Darwin's sticking point, and is the subject of part 2.

"Inheritance," the second part, begins with blending; the qualities of either parent mixed together to produce offspring intermediate between the two. Blending had, for centuries, been the accepted explanation of how inheritance works, but it entails a loss of variation at every step. Darwin's theory, on the other hand, required a steady stream of new variation. In other words, Darwin had a problem.

The actual mechanism for inheritance discovered by Mendel, along with just a few of its many complexities, is the subject of chapter 5. Mendelian inheritance and Darwinian natural selection should have been a match made in Heaven and, had Darwin still been alive when Mendel's work was plucked from obscurity, I have no doubt that it would have been received by him with open arms. Unfortunately the followers of both camps were divided over the question of whether evolution progressed by giant leaps or small steps, a debate that's the subject of chapter 6.

At this halfway stage in the book, shortly after the close of the nineteenth century, it's time to bid farewell to Darwin and his followers and to return to the prerequisites for natural selection.

In chapter 7, the first chapter of part 3, "Variation," I introduce a new and emotive word: "mutation." Despite their association with freaks and monsters, mutations are, in fact, the original source of all variation: just tiny random changes in the way that DNA is copied that can result in major physical differences, or minute ones.

That the same, or very similar, mutations can occur in very different animal groups is the subject of chapter 8, while chapter 9 reminds us that genes are not buttons that can be pressed to magically produce guaranteed results. Traits that evolve under certain environmental conditions often require the same conditions in order to be fully expressed. The environment—internal as well as external—is equally as important as genes.

Moving on to the fourth and final part, "Selection," chapter 10 looks at the many different facets of selection—some of them working in opposition to each other—and their counterparts between wild and domesticated animals. The effects of reproductive isolation on populations and the way that their future evolution can subsequently be influenced by the random action of accidental forces are addressed in chapter 11.

Up to this point the book has dealt exclusively with selective breeding, arguing that artificial selection is comparable with other evolutionary processes and an excellent analogy for Darwin to have used to explain his theory of natural selection. It's only when we get to chapter 12 that I introduce the process of domestication itself and, once again, I consider it as an evolutionary one—not so much a "thing we do to animals" but a gradual process of mutual symbiosis in a world increasingly dominated by humans.

This book is intended, with the benefit of a century and a half of hindsight, to be something akin to what Darwin might have produced as *Variation under Domestication*, had he only had that elusive missing key—an understanding of how inheritance works. In the spirit of his first chapter of *Origin* I've made the case that Darwin's analogy between natural and artificial selection was appropriate in more ways than he could ever have known. Although the book includes a strong historical element, it was not my intention to attempt to write a history of evolutionary achievements. I've kept the focus deliberately on Darwin and the challenges he and his theory encountered up until the beginning of the Modern Synthesis. Although it's been extensively researched from a variety of published sources (there's a selected reading section at the end, though it was impossible to include everything), I've made good use of Husband's extensive knowledge and lifelong experience, combining this with my own interest in evolutionary biology to produce what I hope will be considered a scholarly book, but one brimming with firsthand observations in the style of Darwin himself.

My hopes for *Unnatural Selection* are many and diverse. Obviously I'm praying that it will get good reviews, that it will be stocked by bookstores and libraries all over the world, and that people will flock to buy it. If I allow my imagination to run really wild then it'll maybe even win a prize (boy, I'd *love* to win a prize). My primary hope, however, is that it will encourage people to look at domesticated animals and their environment in a different way, or rather in the same way that you would consider any other animal in its environment. It's time to stop thinking how badly a pet dog would fare in "the wild" and realize that the man-made environment is just an environment like any other. There will likely be pet dogs in the world long after the wolves have all been obliterated. Pet dogs—even the ones with short noses—are, like it or not, an evolutionary success. As I say at the end of chapter 7, my response to anyone complaining, "Look what humans have done to the Pekinese," is to reply, "Look what flowers have done to Sword-billed hummingbirds"!

I have another hope, too. It is that, like my friend's dad whose story is told at the close of chapter 2, one or two skeptics out there might just be inspired to reconsider their views about evolution, perhaps reaching the opinion that it's not such a bad, such a cold, and empty place after all. I wish this, not through any crusader's desire for conquest, but in the same way that anyone might want to share something they find beautiful and moving. Natural selection is indeed a terrifying concept to the human mind. But it also has a profound, breathtaking magnificence and an exquisite poetry. It takes courage to step into the abyss (I've taken that step myself), but, as I'll say again in chapter 3, there is a path, and the view is sublime.

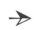

With such astonishing diversity within single species it's remarkable that biologists since Darwin have not paid greater attention to artificial selection. Domestication allows us to see a few of the variations that might have been favored by natural selection under different circumstances—maybe indeed recognize some that were favored. And selective breeding allows us to explore their genetic and developmental boundaries.

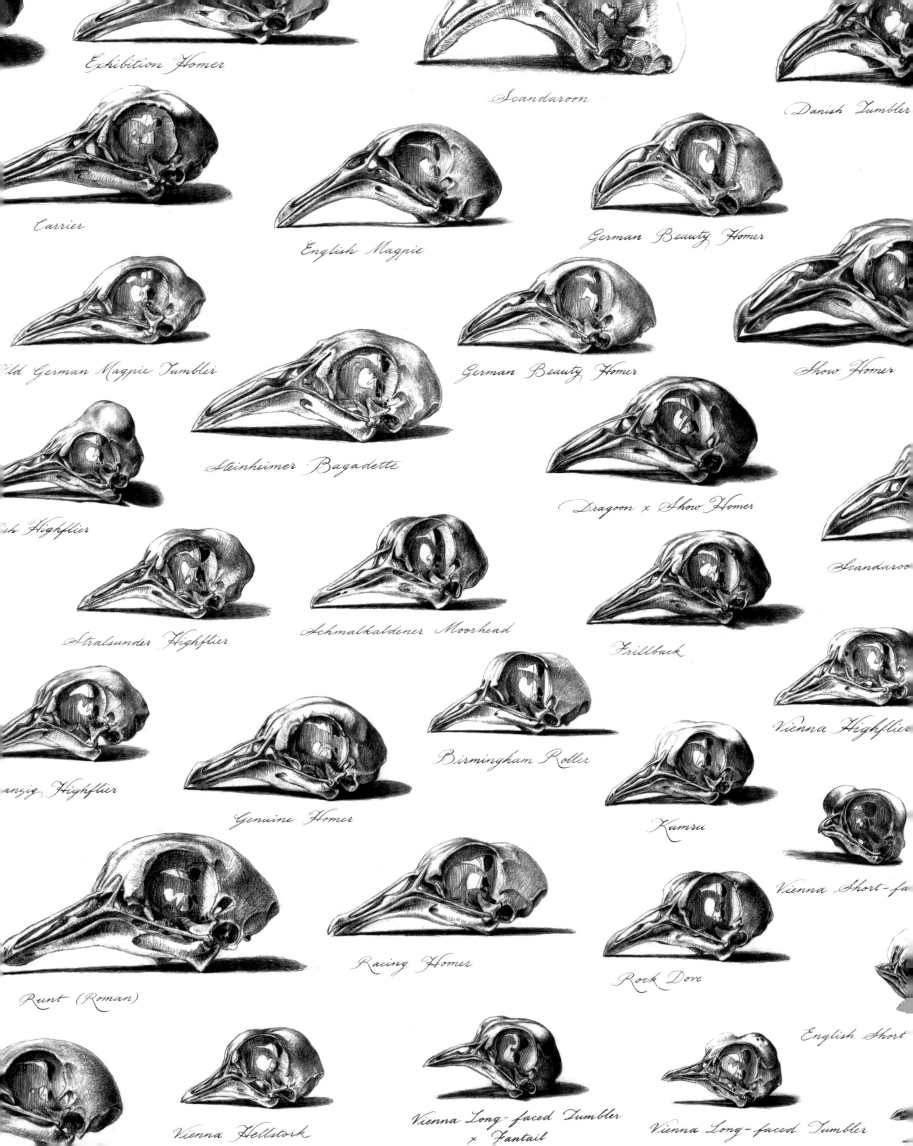

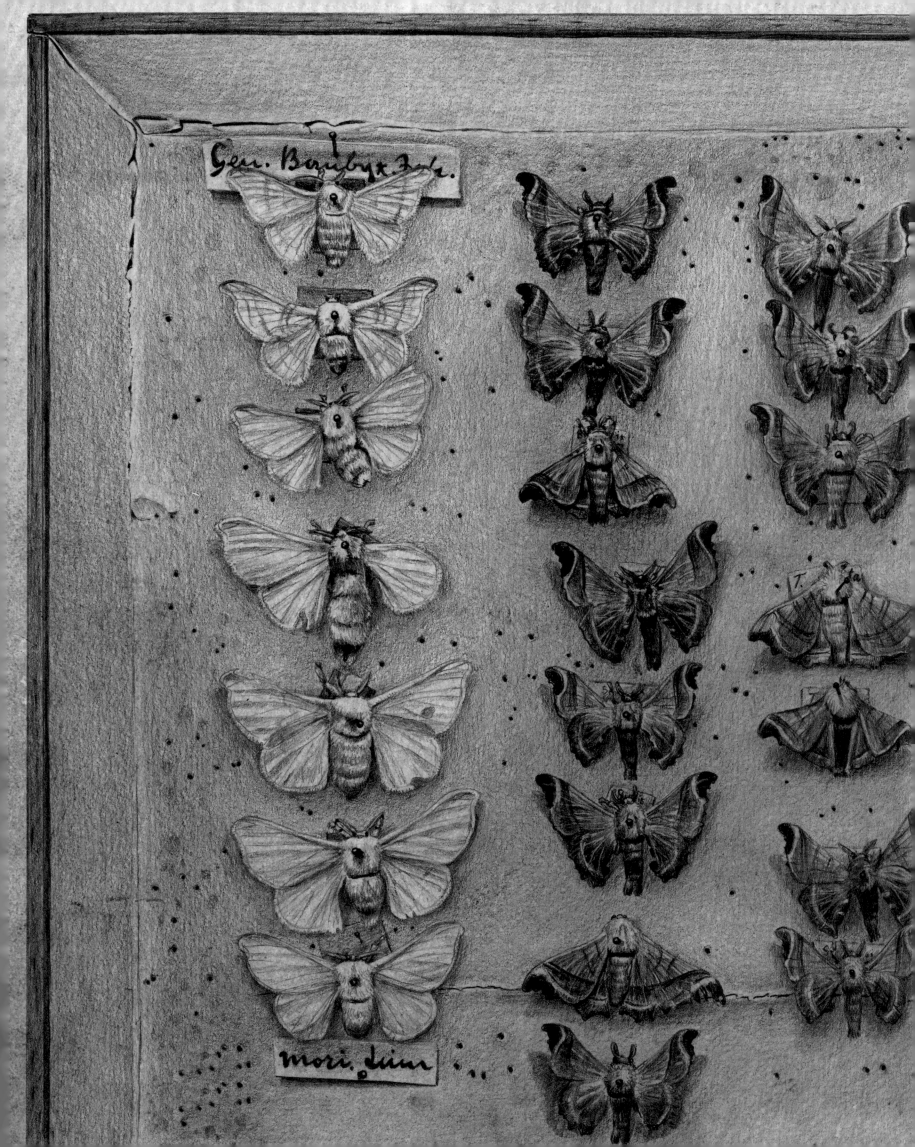

I
ORIGIN

1. Problems with Pigeonholes

1 ~ Problems with Pigeonholes

Names are important. They're a sort of code—an abbreviation, allowing us to communicate without ambiguity or the need for lengthy descriptions. Like any code, the only way a name can be useful is if it's understood by everyone using it. In a small community it makes no difference if everyone calls a Song thrush a Mavis or a Surf scoter a Skunk duck—one name is as good as another as long as the whole population can relate to it. However, a visiting alien or other explorer hearing the words "Bog bull," "Butterbump," "Mire drum," or "Thunder pumper" could be forgiven for assuming they belonged to four separate types of animal when in fact they're all names for a single species: the American bittern. We all know that the single word "robin" refers to two very different birds on either side of the Atlantic. A Butterfische in German is a Rock gunnel fish in English, while a Butterfish in English is a Medusenfische in German.

There's nothing actually wrong with any of these names. They've simply been taken out of their geographical confines to realms where their meaning has been lost or changed. When the community in question is the international scientific community, misinterpretation is only avoided by the use of the most rigidly strict rules—rules to prevent duplication of names, rules to prevent the same name being used for more than one thing, and rules to dictate the form a name must take.

There's only one problem with this: when rules are so inflexible, they can't adapt to changes in understanding. They may make provision for advances in knowledge, but that's another thing entirely.

Our system of zoological nomenclature belongs to a pre-Darwinian era. It was developed by Swedish botanist Carl Linnaeus in 1758 in the celebrated tenth edition of his *Systema Naturae*, though, as with most great achievements, Linnaeus was building on foundations laid by others before him, perfecting a system that was already in place. The same principles are still in use, upheld by the International Code of Zoological Nomenclature (ICZN), often referred to simply as "the Code."

Living as we do, in the third century AD (Anno Darwin, that is), we've had a long time to come to grips with the idea of evolution and to be conditioned to expect classifications of living things to reflect *actual relationships* between and within species. It's almost impossible for most of us to imagine the concept of living things *not* being related to one another. Linnaeus's intention, however, was to group similar things together simply as a means of classification. Similar species were grouped into genera, similar genera into orders, orders into classes, and classes into kingdoms. Only species and genera were considered by him to reflect affinities in nature, which he described as "God given"; the other levels he thought of as merely artificial groupings for the sake of convenience. Indeed, he adopted as his own personal motto "Deus creavit, Linnaeus disposuit" (God created, Linnaeus organized). In pre-Darwinian thinking, classification was purely an attempt to organize God's creations into groups, and the groups into ever larger groups of diminishing similarity. Classification, in its purest form, is an entirely separate discipline from phylogenetics—the organization of living things according to their evolutionary relationships. There's actually no logical reason why it shouldn't be simply an effort to make sense of the organic world and to categorize every animal and plant according to its usefulness or harmfulness, habits or habitat. And that's precisely how it had been for the better part of history—no different from keeping pearl buttons, black buttons, and brown buttons in different

 A drawer of silkmoths in an entomology collection cabinet. The large white moths are the domesticated and flightless *Bombyx mori*. Notice how bulky their body is compared with their relatively tiny wings. The better-proportioned, dark-patterned moths are *Bombyx mandarina*, their presumed wild ancestor. Different names, and different appearances, don't prove that animals are of different species.

compartments of a sewing box. It's pure serendipity, then, that Linnaean classification, drawn in diagrammatic form, results in a familiar treelike structure with tiny branches sprouting from larger branches and so on, ultimately springing from a single trunk. It provided a ready-made framework on which biologists could eventually hang taxa according to their rightful place in evolutionary history—a phylogenetic tree of life.

Such a sublimely elegant taxonomic system appears at first glance to dovetail perfectly with our modern understanding of biology—so much so that we tend to accept it without question. In truth, our practical need to pigeonhole things into distinct categories is at odds with the natural world itself, and arbitrary lines of distinction hinder us in recognizing the presence of the intermediate forms—the "missing links"—we're always seeking. Darwin himself saw the difference between species and race, race and variety, variety and individual as purely arbitrary. Whatever system is used, taxonomy—the science of naming and defining organisms—is an artificial constraint attempting to freeze in time a process that is ever changing; to separate the components of a process that has no truly distinct parts and that works only in unison with every other living thing and its environment.

With wild animals the discipline works tolerably well. Evolutionary change usually works slowly enough for us to convince ourselves that species and races are genuinely divided. It's when we turn to domesticated animals that the cracks appear. Domesticated animals are not separate from the rest of the animal kingdom. They're subjected to evolutionary forces directly comparable with the forces that shape wild animals, and they too evolve to fill the niches presented by a world increasingly dominated by humans. The difference is that domesticated animals change fast.

A universal system of naming requires a universal language. Latin was chosen, though many names are Greek or Latinized versions of other words. (That's why it's better to refer to them as scientific names instead of Latin names.) Instead of using a descriptive passage of text, Linnaeus adopted a two-part name—a binomial. The first part of a scientific name is the generic name, always written with a

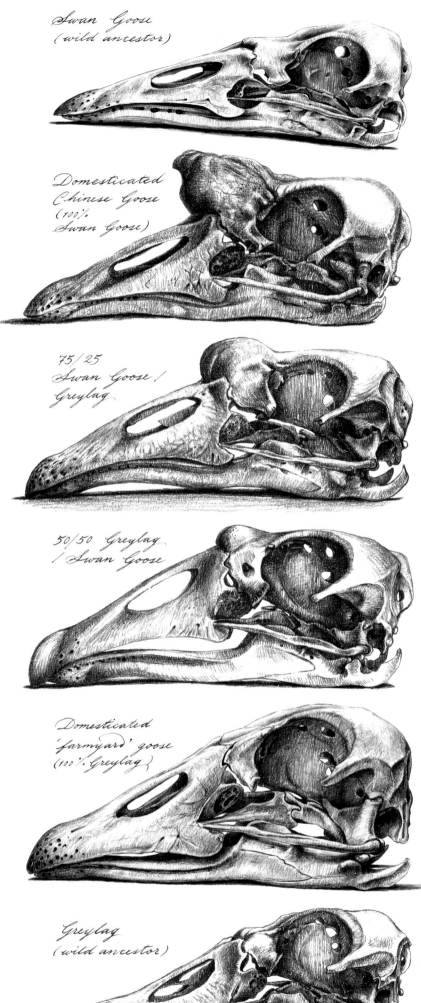

Unlike most domesticated animals, geese have two wild ancestors: the slender, long-billed Swan goose and the bulkier Greylag goose. They interbreed readily and produce fertile offspring, flaunting the established rules that traditionally define species boundaries. Even some recognized breeds are hybrids between the two species.

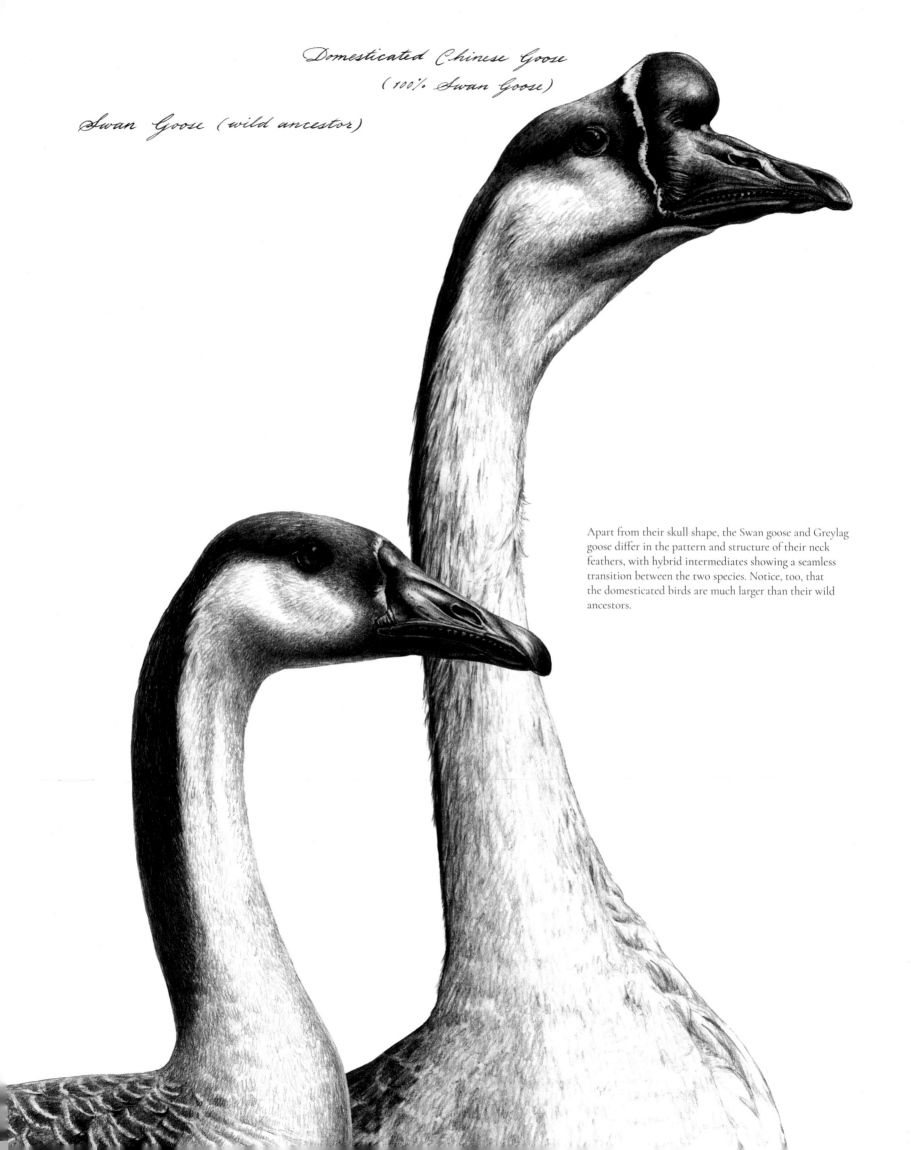

Domesticated Chinese Goose
(100% Swan Goose)

Swan Goose (wild ancestor)

Apart from their skull shape, the Swan goose and Greylag goose differ in the pattern and structure of their neck feathers, with hybrid intermediates showing a seamless transition between the two species. Notice, too, that the domesticated birds are much larger than their wild ancestors.

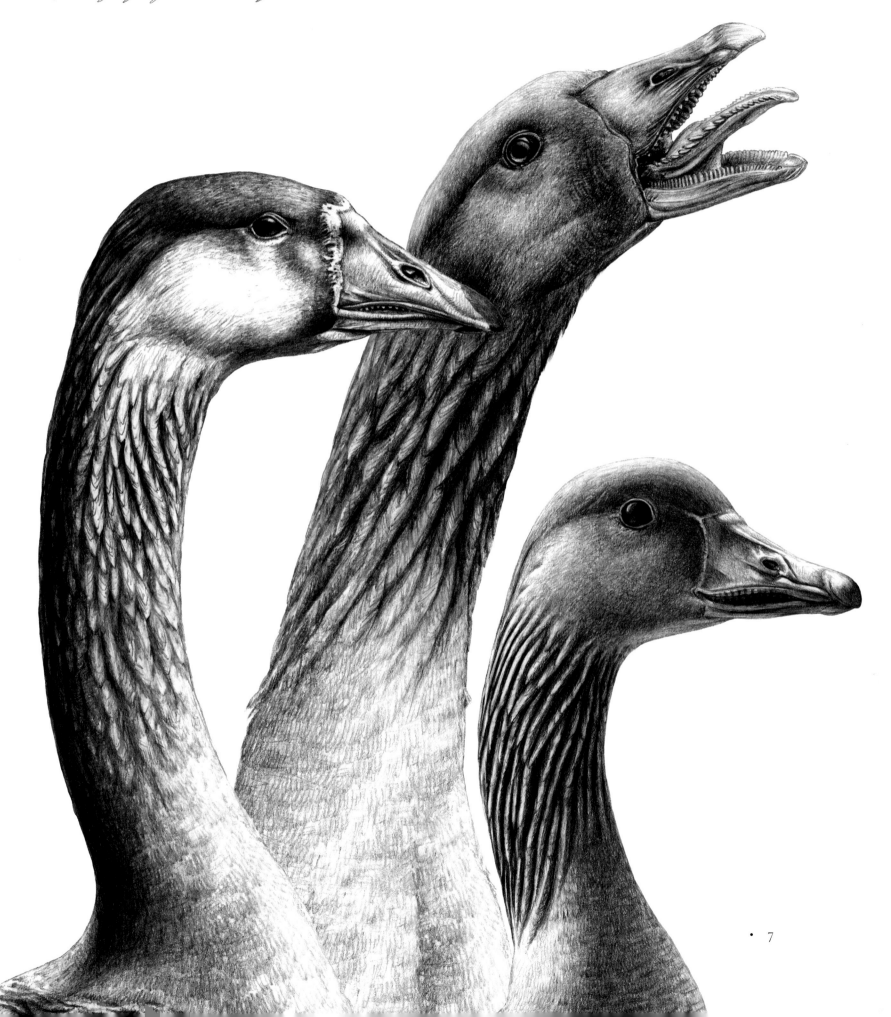

50/50 Greylag / Swan Goose *Domesticated 'farmyard' goose (100% Greylag)* *Greylag (wild ancestor)*

capital letter. This name puts each species in the company of other, similar species. Most bears, for example, share the generic name *Ursus* and that name can't be used for any other genus in the animal kingdom. This is followed by a specific name that gives the species, which is always written in lowercase—even if it refers to a country or person. Only the American black bear is called *Ursus americanus* although lots of animals of other genera have the specific name *americanus*.

In order to name something, you need to be able to define the parameters of that thing—to know categorically when it ceases to be one thing and becomes another. Species are defined as populations of animals that interbreed to produce fertile offspring so, superficially at least, it forms a clear-cut, standard unit. However, species with wide geographical ranges often show a marked degree of regional variation, and these differences give the option of a third name, after the specific name, designating the race or subspecies. The binomial now becomes a trinomial. American black bears from California, for example, are called *Ursus americanus californiensis*.

Deciding on whether races belong to their respective species or deserve to be considered species in their own right is more than enough to keep most taxonomists occupied for life. There are even historical trends for lumping and splitting species and races back and forth. One thing that different races will readily do, and different species *generally* won't, is interbreed, which seems to present a fail-safe way of defining, once and for all, where the parameters lie. However, just because two animals *don't* breed together in practice—for example, if two populations are physically separated—it doesn't necessarily mean that they *couldn't* interbreed if they were reunited. There's the question of how they became separated, and of how long ago, so it's impossible to know where to draw the line. And two species that may never cross paths under normal circumstances may easily do so in captivity.

By defining a species as something that can only interbreed (and produce fertile offspring) with others of the same species, you're effectively denying any possibility that species can interbreed—otherwise they wouldn't be species. But animal species do hybridize, and they do produce fertile offspring. And for evidence you only need to look, once again, to domesticated animals. Take geese, for example.

Geese are among the few domesticated animals that have not just one but two wild ancestors. I don't just mean subtle genomic differences that suggest a hybridization event early on in their domestication history. No, purebred geese that derived from two totally separate species—the Swan goose, *Anser cygnoides*, from Central Asia and the Greylag goose, *Anser anser*, from Central Europe—hybridize readily and regularly. Out of any mixed farmyard flock it's normal to find a substantial number of hybrids between the two. Even several recognized breeds, like the Steinbacher from Germany, are hybrids between the two parent species. The domesticated forms of the Swan goose are the sublimely elegant Chinese goose and the more heavyweight African goose. Although Swan geese have a slender head and bill like a swan, with only a subtly raised "knob" at the base of the bill, both of the domesticated varieties have a deeper skull, and the bill knob is positively enormous. Both, however, share the Swan goose's unusually smooth silky neck feathering and (unless they're leucistic) the deep chocolate brown stripe running from the crown to the base of the neck. Greylag geese have a much deeper, more powerful bill than Swan geese and have the deeply furrowed feathering down the neck so typical of the majority of goose species. Straight crosses between the two are intermediate in every respect: a faintly two-tone, slightly furrowed neck and a medium-weight, moderately angled bill. Three-quarter crosses either way have more of the qualities of that species.

Interbreeding isn't simply a matter of willingness. The fertility of the hybrid offspring is generally considered to be the real test of whether two animals belong to the same species. You can cross lions and tigers together to produce (depending on which parent is which) ligers and tigons, but only very rarely will one of these be capable of contributing to offspring of its own. However, fertility between two species isn't necessarily all or nothing and, once again, it's in domesticated animals that the exceptions are revealed. There are varying degrees of fertility between individuals—and between sexes. Occasionally failure to produce viable offspring is simply a boundary that can be crossed with perseverance.

A perfect example is the Bengal cat, a hybrid, not between two species in the same genus but between two different genera: the domesticated cat and an exotic wild species, the Leopard cat, *Prionailurus bengalensis*, from East Asia. Allegedly, only male cats of the first few generations are sterile, whereas females retain their fertility throughout, and

When animals change over time, the definition of their name changes with them. The animal that we associate with the name "English bulldog," for example, is very different from its personification of 150 years ago. Domesticated animals evolve more quickly than their wild counterparts, raising interesting questions of semantics.

Geneticists have been attempting to re-create the extinct Aurochs—the magnificent wild ancestor of virtually all domesticated cattle—since the early twentieth century. But even if their creations look, and behave, like aurochsen and share aurochsen genes, does this necessarily make them aurochsen? This drawing was made from a cast (but no less impressive) specimen at the excellent State Museum of Prehistory in Halle, Germany.

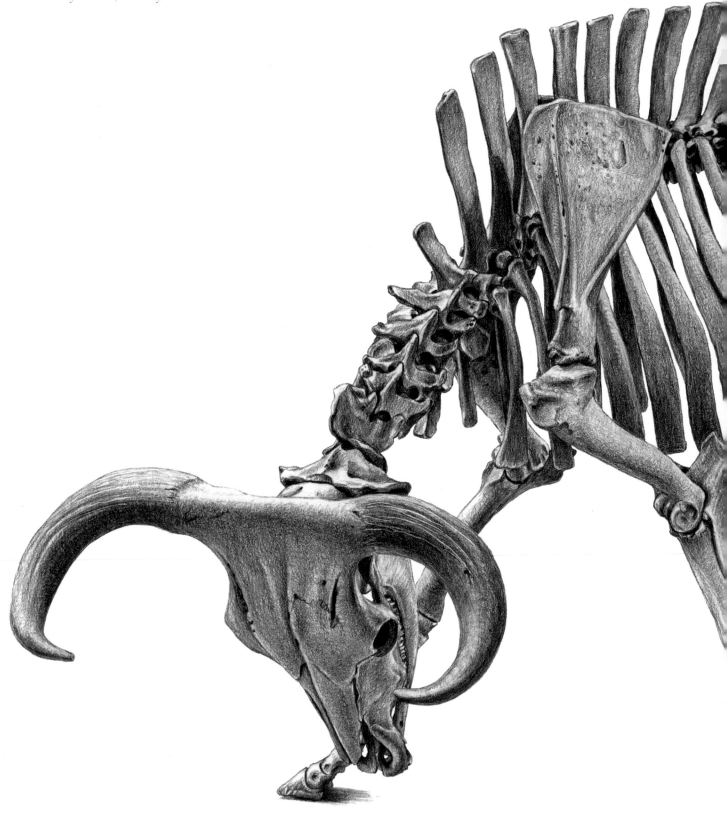

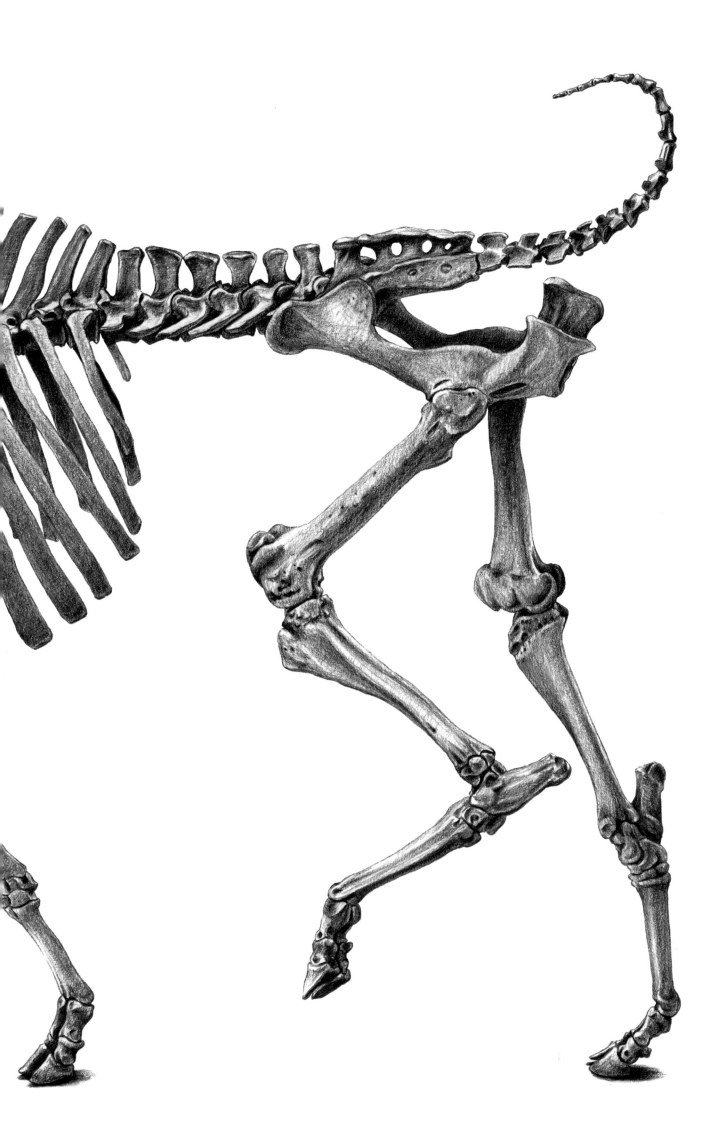

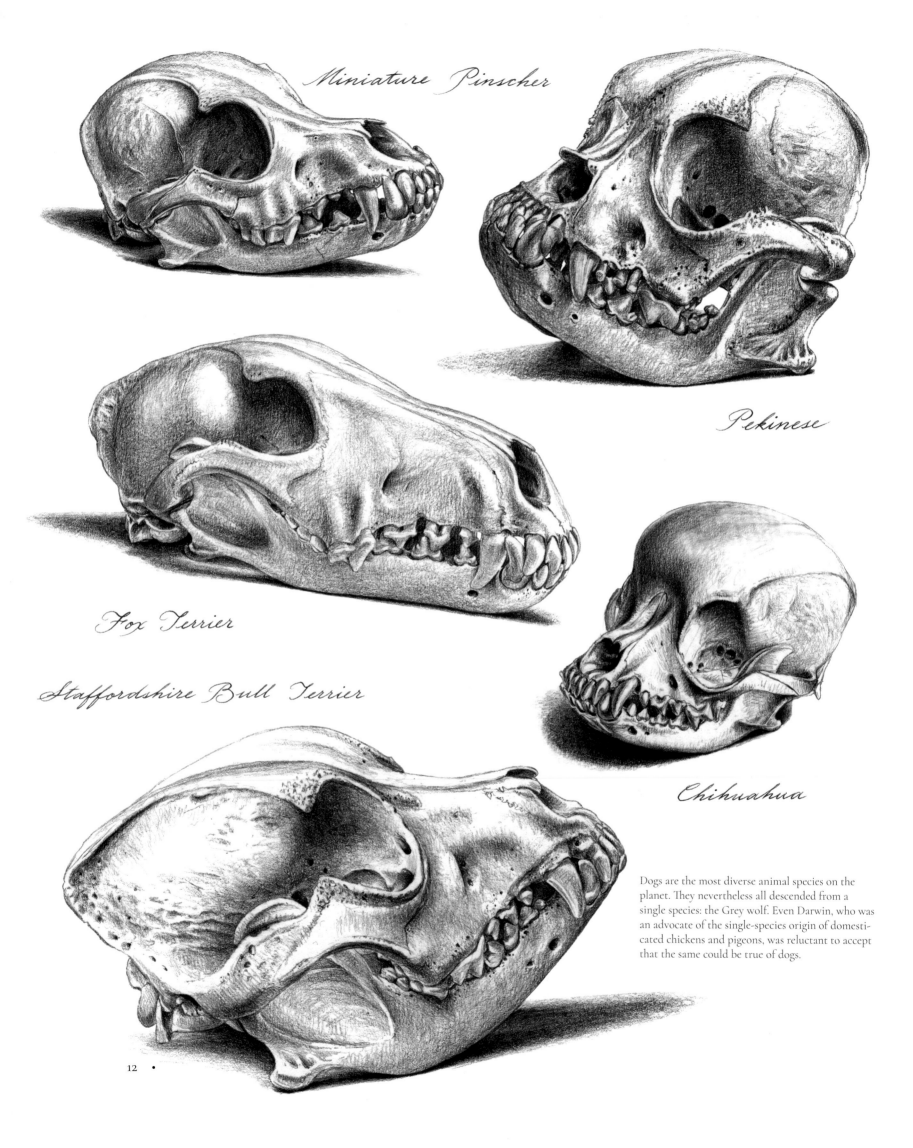

Dogs are the most diverse animal species on the planet. They nevertheless all descended from a single species: the Grey wolf. Even Darwin, who was an advocate of the single-species origin of domesticated chickens and pigeons, was reluctant to accept that the same could be true of dogs.

it's only after the first four generations or so that hybrids lose their wild nature and behave as confident, inquisitive house pets. Bengals are now both popular and plentiful. But despite their establishment as a recognized breed, there's absolutely no provision in zoological nomenclature for Bengal cats or Steinbacher geese, no matter how many generations their pedigrees extend.

Names, as I said at the opening of this chapter, are important. But it's not just a question of everyone understanding the meaning of a name but whether the object of the name—the thing that it stands for—remains constant. Animals change over time, and domesticated animals can change radically within a single human generation. When do we cease using one name and begin using another? If we continue to use the original name for a changing object then the definition of the name changes with it. What then do we do if a fraction of a population changes in one way while the rest remains static, or changes in another direction?

An excellent example is the English bulldog, which we'll come to again later, along with other former working breeds, in chapter 10. The expressions "British bulldog," "Darwin's bulldog," and so forth all conjure up images of the pedigree English bulldogs we've become accustomed to seeing in dog shows—a broad head, undershot jaw, and a short, upturned muzzle. In fact these phrases were coined at a time when bulldogs looked very different indeed. Anyone today seeing a bulldog of the mid-nineteenth century, with its relatively long, straight muzzle, would deny that it's a bulldog at all. So when breeders have attempted to re-create this type of animal (not for the baiting of bulls but as a healthier, more active dog; fit, in theory if not in practice, for its original purpose), they've been opposed, ironically, by hard-core enthusiasts who claim that their creations "are just not bulldogs"!

Now let's look at the same question turned on its head. If two animals are technically the same species, are the same race, look alike, and act alike, but are separated by some other factor, such as time, are they the same?

In the closing years of the Weimar Republic, brothers Heinz and Lutz Heck—both scientists with a keen interest in the newly emerging field of genetics—set themselves a challenge: to re-create, by selective breeding, the extinct Aurochs, the formidable wild ancestor of domesticated cattle. (If it seems strange to end a singular noun with an "s," think of it as an "x" instead, giving aur-ox, and aur-oxen for the plural. It suddenly sounds familiar!) The last wild Aurochs died in Poland in 1627. They must have been spectacular and terrifying beasts. Julius Caesar revered the aurochsen and wrote of them, "They cannot be brought to endure the sight of men, nor be tamed, even when taken young." It's hardly surprising that the idea of bringing back such an iconic emblem of national megafauna was so attractive to Germans at that time. The brothers received funding from Hermann Goering, a founder member of the newly emerging National Socialist Party and a passionate hunter. They worked independently; Heinz, the director of the Hellabrunn Zoological Gardens in Munich, used mostly northern cattle breeds including the Hungarian grey and the Scottish highland. Meanwhile Lutz, director of the Berlin Zoological Gardens, used southern breeds including Spanish fighting cattle and the Camargue cattle of southern France.

Although the resulting Heck cattle never attained the size and stature of aurochsen, and differed subtly in their body and horn shape, the attempt has sparked off other, more scientific, attempts in various European countries, most notably the Taur-Os program in the Netherlands, so it's only a matter of time before there are Aurochs lookalikes once more. But will they be real?

Although virtually all domesticated cattle are descended from aurochsen, could theoretically still breed with aurochsen, and could now be made to look and behave like aurochsen, they wouldn't necessarily *be* aurochsen. To me, the challenge of re-creating an extinct animal from domesticated ones seems comparable with emptying a cup of water into a lake and then trying to retrieve the exact same cupful again. The lake water here represents all the mutations, divisions, recombinations, and extinctions that have happened to the genome since true aurochsen disappeared. And perhaps we should, after all, ask ourselves, "Why?" With the majority of large mammal species under threat of extinction (we can't even preserve our rare breeds of livestock!) maybe we should secure the future of what we still have and, above all, slow the growth in human population before we consider resurrecting animals we ourselves drove to annihilation.

But let's get back to scientific nomenclature. If you discover a new species, naming it is only one of three things you have to do to make it official. The most important thing is that the description is published in the scientific literature. Also, there should ideally be some physical evidence on which to attach the name. This is usually one or

more preserved specimens called "type specimens" that are then deposited in a major museum, but illustrations, or photographs supported by DNA samples, can, under exceptional circumstances, act as substitutes.

Of course, scientists are not infallible. Individuals discovering the same animal in different places publish their own names and descriptions independently. Sometimes this is done entirely innocently. Other times it's a cutthroat competition to publish first. There's just as much likelihood of ending up with four Latin equivalents of Thunder pumper and so on in the scientific literature as in colloquial use, but when the synonymy is realized, priority is given to the first description published and the other three will be abandoned. Equally, two or more species might be found to share the same name. This happened not infrequently in the days when people collected specimens in preference to observing behavior. In these instances one species is kept under the original name and the others split off and assigned new names. Often color mutations were erroneously described as new species. (Husband has single-handedly saved a "species" from presumed extinction merely by proving the only specimen in existence to be an aberrantly colored individual of a familiar existing species!)

The ten thousand recognized bird species and the five and a half thousand species of mammal are all described in the literature along with their numerous races, their seasonal coat and plumage characteristics, and differences between ages and sexes. That's not to mention the multitudes of fishes and even greater multitudes of insects. Com-

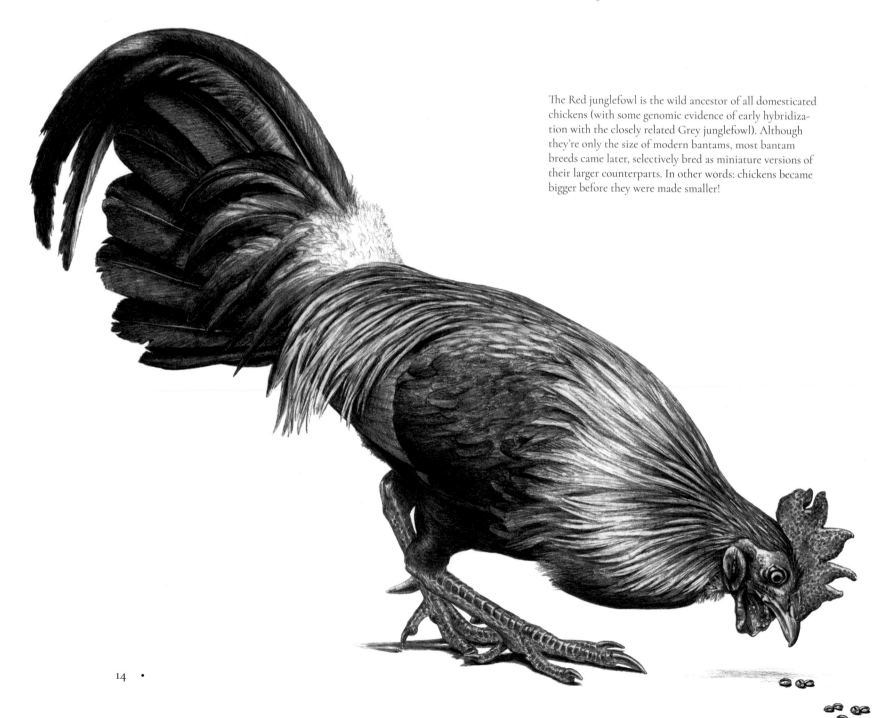

The Red junglefowl is the wild ancestor of all domesticated chickens (with some genomic evidence of early hybridization with the closely related Grey junglefowl). Although they're only the size of modern bantams, most bantam breeds came later, selectively bred as miniature versions of their larger counterparts. In other words: chickens became bigger before they were made smaller!

pare virtually any of these animals with its relevant type specimen and it wouldn't be radically different. So Linnaeus's system appears to work adequately—in 999 cases out of a thousand. However, there's an infinitesimally small percentage of wild animal species that have, under very special conditions, diversified in appearance and habits to the point where they no longer resemble their original form, or even each other. So different are they that scientists, oblivious of their ancestry, have named these forms as separate species. I'm speaking, of course, of domesticated animals.

All domesticated animals are descended from a wild ancestor (with additional ancestral species sometimes contributing to the genome). Even though they may have diversified into a multitude of forms, sizes, coat types, and colors they all belong to the same species and would, theoretically at least, all be able to breed and produce viable offspring. Obviously some anatomical and behavioral details would prevent this from happening in real life, but genetically at least it's quite possible. Silkmoths, *Bombyx mori*, were domesticated in China and have been bred commercially for so many centuries that they bear no resemblance whatever to their presumed wild ancestor, *Bombyx mandarina*. Animal rights activists wouldn't achieve much by releasing silkmoths into the wild. They've become totally dependent on humans for their reproduction and have even lost the power of flight.

In some cases the wild ancestor of a domesticated animal is extinct or has been separated for so long that the relationship can only be proven by genome sequencing. Dogs diverged from wolves so long ago that their ancestry is barely recognizable in the numerous breeds. Indeed dogs are so diverse that even Charles Darwin, who recognized the common ancestry of domesticated chickens and pigeons, simply couldn't believe that they might have originated from a single canid species.

Linnaeus allocated scientific names to many domesticated animals, purely in recognition of their existence. He also, by chance, named many of their wild ancestors too. Remember that he wasn't attempting to name things according to their true relationships. Even if he had been, it's unlikely that he could have identified the Mouflon, *Ovis orientalis*, as the primary ancestor of the domesticated sheep, *Ovis aries*, and certainly not the dog, the most diverse of any single species—which he named *Canis familiaris*—as the descendant of the Grey wolf, *Canis lupus*.

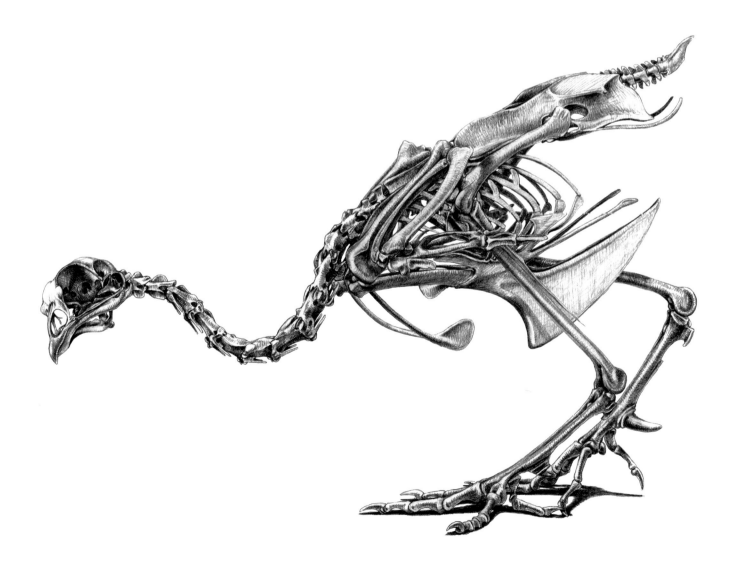

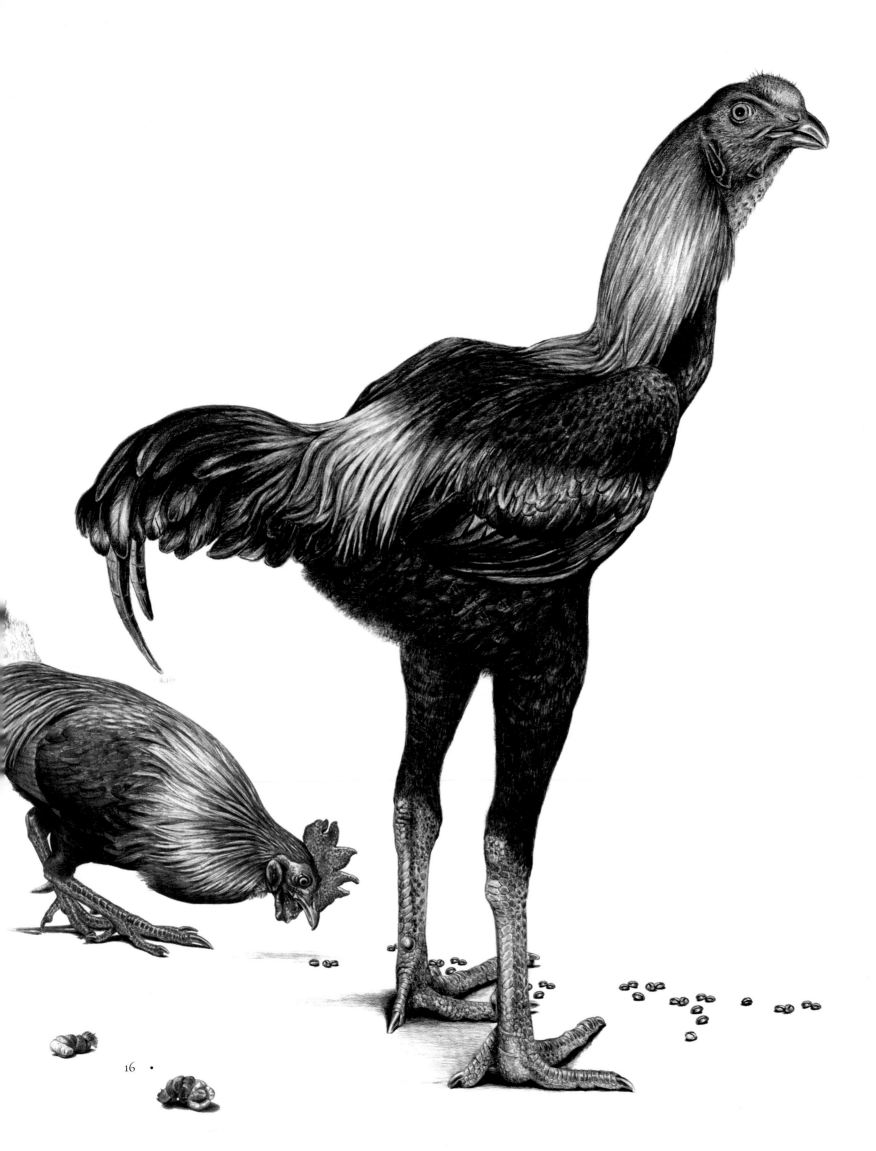

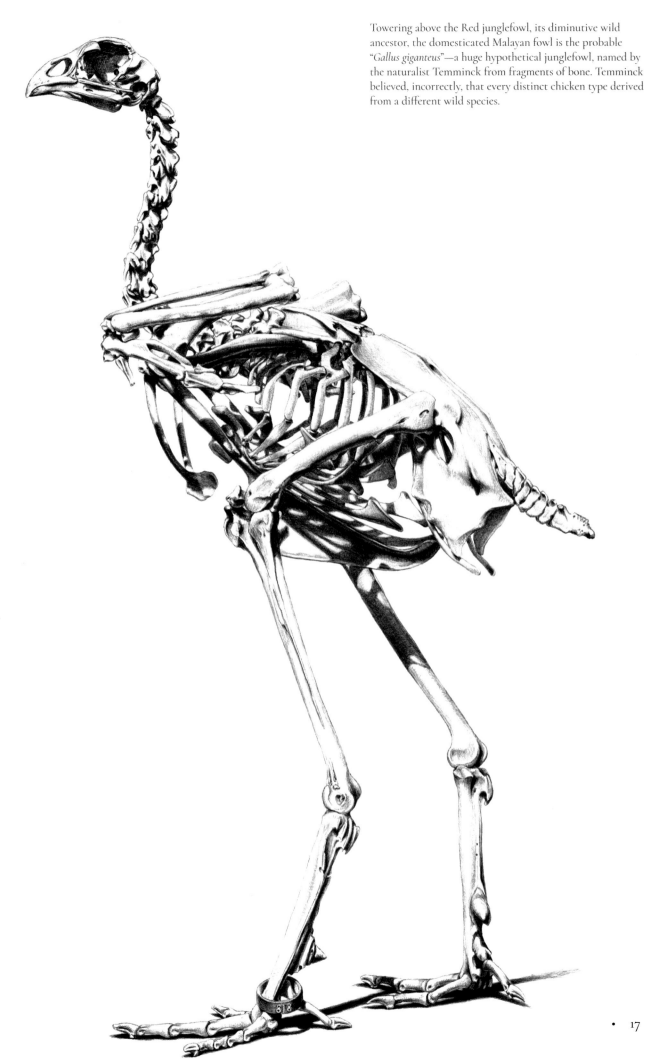

Towering above the Red junglefowl, its diminutive wild ancestor, the domesticated Malayan fowl is the probable "*Gallus giganteus*"—a huge hypothetical junglefowl, named by the naturalist Temminck from fragments of bone. Temminck believed, incorrectly, that every distinct chicken type derived from a different wild species.

Look carefully at your next chicken dinner and you'll notice there's something missing in these pictures—the "parson's nose." "Rumplessness" is a characteristic of several domesticated chicken breeds. The birds lack not only tail feathers but the underlying tail vertebrae and musculature too. The discovery of this trait in wild Ceylon junglefowl in the nineteenth century led the naturalist Temminck to assume that domesticated rumpless fowl have a rumpless wild ancestor. They don't.

Most of these names—and there are many more pairs like these—were published in the same edition of the *Systema Naturae*, in 1758. So, according to the laws of nomenclature, they have equal priority; both can legitimately be used regardless of the fact that they actually refer to the same species.

If this wasn't bad enough, there are yet more examples where the description of the wild ancestor came after that of its domesticated form. The Wildcat, *Felis silvestris*, was described by Johann von Schreber in 1777, but because of the rule of priority it has, *technically* at least, been obliged to share the same name as its domesticated counterpart, *Felis catus*, which Linnaeus described in 1758. This example is complicated further by the fact that the Wildcat has no fewer than five distinct geographical races. House cats are thought to have descended from the African race, *lybica*, though they readily interbreed with the European race, *silvestris*.

For half a century or more, numerous solutions have been proposed in an attempt to bring some conformity to the naming of domesticated animals and their wild ancestors. One was to put the specific names for domesticates in quotation marks; another was to use the wild species' name suffixed by *f.* (= *forma*) and then the domesticate name. Another suggestion was to abandon scientific names for domesticates altogether (including all those first

established by Linnaeus)—quite a brutal act with serious implications for the historical material. A rather more complicated solution virtually guaranteed to fail was to add a string of suffixes that would designate an animal either "*familiaris*" (domesticated), "*ex-familiaris*" (feral), or "*praefamiliaris*" (on its way to becoming domesticated)—and gave the option of including the race of the wild ancestor and even a Latinized version of the breed name. What all of these suggestions had in common is that they flaunted the established rules of zoological nomenclature, a system simply not able to cope with such unconventional things as domesticated animals.

Eventually the system itself had to change. In 2003 the ICZN deemed it acceptable to use the designated name for the wild ancestor in preference to its domesticated form for seventeen species regardless of priority, with the option of using the name of the domesticate as a subspecific name afterward. The upshot of all of this is: it's okay to call dogs *Canis lupus familiaris*.

It's still an uncomfortable compromise, nevertheless. Subspecific names are correctly used to designate geographical races, which domesticated animals categorically are not. The fact remains that, regardless of the thoroughness of the Code, domesticated animals just don't fit.

The plant kingdom has its own code of nomenclature, geared specifically toward plants. It's a lot more "cultivation-friendly" and even has special provision for something plants do readily but which animal species are, as we discussed earlier, *supposed* never to do: hybridize.

As we look deeper into the genome of different domesticates we discover more and more cases in which additional races or even species may have contributed to their genetic makeup in the early stages of domestication. Some species were domesticated independently in different geographical areas across their range, so the wild ancestor can be attributed to more than one race. If the races are then split by taxonomists into separate species the domesticated descendants suddenly take on an additional species identity! Others genuinely have more than one wild ancestor. As we've seen, reproductive compatibility isn't as exclusive as we might think. When animals are transported out of their immediate geographical range by their human guardians, a little sex with the locals is to be expected.

There's long been a debate on the origin of the domesticated chicken, which superficially appears to challenge Darwin's view that chickens have a single wild ancestor, the Red junglefowl, *Gallus gallus* (known as *Gallus bankiva* in those days). The debate rests on the fact that many chickens have yellow legs and skin, caused by a build-up of yellow pigments—carotenoids. Red junglefowl produce an enzyme that breaks down carotenoids, whereas Grey junglefowl, *Gallus sonneratii*, don't. That the Grey junglefowl has contributed to the chicken genome has now been proven by genetic analysis. However, this isn't quite the same as having multiple ancestors. Theoretically it only takes a single cross to release a variant recessive gene into a population. Despite what you might read in the popular science press, it categorically doesn't mean that Darwin was wrong. It merely adds greater detail to what we already know about chicken ancestry.

You have to understand it in its historical context. Prior to Darwin, every distinct type of domesticated animal was presumed to have arisen from a similar ancestral type. No one would have argued that animals don't change at all—there was ample evidence of the improvement of breeds under domestication. But the changes were thought to have been parallel and linear, with the same definitive types in existence for all time. For example, the enormous, long-legged fighting chicken, the Malayan fowl, brought to Europe from Southeast Asia, was attributed to an extinct giant species *Gallus giganteus* and not to the diminutive Red junglefowl. It was named by early nineteenth-century Dutch naturalist Coenraad Temminck, from some fragments of large chicken bones, which probably were just bones of Malayan fowl. Temminck was adamant that what he recognized as the six main domesticated chicken types had each descended from an ancestral species. As well as the aforementioned *Gallus bankiva* and *G. giganteus* there was *Gallus morio*—the alleged ancestor of all dark-skinned chicken breeds—*Gallus lanatus* that gave rise to chickens with silkie plumage (in those days most "silkies" didn't have dark skin as they do now), and *Gallus crispus* with frizzled plumage. Most of these were conveniently presumed to be already extinct.

The sixth is rather more interesting. This was named by Temminck *Gallus ecaudatus*, meaning that it lacked a tail. Taillessness is a feature of several domesticated chicken breeds (more correctly termed "rumpless"). Not only are the tail feathers missing but so are the underlying vertebrae and all their associated musculature. It's caused by a single

There are hundreds of domesticated pigeon breeds; some are very similar, while others, like this Norwich cropper (left) and Jacobin (right), are as different as two birds can be. All of them, however, are descended from the same wild species, the Rock dove, *Columba livia*. Norwich croppers have, incidentally, been used in crosses with Jacobins to give the latter a more vertical posture.

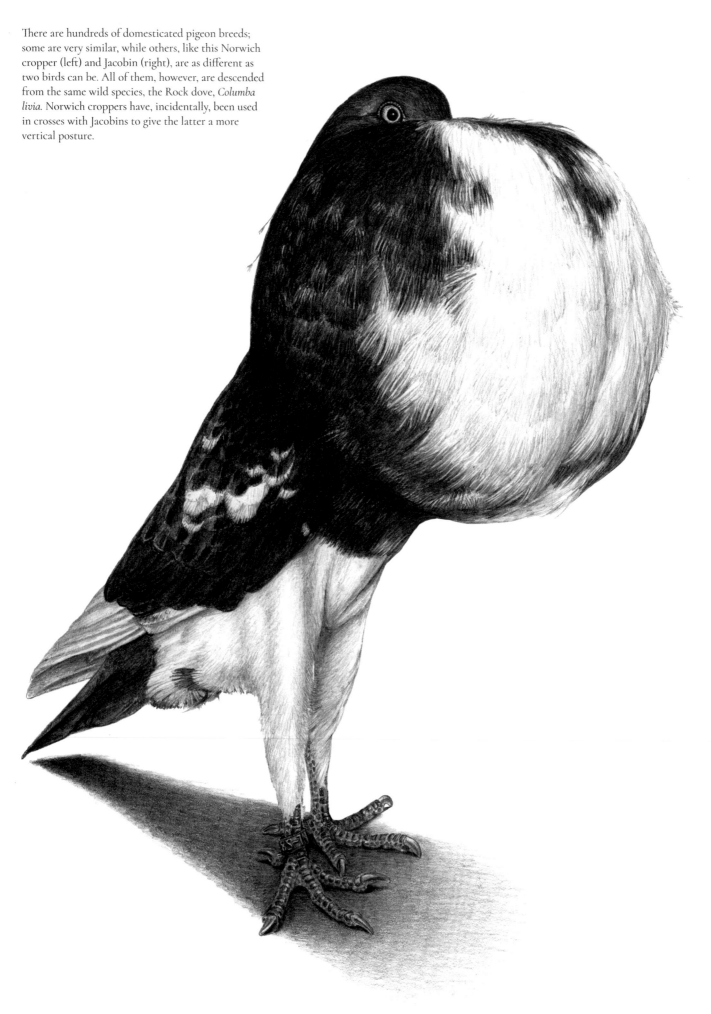

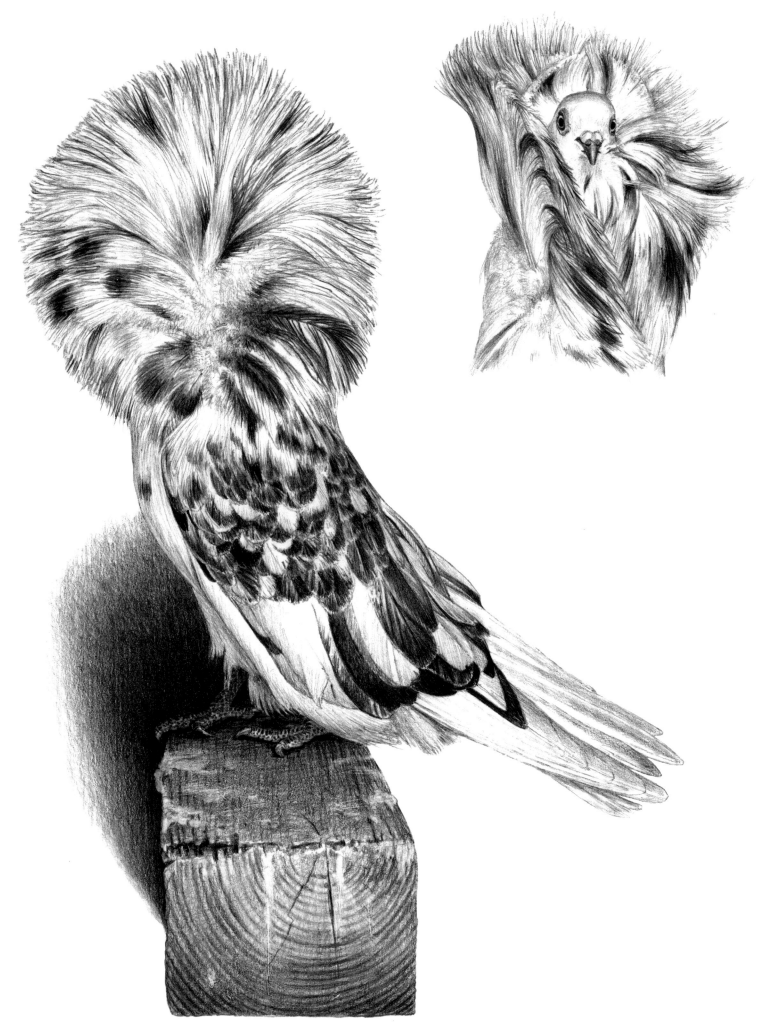

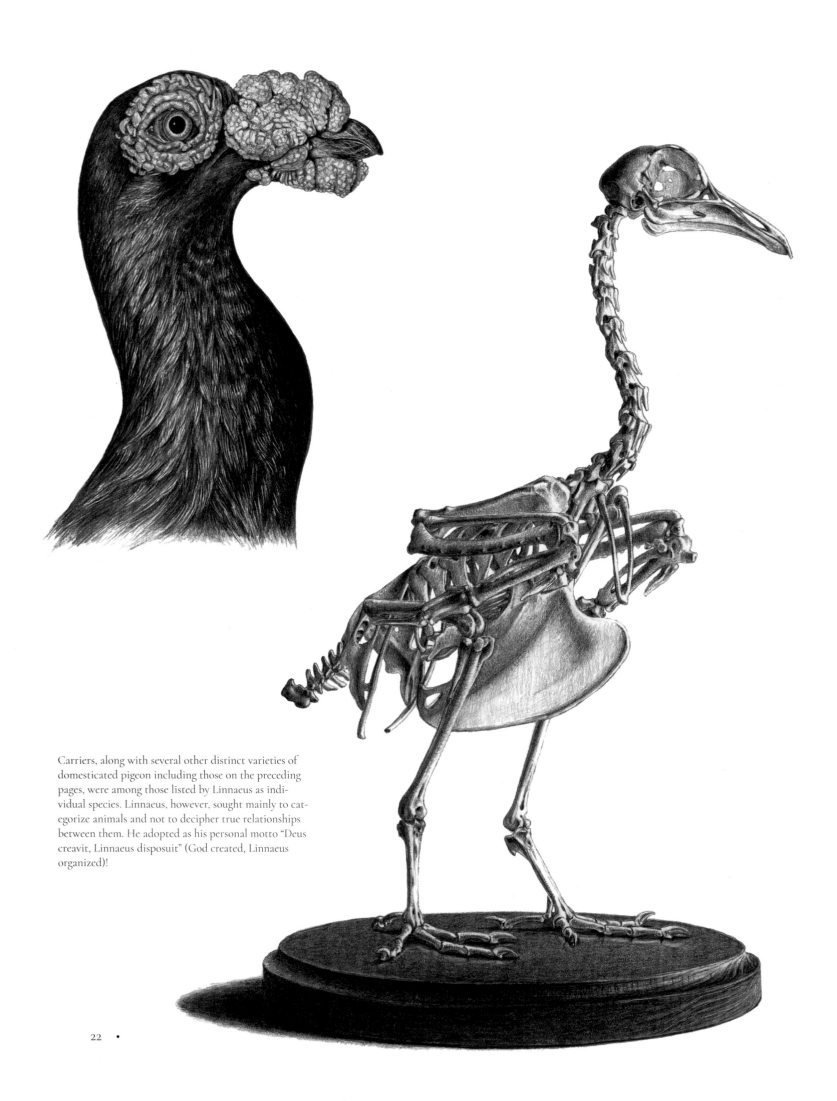

Carriers, along with several other distinct varieties of domesticated pigeon including those on the preceding pages, were among those listed by Linnaeus as individual species. Linnaeus, however, sought mainly to categorize animals and not to decipher true relationships between them. He adopted as his personal motto "Deus creavit, Linnaeus disposuit" (God created, Linnaeus organized)!

genetic mutation, which must have occurred independently in at least two junglefowl species, as the specimens described by Temminck (still housed in the Netherlands' national museum of natural history) are clearly the undomesticated Ceylon junglefowl—*Gallus lafayettii*.

Let's not think too badly of Temminck. As we've seen, Darwin himself made the same error with dog breeds. Linnaeus, too, named the six principal fancy breeds of domesticated pigeon—Fantails, Turbits, Pouters, Carriers, Runts, and Jacobins (he later added three more)—describing them as defined species without making any special distinction from the wild pigeon species of the world. They were simply types of pigeon that were kept by man and were supposed to always have been kept by man.

Though Temminck was wrong about the parallel lineages of chicken types he was ahead of even Darwin when it came to pigeons. Individual varieties of domesticated pigeon, as Temminck quite rightly suggested, are neither separate species nor subspecies. They evolved by artificial selection from a single wild ancestor, the Rock dove. So all these pigeon breeds mentioned, and hundreds more, share the scientific name *Columba livia* (with the option of an added *domestica* afterward).

There is, incidentally, no difference between doves and pigeons. The words can be used interchangeably. Rock doves and Rock pigeons; Fantail doves and Fantail pigeons—both are exactly the same, though an ornithologist would usually reserve the word "dove" to refer to the smaller species. Throughout this book I'll refer to the domesticated form of *Columba livia* simply as "pigeons" when I'm not mentioning the individual varieties.

For Darwin and Temminck to question whether these very diverse forms may have arisen from fewer ancestors—even a single ancestor—was a stroke of brilliance. From there it was a logical step for Darwin to apply this reasoning to wild animals and to ask whether they too might share a common ancestor. Instead of parallel, linear evolution Darwin gave us branching evolution—the "tree of life."

Although the diverse forms of domesticated pigeons and other animals belie the fact that they are the same species, the individual varieties are far from irrelevant. Unfortunately, however, there's still a great deal of ignorance and prejudice against the products of domestication, even at top scientific institutions. Countless valuable specimens have been, and continue to be, rendered worthless by museums stripping them of their breed data simply to conform to established taxonomy.

For Darwin, and for the more enlightened biologists of today, the perpetual changes brought about by selective breeding illuminate our understanding of evolutionary processes in wild animals—which is precisely what this book is all about. Selective breeding has been described as the greatest of all scientific experiments. And the laboratories where this groundbreaking science is taking place? Well, most of them are the backyards, smallholdings, and homes of thousands upon thousands of humble animal fanciers. We can learn a great deal about the natural world by paying more attention to their achievements.

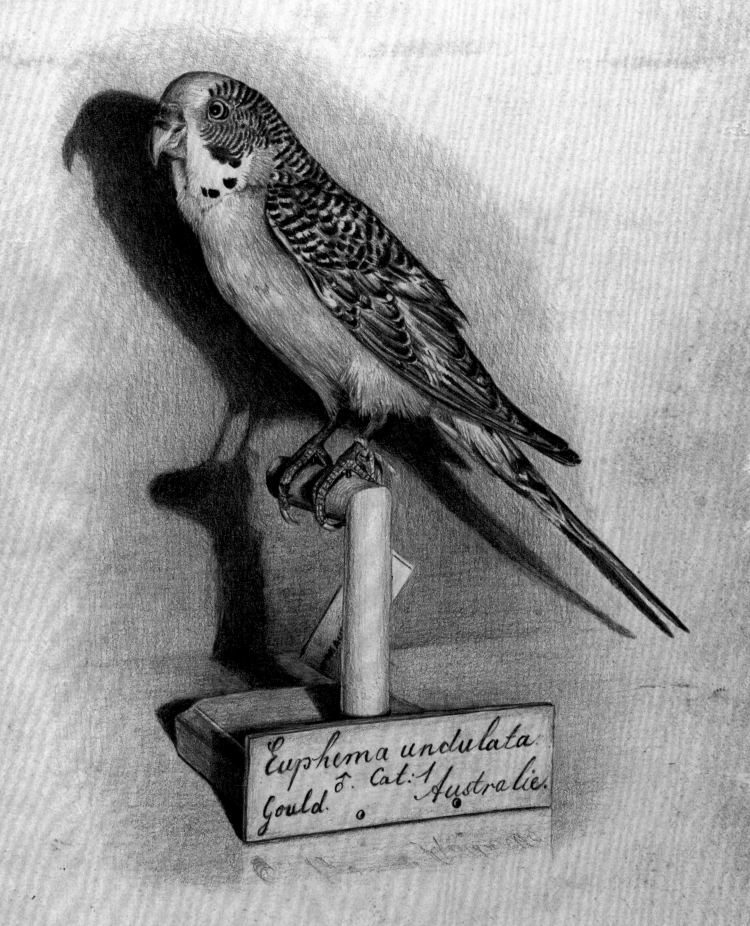

I

ORIGIN

2. Plastic Animals

2 ~ Plastic Animals

The Albert Heim Foundation for Canine Research in Bern, Switzerland, houses one of the most remarkable scientific collections in the world: an entire department of the national museum of natural history devoted to just a single species. But anyone expecting uniformity would be gravely mistaken. For one whole, blissful week I delved through avenues of drawers packed with dog skulls, lovingly examining the remains of narrow-headed borzois, great-jawed mastiffs, and tiny bulbous-headed chihuahuas; skulls with shortened upturned muzzles and skulls with downturned muzzles. I handled the skull of Barry, the famous mountain rescue dog of the Great St. Bernard Hospice—not very much different from any other large dog skull but a world away from the modern pedigree St. Bernards that share his drawer. Yes, it wasn't just the diversity between breeds that struck me but the diversity within the breeds themselves. Although the modern counterparts were all very distinctive, exaggerated even, the oldest specimens were more generic, indistinguishable from the oldest skulls in other drawers. Oldest of all were a number of Neolithic dog skulls (long ago separated from their teeth) and all more or less identical.

I was suddenly reminded of a black-and-white photograph I'd seen reproduced in a magazine article about the history of Crufts Dog Show. It had looked like an everyday family dog, like a Golden retriever. But the caption said it was a Pyrenean mountain dog. I was puzzled—I'd always prided myself on my dog breed identification. It couldn't be explained away as a bad representative of the breed because it had won a prize at Crufts. Then I'd noticed the date on the caption—this was how Pyrenean mountain dogs had looked fifty years earlier.

I was surprised to reflect that even the most idiosyncratic breeds must have looked very ordinary a hundred or so years ago. For example, only a slight shortening of the skull, giving an undershot lower jaw, distinguished the bulldog of the early nineteenth century, and even more remarkable still was the transformation of the Bull terrier. Bull terriers were historically rat-catching dogs—the "bull" in their name comes from the fact that they were created by crossbreeding bulldogs and terriers: bull + terrier. They'd had a straight skull originally, even with a fractionally upturned muzzle. Over time the muzzle has rotated downward through more than 45 degrees, giving them their unique charismatic profile. It's still possible to find dogs very similar to the original, straight-nosed Bull terrier in Pakistan, the descendants of dogs that were imported by the British army during the Raj.

Of course, no one breeds animals for the appearance of their skull or skeleton. Many breeders have no idea what the underlying skeleton of their charges even looks like. They select animals for their usefulness or commercial properties or, in the case of dogs and other exhibition animals, according to recognized breed standards describing how the perfect example of that breed ought to look, rather like a "virtual type specimen." Breed standards are revised every so often, keeping the elusive goal always just a little out of reach, unconsciously ensuring that the breed's appearance is in constant flux, even though its name might stay the same.

The transformation might not always be permanent or in one direction. Growing awareness of animal welfare issues might call for a reversal of some features, or fashions might simply change. Dogs are an obvious example, but change is an inevitable result of selective breeding of all domesticated animals, and plants too, just as changes result from similar evolutionary forces in nature. Take the posture of Fantail pigeons, for example.

 When the Budgerigar was introduced into England from its native Australia in the mid-nineteenth century it immediately began to increase in size. This may have been a result of unconscious selection for large birds in captivity, or of its nomadic lifestyle in the wild, favoring only the smallest birds. This wild specimen is from the collection of the famous ornithologist and publisher John Gould.

As you can see from their skull shape, some of the most distinctive modern dog breeds, like the St. Bernard, were historically more generic in appearance. Animals are plastic things with tremendous potential for physical change. Dog skull shape is perhaps the most plastic of all.

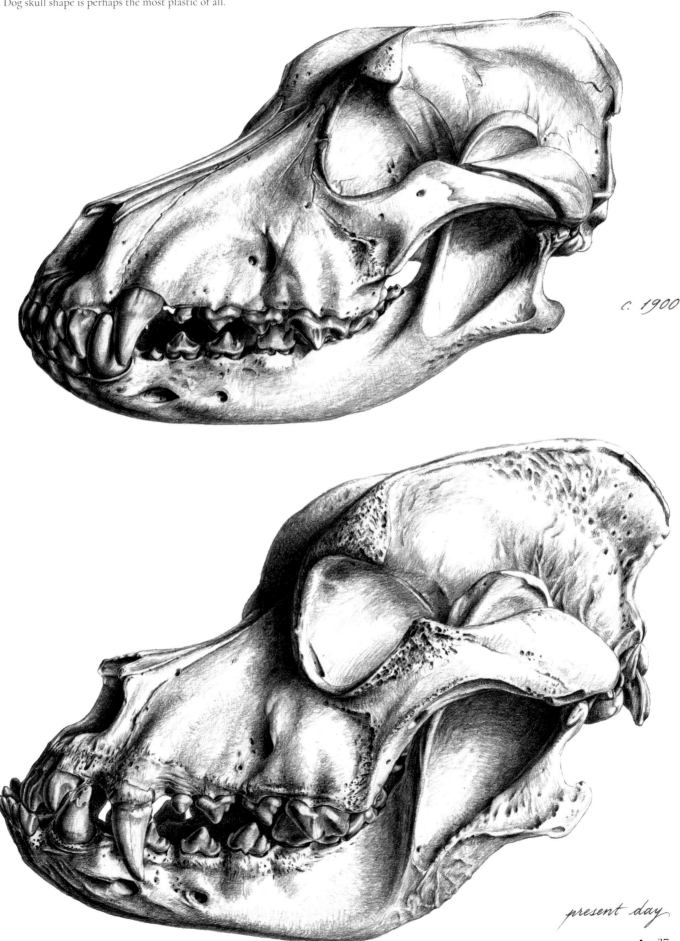

c. 1900

present day

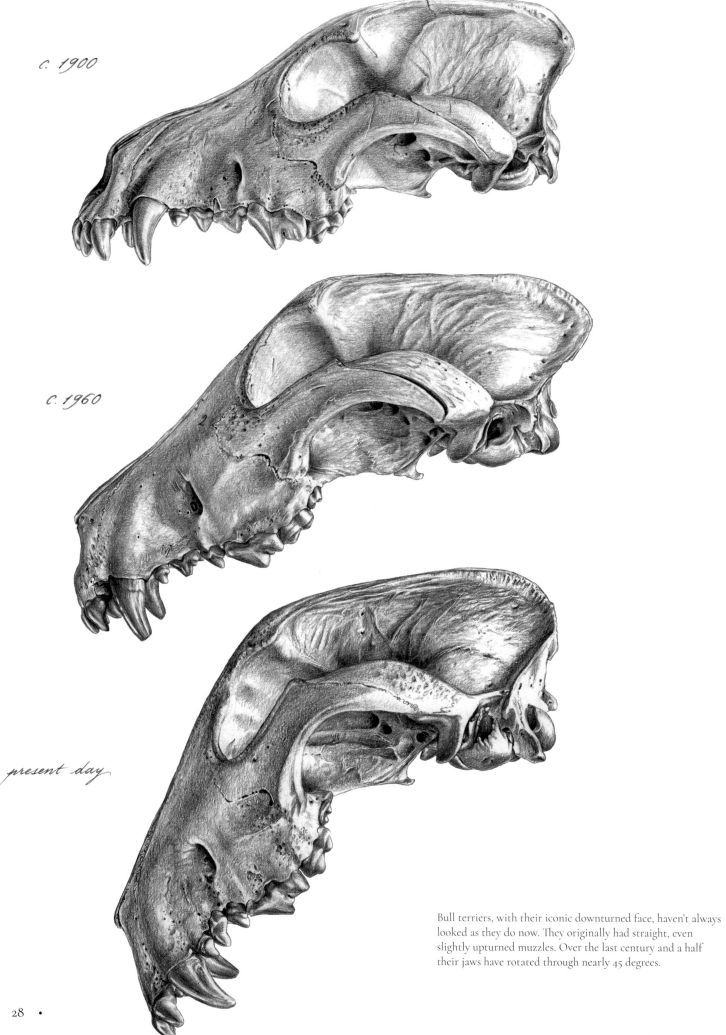

c. 1900

c. 1960

present day

Bull terriers, with their iconic downturned face, haven't always looked as they do now. They originally had straight, even slightly upturned muzzles. Over the last century and a half their jaws have rotated through nearly 45 degrees.

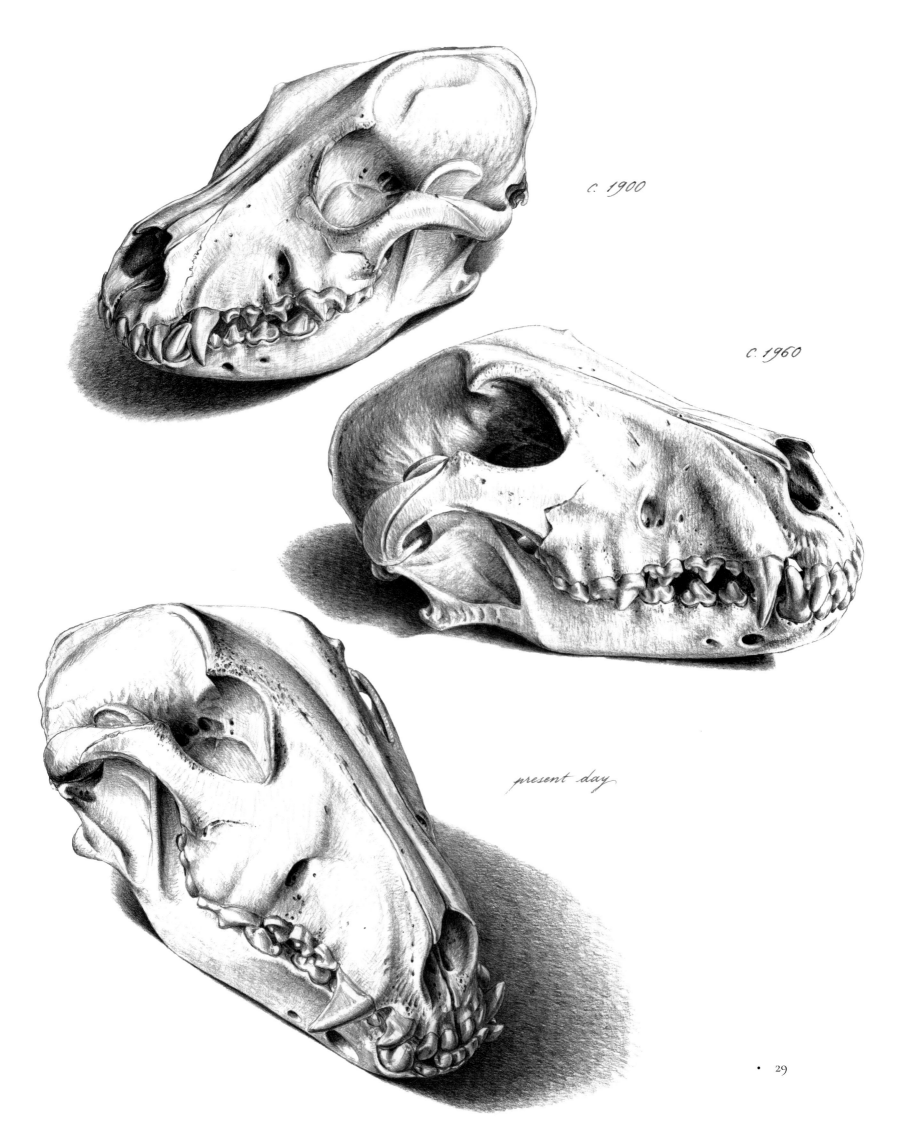

c. 1900

c. 1960

present day

• 29

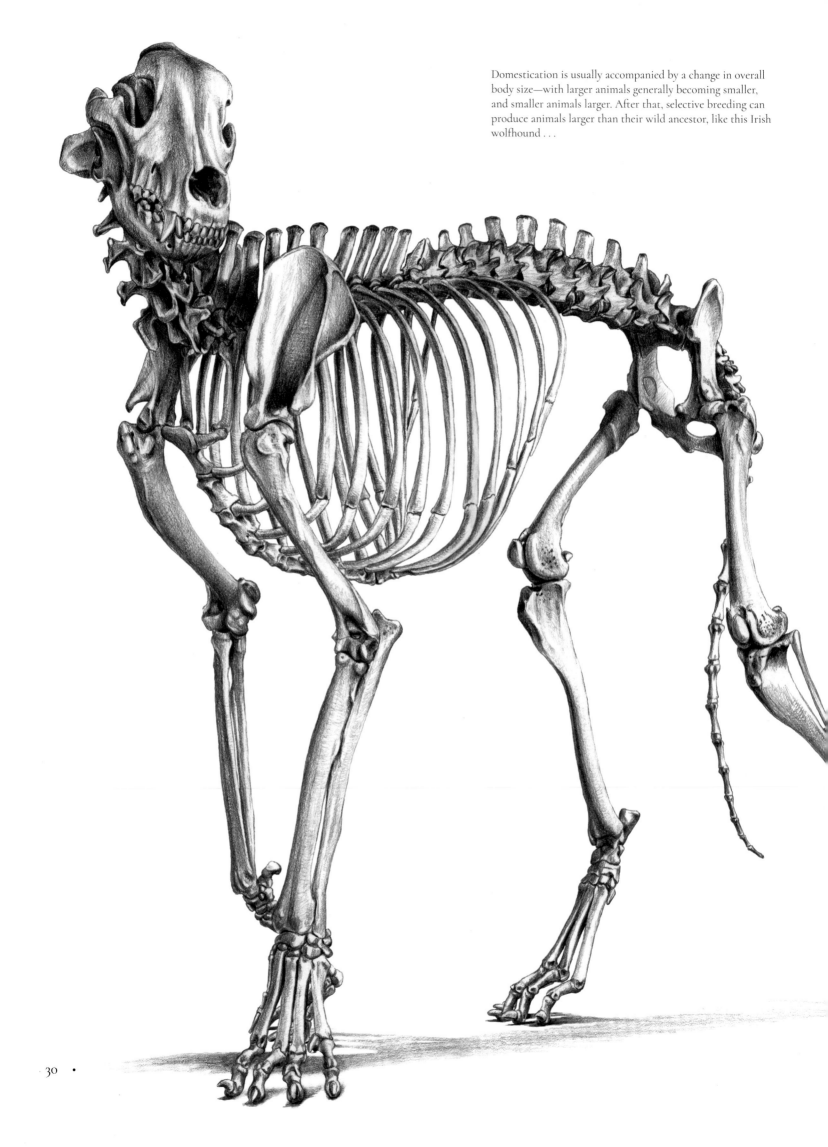

Domestication is usually accompanied by a change in overall body size—with larger animals generally becoming smaller, and smaller animals larger. After that, selective breeding can produce animals larger than their wild ancestor, like this Irish wolfhound . . .

Early fantails were rather horizontal. You can still see birds like them in the ornamental "garden fantails" that haven't been subjected to selection for shows. The tail slopes diagonally upward with the tip just a little lower than the head. It's their neck that's their loveliest feature, typically held in a graceful swanlike S shape that pushes the breast forward. Incidentally, another breed that shares the Fantail's elegant neck carriage is the Mookee, and both have a habit of quivering their neck when they're excited. It's likely that the Fantail and the Mookee correspond to the Broad-tailed shaker and Narrow-tailed shaker described by English ornithologist Francis Willoughby in 1678, and it's probable that they share a common origin. But to return to fantails, fanciers increasingly selected birds for a more erect posture, gradually resulting in the rotation of the entire body into an almost vertical position. The orientation of the thighs remained roughly horizontal, but instead of lying along either side of the rib cage they now spanned the depth of the abdomen. The neck became more tightly curved too, which, in combination with the upright posture, actually placed the head well below the level of the breast, so when viewed head-on it was impossible to see the head at all! In fact the neck was selected to sweep so far backward that the vertebral column evolved a slightly concave dip to accommodate it. Birds in the most extreme show positions would frequently stand on tiptoe to fine-tune their balance, maintaining their center of gravity over their feet. This type of fantail is rarely seen nowadays, however, and certainly never at shows. For my illustrations I used one of our own, non-exhibition birds (which also happened to have the silkie feather mutation—much more about this later) and her father, who generously donated his skeleton after his death.

Gradually, fantail fashions changed again. This time the body became tilted forward once more toward the diagonal but also sank lower, bringing the knees up above the level of the thighs. The neck remained swept back to cushion the head just above the rump and, with the tail now held perfectly erect and spread, the whole bird has taken on rather spherical proportions.

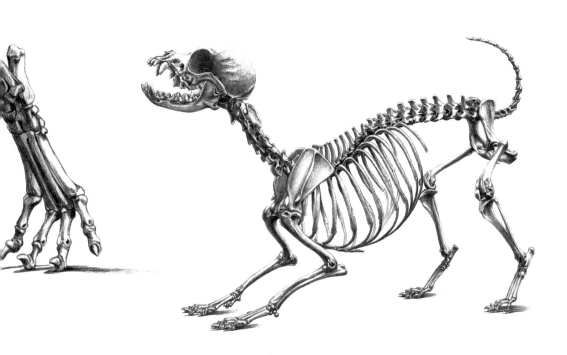

. . . or significantly smaller. This is a Chihuahua—tiny, but every inch a descendant of wolves!

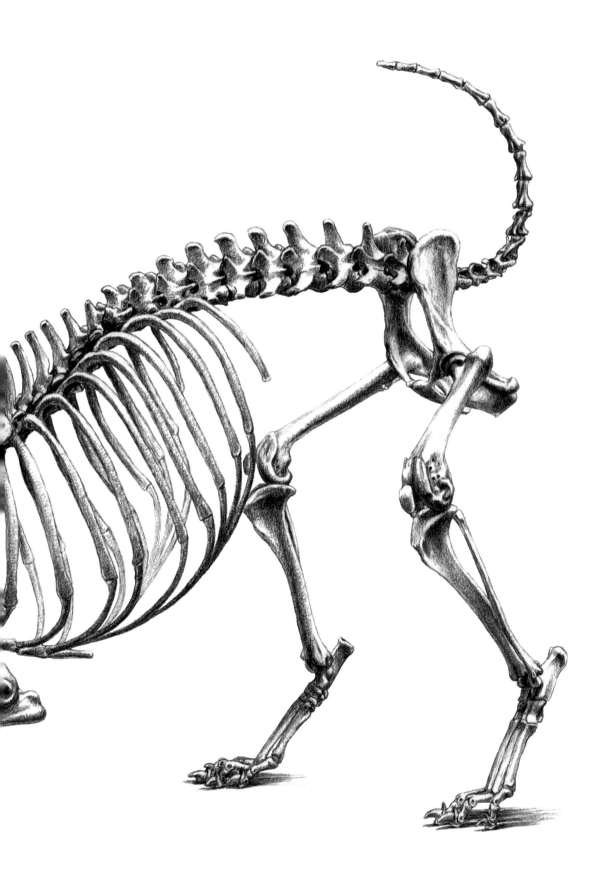

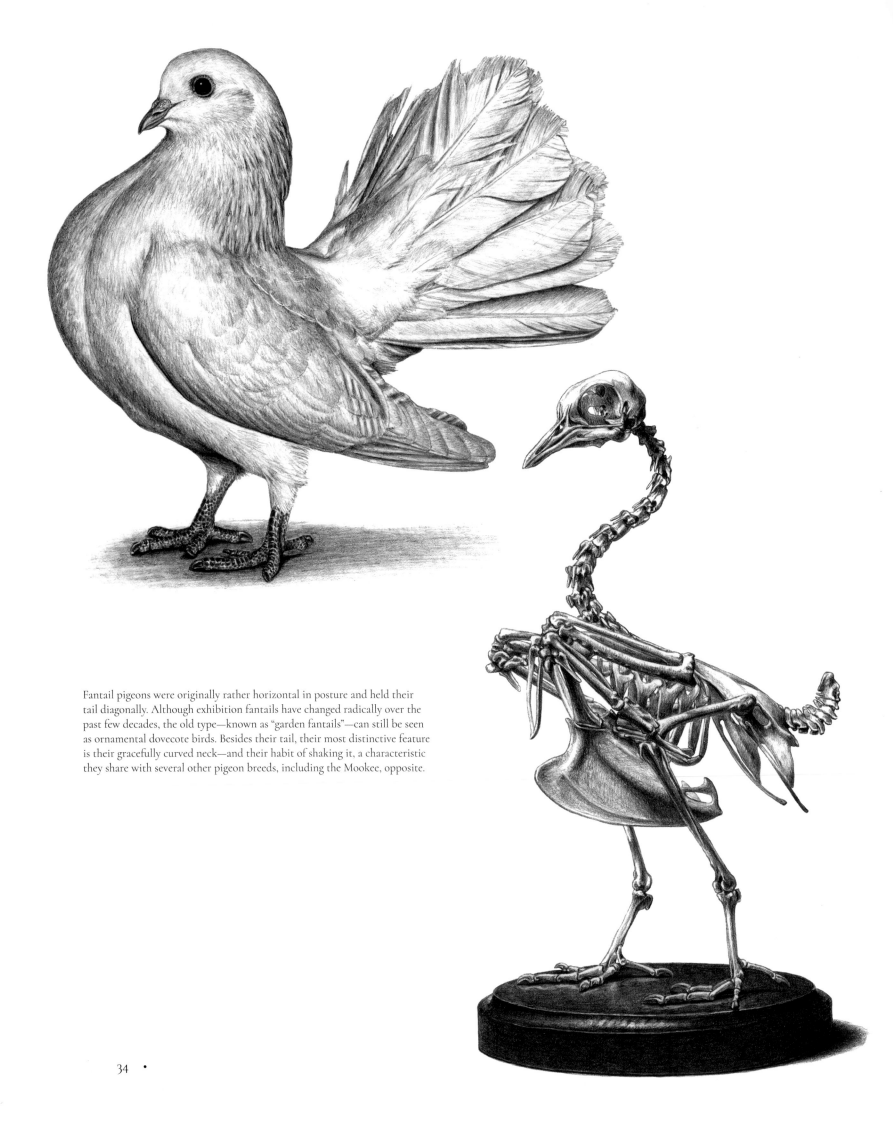

Fantail pigeons were originally rather horizontal in posture and held their tail diagonally. Although exhibition fantails have changed radically over the past few decades, the old type—known as "garden fantails"—can still be seen as ornamental dovecote birds. Besides their tail, their most distinctive feature is their gracefully curved neck—and their habit of shaking it, a characteristic they share with several other pigeon breeds, including the Mookee, opposite.

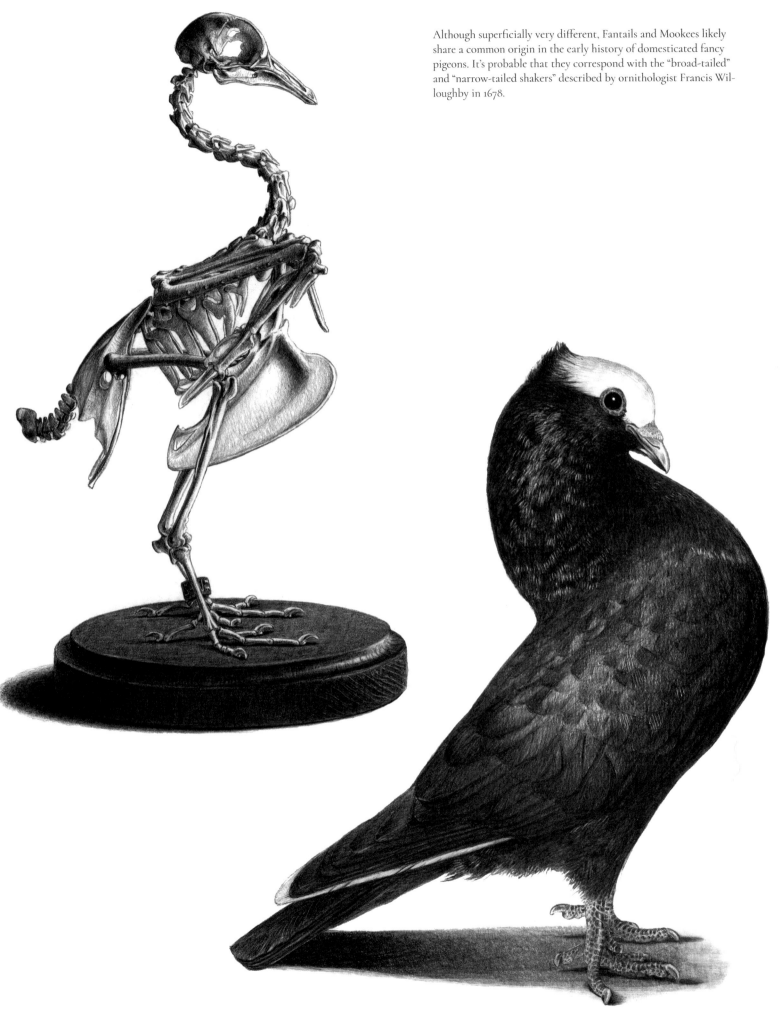

Although superficially very different, Fantails and Mookees likely share a common origin in the early history of domesticated fancy pigeons. It's probable that they correspond with the "broad-tailed" and "narrow-tailed shakers" described by ornithologist Francis Willoughby in 1678.

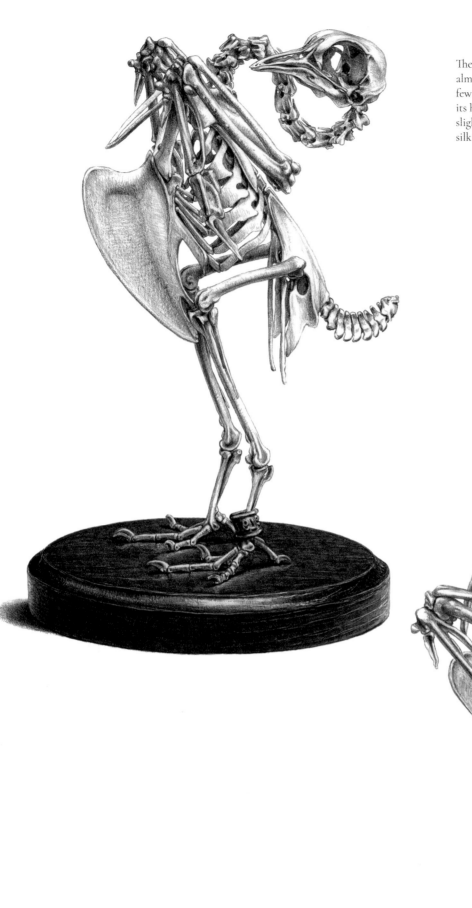
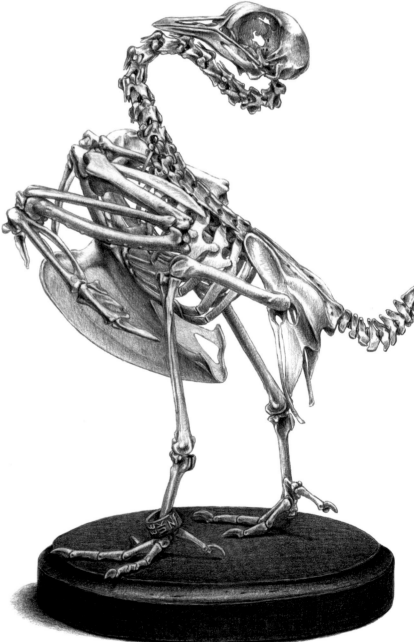

The current trend in exhibition fantail pigeons is for birds with an almost spherical body shape and erect tail (below). However, just a few decades ago, a "good" fantail would have stood almost vertically, its head tucked well below the level of its shoulders, and its tail slightly tilted (above). The bird shown here is one of our own, with silkie plumage.

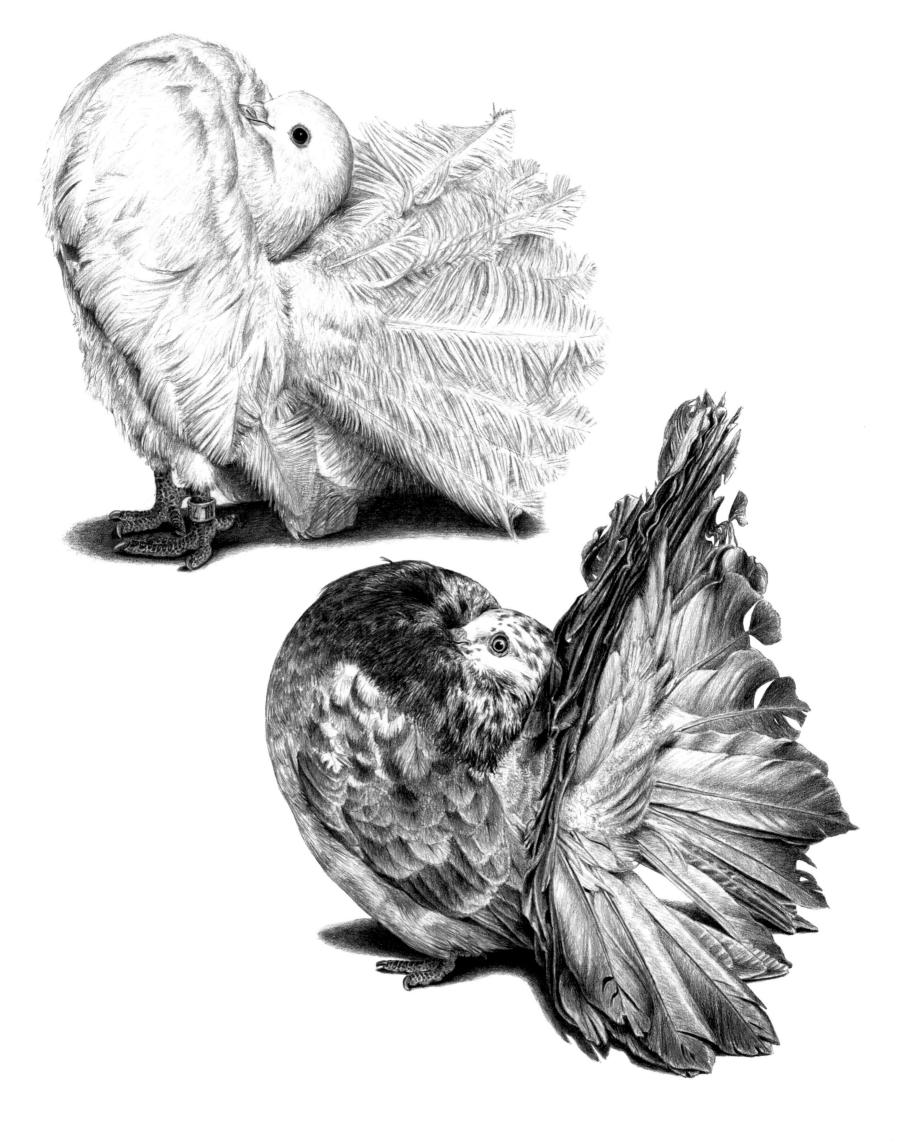

With changes happening so rapidly, domesticated animals provide a priceless opportunity for scientists to study the sorts of anatomical transformations that are possible. But for that, they need specimens. Unfortunately, as I mentioned briefly at the end of the last chapter, there are pitifully few museums that give domesticated specimens the respect they deserve. Neither is there a precedent for deceased pedigree animals to easily find their way to the institutions where they'd be of most use to scientists. The canine research foundation at Bern is a shining exception.

One highly eccentric though virtually unknown collector who took domesticated animals very seriously indeed is worthy of mention here and really deserves a biography of his own. Dutch zoologist Willem van Heurn built up extensive collections of cats, dogs, pigs, and chicken egg aberrations throughout the mid-twentieth century. Even in the final weeks of his life he prepared specimens on a special table rigged up on his sickbed! The Large white pig skull pictured overleaf, along with the drawer of piglet skulls on the opening page of chapter 6, are from his collection, now in the Dutch national natural history museum in Leiden. Trust me; you really don't want to know how he acquired many of his specimens—especially the cats. He nevertheless kept meticulous and scientifically valuable records of weights and measurements and individual variations in the number of bones.

No matter how good a museum collection is, inevitably some areas will be better represented than others. There will always be gaps: gaps in the species or breeds represented, in the historical period they represent, or in the geographical locality they were from. In ideal circumstances, where there's a good series of specimens from the same geographical area, with no major time gaps, any gradual transformations in a breed's appearance are easier to visualize. In others the progression seems jumpy, as though these were entirely different species thrown together.

I should point out here that there is nevertheless a great deal of "jumpiness" in domesticated animal varieties. This is because all dogs (or pigs, or chickens, or whatever) belong to the same species, so they're capable of interbreeding. Moreover, virtually every recognized breed has, at some point in its history, been crossed with another in order to gain, or give, particular qualities—to improve existing breeds or create new ones.

No matter how many specimens exist, they're only as valuable as the data that accompany them. Most important are the date and locality, though the addition of information about their parentage and bloodlines offers the valuable potential to truly bridge the gaps between individuals

and separate out the threads of the relationships between them. In this way a pedigree or family tree works in a comparable way to an evolutionary "tree of life." Another museum I visited during my research was the Julius Kühn Domesticated Animal Museum in Halle, Germany, which began its existence in the mid-nineteenth century as an experimental breeding farm to study the inheritance of traits in domesticated animals. It still occupies the original farm buildings. Now the skeletons of cattle and sheep inhabit the same cowsheds and stables where the animals resided during their lifetime, complete with meticulous records of their genealogy, detailed descriptions of their growth and development, and even a complete photographic archive. Any one of these elements would be valuable on its own, but together they're a priceless scientific resource and a poignant slice of cultural history.

Without documentation like this, individual specimens represent separate points over time and not a seamless progression through it. Imagine cutting down through plant roots with a spade—you can see the sections of some of the roots but can't always tell whether one is connected to another or, if so, which one, or where they join along their length. In just the same way, the evidence of change that has occurred over relatively short time spans in domesticated animals cannot be assumed to be just a linear progression. There are branches, too, and points in history where one physical type breaks away from another to form two or more diverging types—just as they do over vast time spans in wild animals.

One thing the branches of an evolutionary tree should never be able to do is rejoin. But because of the frequency of crossbreeding that I mentioned earlier, this is precisely what would happen if you were to attempt to draw an evolutionary tree for, say, domesticated pigeons, as Darwin did, instead of a family tree of related individuals. Crossbreeding is a subject we'll be coming to in much greater detail in chapter 4 and in no way diminishes the remarkable plasticity of animals that is the subject of this chapter.

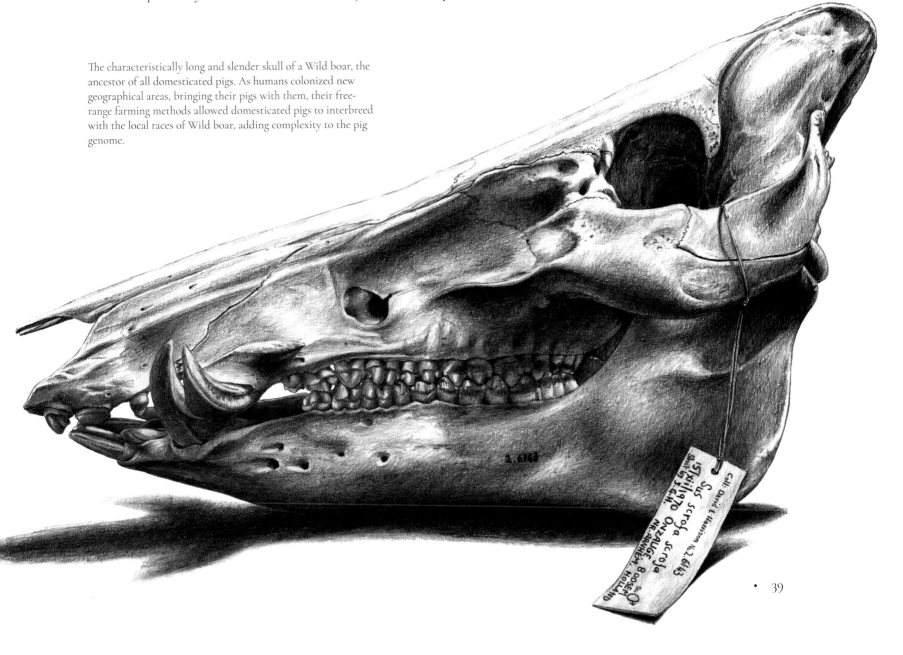

The characteristically long and slender skull of a Wild boar, the ancestor of all domesticated pigs. As humans colonized new geographical areas, bringing their pigs with them, their free-range farming methods allowed domesticated pigs to interbreed with the local races of Wild boar, adding complexity to the pig genome.

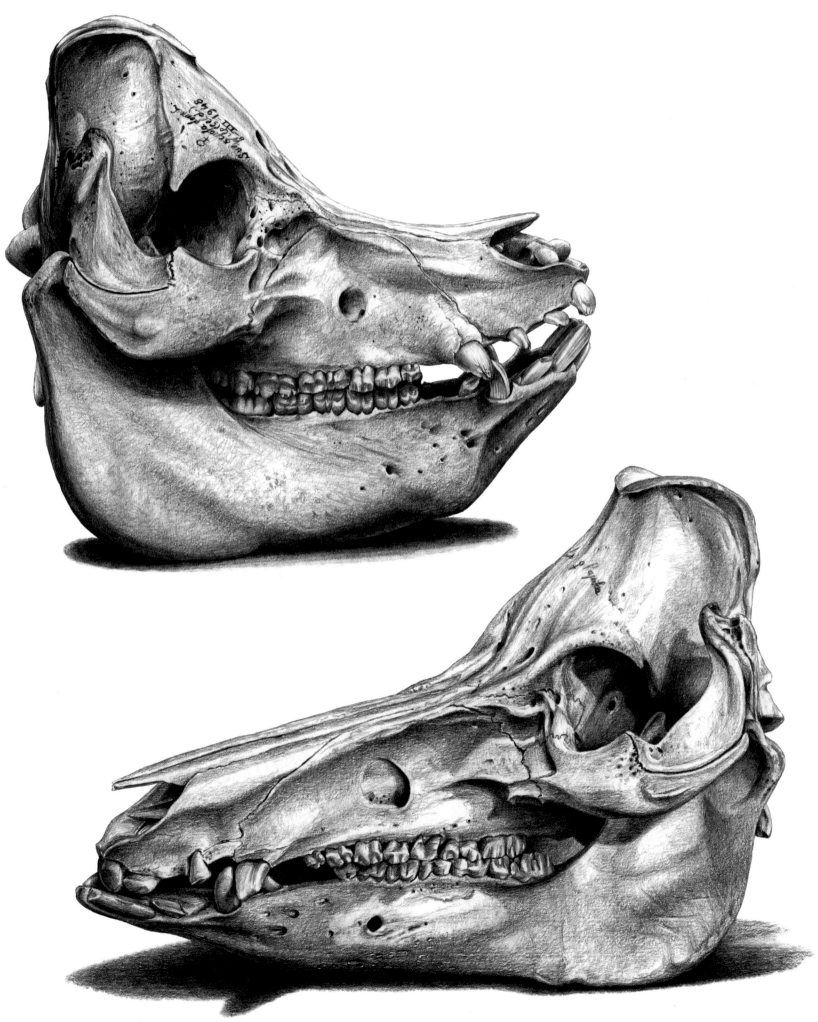

Pig skulls are second only to dogs in their remarkable plasticity, and it's evident that there are more factors at work than merely shortening of the skull length. For example, there's the angle of forehead to muzzle, as seen in this Mangalitza pig (below), and the increased width, evident in the Large white (above).

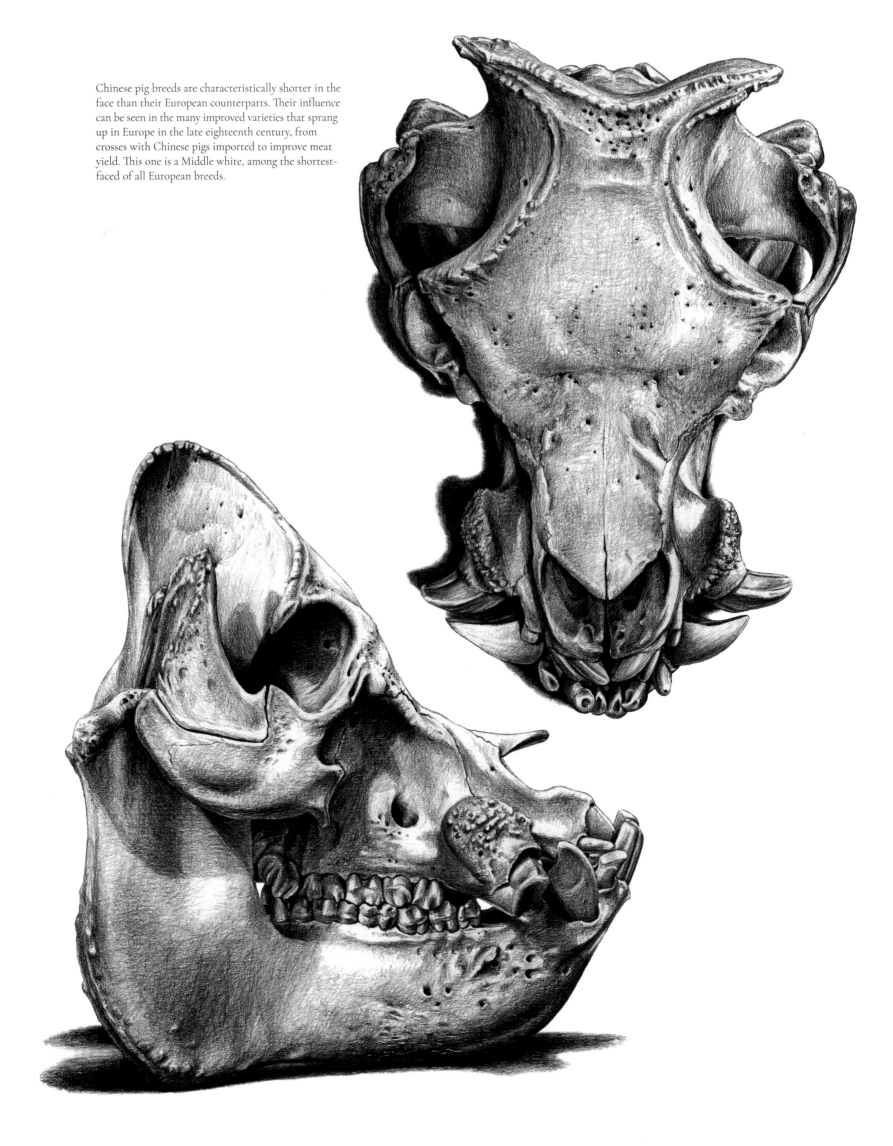

Chinese pig breeds are characteristically shorter in the face than their European counterparts. Their influence can be seen in the many improved varieties that sprang up in Europe in the late eighteenth century, from crosses with Chinese pigs imported to improve meat yield. This one is a Middle white, among the shortest-faced of all European breeds.

When I talk about plasticity I'm not talking about growth, or flexibility, or the ability of individuals to overcome physical disabilities. I'm talking about the potential for changes to accumulate over successive generations and, most importantly, to branch and divide into multiple diverse forms. Plasticity isn't quite the same as adaptability—it's more the *capacity* to adapt or to be molded by other evolutionary forces. Some features have the potential to change in more radical ways than others (for reasons that we'll touch on later in this book), and dog skull shape is arguably the most radical of all.

After dogs, the second prize goes to . . . pigs. In their case it wasn't as a result of deliberate selection for appearance or function but through a complex history of human migration around the globe—pigs in tow. Pigs were domesticated independently in Europe, western Asia, and China, resulting in a plethora of local types, though it was in China where the first real breeds were developed—there were over a hundred by the end of the nineteenth century. To complicate things further, the nature of historical pig husbandry allowed domesticated pigs to continue to interbreed freely with the various races of their ancestor, the Wild boar, which still occupies much of its former geographical range, so the genetic effect has been rather like shuffling a pack of cards.

Chinese pig breeds are characteristically shorter in the face than their European counterparts and their influence can be seen in many varieties, including the radically short-faced Middle white, that sprang up in the late eighteenth century from crosses with stock imported to Europe from China to improve their meat yield (nowadays Europe is exporting pigs *to* China!). However, there's much more going on than just shortening of the skull. There are at least three different variables affecting the length and breadth of the skull and the angle of the forehead to muzzle. In different combinations, and expressed to different degrees, this has resulted in an astonishing diversity of skull shapes, all the accidental result of selection for other qualities.

Pig genomics have been studied in some detail, and the full version as we understand it so far is infinitely more complex than the limited précis given here. But perhaps that's a reflection on how much we know. Given the time spans, and the geographical movements of human populations, it's likely that the history of most domesticated animals is equally complex; the more we know, the more we recognize that things are never straightforward.

It's not just domesticated animals that change. All organisms do. However, changes in wild animals usually appear to be so slow as to be imperceptible while in domesticated animals it's easy to observe these evolutionary patterns within a single human lifetime. Even for a twenty-first-century audience it's difficult to truly embrace the idea that the animals we can pin names to and categorize rigidly into taxa—animals that appear to have remained the same throughout human history and show no signs of becoming anything else in the foreseeable future—are the plastic and ever-morphing things they are. All we see is a cross section of what exists at any one moment in time. To zoom upward from our root analogy, it's like looking down onto a tree: you can see the topmost twigs in sharp detail, but beneath that, which twigs are connected to the larger twigs, and the even larger branches, is anybody's guess. The fossil record shows us a very incomplete picture of a few of the things that existed at *other* points in time, but it's still not possible to work out all the relationships, beyond recognizing certain similarities. And to make matters worse, the very plasticity of animals allows them to adapt so well to their environment that they end up resembling things that they are not.

This was the problem facing scientists in Darwin's time. The many anatomical similarities between fossilized and living organisms, or organisms inhabiting different landmasses, all supported the argument for what was then called the "transmutation" of species. Few serious naturalists would have put their hand on their heart and declared that all species had remained completely unaltered since the Creation. The question was *how* this change could have come about and how this could result in adaptation.

The crucial first step toward understanding is summed up in the justifiably famous diagram in Darwin's notebook of a branched line, labeled simply, "I think." No few lines ever cost such mental effort. Until this time the prevalent belief was that all the species currently in existence could be traced back to their equivalent ancestral form along parallel *unbranching* lines. It was even quite a popular idea because it seemed to represent improvement. In his 1844 book *Vestiges of the Natural History of Creation*, Scots journalist Robert Chambers, writing anonymously (he finally thought it safe to reveal his identity by the twelfth edition), applied this theory not just to animals and plants but to the whole solar system. Despite attacks from theologians and the senior scientists of the day (Adam Sedgewick, Darwin's former tutor at Cambridge, said it was so foul it must have been written by a woman!), it sold

a staggering one hundred thousand copies—a remarkable feat that I can only aspire to—and Prince Albert read from it aloud to Queen Victoria every afternoon.

Domesticated animals were included in this belief, and it was commonly upheld by fanciers that all domesticated varieties had descended from a long line of inferior models, each lineage dating back to its respective wild ancestor now conveniently proclaimed to be either extinct (unlikely) or hitherto undiscovered (even less likely)—just like Temminck's theory about multiple chicken ancestors described in the previous chapter.

It is, however, surprisingly easy to find ample evidence of branching phylogenies in domesticated animals. The creation of the Cavalier King Charles spaniel is a good example and a particularly interesting one as it involves a deliberate backward trend.

When New York business tycoon Roswell Eldridge attended Crufts Dog Show on a visit to England in 1925 he was very disappointed not to see any of the pretty little toy spaniels with the pointed muzzles that so epitomized Old Master paintings from the time of King Charles II. The toy spaniels popular by this time (officially named King Charles spaniels in 1902) had flattened faces with virtually no muzzle at all. Already by 1848 the naturalist William Youatt in his book *The Dog* had complained, "The muzzle is almost as short, and the forehead as ugly and prominent as the veriest bulldog. The eye is increased to double its size and has an expression of stupidity with which the character of the dog too accurately corresponds." The altered features may have been due in part to crossing-in breeds like the Pekinese or the Japanese chin. Pugs are often blamed, too, though they've also undergone a snout-shortening transformation. Look at Hogarth's pet pug in his self-portrait, for example. The fact remains that by 1925 flat-faced spaniels were in vogue and deliberately favored by breeders over pointy-nosed spaniels.

Eldridge's response was to place an advertisement in the following year's Crufts schedule offering a £25 prize each (then a considerable sum of money) for the best dog and bitch of the "old type" spaniel—"as shown in pictures of Charles II's time, long face, no stop, flat skull, not inclined to be domed." Inspired by the prospect of such a fortune, and no doubt bemused that someone would pay good money for rubbish they would have otherwise have drowned, breeders answered the call.

Thus a new breed of dog, the Cavalier King Charles spaniel, was born. (Ironically the name "Cavalier" was taken from the 1832 painting by Sir Edwin Landseer, *The Cavalier's Pets*—several centuries after King Charles II!) A comparison between the skulls of Cavalier King Charles with those of the centuries-old toy spaniel shows that the head shape of the two would have been remarkably similar, suggesting that Eldridge's efforts paid off. Two years after the initial advertisement was placed, a breed club was established and, despite ridicule from the hard-core King Charles breeders, the Cavalier King Charles spaniel was accepted by the Kennel Club of Great Britain in 1945—though Roswell Eldridge would have been disappointed to learn that it wasn't embraced by the American Kennel Club until 1997.

To move on to an avian example, the Budgerigar doesn't have any established breeds, but it too has changed considerably—and in a remarkably short time span. The species can even be said to have split into three distinct branches.

"Budgies" have only been domesticated since the mid-nineteenth century. The first pair was brought to England from their native Australia by renowned publisher and ornithologist John Gould, who described them as "the most animated, cheerful little creatures you can possibly imagine." They became instantly popular as pets and almost immediately their average size began to increase. By 1900 budgies were already significantly larger than their wild counterparts, long before the trend for large exhibition budgerigars began to set in. This change may well have been a result of an unconscious association of size with health or vigor. (Even now we attach an unaccountable importance to the weight of human babies at birth.) Another possibility is that large individuals were less successful in their original habitat. Budgerigars are nomadic, with flocks traveling vast distances across arid scrub and grassland from one meager water supply to the next. Prolonged periods of sustained flapping flight require a great deal of energy and can generate a dangerous heat level, which is easier for a small animal with a larger relative surface area to keep in check. This is only speculation, but the truth remains that the size of wild budgerigars perfectly fits their not-insubstantial metabolic demands. It's sometimes difficult to know whether a change is the result of positive selection *for* something or reduced selection *against* something. Either is equally likely if environmental conditions have altered radically, for example, in a newly domesticated animal, and it's probably a little of both.

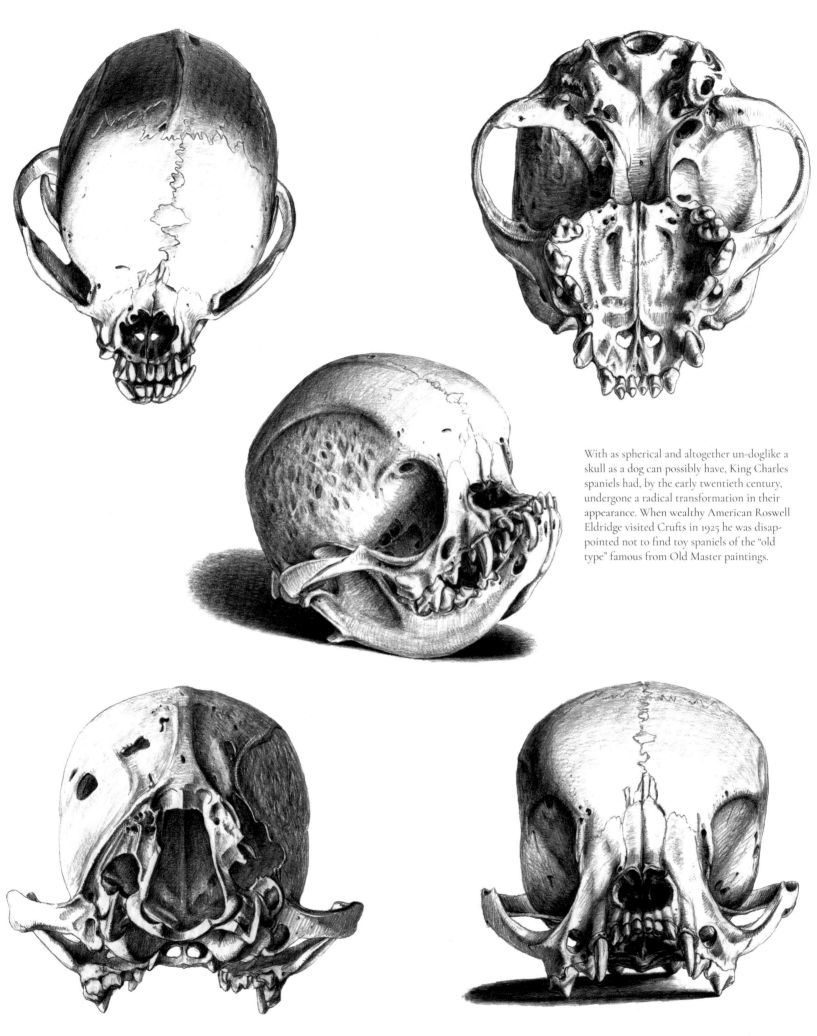

With as spherical and altogether un-doglike a skull as a dog can possibly have, King Charles spaniels had, by the early twentieth century, undergone a radical transformation in their appearance. When wealthy American Roswell Eldridge visited Crufts in 1925 he was disappointed not to find toy spaniels of the "old type" famous from Old Master paintings.

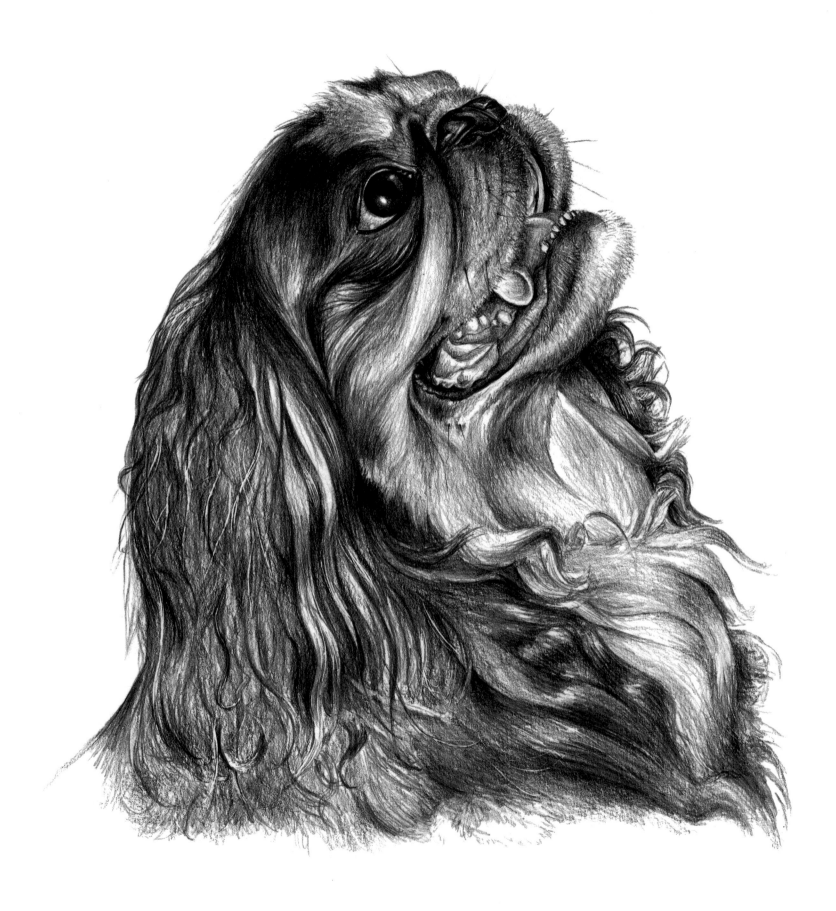

By financing special prizes for toy spaniels of the "old type" at Crufts, Roswell Eldridge was instrumental in the creation of a new breed, the Cavalier King Charles spaniel. Both the King Charles (left) and Cavalier King Charles (right) now exist side by side—two twigs springing from the same evolutionary branch.

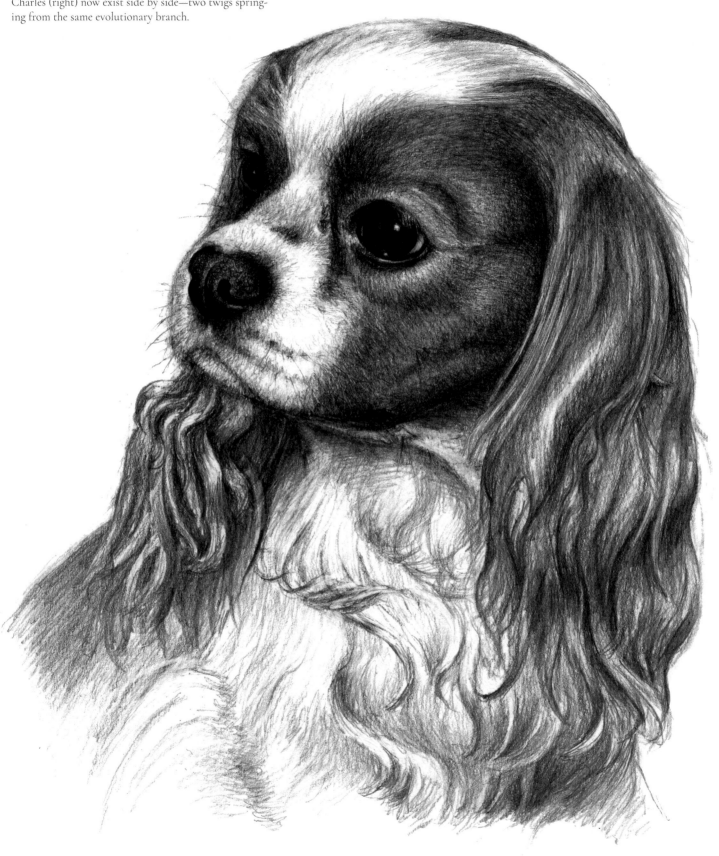

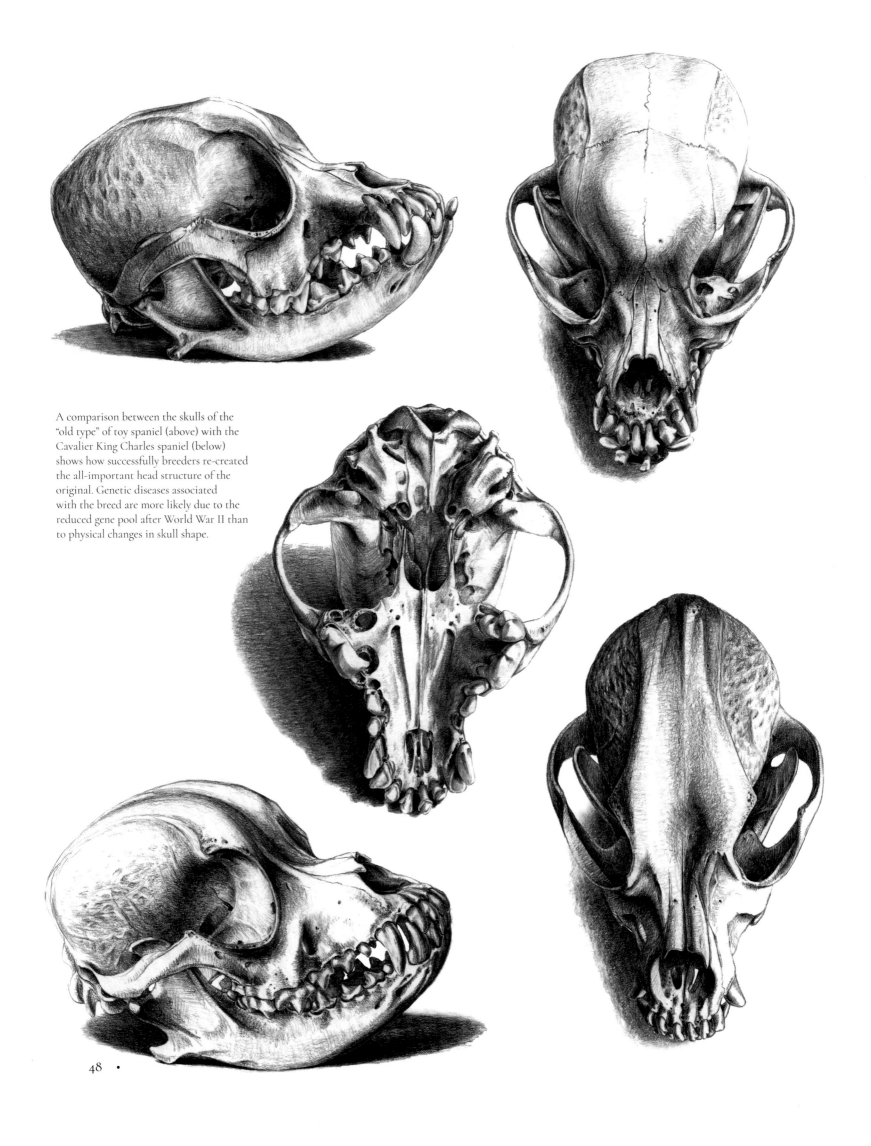

A comparison between the skulls of the "old type" of toy spaniel (above) with the Cavalier King Charles spaniel (below) shows how successfully breeders re-created the all-important head structure of the original. Genetic diseases associated with the breed are more likely due to the reduced gene pool after World War II than to physical changes in skull shape.

48

Since the 1960s, the preference for large birds among exhibition budgie breeders has pushed their size to ever-greater extremes. There's a limit to how far you can go—size in a single species can't go on increasing forever—but this hurdle was overcome by unconsciously selectively breeding for longer feathers too, giving the illusion of a much larger bird. Nowadays, the feathers are so long that the "best" show birds can look a bit disheveled to the uninitiated non-fancier. Pet budgies, meanwhile, although larger than their wild counterparts, resemble them far more closely than they do the exhibition birds. So, in less than two hundred years, domesticated budgerigars have not only changed from the wild-type, they've effectively split into two additional distinct types. It takes only the reproductive isolation of populations, in this case the large, long-feathered show budgies becoming separate from the smaller pet budgies (and both being permanently separated from their diminutive Antipodean ancestor), to bring about a new branch on the tree.

Of course, neither of these two twentieth-century examples was available to Darwin in his attempts to find a mechanism for evolution, but he had plenty more. There's nevertheless a big difference between selecting known historical examples of divergence and announcing it a universal phenomenon. What was needed was to turn the argument on its head and trace existing diversity back to a single species.

It was by crossing several distinct pigeon breeds together for three or more generations that Darwin's attention was drawn to the emergence of patterns and colors closely resembling the wild Rock dove. According to the linear change theory this shouldn't have been possible—any reversion to an ancestral type should have resulted in offspring with the same qualities as the parent stock. What if, Darwin concluded, this meant that all the hundreds of pigeon varieties—the short-billed Owls and Turbits, the hook-billed Scandaroon, the frilled Jacobin, enormous Runt, and tiny Figurita—had actually descended from a single wild ancestor? As he wrote in the *Origin of Species*:

> Altogether at least a score of pigeons might be chosen, which if shown to an ornithologist, and he were told that they were wild birds, would certainly, I think, be ranked by him as well-defined species. . . . Great as the differences are between the breeds of pigeons, I am fully convinced that . . . all are descended from the rock-pigeon.

Darwin wasn't alone in this theory. As we've already seen, Temminck had reached the same conclusion, along with several of Darwin's colleagues in the pigeon fancy. Among these was James Lyell, who, in his 1881 book *Fancy Pigeons*, openly questioned the multiple-ancestor theory of pigeon origin with special regard to pigeons with silkie plumage pictured earlier in this chapter. (Silkie pigeons—at that time known as "lace pigeons"—are flightless and rather susceptible to the rain.) "If fancy pigeons were separate creations and not descended from a common origin, I wonder how the Lace Pigeon existed till taken in charge by pigeon fanciers."

Although the creation of new breeds of domesticated animal might seem superficial compared with the lofty science of speciation, it nevertheless shows how easily an animal lineage can be split into multiple isolated forms. Although different varieties of the same species can reproduce together, exhibition breeders will usually ensure that they don't, which is just as effective as being isolated on a remote oceanic island. Indeed, Darwin saw varieties simply as incipient species. No serious budgerigar fancier would cross his stock with a budgie from a pet shop, and never again will pedigree King Charles and Cavalier King Charles spaniels be permitted to interbreed. All will now continue to evolve along their respective trajectories.

This is a significant point. With multiple branches all continuing to evolve independently, and all extant animals occupying only the very tips of these metaphorical branches, it can't logically be said of animals in existence at any one time that one type can have evolved from another. So while it's true to say that fantails are probably closely related to mookees, or that man's closest relative is the Chimpanzee, it's quite erroneous to think that fantails evolved

Skulls of domesticated pigeons, all sharing a common ancestry with the Rock dove and showing the enormous diversity of possible forms. Despite the apparent intermediate stages, all these birds are contemporary and represent the tips of evolutionary branches. From appearance alone, assumptions about which branch sprang from which would be merely guesswork—especially as many breeds were created by crossing.

Exhibition Homer

Scandaroon

Carrier

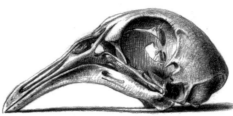
English Magpie

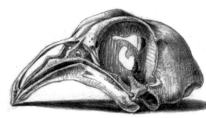
German Beauty Homer

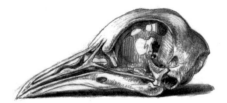
Old German Magpie Tumbler

Steinheimer Bagadette

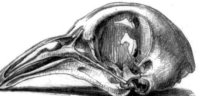
German Beauty Homer

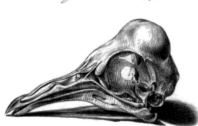
Polish Highflier

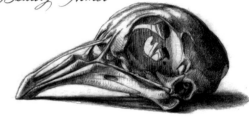
Dragoon x Show Homer

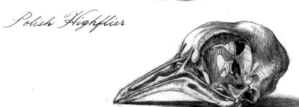
Stralsunder Highflier

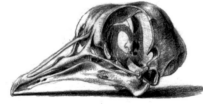
Schmalkaldener Moorhead

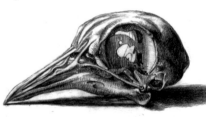
Frillback

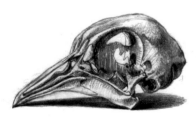
Danzig Highflier

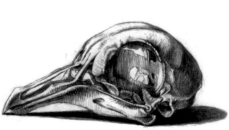
Genuine Homer

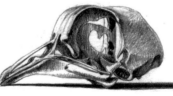
Birmingham Roller

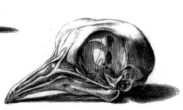
Kumru

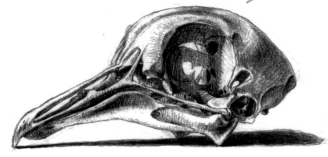
Runt (Roman)

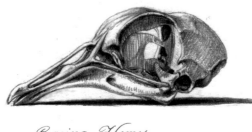
Racing Homer

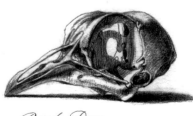
Rock Dove

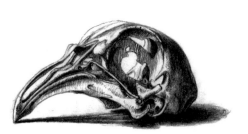
Danish Tumbler

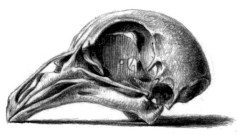
American Show Racer

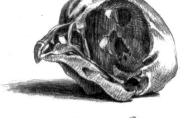
African Owl

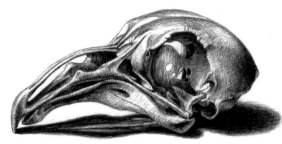
Show Homer

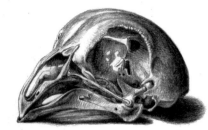
Show Antwerp

Ancient Tumbler

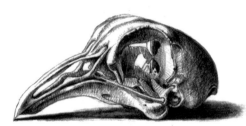
Scandaroon x Barb

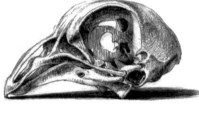
Old Dutch Owl

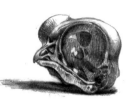
Vienna Short-faced Tumbler

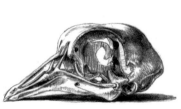
Vienna Highflier

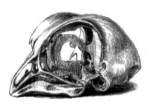
Königsberg Colourhead

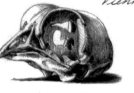
Taganrog Tumbler

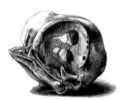
English Short-faced Tumbler

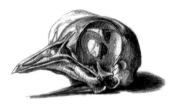
Kumru x Figurita

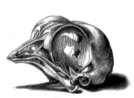
Figurita

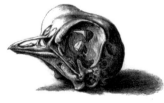
Portuguese Tumbler

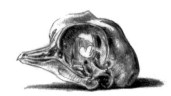
Berlin Short-faced Tumbler

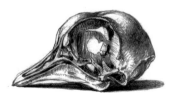
Vienna Hellstork

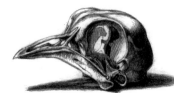
Vienna Long-faced Tumbler x Fantail

Vienna Long-faced Tumbler

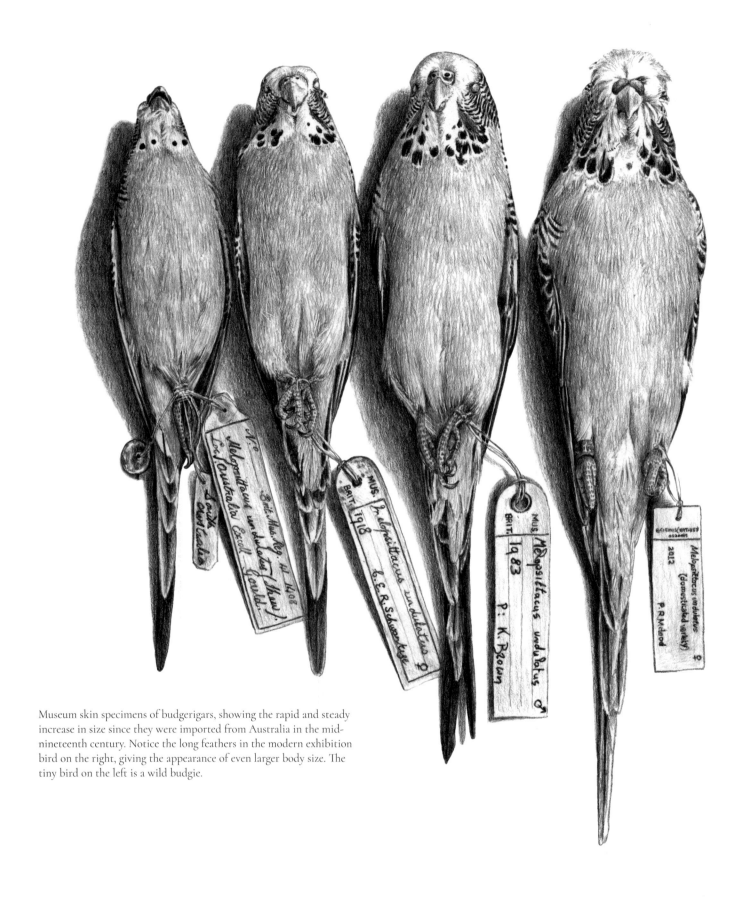

Museum skin specimens of budgerigars, showing the rapid and steady increase in size since they were imported from Australia in the mid-nineteenth century. Notice the long feathers in the modern exhibition bird on the right, giving the appearance of even larger body size. The tiny bird on the left is a wild budgie.

from mookees or that man evolved from chimps. They share a common ancestor, and these ancestors share common ancestors with other, less similar, animals—on and on to the very base of the tree. None of the contemporary products of evolution is more "perfect" or more highly evolved than another.

While it's true that some animals might appear to evolve more slowly, or even remain in stasis for lengthy time periods, the mechanism that drives evolution—natural selection—is never-ceasing. Neither does evolution work only in a single direction over large time scales. The smallest shift in conditions can bring about short-term changes that pendulum back and forth every few years with little or no overall difference, particularly in small populations that are more sensitive to environmental fluctuations. Everyone knows, for example, that the various bill shapes and sizes of the thirteen species of Galapagos finch rapidly adapted to fill niches usually occupied by birds of several different families. But, thanks to the recent groundbreaking research of Rosemary and Peter Grant from Princeton University, we now know that as conditions fluctuate, the finch populations undergo short-term evolutionary changes as well.

Darwin's own specimens of Galapagos finches collected during the *Beagle* voyage, along with specimens from more recent collectors, were kept in a cabinet just outside my former office at the British Natural History Museum and I had plenty of opportunity to examine them. The difference between individuals of the same species, even over the shortest of time periods, was astonishing. The massive-billed Large ground finches collected on the *Beagle* voyage had a noticeably larger bill than those collected a few decades later. Again, later still, the average bill size had increased once more. These oscillations are rapid adaptations to sporadic periods of high rainfall or drought, affecting the abundance of seeds of varying sizes. When large-seeded plants are prolific, the larger-billed Large ground finches will thrive, while smaller seeds give the smaller-billed individuals the selective advantage.

Darwin recognized the power of animals to change and diversify—their plasticity—as the keystone of his evolutionary theory. And he saw in the way breeders change the appearance of domesticated animals the perfect analogy to illustrate how evolution works. As effective a subject for experimental studies as bacteria or fruit flies (and infinitely more attractive), artificial selection of domesticated animals offers a parallel to evolution at every level. In only fifteen thousand years—announced celebrated geneticist Dmitry Belyaev, addressing the 1978 International Congress of Genetics in Moscow—domesticated animals have produced the greatest change in behavior and form than has ever occurred in evolutionary history.

At a more humble but no less profound level, I heard a touching story from an acquaintance of mine, Mark, a university professor of paleontology in the western United States. Mark dreaded visits with his father. They belonged to two different worlds, and every attempt at conversation was a minefield of conflicting opinions. Over an uncomfortable dinner one evening the subject turned to Mark's work and, despite his best attempts to head it off, from there to evolution. He groaned inwardly, expecting the usual religious fundamentalist arguments; his dad belonged to a tight-knit rural community of churchgoers. But they didn't come. Instead the old man looked thoughtful. "You know, son," he said, "I've lived around these parts a long time and always there were animals around on the farms; hogs and cattle and the like. Over the years I've seen that these are different from how they used to be. Anyway, I've been thinking that if the hogs and cattle can change, well, maybe it's just possible that other animals can change too."

I
ORIGIN

3. Darwin's Universal Law

3 ~ Darwin's Universal Law

I was sixteen years old when I first attempted to read *On the Origin of Species* and, I'm sorry to say, I didn't get very far. I was expecting a book about exotic wild animals and their adaptations. I certainly hadn't been prepared to trawl through page after page of discussion about domesticated pigeons, which I, in my ignorance, considered unworthy of attention. To my disgust the whole of the first chapter was devoted to variation under domestication and to pigeons in particular; discussing the origins of different varieties, conscious and unconscious selection, and the differences between varieties and species—all things that I found very tedious. Then there was the matter of the language, which was rather cumbersome for a twentieth-century teenager. The bottom line though, I think, was that I was simply not able to imagine a worldview in which evolution was not taken for granted. I gave up even before the end of chapter 1 and returned it to the bookshelf.

I still haven't sat down and read *Origin* from cover to cover, but I have listened to it several times as an audiobook during the long hours working on these illustrations, and I can honestly say that it's inspirational. The final passages in particular are as beautiful and deeply moving a piece of writing as you'll find anywhere in literature. I can't read them without being close to tears, and I'd urge anyone who fears that natural selection is too nihilistic, too cold and dispassionate, to take a moment to read them:

> There is grandeur in this view of life, with its several powers, having been originally breathed into a few forms or into one; and that, whilst this planet has gone cycling on according to the fixed law of gravity, from so simple a beginning endless forms most beautiful and most wonderful have been, and are being, evolved.

While I was unable to imagine a world without natural selection, Darwin's audience was unable to imagine a world with it. People had an idealized vision of nature as something pure; the idea that life had no greater purpose would have been abhorrent. Adaptations—far from providing evidence for evolution—gave extra strength to the argument that they were too perfect to have come about without a directed plan. Natural selection would have seemed a terrifying, godless abyss.

This is where the domesticated animals came in. There was a reason why Darwin began his species book (as he called it) with these, and we touched on that reason at the end of the last chapter. If people can accept the idea of creating and adapting varieties of domesticated livestock by gradual selection, they've taken the first step off the precipice and found that there's a path. From there on it's an easier route to accepting that species—even all forms of life, including man—can be formed in the same way.

The question of whether Darwin too was led toward his theory by following this path, or whether it was just a cunning bit of psychology to lure his readers in, is a subject much debated by scholars. In later life Darwin claimed that artificial selection was instrumental in the formulation of his theory of natural selection in nature, and I believe that it would have certainly made a major contribution. Nineteenth-century naturalists were just so much more eclectic than their modern-day counterparts and eager to learn from any source.

Some of Darwin's own skeletons of domesticated pigeons. Darwin kept fancy pigeons for several years, conducting breeding experiments and carefully comparing their skeletons in an effort to understand the mechanism for evolution.

Skull of a Niata cow, an extinct short-faced, or brachycephalic, variety from South America. Darwin observed these unusual cattle on several occasions while traveling in Uruguay during the voyage of the *Beagle*, comparing them with short-faced dog breeds such as bulldogs and pugs.

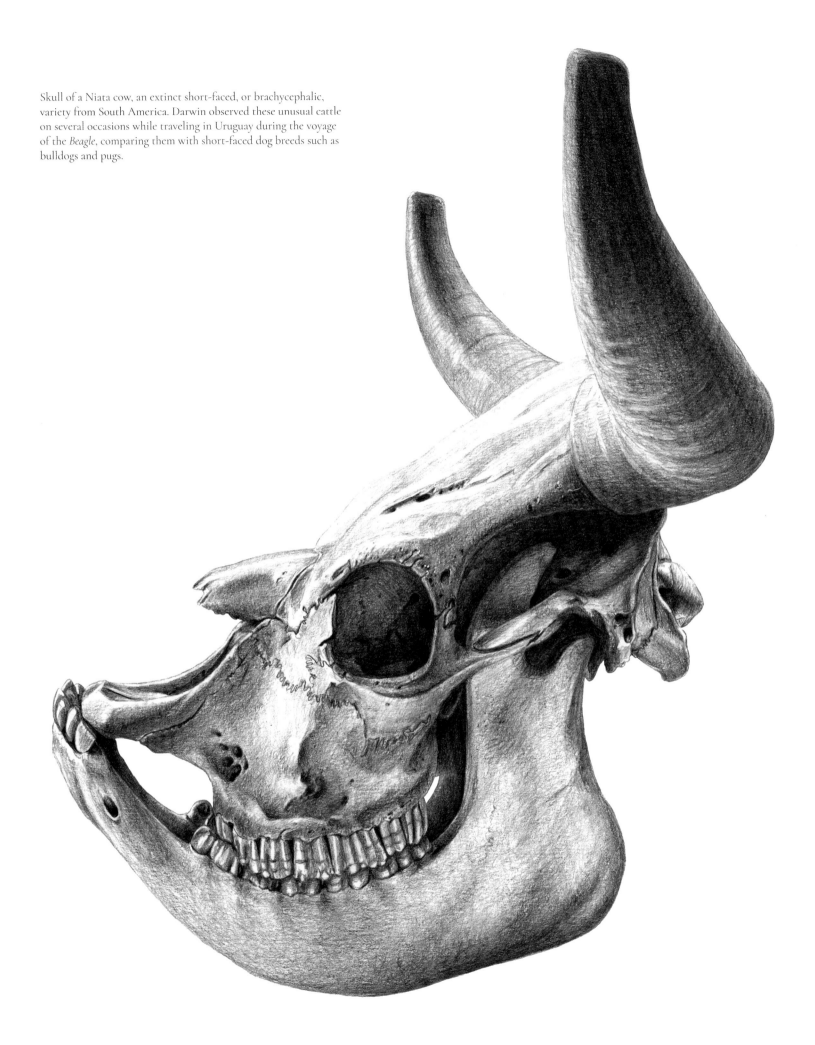

In hunter-gatherer communities, there's nothing as valuable during lean times as a good hunting dog. When humans depend on dogs for their own survival, they'll protect the best ones at all costs, resulting in more efficient animals with each generation. Gradually, distinct types evolve, each suited to its particular prey.

Even during the *Beagle* voyage, when he was still a very young man, Darwin was as ready to make observations about domesticated animals as wild ones. For example, he took a great interest in the short-faced Niata breed of cattle that he saw in Uruguay, comparing their unusual skulls with those of bulldogs or pugs. From the native inhabitants of Tierra del Fuego he learned that in times of hardship the old women of the community would be killed and devoured instead of the dogs. "Doggies catch otters, old women no." Although it undoubtedly filled him with nothing but repugnance at the time, in future years this impressed on Darwin the high value placed on good hunting dogs that would ensure their survival at all costs. Over many generations of unconscious selection, he realized, better and better hunting dogs would be produced.

We've already discussed how different scientists had different opinions about the single- or multiple-species origins of various domesticated animals. Darwin, as we've seen, believed that all domesticated pigeons, and chickens too, had originated from a single wild ancestor—though he had reservations about dogs. What interested him, then, was how a handful of wild ancestral species could diversify into such a staggering number of separate breeds and varieties. He wasn't especially concerned with the process of domestication itself. In fact it was his half cousin, the prodigiously versatile Francis Galton (later to be known for his work on eugenics), who was first to publish on the qualities that make some animals and not others suitable subjects for domestication. Darwin's interest was in what happens *after that*; principally in how the increasing number of breeds and varieties produced by selective breeding might be analogous with the process of increasing diversity in nature—using it as a metaphor for evolution rather than as an evolutionary process in its own right. It's the purpose of this book to show what an excellent metaphor that was—even more appropriate than Darwin himself knew.

Darwin described *Origin* as one long argument, and that's exactly what it is: a scrupulously thorough account of his theory of evolution by natural selection, or "descent with modification." As is true of most scientific discoveries, the popular idea of Darwin having a "eureka moment" while on the Galapagos Islands is pure mythology. Yes, the Galapagos raised some fundamental questions, but the theory of natural selection was borne of careful reasoning, meticulous experimentation, and many years of self-disciplined hard work. The real legacy of the *Beagle* voyage was that it taught Darwin to observe carefully and to think for himself. Even the Galapagos finches, which are associated so closely with Darwin, barely made an impression on him at the time. It was only after his return to England and Darwin had shown his bird specimens to John Gould at the Zoological Society of London that their significance, as diverse descendants of a single ancestral species, became apparent.

Twenty-three years passed between the *Beagle* voyage and the publication of *Origin*. After the five-year voyage, recurring ill health prevented Darwin from ever leaving the British Isles again, but he found everything he needed for his continued research from the local natural history, in the domesticated animals and cultivated plants that he and his acquaintances kept, and through his abundant correspondences. He was especially interested in domesticated varieties that may have been reproductively isolated for some time, maintaining the belief that varieties were just species in the making. He wrote to naturalists living abroad requesting specimens of pigeons and poultry (among them, in Borneo, a young English naturalist named Alfred Russel Wallace), and he picked the brains of everyone who might have information he could use, from the loftiest academic to the humblest gardener.

Eclecticism, an inquiring mind, and an astounding capacity for industry were the hallmarks of the Victorian naturalist, and few restricted themselves to any narrow field of specialism as biologists do now. Furthermore, the fashion for raising captive animals of all varieties—pigeons, poultry, rabbits, dogs—was at the height of popularity across the whole spectrum of social classes. So, in an effort to make sense of the bigger scientific questions—questions like the transmutation of species—most naturalists would as readily turn to horticulture as to botany, or to the various products of selective breeding as to animals in the wild. These associates and many more must have contributed to endless stimulating discussions of experiments and observations, providing much of the raw material for Darwin's evolutionary thinking.

Darwin's associates included William Tegetmeier, an expert on pigeons, poultry, and beekeeping, and the self-taught but quite brilliant ornithologist William Yarrell, whose suggestion it was that Darwin should keep pigeons. Then there was pharmacist Jacob Bell, a breeder of Bloodhounds whose passion for dogs was only rivaled by his passion for art (when a favorite dog sustained serious injuries falling from a balcony, Bell rushed her not to the vet but

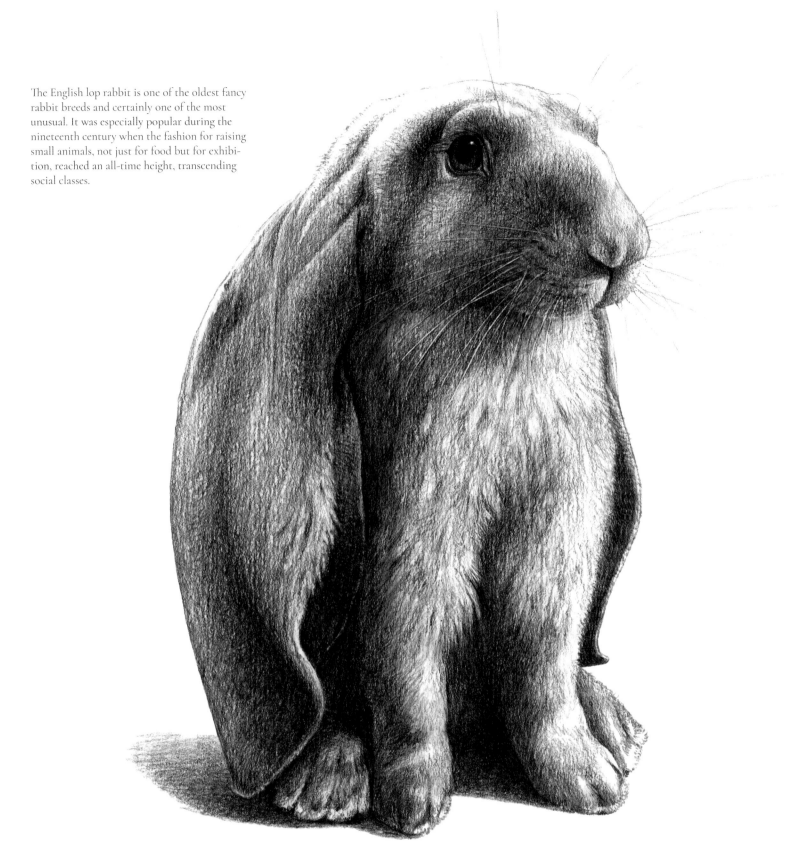

The English lop rabbit is one of the oldest fancy rabbit breeds and certainly one of the most unusual. It was especially popular during the nineteenth century when the fashion for raising small animals, not just for food but for exhibition, reached an all-time height, transcending social classes.

to Sir Edwin Landseer to be immortalized on canvas before she died!), and Darwin's own second cousin and close friend William Darwin Fox, a clergyman, entomologist, and great lover of dogs and outdoor pursuits.

In addition to his socially privileged peer group, Darwin also rubbed shoulders with the unlettered artisan class of pigeon enthusiast from the Spitalfields area of London's East End, the dark heart of the English pigeon fancy. In September 1856 he wrote proudly to an American colleague, "I have now a grand collection of living and dead pigeons and I am hand & glove with . . . Spital-fields weavers and all sorts of odd specimens of the human species who fancy pigeons." Darwin probably thought these excursions into the less salubrious parts of London a grand adventure,

though it's likely that the Spitalfields weavers thought Darwin a bit of a joke and almost certainly sold him inferior birds at inflated prices!

In Darwin's own words he "soon perceived that selection was the keystone of man's success in making useful races of animals and plants. But how selection could be applied to organisms living in a state of nature remained for some time a mystery."

The answer didn't come to him from the field of biology but from the words of economist Thomas Malthus, whose controversial book *An Essay on the Principle of Population* was already in its sixth edition by the time Darwin picked it up in 1838. Any population of individuals, Malthus argued, increases at a greater rate than available food resources, leading to famine and poverty if allowed to continue unchecked. In a nutshell: competition for limited resources is the normal state of play. It gets more intense during times of shortage and slackens off under more favorable conditions. So any slight difference between individuals might make all the difference to survival. Darwin wrote of the revelation in his autobiography, "It at once struck me that under these circumstances favourable variations would tend to be preserved, and unfavourable ones to be destroyed. The result of this would be the formation of new species."

The exact same competition for existence goes on in the domestic chicken coop or pigeon loft where choices need to be made about which animals are removed and which are kept in the population. Imagine a medieval housekeeper harvesting squabs—pigeon chicks—for the table from a large old-fashioned dovecote building. Why climb a ladder to the upper levels when there are birds for the picking lower down? By this simple act of laziness the fortunate birds that get to nest high up pass on their preference for high nest sites to the next generation. In fact the housekeeper is filling the role of any terrestrial predator at a bird colony, picking off lower-ranking breeders from the less select sites at the periphery of the group.

Pigeons are prolific. They're assembly-line breeders. It's true they lay only two eggs in a clutch, but they make up for this by laying them all year round and as often as they can. Pairs dive into parenting with equal enthusiasm; the moment the chicks have fledged it's out with the old, in with the new, and the adults simply can't wait to start all over again. Throw out any notions you had about doves of peace and so forth—pigeons are aggressive and territorial and, whatever the reason for keeping them—for meat, racing, exhibition or, like us, for experimental breeding—overpopulating a loft just isn't an option. Husband had been keeping pigeons for nearly three decades before we met and at first I found the need for population control unacceptably ruthless. I embarked on all sorts of emotional crusades to attempt to save the life of every unwanted individual before finally resigning myself to the fundamental truth about artificial—and natural—selection: more are born than can survive. And the survivors survive for a reason.

In the protected environment of the pigeon loft, where human choice is the principal selective force, change can happen very quickly. Advantageous traits that give a competitive edge might equally be favored under natural selection as by a human owner. However, as we saw in relation to the size of budgerigars in the previous chapter, in wild animals in a stable environment there's an additional degree of selective pressure *against* change. In fact the process of evolution in wild animals is generally so slow that it can't be easily observed, even if a human lifetime spanned a thousand years. This is why Darwin was unable to provide concrete cases of evolution in nature and had, instead, to rely on observable examples of animals and plants under domestication.

"It's so slow that no one can see it happening" might sound like a bit of a lame argument even to us. But to a nineteenth-century audience there was an additional barrier to overcome: time. According to accepted wisdom, there simply wasn't enough of it to have allowed gradual evolution to take place. The world, according to seventeenth-century scholar James Ussher, was created at around 6 p.m. on 22nd October 4004 BC. (I'd fully intended to throw a party for all my biologist friends in 2004 to celebrate the 6,000th birthday of the earth, but when the time came it completely slipped my mind.) Although by the early nineteenth century few scientists took Ussher's chronology seriously, anyone venturing to guess the age of the earth fell woefully short of the mark. Most geologists of the period believed that the earth as we know it, with its mountain ranges and deep canyons, was formed by some catastrophic event. Vulcanists competed with neptunists over whether the earth's rocks were formed in cataclysmic fire or in water. No one could deny they're exciting, romantic, mental images.

Then, in the 1830s, geologist Charles Lyell, who was to become a close friend of Darwin, shattered the idyll in his three-volume masterpiece *Principles of Geology*. Lyell, developing ideas first suggested by James Hutton, proposed

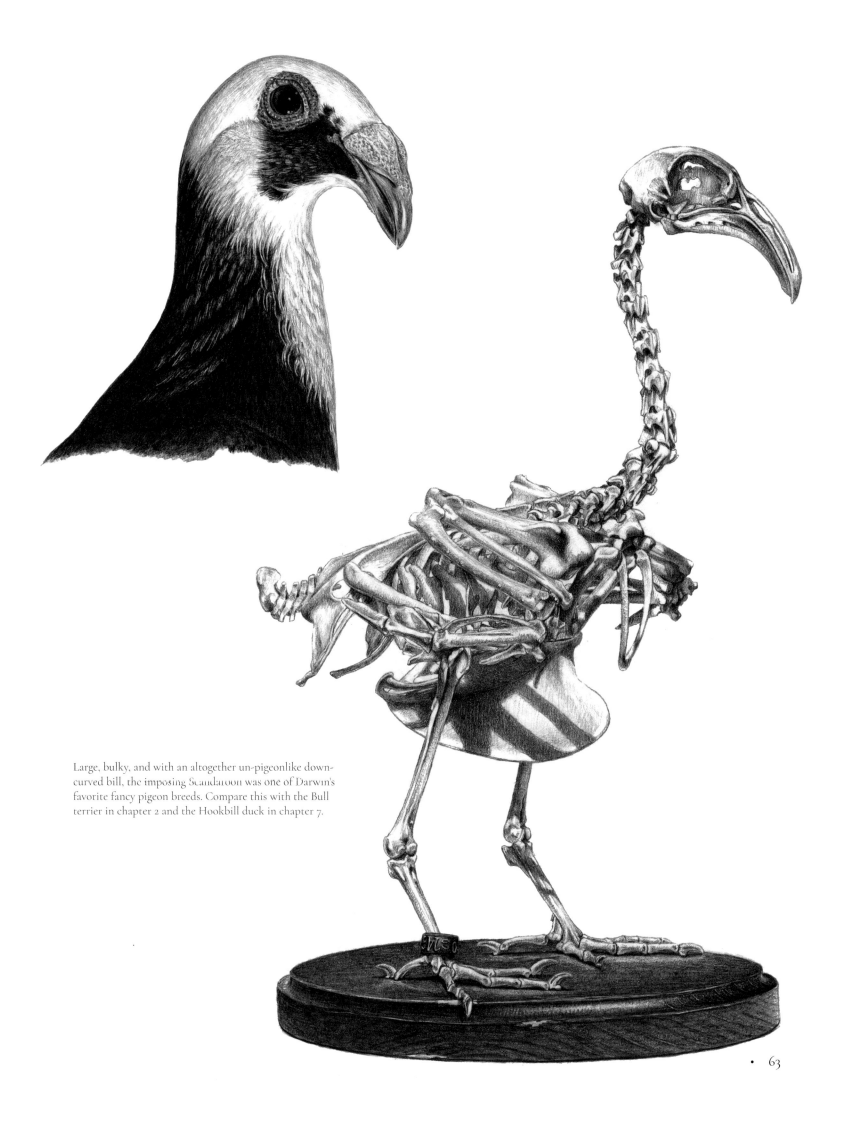

Large, bulky, and with an altogether un-pigeonlike down-curved bill, the imposing Scandaroon was one of Darwin's favorite fancy pigeon breeds. Compare this with the Bull terrier in chapter 2 and the Hookbill duck in chapter 7.

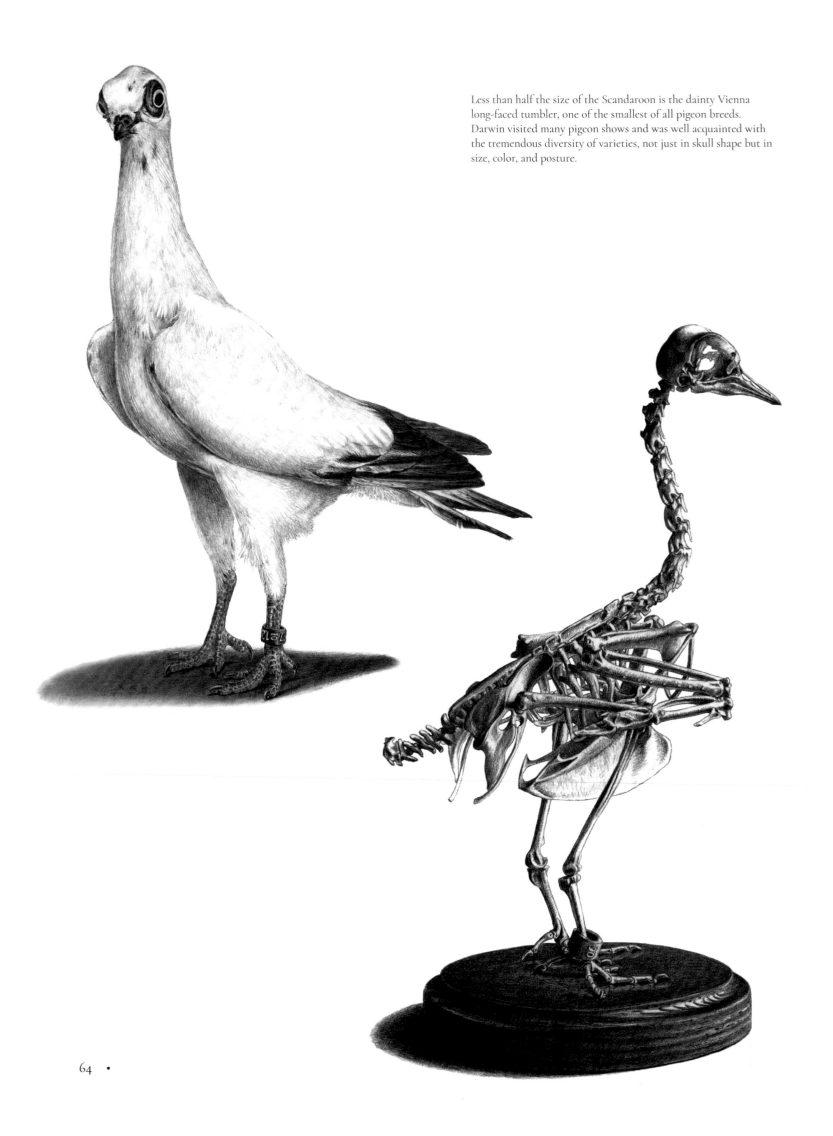

Less than half the size of the Scandaroon is the dainty Vienna long-faced tumbler, one of the smallest of all pigeon breeds. Darwin visited many pigeon shows and was well acquainted with the tremendous diversity of varieties, not just in skull shape but in size, color, and posture.

that the forces that shaped the world are the same as those we see around us every day, and are *still shaping it*. Consider a heavy downpour carrying little rivulets of mud downhill; the action of ice in rock fissures; wind across a cliff face. Yes, there were still volcanoes, but not mass eruptions changing the entire surface of the earth. There were still glaciers that deposited large boulders and carved wide valleys. And the earth had been transformed by not just one but a whole series of ice ages. These were not sudden catastrophes but a succession of long, slow processes acting in unison with everyday forces spanning, not hundreds of years, or even thousands, but countless millions of years. Yes, Lyell took all the fun out of catastrophism, but by suggesting that the earth was far, far older than anyone could have imagined, he replaced it with something truly awesome, something that no human brain or the brain of any living creature can even begin to comprehend: the concept of unfathomable deep time.

With this "uniformitarian" view, there was plenty of time for the slow formation of the landscape by the constant action of wind and water, ice and fire, without the need for sudden catastrophes. And enough time for the gradual evolution of all life on Earth. In many ways, *Principles* can be seen as the geological precursor to Darwin's theory of natural selection, advocating constant, gradual change by processes that can be observed around us, every day. Darwin instinctively knew that the mechanism for evolution he sought would be the biological equivalent of a physical law, like Newton's laws of gravity and motion, and this is precisely what he arrived at in the elegantly simple and timeless theory of natural selection. The beauty of such a law is that it works on the principle of logic, like a mathematical equation. It never becomes outdated and transcends all subsequent scientific developments, working equally well at the level of populations or ecosystems, at the molecular and even the cultural level. Even the important questions that Darwin left unanswered or answered incorrectly—like how inheritance works and how variation is generated—are mere details that in no way undermine its effectiveness. It goes like this:

1. Offspring tend to inherit qualities from their parents.
2. All individuals are different from one another, so some differences may be expected to have an advantage over others.
3. More individuals are born than will survive to reproduce; therefore the advantageous qualities may have a higher chance of being passed to the next generation, increasing the ratio of these types in a population.

One grossly crude misinterpretation of natural selection is to assume that the physically strongest, most aggressive individuals survive or, worse still, have the right to survive. This is why the arguments for "social Darwinism" are so deeply flawed and dangerous. "Survival of the fittest" is actually one of the most troublesome phrases in science. It was originally coined, not by Darwin, but by philosopher and economist Herbert Spencer, unwittingly the first of many who attempted to extend biological concepts to human society without fully understanding them. It didn't appear in *On the Origin of Species* until its fifth edition in 1869, ten years after its first publication. Darwin interpreted the phrase as "best fitted" for the environment, and "fitness" is still used in biological jargon to mean "potential reproductive success." Unfortunately, most people don't know that. Being "best fitted" has nothing to do with fitness in the physical sense; it doesn't mean healthiest, strongest, or most virile, or, in the modern British slang sense, sexy, as in "Cor, she's fit!" All of these things, and especially the sexiness, can have a substantial impact on success, however, which is why the misunderstanding has persisted for so long. Even the "survival" part is wrong, as natural selection doesn't depend on long life but on how many viable offspring you manage to produce.

People often confuse evolution with adaptation, or interpret it as a deliberate, driven process as though guided by the will of the animal. Adaptation might be the net result of natural selection, but it's not the aim. Natural selection has no aims. Neither does it necessarily produce the best or most perfect adaptation. It all depends on the starting point—which is why animals can be seen to have adapted to similar niches in many different ways; they're just different routes to the same end.

Inheritable variation between individuals is at the root of all adaptation, and the perpetual generation of these variations happens by entirely random processes. There's actually far more likelihood that a harmful variation will arise, or one that has no effect whatsoever, as one that's beneficial. We mostly get to hear about the beneficial variations because these are the ones that stick around.

If this is all sounding uncomfortably cold and mechanical, remember that this is only one part of the equation. The other part, the part concerned with selection—although unguided—is about as non-random as it can be. The

slightest difference that a variation makes can influence survival. In the country of the blind, so the saying goes, the one-eyed man is king. A rudimentary eye when before there was no eye, a membrane that can generate lift, a thicker coat in a colder climate, a more cryptic pattern, a greater tolerance of stress levels in a rapidly expanding population—all of these slight benefits can influence the number of offspring an individual is able to produce within its lifetime. Like a snowball rolling downhill—gradually, over countless generations, these tiny variations accumulate. Likewise the smallest, seemingly insignificant factor in the environment has the power to exert its influence too. It gets really interesting when you look at the interrelationships between whole groups of organisms with their environment and the complex ecological webs that are kept stable only by the constant action of natural selection. In this way unimaginably sophisticated adaptations can come into existence unaided by an intelligent external force, simply by the action of countless tiny steps.

What each of these steps, these slight differences, has in common is that they must have conferred a competitive advantage, or at least no disadvantage, at every generation. I'm not just talking about the lifespan of a population or even a species but throughout a history that may have spanned a multitude of taxa—way, way down through the branches of the evolutionary tree. Philosopher and evolutionist Daniel C. Dennett compared it with winning every consecutive game of heads and tails billions of times in a row, which, unlikely as it sounds, is actually a logical necessity as long as there are enough players to keep the league going. No loser gets a second chance, though certain adaptations may do better in some environments than in others.

Interestingly, this is one respect in which artificial selection potentially departs from natural selection—breeders, as intelligent "designers," are able to use their knowledge of inheritance to plan ahead and engineer an outcome several generations in advance—the equivalent of the chess strategy losing the battle to win the war.

The very same laws of natural selection also act to produce diversity that has nothing to do with adaptation. You wouldn't say that a peacock's train is an adaptation to its environment; it's counterproductive to staying alive: it's cumbersome, it's costly to grow, and it makes you easy prey for predators. No, a peacock's train is a response to the wishes of peahens. (It's actually the number of the beautiful eye-like markings that the girls really go for, and a large train has room for more "eyes.") But once again, no two peacocks are the same and the most impressive individuals that the females select to breed with pass on their potential for superior trains to their offspring. Even the female offspring inherit the bias toward this type of train. In fact what females really want in a male is a train that's even larger, but, as this would probably get the males eaten by predators before they have a chance to breed, these megasexy peacocks wouldn't be passing on anything to future generations. But as long as peacocks can survive, the train will go on getting bigger and bigger. The two, sometimes conflicting, types of selection are acting at once—natural selection to the environment adapts peafowl for staying alive long enough to breed, while runaway sexual selection determines which individuals have the most breeding success. Both conform to Darwin's law of natural selection: random heritable variation + non-random selection = evolution.

Exactly the same divisions occur within artificial selection too. At the most basic level, domesticated animals have all adapted to novel environments (close proximity to man and other animals, different climates, different foods, reduced sexual competition, and so on). They're also being subjected to what Darwin called unconscious selection by man, like favoring larger animals because size implies health and vigor; individuals with attractive colors or markings, or the most docile animals that are easiest to handle. All these things can be seen as brands of adaptive environmental selection, comparable with normal natural selection in wild animals and they can fluctuate, or progress quite slowly. But as soon as you introduce competition between other individuals of the same type—horse races and dog shows, for example—just like the peacocks' train, the rate of evolution enters a positive feedback loop and has the capacity to go off the scale, exactly as it does with sexual selection in nature. So, in the artificial selection of domesticated animals, passive and runaway forces operate simultaneously and often in opposition, just as they do in natural selection in wild animals.

Another example that also seems to defy the principles of natural selection is the evolution of sterile workers in social insect colonies. If natural selection is based on the inheritance of traits that may give them greater reproductive success, how, reasoned Darwin, could populations evolve in which a proportion of individuals appears to have sacrificed their reproductive capabilities for the greater good? Once again, domesticated animals were able to provide Darwin with an analogy that helped him make sense of the problem. By comparing the non-breeding insects

All animals and plants are subject to slight individual variation. While the variations that occur are entirely random, the question of whether or not they give a reproductive advantage is decidedly non-random. Size differences in domesticated Mallard ducks (below) have allowed the creation of large meat breeds, like the Pekin duck (top left), down to the tiny (but vociferous) Call duck (top right), used as decoys.

with non-breeding commercial livestock destined for slaughter, he came to understand that continued selection for a trait can be maintained through the parent generations, even though they might not share that trait themselves.

Intelligent, industrious, and thorough though he was, Darwin was not, I believe, ahead of his time. Like most great men, his contribution was largely built on the foundations laid by other thinkers before him. In his book *Zoonomia* of 1794 (in my youth I always misread this as "*zoomania,*" which I thought was a splendid title!), Charles's own grandfather Erasmus Darwin had actually suggested that all life was in a perpetual struggle for existence and had descended from a common ancestor. In 1809 French naturalist Jean-Baptiste Lamarck had formulated the first truly cohesive theory of evolution, which moreover was the first to recognize environmental factors as the agent responsible for adaptation. Lamarck adopted, as his means of variation, characters acquired during an organism's lifetime that he assumed to be inheritable—a perfectly reasonable though incorrect assumption and one Darwin and many later scientists never completely rejected. Tragically Lamarck is more often associated with his mistakes than with his achievements, which were many and profound. I've stubbornly refused to speak of "Lamarckism" in this book, instead using the phrase "inheritance of acquired characteristics."

The stage was set for natural selection, and it was only a matter of time before the components of the idea were put together by others to the same end. Again in 1809 the talented poultry and pigeon breeder Sir John Sebright (best known for the creation of the remarkable bantam breed we'll be discussing later in this book) inadvertently hit the nail on the head in a letter titled "*The Art of Improving the Breeds of Domesticated Animals,*" saying, "A severe winter, or a scarcity of food, by destroying the weak and the unhealthy, has all the good effects of the most skilled selection." Darwin was warned repeatedly by Lyell to publish quickly or be scooped by another. But he disregarded his friend's advice and pottered on with his experiments, his other publications, and the gathering of evidence to

Commercial meat broiler chickens are bred to gain weight fast and are usually slaughtered at around six weeks of age. Even if they're raised to adulthood, as this bird was, their skeleton is not sufficiently strong to support their excessive musculature (see the illustration in chapter 10). Breeding is therefore out of the question. The paradox of how celibate animals can be developed by artificial selection helped Darwin understand the evolution of sterile workers in social insect communities.

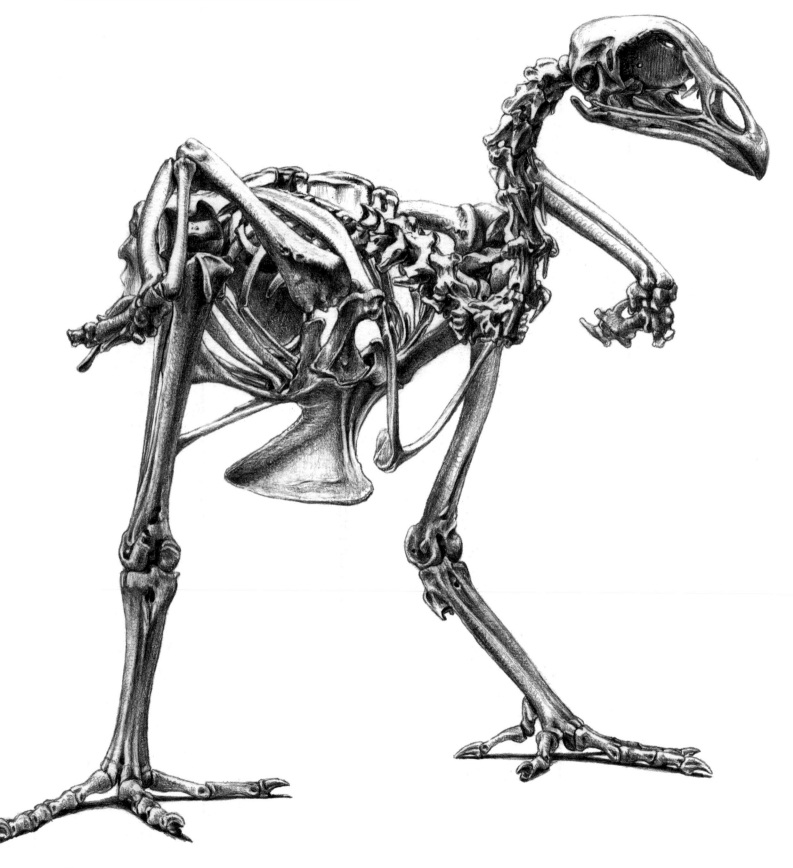

test his theory. By June 1842 he'd written a 35-page synopsis. Two years later it had been expanded and carefully rewritten into a 230-page essay. In 1856 he drafted what he planned to be an enormous book called *Natural Selection* (he called it his "big book"), which would probably have been very dry reading indeed.

On 18th June 1858, however, when the manuscript was half way toward completion, the morning post brought Darwin a catalyst that would spur him into action: an unpublished paper by Alfred Russel Wallace titled "*On the Tendency of Varieties to Depart Indefinitely from the Original Type.*" The paper was Darwin's theory of natural selection in a nutshell. "I never saw a more striking coincidence," wrote a dismayed Darwin to Lyell. "If Wallace had my manuscript sketch written out in 1842 he could not have made a better short abstract! . . . So all my originality, whatever it may amount to, will be smashed." Darwin, in collaboration with Lyell and the botanist Joseph Dalton Hooker, a mutual friend, acted swiftly under the cloak of magnanimity, arranging the presentation of a joint Darwin-Wallace paper (with himself as lead author, of course!) at the Linnaean Society a fortnight later. Neither author was present on the day. Wallace, still in Indonesia, was oblivious of the meeting, and Darwin was at home with his family, racked with grief over the death of his baby son from scarlet fever just a few days earlier.

I've attended and given talks at the Linnaean Society of London, so I've seen the large commemorative bronze plaque on the wall marking the site of this auspicious presentation. But at the time the paper met with very little interest and certainly fell far short of the triumphant reception Darwin had anticipated. The president of the society later reported that the year had not thrown up any revolutionary discoveries, and one commentator had even gone so far as to add that "all that was new in them was false, and what was true was old." After a few days licking his wounds Darwin threw himself wholeheartedly into a brand-new book: a popular book—*On the Origin of Species by Means of Natural Selection*—a fraction of the size of his intended tome. It took only thirteen months to write and, on its publication in November 1859, was an immediate success, launching Darwin into the international limelight.

One last anecdote deserves to be told on the subject of the rise of the idea of natural selection. While thumbing through the *Gardeners' Chronicle* in April 1860 Darwin happened to notice an irate letter from a Patrick Matthew—a name completely unknown to him—berating Darwin for not acknowledging him as the original author of the theory. Darwin hurried to procure a copy of the publication in question, an obscure little book of 1831 titled *On Naval Timber and Arboriculture*. Sure enough, tucked away in an appendix, was a concise definition of the requirements for natural selection written, as though it was the most obvious thing in the world, twenty-eight years before the publication of *Origin*. In a delightful example of Victorian gentility, Darwin and Matthew exchanged a series of letters in *Gardeners' Chronicle*, Darwin conceding to Matthew's claim of priority and Matthew assuring him that he deserved the credit anyway as he'd put so much work into gathering all the evidence!

Darwin didn't put away his "big book." Writing *Origin* in such a hurry meant that he had been forced to leave several assumptions untested, and the most glaring omission—the proviso that the whole theory of natural selection rested on—was the mechanisms for inheritance and variation. It was these questions fundamentally that Darwin had been tackling with the experimental crossbreeding of pigeon varieties, as he prepared and measured their skeletons, and in his experiments with the crossbreeding and self-fertilization of plants. It was these questions he was considering throughout his years of interrogatory correspondences with every sort of animal and plant breeder all over the world. His work to fill these gaps had begun before the publication of *Origin* and continued for many years after, eventually culminating, in January 1868, in the massive two-volume work *The Variation of Animals and Plants under Domestication*. I've timed the publication of this book as a celebration of its 150th anniversary.

Variation lacked the clarity and confidence of *Origin*. Where *Origin* was one long eloquent argument for a simple formula, *Variation* was a rambling string of examples; a messy train of thought leading to a conclusion Darwin knew deep down to be flawed. Even so, it was an impressive collection of accounts and observations. How ironic, that for all his copious letter writing, the questionnaires he sent out to breeders of plants and animals around the globe, and the extensive reading and meticulous research with which he informed himself of every possible source of useful material, Darwin allowed one crucial contact to escape his notice. For there was someone, at exactly the same time, conducting very similar breeding experiments to his own and with the same purpose in mind—someone studying inheritance in pea plants in a monastery garden in Brno.

II

Inheritance

4. Colored Liquid; Colored Glass

4 ~ Colored Liquid; Colored Glass

One winter's afternoon, many years ago, I could have been seen fighting my way through a snowy squall across a desolate expanse of common land in northeast England leading a nanny goat on a length of rope. I was looking for a billy goat. My goat, Alice, was in heat, and, as she was destined to be a milker, she had first to conceive. Goats don't remain in heat for very long, so, regardless of the inclement weather, I was forced to answer the need for immediate sex. There were usually animals tethered out on the common and, as I hadn't the slightest intention of paying for the service, it was a case of seizing an opportunistic union when no one was looking. Alice was a strapping beast, of no particular breed, but quite the tallest goat I've ever seen. However, the only male I could find that day was a tiny pygmy goat that could have easily walked between Alice's legs without touching her belly. Undeterred, I untied the little chap and led both animals to a steeply sloping bank where I re-tethered the male at the top, and Alice at the bottom, thereby compensating for his vertical challenges at least. Five months later she gave birth to two normal-sized kids, each barely smaller at birth than their pygmy goat father.

These were not hybrids of course; all domesticated goats belong to the same species and despite their diversity of appearance are equally capable of interbreeding to produce little—or large—kids of their own. For anyone who knows something of genetics or has experience in goat breeding, the fact that Alice's kids were not pygmy—dwarf—goats but normal sized, won't come as much of a surprise. Assuming that the parents were both purebred for their respective sizes, all the offspring of such a union would inherit one copy each of both parents' genes and, as normal size prevails over dwarfism, each would carry a dwarf gene but not actually show it. If I'd wanted a pygmy goat of my very own, and if the kids were of opposite sexes, all I would have had to do would be to breed them together to have a 25 percent chance of one being born.

This is the classic pattern of inheritance discovered by Augustinian friar Gregor Mendel. Every individual inherits two sets of instructions for every trait, one from each parent. If the parents' traits are different from each other, for example, dwarf and normal sized, one is probably dominant over the other. If there's a dominant trait present in the pair, that's the one that will be expressed. If there's not—if both of the pair are recessive—then that's the trait that'll be shown. The ratio of different characteristics shown in the offspring of every generation all depends on the genetic makeup of the parents, and even though they might have the appearance of one thing, it doesn't mean they're not carrying genes for something else.

Working patiently year after year in the garden of St. Thomas's Abbey in Brno (now part of the Czech Republic), Mendel diligently and methodically crossed together different varieties of pea plants, observing the ratios of the offspring of the contrasting forms. He was careful to choose traits that lacked intermediates; they were either one thing or another, like smooth skinned or wrinkly skinned, and he made sure that all his individual plants consistently produced others of the same type when self-fertilized before he began crossing strains together.

This little piglet (from the Julius Kühn Domesticated Animal Museum in Halle, Germany) is a cross between a domesticated white (leucistic) pig and its wild ancestor, the Wild boar. In the areas not affected by leucism he shows the characteristic striped pattern of Wild boar piglets.

The green color of wild budgerigars is due to a combination of blue (really black) melanin pigment and yellow psittacin pigment: blue and yellow make green. Take away one or the other and you'll get a yellow, or a blue, budgie which, when crossed together, would produce green again. This could be explained by blending inheritance—but not the occasional appearance of white budgies when the green ones are interbred!

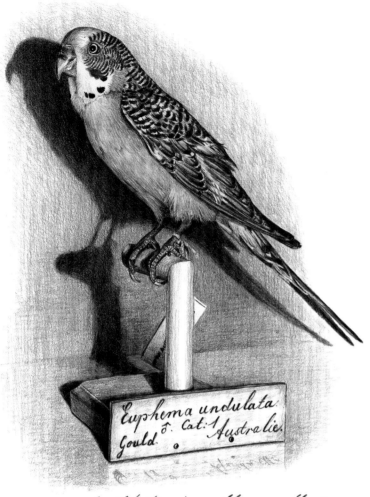

green (wild type) = blue + yellow

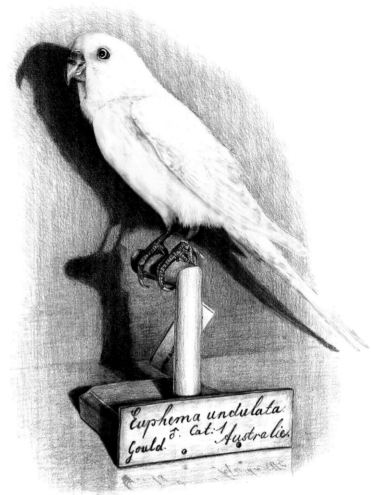

yellow = green − blue

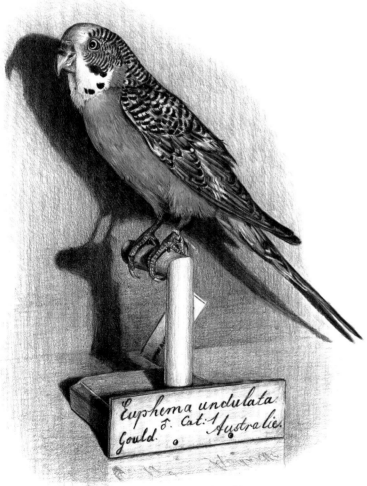

blue = green − yellow

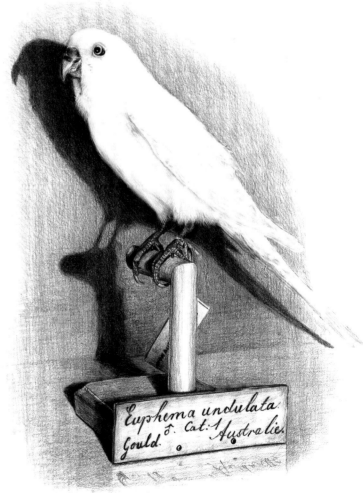

white = no colour!

Not all inherited pairs of traits are genetically dominant or recessive to one another. When rabbits with a certain type of leucism are paired with solid-colored animals, both traits share dominance, resulting in white rabbits with an attractive pattern of colored spots and stripes. Although this has the appearance of blended inheritance, it's not.

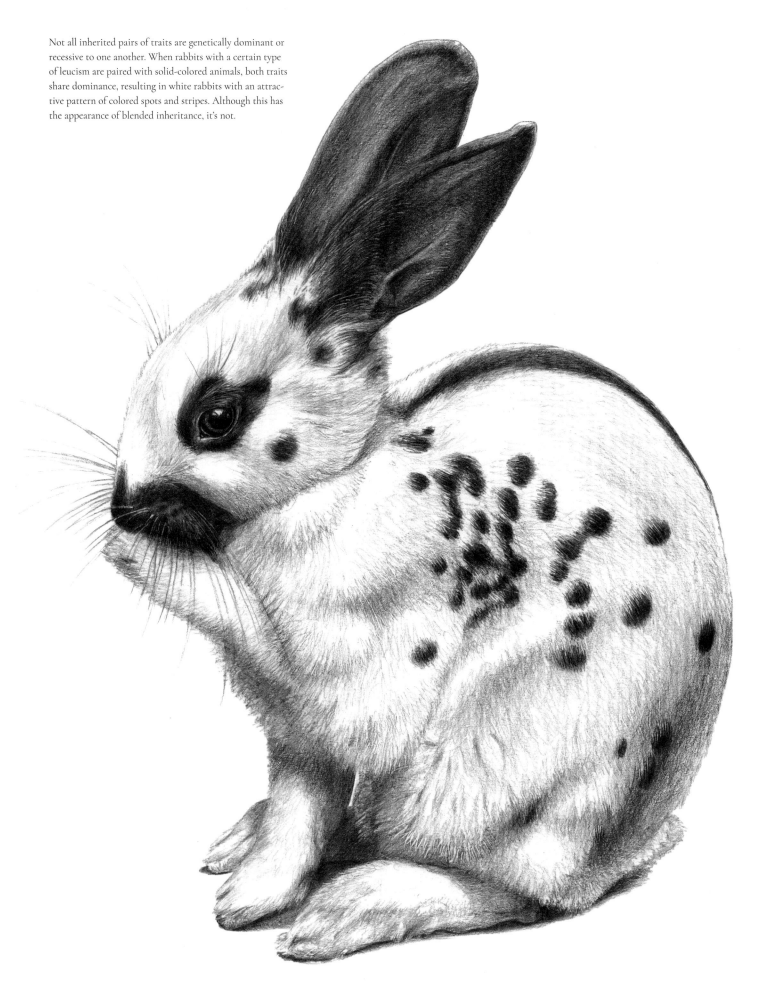

It wasn't piety but poverty that led Mendel to the monastic life, but there were few other options available for a poor farmer's son to receive a university education. His ambitions to become a teacher were thwarted by discouraging results in his oral examinations, so Mendel resigned himself to his studies, disappointed.

While Darwin was conducting his breeding experiments on pigeons, writing *On the Origin of Species*, receiving accolades and condemnations, gathering information from every source known to him, and desperately seeking a way that inheritance could provide the variation required for evolution to work, Mendel was quietly, invisibly, unremarked and uncelebrated, conducting the research that would eventually change the face of science forever. His results were presented at two meetings of the Natural History Society of Brno, which even gained some press coverage in the local newspapers, and published in a paper titled "Experiments in Plant Hybridization" in the journal *Proceedings of the Natural History Society of Brünn* (the German name for Brno) in 1866. It attracted no interest from the scientific community whatsoever.

Mendel's peas were actually no more true hybrids than the goats discussed earlier, but the term was used loosely and the paper was dismissed as being about hybridization rather than inheritance. Mendel's appointment to the role of abbot of St. Thomas's the following year forced him to abandon any further study and devote the remainder of his life to administrative chores, particularly to defending the monastery against some newly imposed government taxation. He died in 1881, unknown except for his religious office, and, in an effort to bring an end to that nasty taxation business, his papers and manuscripts—along with all the carefully documented methods and results of his scientific research—were burned.

The revelation of Mendel's legacy wasn't that characteristics are somehow passed down from one generation to the next; that's patently obvious. It wasn't even about *how* they're passed down; that's the dominion of molecular geneticists. The bottom line is that he showed that outward characteristics (the phenotype) are the manifestation of distinct hereditary units (the genotype) that can be put together in one animal or plant to produce one result and recombined in the next generation to produce a different result (and here's the important bit), the *units themselves remaining unchanged*. The official term is "particulate inheritance." Think of it as layers of colored glass, like filters on a camera, or those special glasses opticians use to test your eyes. They can be added together to produce a different effect or recombined to give new effects. The particles in particulate inheritance, of course, are the things we now call genes.

The alternative to this, and the prevailing opinion—from Aristotle all the way through to the early twentieth century—was that inheritance worked by a process of blending. It wasn't a written theory or even a hypothesis; it was just a general vague belief with many permutations. Blending involves a combination of the qualities of both parents producing a result that's intermediate between the two. That might initially sound quite convincing. After all, we do inherit half of our genetic material from each of our parents. The difference is that blending is permanent, and the hereditary units are irrevocably changed by every combination. If particulate inheritance can be compared with layers of colored glass, then blending inheritance is the equivalent of a mixture of colored liquids that, once added together, can't be separated. Anyone who's made a mistake mixing paint knows there's no way of going backward. You just have to pour the mixture down the sink and start again. Well, blending inheritance is just like that. There's no distinction between phenotype and genotype, no surprises further down the line, and absolutely no chance of two normal-looking goat parents suddenly producing a pygmy goat kid. Most significantly of all, blending actually reduces variation within a population.

This proved to be a major stumbling block for Darwin, whose theory of evolution by natural selection depended on a constant source of new heritable variation on which selection could operate. Variation is fuel to the fire of natural selection; it's consumed and destroyed by it, yet it's crucial for any accumulative change to take place. After years of laborious work on *The Variation of Animals and Plants under Domestication*—the book that was intended to resolve this issue—Darwin was still no closer to finding a solution. He was thus understandably irritated to read a review of *Origin* published in the *North British Review* in 1867 condemning natural selection as an unworkable theory on the grounds that blending inheritance would deem it impossible. The author of the review, a Scots engineer with the memorable name of Fleeming Jenkin, was a staunch advocate of blending. In a finite population, Jenkin argued, blending would eventually lead to uniformity. For natural selection to work, however, the inheritance of favorable variations necessarily leads to increasing *diversity*. His reasoning was quite correct even though his argument should

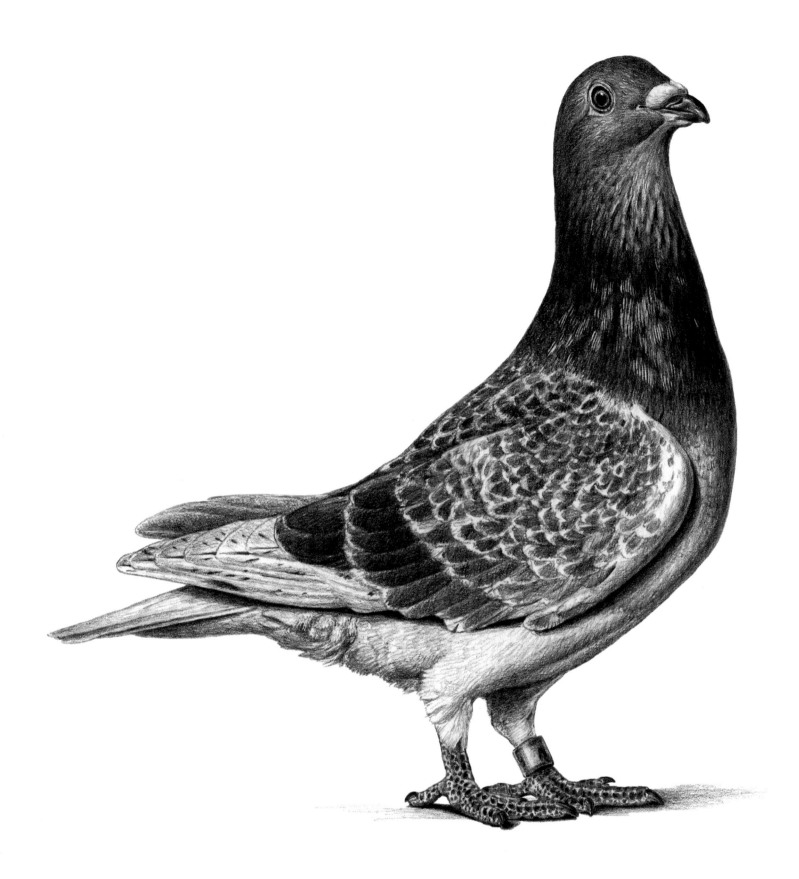

Racing homers are the elite of all flying pigeon breeds, with remarkable speed and homing ability. Although their performance requirements have eventually resulted in birds of a very uniform appearance, they were created and perfected by crossing in a medley of different breeds. Notice the deep muscular chest, the short, slightly tapered tail, and pointed wings—all adaptations to prolonged fast flight.

have been turned on its head: natural selection indeed generates diversity and requires a constant source of new variation, therefore *blending inheritance* can't work!

Jenkin's review plagued Darwin by highlighting the major flaw in his reasoning. The problem is that the results of crossing aren't always as statistically predicable as they are with smooth × wrinkly peas, or normal goats × pygmy goats. Darwin only had personal observation at his disposal, and what he observed and heard reported was a chaos of conflicting information that appeared to add up to nothing.

Crosses between distinct pigeon varieties, for example, in colors of pale gray, yellow, and red, can yield uniformly black offspring. All very confusing if you're an advocate of blending inheritance, but particulate inheritance can explain this easily. Pairs of recessive traits that were able to be expressed in the purebred varieties are split up by crossing and paired with dominant traits that take precedence. Simple! Future pairings of the black offspring with the original breeds would have resulted in the reappearance of some of those attractive colors in the next generation.

Budgerigars too could yield surprises. Wild budgerigars are green, and for several years following their introduction to Europe as pets, all budgerigars in the world remained steadfastly green. They were green because they produce yellow psittacin pigment and also blue melanin pigment (in fact this is really black pigment that appears blue in certain areas because of the structure of the feathers). Everyone knows that blue and yellow together make green, but this isn't just a rule applied to mixing paint—it applies to colors in nature too. Then suddenly a genetic mutation occurred that prevented the melanin from being expressed, leaving . . . a plain yellow budgie. All the blue and black were gone, including the black bars on the feathers, and the spots on the cheeks. In place of the iridescent purple cheek spot there was just a white, unpigmented patch.

In time, another mutation occurred that removed the yellow pigment from green budgerigars to produce blue budgies, along with all the familiar budgie markings. When blue and yellow budgies were crossed together: lo and behold, green budgies reappeared! So far this could equally be explained by blending inheritance. But when this generation of green budgies was interbred, a new color emerged too—or more correctly, an absence of color.

As both mutations involve an instruction to prevent the expression of one of the two pigment types, there's a 1 in 16 chance of inheriting *both* of these instructions together, giving white budgies. How could people possibly have known then that, while the blue and yellow birds were genetic mutations (they would have been called "sports" in those days), the white birds were the eventual result of mixing these mutations together?

There are some examples of crossings that do produce a proportion of offspring that seem to be intermediate between their parents. A cross between a solid-colored rabbit and a certain sort of white rabbit will give a litter of white-bodied rabbits with a pattern of colored spots and stripes. But in crosses between two spotted rabbit parents, every litter yields a 25 percent chance of solid-colored offspring and 25 percent of predominantly white offspring, so only half are of the parental type. Although this gives the appearance of being a blend of the parental markings it's actually the result of the two parental traits *sharing* dominance instead of one being dominant over the other. In this case, a certain trait for leucism (there are lots of different sorts of leucism, but all prevent the expression of color to some degree) is equally dominant with its alternative, which is non-leucism, that is, normal color expression. A simple way of looking at it is that leucism and color expression are fighting for supremacy, but as the battle is evenly matched the color is able to show through only in some areas and not in others. The kits that receive the trait for leucism from both parents are the mostly white ones, while those that don't receive it at all are the colored ones.

The mounted piglet at the beginning of this chapter (a specimen at the Julius Kühn Domesticated Animal Museum in Halle, Germany) is also leucistic, as you can see from the white patches. He was the result of a cross between a domesticated white pig (many domesticated pigs are white; they only appear pink because the skin shows through) and a Wild boar—their wild ancestor. So in the areas not affected by leucism he has the characteristic striped pattern of any Wild boar piglet.

Slate blue rabbits could also be considered intermediate in appearance between black and white, and if you believed in blending inheritance you'd probably try to explain it this way. But you'd be wrong. Blue rabbits are black rabbits with an additional trait to dilute the amount of pigment deposited. So the color is expressed all over but in a diluted form. In this case the trait is wholly recessive, so all blue rabbits have two copies of the genetic instruction

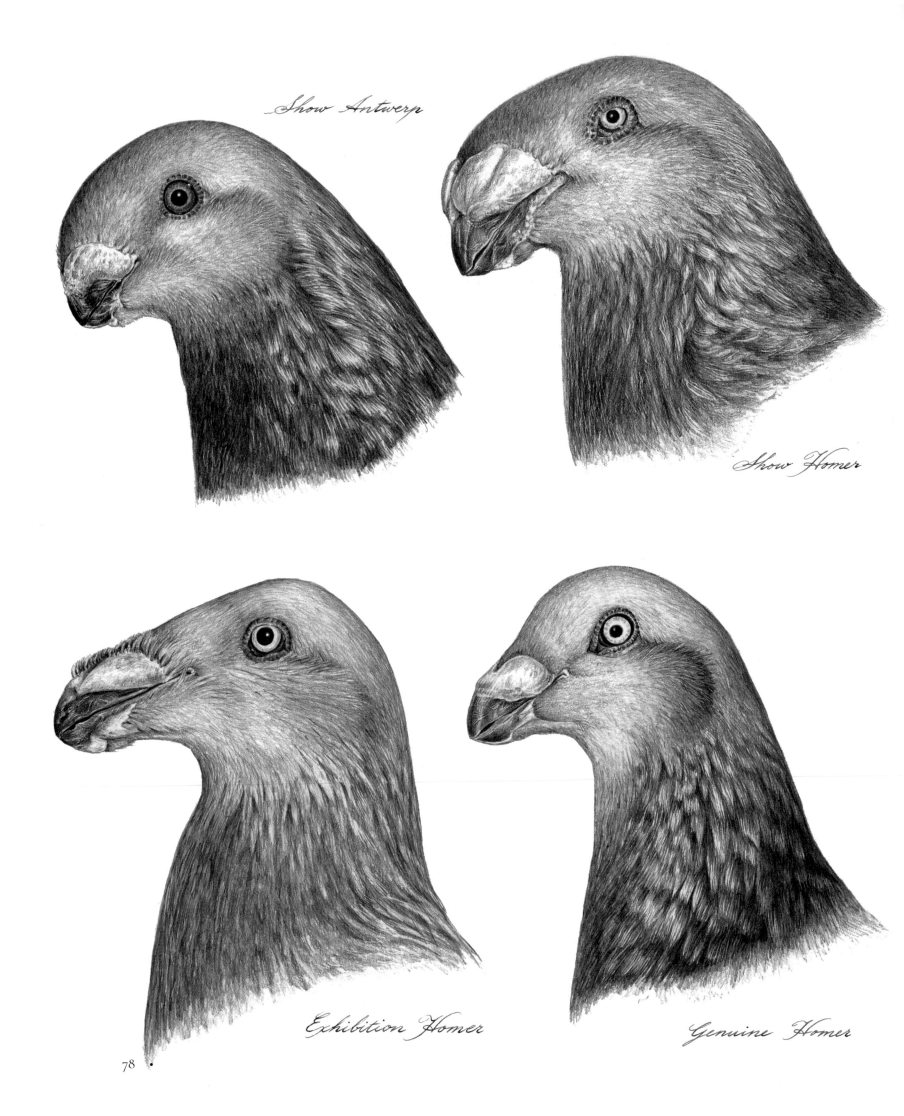

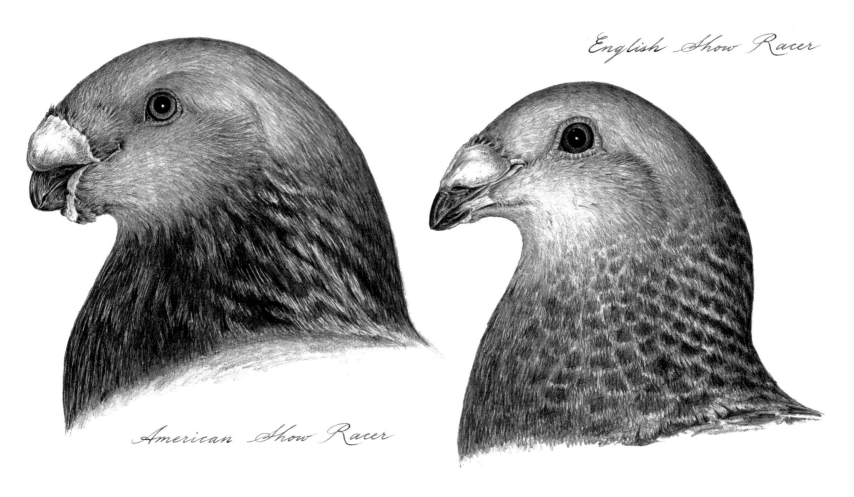

In the nineteenth century, when Racing homers were still highly variable, fanciers attempted to standardize their appearance for exhibition. The results, using a multitude of crosses, were ever-changing, culminating in a string of new breeds—the opposite of the intended effect.

to dilute (and no dominant instruction not to), which means you can breed blue rabbits together to your heart's content and get only blue rabbit progeny, all of the same color intensity.

Blue in chickens, however, works in a similar way as it does in spotted rabbits, except here the competing effect of the two incompletely dominant traits results in dilution of the color instead of its expression in patches. Palomino horses are another example, while roan cattle have an even mixture of white and colored hairs. It's important to realize that the many breeds that express these traits have been honed into their particular appearance by years of selective breeding. Merely introducing the genetic traits to the appropriately colored animals won't produce a show-quality rabbit or chicken of any particular breed.

These results would have been bewildering to anyone striving to understand the source of natural variation, unless they'd first grasped the distinction between blending and particulate inheritance and rejected the former. The genetic reasons for many more inconsistencies will be explained in the following chapters, but my purpose here is to convey the difficulties that Darwin struggled with for so long. A pamphlet he circulated to breeders as early as 1840 lists twenty-one questions (in fact each question was comprised of multiple additional questions) relating to the results of various crosses: Will the progeny of a cross between two races be constant or will it return to the appearance of either parent? In crosses between old breeds and new breeds, does the old breed take priority? Are any peculiarities in structure inherited by the grandchildren and not by the children? Can you give examples of new varieties that are not simply intermediates between two established kinds?

The questions related to crosses between species, between varieties, and between individuals of the same breed. They touched on behavior and learning ability as well as appearance. They sought to compare the productivity of

crossbreeds with the decline of inbred stock. They delved into the influence of earlier matings on future progeny and the inheritance of learned behavior. In short, Darwin was casting his net too wide. Perhaps he was attempting to find a solution as simple and eloquent as natural selection. Mendel, by comparison, had deliberately selected the narrowest parameters possible and by doing so had succeeded in uncovering the very cornerstone of what would turn out to be an unfathomably complex subject.

The result was that Darwin at first underestimated the value of crossing—that is, sexual reproduction—in animals as a means of increasing variation. This is sometimes, wrongly I think, interpreted as a calculated effort to undermine *crossbreeding* between varieties in favor of gradual accumulative selection. Darwin was far too knowledgeable about breeding practices to fall into such a trap. The value of introducing new strains to improve the productivity of livestock and of combining traits to create new exhibition breeds would have been well known to him. Darwin's mistake was that he was looking for exact intermediates between the parent varieties, not for individual traits to be inherited separately.

A skilled breeder can, in very few generations, create a new variety or enhance an existing one by transferring a particular trait from one breed to another without compromising its other qualities. The Jacobin and Norwich cropper pigeons pictured in chapter 1, for example, are often interbred to give the Jacobin a more upright posture, which in no way compromises its magnificent ruff of long neck feathers. Similarly, Darwin's friend Tegetmeier, in his book on racing pigeons, described the crosses used to improve their performance, including some seemingly very unlikely ingredients from breeds not known for their aerial prowess. Nowadays racing pigeons are fairly uniform in appearance, though a range of colors. Every now and then, however, one appears that bears a little frill or a crest; a lingering genetic remnant of the breeds used to create them.

In Darwin's time, the component parts of racing pigeons were much more obvious. Although they were doubtlessly the best flying and homing pigeons in the world, they came in a motley assortment of shapes. Their head shape in particular was highly variable; some had a thin, pointed head and bill, others a strongly rounded head and curved bill.

In the mid-nineteenth century the legendary reputation of Belgian racing pigeons had begun to excite interest in the creation of a dual-purpose bird among English pigeon fanciers—one that was fit for its original performance but of a consistent appearance for exhibition. The first deliberately-produced exhibition racing pigeon was named the Show Antwerp. (The reference to the Belgian city here is rather confusing as the breed was an English creation, but the name "Antwerp" was used by fanciers synonymously with racing pigeons.) The large rounded head was accentuated through outcrosses with another breed called an "owl," and three forms were produced depending on bill length: short, medium, and large, though the medium form was later abandoned to avoid gradation. A second version, the much larger Show homer, sprang from the large-billed variety, eventually having its facial features exaggerated still further by crossing in the charismatic Scandaroon (pictured in the previous chapter and a personal favorite of Darwin's) with a curved head and distinctive hooked bill. Although its extreme looks were popular with some fanciers, there were many who disliked the head and bill shape and wanted to return to the pre-Scandaroon version. So a third, straight-headed breed was produced by other crosses, this one called the Exhibition homer. Things were by now deviating a long way from the original Belgian racing birds and, without direct selection for their original purpose, none of these exhibition varieties had retained an aptitude for competition flying. Fourth in the series was the paradoxically named Genuine homer. There's also the Show racer from America and a finer-billed English Show racer. From Germany we have the Beauty homer—a truly stunning bird but totally useless as a flying breed. The list goes on. The most recent development is for racing homers to be deliberately created in different colors too. All of these fancy homer breeds still exist and can be seen at any pigeon show, though their appearance is continually being modified by selection.

In fact the creation of new varieties by crossbreeding has in recent years reached the height of fashion. The Naked-neck fowl has been crossed with Silkie fowl to produce the fluffy-plumed, bare-fronted Showgirl. Hairless Sphynx cats have been combined with the short-legged Munchkin to produce the Bambino, and there's a long, long list of designer dog combinations—invariably involving poodles—with portmanteau names incorporating "poo" or "oodle" somewhere. I have a cross between a Welsh border collie and a Standard poodle. I'm sure there's a name for that, but I'd rather not know what it is.

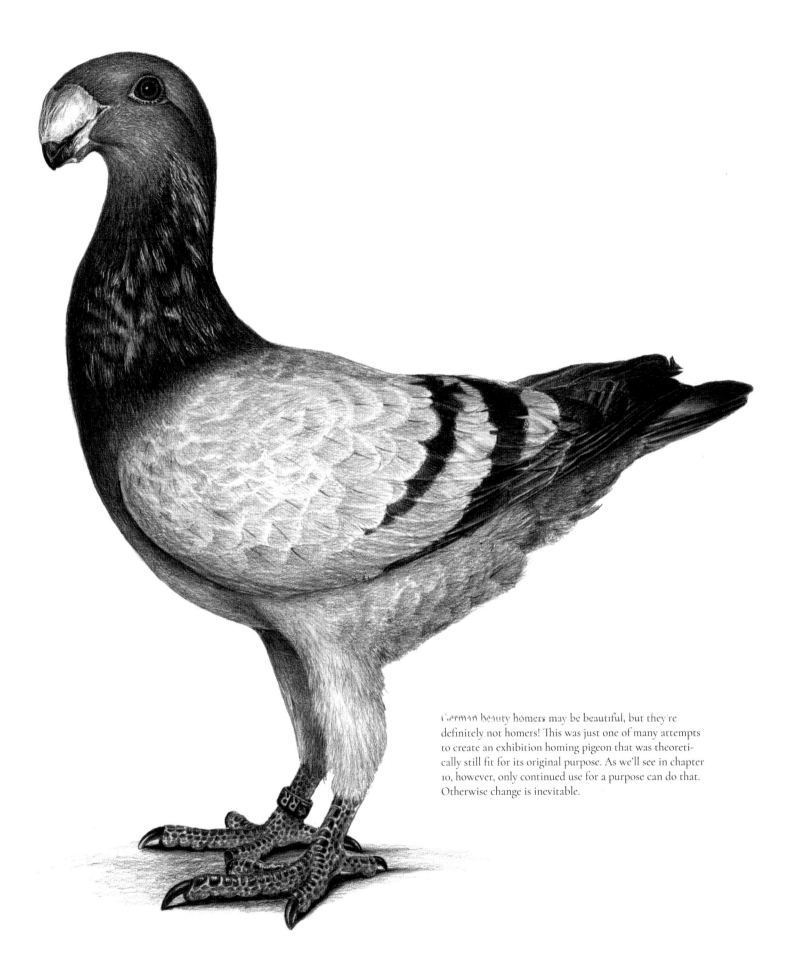

German beauty homers may be beautiful, but they're definitely not homers! This was just one of many attempts to create an exhibition homing pigeon that was theoretically still fit for its original purpose. As we'll see in chapter 10, however, only continued use for a purpose can do that. Otherwise change is inevitable.

Even when new breeds are created by deliberate crossbreeding, change continues long after the initial combination of traits, as a result of selection. Selection can continue to work—in fact *will* continue to work, either consciously or unconsciously—favoring some variations and eliminating others in an inexorable process of evolution, just as it does in nature. The diminutive Serama, for example, the smallest variety of chicken, was deliberately created in Malaysia for its aesthetic appeal from a variety of bantam breeds. But this was only the first stage. From there the process has been taken over by selective breeding, and it's that that's responsible for the Serama's continued reduction in size, heraldic-looking vertical posture, and backward sweep to the neck.

Disenchanted with crossing because of its perceived blending effect, Darwin turned instead to characteristics acquired throughout an animal's life, especially as a result of use and disuse. The floppy ears of many domesticated animals, he reasoned, were the result of not needing to be as alert to predators as a wild animal would be. Well, it's

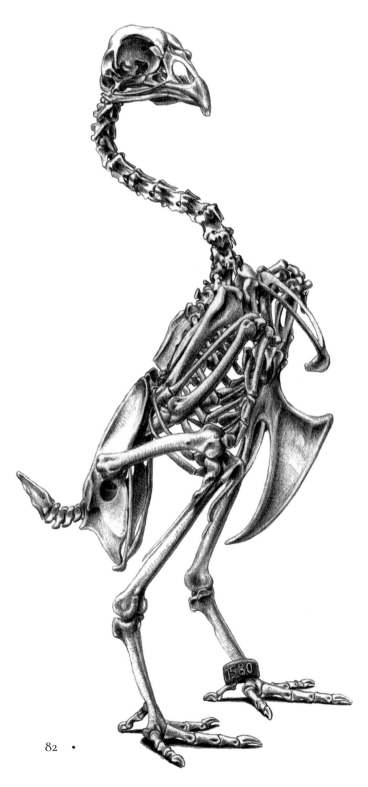

sort of true; certainly a floppy-eared impala or zebra might not last long in the Serengeti, but that doesn't mean that animals in predator-free environments will immediately let their ears down. (Actually it turns out that floppy ears *may be* more likely to occur under domestication than in wild animals, though it has nothing to do with their redundancy from detecting predators. But you'll have to wait until chapter 12 for that.)

In fact nothing that happens during an animal's lifetime is able to influence the genetic information that's already safely tucked away in the sex cells, at least not in a way that has any meaningful influence at an evolutionary level. This was eventually proven by German biologist August Weismann in 1887 through an experiment in which he cut off the tails of 68 mice for five generations until, after 901 mice had sacrificed their tail in the name of science, he reported, "there was not a single example of a rudimentary tail or of any other abnormality in this organ." Weismann had begun this experiment already confident of the outcome, in response to a spate of reports about a cat in the Black Forest area of Germany that had allegedly lost its tail in an accident, then given birth to subsequent litters of tailless kittens. He quite rightly pointed out that a spontaneous mutation for taillessness would have yielded the same result, as would a history of interbreeding with a Manx cat, a naturally tailless breed that may have been imported to the area from the Isle of Man.

It's human nature to seek supernatural answers to explain unlikely coincidences. Indeed, the greater the odds against something like that happening, the more certain it is that an inherited influence of an event will be proffered as the only explanation. Take Ragdoll cats, for example. Ragdolls are so docile they're positively floppy—hence their name. The founder population was the progeny of a former stray named Josephine who, before she was seriously injured by a car in 1965, had consistently given birth to feisty kittens with a feral temperament like her own. So, when the docile post-trauma kittens began to appear it was naturally assumed that they'd inherited their mother's enforced inactivity.

Our little Serama cockerel, Caspar, and (left) a Serama skeleton (not Caspar). Seramas are the smallest chicken breed, created purely for their aesthetic appeal from crosses using a variety of bantams. The further size reduction and heraldic upright posture were a result of continued selective breeding. Caspar has not only silkie plumage but henny feathering too, which is described in chapter 9.

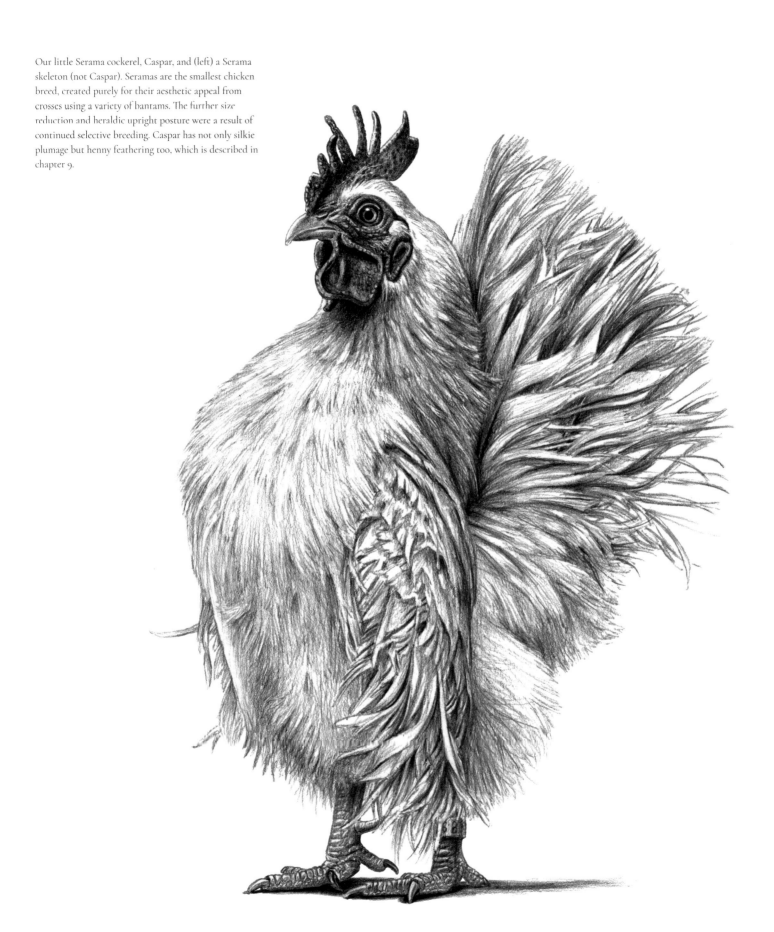

Another tale, this time from the distant past, is the red spot often seen on the forehead of red-and-white King Charles spaniels (the pattern known as Blenheim for reasons that will become clear). This was said to be the inherited thumbprint of Sarah Jennings, the 1st Duchess of Marlborough, who repeatedly fondled her dog's head in anguish while her husband, John Churchill, fought in the War of the Spanish Succession. His victory in the Battle of Blenheim in 1704 earned him the royal gift of a splendid estate in Oxfordshire, promptly renamed Blenheim Palace, where Blenheim-marked King Charles spaniels have been kept for centuries since—all bearing the red thumb spot.

The prize for the most convincing case, however, has to go to the following example, surely straight out of *The Twilight Zone*. In the mid-twentieth century a Foxhound bitch named Fashion was entered into a field trial in Kentucky. All the dogs were painted with a number on their side so that they could be identified from a distance, and Fashion was painted with a number 14. Foxhounds usually have irregularly shaped colored patches on their sides, but when Fashion gave birth to her next litter, one of the pups was clearly marked with a patch perfectly formed in the shape of a number 14!

The idea that the qualities acquired during life can be passed down to one's offspring is an attractive one, particularly if those characteristics reflect the admirable result of honest endeavor and achievement. Contradictory to the principle of blending, these qualities in offspring were—and sometimes still are—usually attributed to the male parent, with the mother's experiences being blamed for less desirable traits. Pedigrees and family trees invariably trace the male lineage, with bloodlines continued by female offspring dismissed as "interruptions."

A notable exception is the centuries-old oral tradition of the Bedouin in recording the ancestry of their Arabian horses through the female line—equally biased but a refreshing change. Mares were the most useful war horses and, as the practice of castrating males was not in common usage, males not required for breeding were invariably destroyed. The ancestry of the most highly valued purebred females (known as *asil*) could be traced through many generations, and crossbreeding between asil and non-asil—common horses of unknown descent—was taboo. If such a crossing ever accidentally occurred, the mare and all her future offspring would be deemed contaminated.

An Arabian mare owned not by the Bedouin but by an Englishman, George Douglas, 16th Earl of Morton, in the early nineteenth century is, however, the most famous example of this particular brand of inheritance mythology. It's called telegony, and it's the belief that the sexual encounters of the female will influence the progeny from future matings.

The story begins in Africa. In the late eighteenth and early nineteenth centuries the major hurdle to European colonization of the "dark continent" was disease, particularly sleeping sickness, which

It's human nature to seek supernatural answers to explain unlikely coincidences. A spate of reports of a cat that had lost its tail in an accident and afterward given birth to tailless kittens prompted German biologist August Weismann to conduct an experiment to prove that acquired characteristics can't be inherited.

affected both the colonists and their horses. No one as yet had a cure or vaccine against the disease, but if the horses could be prevented from dropping like flies then at least part of the problem would be solved. Lord Morton recognized that the African wild horses—the zebras and the semi-striped (and now-extinct) Quagga—had some immunity to local disease. His proposal was to produce hybrids between quaggas and horses that could be shipped to Africa as a commercial asset—much as hybrids between female horses and male asses (mules) have, for centuries, been deliberately produced as a beast of burden.

Acquiring a Quagga stallion was the easy part. Even the difficulty of producing a hybrid foal didn't prove unsurmountable. But producing animals that would be consistently useful turned out to be too much to ask. The first and only foal was so intractable and wild that the project was abandoned. There was, of course, no option of selectively breeding for tameness, as interspecies hybrids are almost always sterile. The chestnut mare was passed on to a friend and mated with a fine black Arabian stallion. She then proceeded to do something altogether unexpected. She gave birth to a semi-stripy foal. And then another.

This is a story often told to illustrate the fallacy of telegony. The usual description of the Arab offspring is that they had stripy legs, and the textbook answer is that many foals are indeed born with stripes on their legs that disappear as they get older. I took the trouble to examine the six beautiful oil paintings by Swiss artist Jacques-Laurent Agasse that were commissioned by Lord Morton for the Royal College of Surgeons in 1821, showing the mare, the Quagga, the Arabian stallion, and their respective offspring. Sure enough, both purebred colts have extensive striping on their withers and one has it also on its legs (the other's legs are dark, with one white foot like its father). Both in fact are, superficially at least, more quagga-like even than the quagga/horse hybrid.

There's no scientific evidence to support telegony, and there have been plenty of experiments conducted since—with horses and zebras and with laboratory mice—all of which have failed to yield conclusive results. But the offspring of Lord Morton's mare certainly make a very intriguing argument.

Darwin eventually re-evaluated his opinions on the value of crossing though it's remarkable that, for all his work on cross-fertilization in plants, he never fully came to appreciate its significance. Sexual reproduction is, in fact, the most potent source of new variation on which natural selection has to work, repeatedly shuffling and cutting the pack, dealing out a different hand each time.

Neither did Darwin abandon his belief in the inheritance of acquired characteristics. Partly in response to Fleeming Jenkin's criticism, he devised a rather shaky modification of the blending theme (based on the theories of ancient Greek philosopher and physician Hippocrates from around 400 BC), which he described at length in *Variation under Domestication*. He called it pangenesis. Every cell, he alleged, produces minute particles called gemmules that circulate around the body, eventually congregating in the reproductive organs prior to being passed on to future offspring. As circumstances throughout life affect the cells, so the gemmules become modified, subtly changing the information that's inherited. If the offspring of a cross is more similar to one parent than the other—like the kids of Alice and the pygmy goat—then there must have been more, or more potent, gemmules in that individual. Gemmules could lie in dormancy then re-emerge to be manifested as ancestral forms, or as the re-embodiment of a former lover. They could become misdirected and produce monstrosities. They could interact with embryonic cells to trigger developmental processes. The re-invention of pangenesis was Darwin's quick fix to all his heritable variation problems. Gemmules could explain everything.

Darwin was mistaken. The answer did not lie in blending but in particulate inheritance: the colored glass. Gemmules couldn't explain everything. But genes could.

II

Inheritance

5. A Question of Dominance

5 ~ A Question of Dominance

According to popular legend the glamorous dancer Isadora Duncan, enjoying a flirtatious tête-à-tête with the playwright George Bernard Shaw, made him the following proposition: with her looks and his brains, she said, they would be sure to produce a most perfect child together. "Indeed," replied Shaw, in razor-sharp repartee, "but what if the poor child had my looks and your brains?"

Big things like "looks" and "brains" are of course far too complex to be inherited in a single helping. And even if they weren't, it wouldn't come to a toss-up between one and the other. What is quite correct is that, even if it resembled neither parent, or bore a closer resemblance to a more distant ancestor, the child would have inherited every one of its features from George and Isadora. But as we saw in the last chapter, that doesn't mean that it's simply a blend of both.

Every individual animal and plant that reproduces sexually has two sets of genetic instructions—one inherited from each parent—arranged on paired lengths of tightly coiled DNA called chromosomes. Chromosomes float freely in the nucleus of every cell in the body and usually only come together when it's time for the cell to divide. Each of the two sets contains the instructions for the development of an entire organism, and every cell possesses a copy of both, even though much of it may not be useful to that particular cell. I said every cell, but there's one vital exception: the gametes—the sex cells—have only one.

The reason for this is that if eggs and sperm each contained all the genetic material of both parents, then the amount of information passed down from parent to offspring would be doubled at every generation: four, eight, sixteen—soon there would be billions of sets of competing instructions. No, sex cells are formed in a way unique to them. Instead of generating identical copies of themselves as body cells do, the two sets of information are duplicated in the usual way, then whole sections are detached and exchanged between the chromosome pairs in a process called "crossing-over." Then all are divided in half to make four entirely random single sets of instructions. Every resulting sex cell has only one copy of the parental genetic material, but it has one copy of everything it needs. After sex with another individual, when two sets of these "haploid" cells are united, the genetic information is once again restored to its full complement in the fertilized egg, and the single chromosomes from both parents are united into new pairs.

Random as the mix of parental characters may be, they're not randomly mixed together. Every chromosome contains instructions for specific tasks, arranged in a specific order. Virtually every characteristic has its counterpart on its chromosome partner, so when pairs are united, they line up in exactly the same configuration as one another. At any given location along the length of a chromosome (called a locus, or loci in plural), the nature of the instructions will be the same within a species, even if the instructions themselves are slightly different. This is one of the reasons why hybrids between species, which may have different arrangements in their genetic material or even different numbers of chromosomes, are usually incapable of producing fertile offspring.

For Darwin and his colleagues in the pigeon fancy, the creation of the almond pattern in the English short-faced tumbler represented the pinnacle of achievement in selective breeding. Although the inheritance of this complex combination of traits must have seemed bewildering, breeders have nevertheless successfully risen to the challenge for centuries.

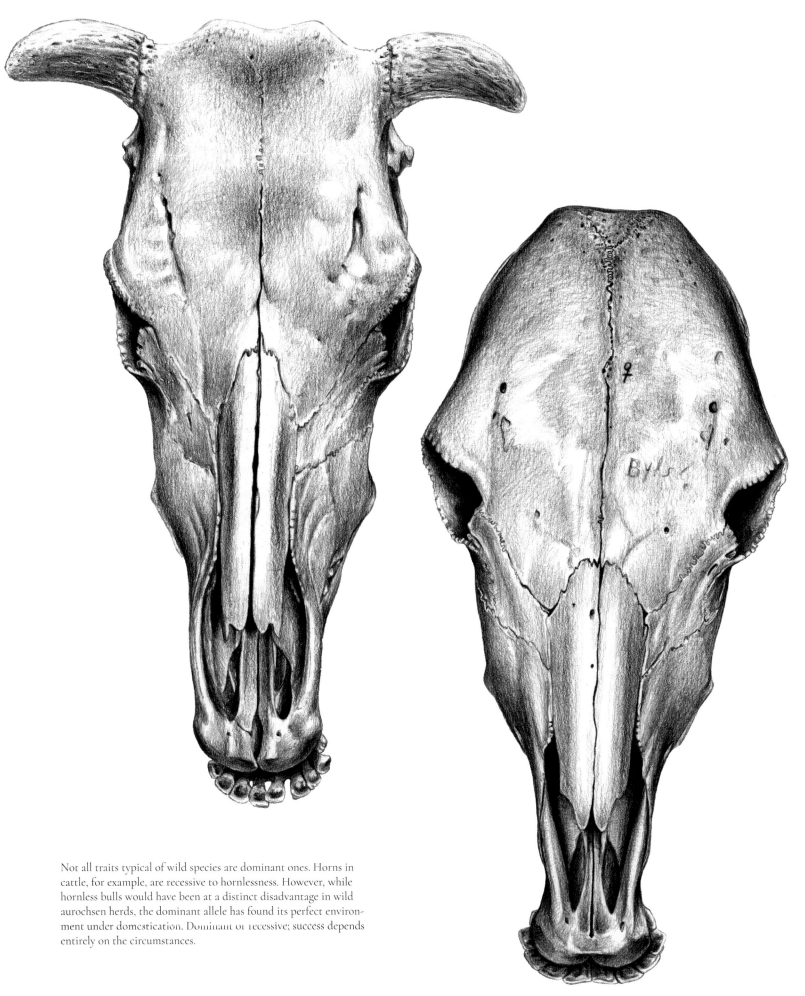

Not all traits typical of wild species are dominant ones. Horns in cattle, for example, are recessive to hornlessness. However, while hornless bulls would have been at a distinct disadvantage in wild aurochsen herds, the dominant allele has found its perfect environment under domestication. Dominant or recessive; success depends entirely on the circumstances.

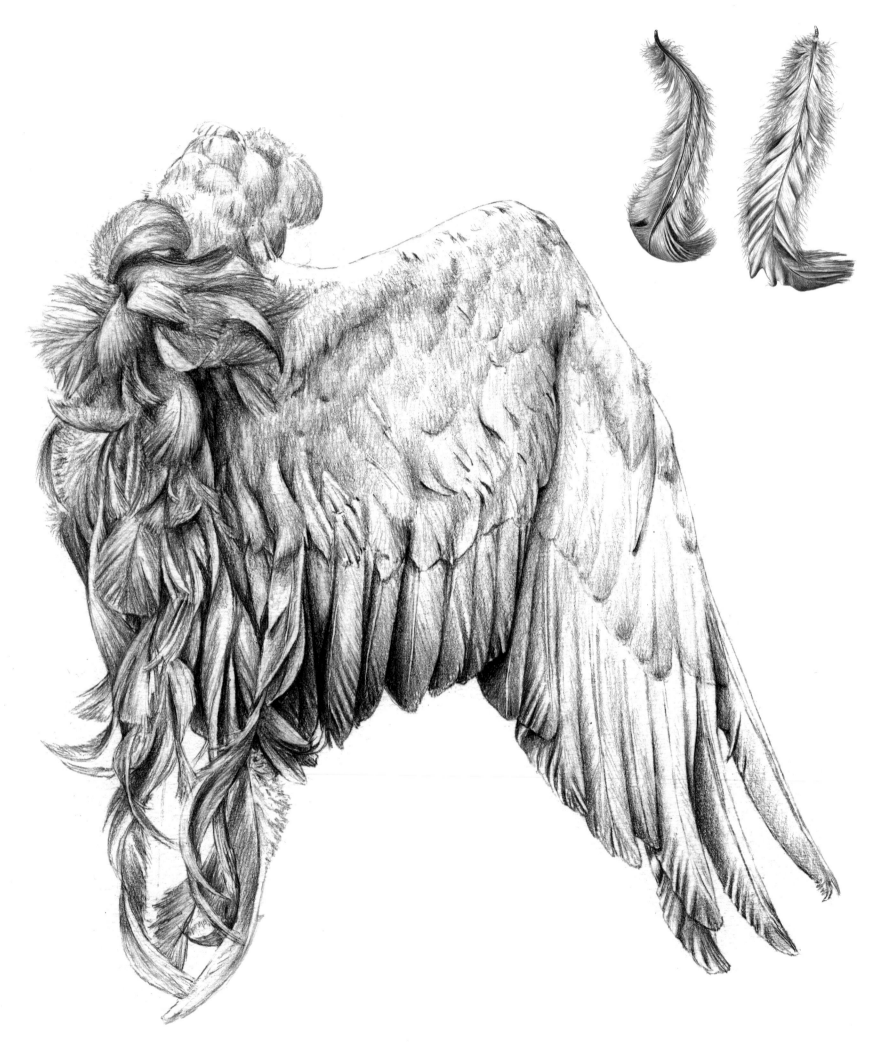

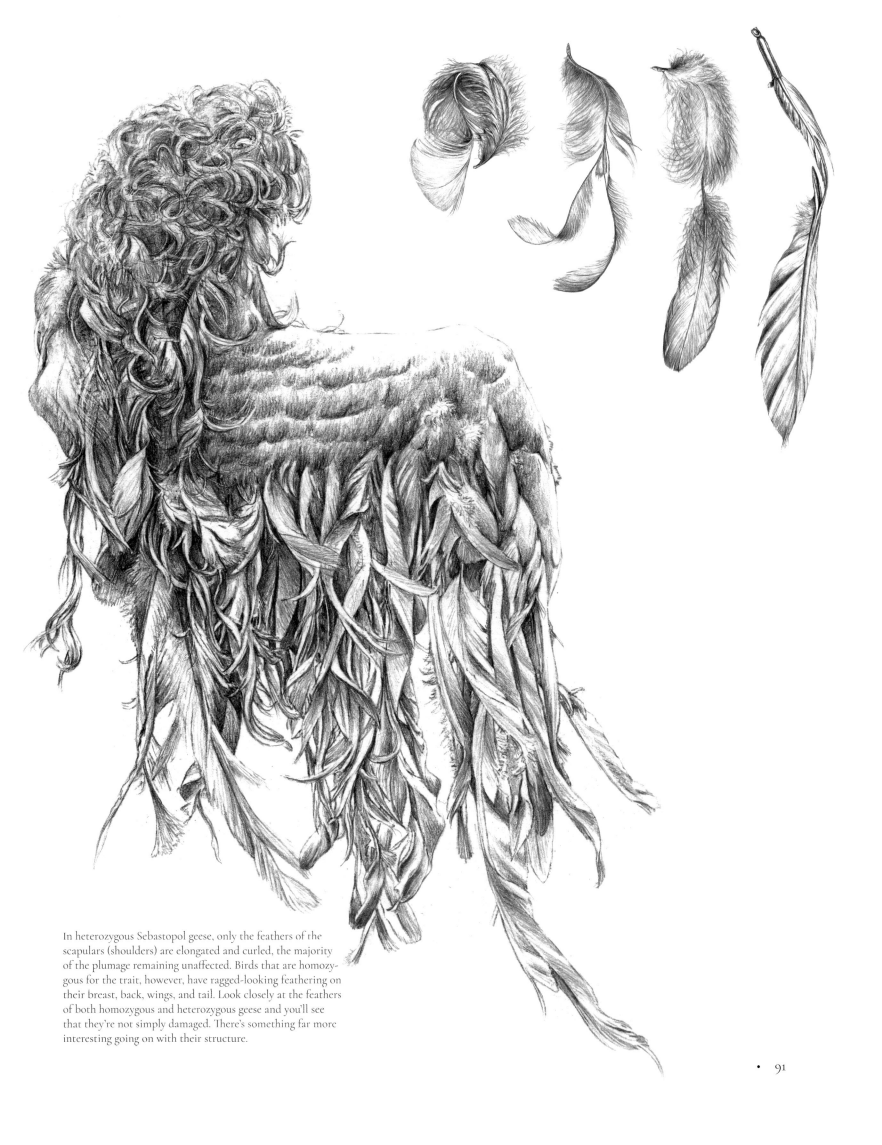

In heterozygous Sebastopol geese, only the feathers of the scapulars (shoulders) are elongated and curled, the majority of the plumage remaining unaffected. Birds that are homozygous for the trait, however, have ragged-looking feathering on their breast, back, wings, and tail. Look closely at the feathers of both homozygous and heterozygous geese and you'll see that they're not simply damaged. There's something far more interesting going on with their structure.

Because the loci are in pairs, there are always two versions of instructions. Sometimes these instructions are the same, and sometimes they're contradictory, and it's the combination of these, as long as environmental conditions are suitable, that dictates how they will manifest themselves in the living animal, in what we call the phenotype.

In an imaginary world in which all living things are uniform, the instructions we'd receive from each parent would be identical. (In fact this is an impossible scenario as sexual reproduction only evolved because of its capacity for generating variation.) In the real world, thankfully, mutations occur that alter the instruction at a given locus and, if these don't prove to be disastrous for the individual, it results in an alternative version becoming available, to be passed down to future generations.

There can be any number of mutations at the same point, resulting in many different potential outcomes, but as no more than two alternatives can occupy any individual organism at a time—one from each parent—there are only ever two sets of instructions that can affect the phenotype of an individual. These alternative sets of instructions are called alleles.

In the most straightforward example of two different alleles being paired up together, one takes the lead and dominates the effects of the other. If the dominance is absolute then there will be no difference in phenotype whether one or two alleles are present. Only if there's no dominant allele to take over is a recessive pair of alleles able to assert itself.

It's easy to assume that alleles fall into just two categories: dominant and recessive. That's not the case, however. A genetic instruction with a single allele is neither dominant nor recessive; it's a comparative term, like lighter or heavier. The distinction refers only to its relationship with other alleles in how it influences the phenotype.

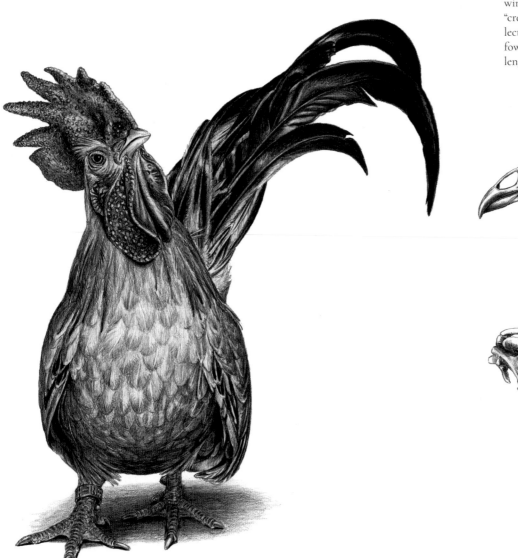

While the small body size of the Chabo, or Japanese bantam, is a result of selective breeding, the disproportionately short wings and legs were initially caused by an allele known as the "creeper" gene, a form of dwarfism—though centuries of selection have shortened them further. The towering Malayan fowl (opposite) is there to show the opposite extreme in leg length!

Because of the associations surrounding the idea of dominance and recessiveness it was long assumed that dominant alleles reflect the natural order of things and will inevitably swamp recessive ones out of existence. This is categorically untrue. It makes no difference whether alleles are dominant or recessive. Their frequencies change only as a result of evolution. Both can be present within the same population and can even be used to measure whether, and how quickly, evolution is taking place. In situations in which the process of evolution can be actively observed—like isolated island groups—unexpectedly stable frequencies can highlight some interesting permutations.

In sheep, the trait for being horned shares a locus with the equally dominant trait for having tiny vestigial horns called scurs (there are also recessive alleles for being completely hornless—polled—in both sexes, or in the females only, but forget about these for now). You'd think that in a species in which horns play a role in sexual selection, sheep with scurs would soon diminish in favor of their larger-horned cousins. However, long-term studies of the ancient, feral Soay sheep, which live in an entirely unmanaged state on the isolated St. Kilda archipelago (about forty miles west of Scotland's Outer Hebrides in the Atlantic Ocean), have revealed that the scurred sheep have maintained a consistent percentage within the population over many years. The answer is that although these less well-endowed sheep father fewer lambs per year, their life expectancy is far greater. Thus their overall reproductive success equals that of the large-horned rams that enjoy a short life of glory. In this way satellite groups can maintain a genetically stable foothold within a larger population simply by virtue of being in a minority. Should their numbers increase within the population, sexual selection within the splinter groups would take over, and the cycle would begin again.

Recessive alleles get a bad press. In combination with a dominant allele to mask their effects they can be passed down through generations undetected, steadily multiplying in populations without ever manifesting themselves, so they're virtually impossible to eradicate if you don't want them. Until recent genome testing techniques became available the only way to determine whether hidden recessive genes were present was by breeding, and in slow-reproducing animals like horses and cattle it was almost impossible to be certain that nothing

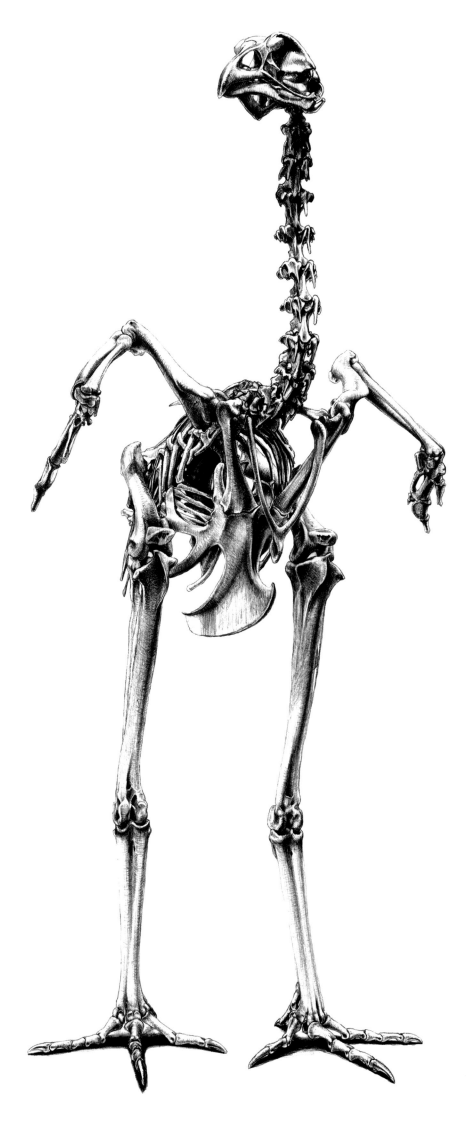

Although they're not as obviously short-limbed as the Chabo, Indian game fowl also possess an allele for disproportionate dwarfism—known as "Cornish lethal." Although the outward effects are similar to those of the creeper allele, you can see the difference in the skeleton. The fibula (the slender bone on the outside of each leg—the bone often used as a toothpick) is much thicker than usual, and is joined to the tibia (the shank) at its lower end.

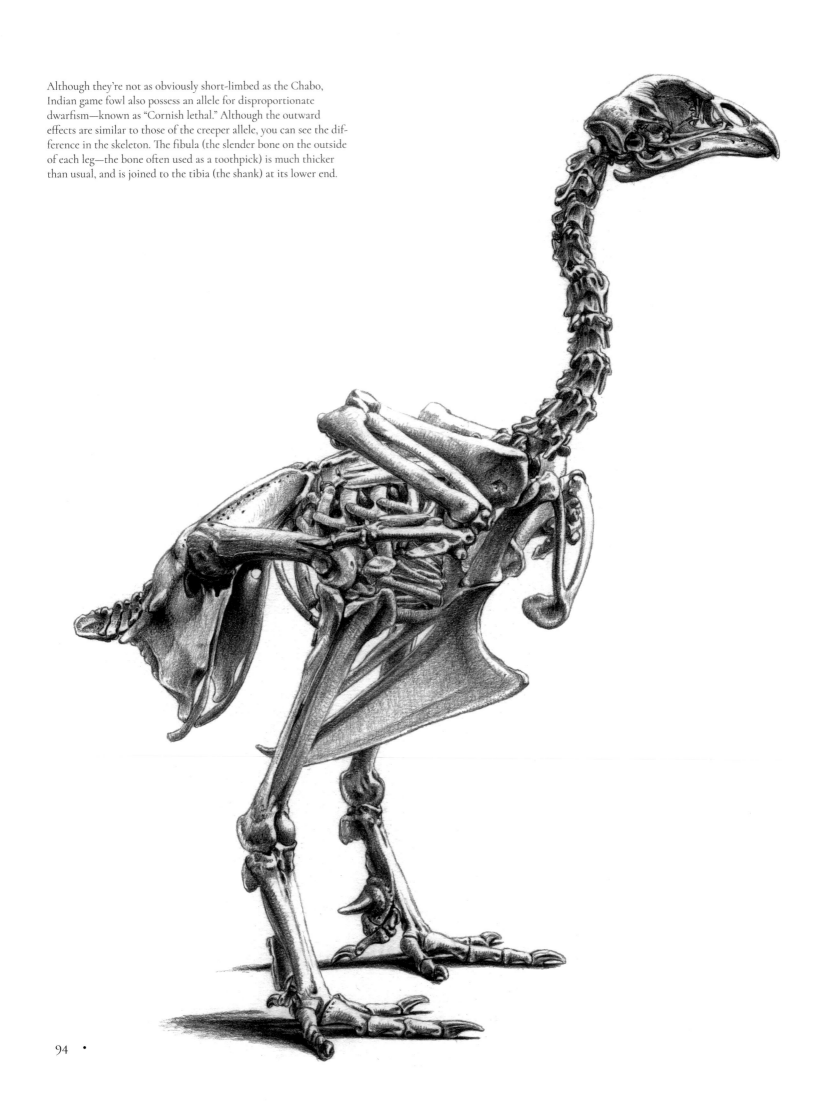

unexpected would eventually pop up. Genotypes are invisible until they express themselves in a phenotype; animals don't come labeled with Pp (a hornless cow carrying the recessive gene for developing horns) or PP (a hornless cow with nothing up its sleeve). Many animal breeders therefore choose to follow a practice of strict inbreeding in order to weed out unwanted recessive alleles that are eventually forced to show themselves.

Dominant traits, on the other hand, have nowhere to hide. You only need to receive an allele from one parent in order for it to show itself, and if it turns out to be harmful or unwanted then natural or artificial selection can prevent it from being passed on any further (unless it's a trait that expresses itself only in old age, by which time the gene-spreading damage is already done).

Mendel had been very careful to begin with strains of plants that "bred true," that is, consistently produced offspring that resembled the parents for many generations. Breeding true comes from having two copies of the same allele. It's called being homozygous. (If you have one copy each of two different alleles you're heterozygous.) In a population of individuals that are homozygous for a given trait it doesn't matter whether these alleles are dominant or recessive as there are no others available for them to combine with.

There's actually no reason to suppose that recessive alleles should be any more harmful than dominant ones, and many traits in normal wild animals are recessive. All variation depends on environmental circumstances, and traits that might prove fatal in one situation can be advantageous in another. Horns are a good example.

A polled Aurochs bull battling for supremacy in a primeval forest would not have presented a very intimidating obstacle to a horned bull and therefore wouldn't have had much opportunity of passing on the character to its successors. Yet the allele for being polled in cattle is actually dominant over the allele for having horns. It took domestication to alter the circumstances in the polled cattle's favor, so when hornless cattle began to appear under domestication (the first ones are recorded from archaeological evidence dating back eight thousand years and they occur quite frequently in the art of ancient Egypt) their merits were quickly recognized. Horned cattle are dangerous. They're dangerous to their handlers and they're dangerous to each other, which means they have the capacity to hurt farmers economically as well as physically. Modern-day shipping of live animals for the meat industry poses a particular problem. It creates a bad impression if animals arrive at their destination riddled with puncture wounds, even if they are to be slaughtered shortly after.

So, in the evolutionary history of aurochsen and their many descendants, polled versions are now at a positive advantage. Despite the dominance of the allele, however, the challenge of introducing the trait for hornlessness into the most valuable beef breeds, without compromising their productivity by outcrossing, can't be overcome fast enough. In preference to selectively breeding the trait into herds, controversial techniques for "gene editing" are being introduced to alter the genetic coding manually instead.

In an evolutionary context, recessive mutations have a distinct advantage. Selection acts only on the phenotype of an animal, not on the invisible genotype. So new dominant mutations are expressed straightaway by an individual, and get only one chance to prove their worth. Recessive alleles meanwhile can accumulate unseen within a population, giving them multiple opportunities to be favored, or not, by natural selection when they're finally expressed.

Straightforward dominant or recessive traits are what we now refer to as Mendelian inheritance. In his experiments with pea plants Mendel wisely selected and restricted himself to seven pairs of contrasting traits that had no intermediate forms, so the offspring of every generation could be statistically divided without ambiguity. The first generation would all be of the dominant phenotype, as every recessive allele would be paired up in combination with a dominant one. But if these were then bred together, a quarter of their offspring would have two copies of the recessive allele and thus be of the recessive type. He also combined these traits by crossing to prove that they could segregate independently in future generations without becoming blended together.

With the benefit of hindsight Mendel had been extraordinarily fortunate in his choice of characteristics to study. There are many, many exceptions to classic Mendelian inheritance, and there was a lot that could have biased his results without him even knowing. Two of his traits share the same chromosome, and if they'd been sufficiently close together to avoid being separated in the crossing-over process, they could easily have messed up all his neat statistics about independent segregation.

As we've seen with the rabbits and chickens in the previous chapter, it's possible for the opposing effects of two incompletely dominant, or equally dominant, alleles to result in both traits being expressed. (In fact the only real difference between these definitions is in the way they're expressed; some traits simply can't exist in an intermediate form and instead are both present.) There are numerous examples of alleles that have incomplete dominance over their counterpart. Many domesticated animal breeds have two or three recognized forms: the homozygous dominant at one end of the scale; at the other, the homozygous recessive, which of course bears no hint of the trait in question and has no allele of the trait to pass on. In the middle is the heterozygous combination of both alleles that expresses the trait in an intermediate form.

A chicken breed called the Naked-neck fowl (for obvious reasons) has a completely naked neck and upper breast in its dominant homozygous form, with large spaces between the feather tracts. The heterozygous birds, in comparison, are more densely plumaged, with an incongruous-looking tuft of feathers at the front of the neck. Homozygous recessive birds are not recognized by the fancy and are just normal-looking chickens. We'll be returning to Naked-neck fowl later in this book.

Another example is the silkie mutation in pigeons. In several bird groups, mutations can affect the microstructure of the feather, rendering it impossible for the barbs to form a continuous vane and giving the feathers a delicate, lace-like appearance. This is the result of different genes in different bird groups; in some it's dominant and in others recessive. In pigeons, the "silkie" or "lace" mutation is incompletely dominant, so birds that are homozygous for the trait are more extreme in appearance (and look distinctly disheveled) compared with the very attractive heterozygous individuals, like the fantail pictured in chapter 2.

In silkie pigeons all the plumage is affected, but to a greater or lesser degree. In another feather mutation, found in Sebastopol geese, the difference between homozygous and heterozygous individuals can be seen not only in the degree of expression in the affected feathers but in the feather groups per se.

All Sebastopol geese have their head and neck covered in normal smooth plumage, but in other parts of their body the feathers are elongated and curled and have a very unusual structure. Look carefully at the feather illustrations and you'll notice that beyond what appears superficially to be just ragged plumage there's something altogether more interesting going on. In some, sections of feather vane are actually forming within the shafts, pushing the two sides apart. In others, what appear to be extra-long feathers are in fact two or more feathers, complete with downy bases, growing end to end like a string of sausages along the same shaft.

In heterozygous Sebastopols the affected plumage is mainly restricted to the scapular tracts arising from the shoulders, with other feathers being changed in only subtle ways. By contrast, the homozygous birds have long, ragged-looking feathers not only on their scapulars but also on their upper wing coverts, breast, and back, while their flight feathers are short and stunted. Whenever I see them I'm reminded (in looks if not in temperament) of the comedian Rod Hull's irascible glove puppet, Emu, from TV shows in the 1970s. Sebastopol geese are actually very docile.

In exhibition animals it's the heterozygous form that's generally the most desirable, and these too will be the animals used for breeding, producing an average of 50 percent heterozygous offspring when crossed together. The other 50 percent is comprised of equal proportions of both homozygous extremes, with the recessives sadly a genetically useless by-product. Populations comprised of different forms like this (it's called polymorphism) occur in wild animals too, for example, in Arctic skuas, or jaegers, which have a homozygous recessive pale form and an incompletely dominant dark form, along with heterozygous birds of intermediate plumage. Based on Husband's research, it's likely that New Zealand Weka rails are a comparable example. Polymorphism is perhaps best known in the big cats, most famously in black panthers, the melanistic form of the Leopard. This is a case of straightforward Mendelian inheritance, however, with the allele for the spotted coat in this case being completely dominant over the allele for melanism. In Jaguars the melanistic form is dominant.

Had Mendel inadvertently selected a characteristic with incomplete dominance, his crosses would have yielded 100 percent of offspring bearing only a slight resemblance to both parents, which he could be forgiven for mistaking as a blending of parental characteristics, as many had before. But he was a meticulous researcher, and his choice of not one but seven pairs of contrasting traits increased the likelihood that he would have at least one example of

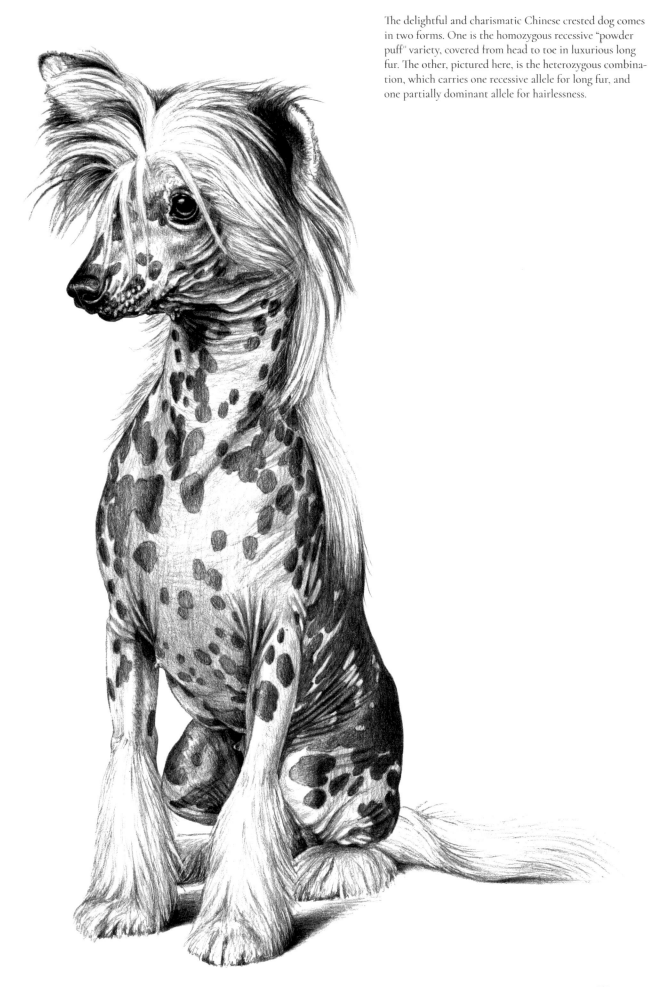

The delightful and charismatic Chinese crested dog comes in two forms. One is the homozygous recessive "powder puff" variety, covered from head to toe in luxurious long fur. The other, pictured here, is the heterozygous combination, which carries one recessive allele for long fur, and one partially dominant allele for hairlessness.

• 97

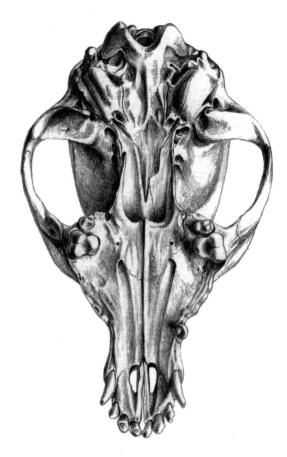

straightforward inheritance to compare with. So in this hypothetical scenario there's a good chance that he may have interpreted the result correctly as incomplete dominance, especially if he went on to breed further generations.

It's important to remember that the genotype of the parents can usually only be revealed by the phenotype of the offspring or, more specifically, by the ratio of different phenotypes to one another within each generation. It's only by comparing these ratios, based on predicted Mendelian statistics, that there can be any indication that a proportion of your offspring might be missing. This was precisely how the phenomenon of lethal genes came to be discovered by French biologist Lucien Cuénot in 1905, a few years after Mendel's work was rediscovered.

With plants, any seedling that dies off or a seed that fails to germinate can be easily identified and included in the total number. In birds too, any fertilized but unhatched eggs can be accounted for. But in mammals an embryo that's reabsorbed in the early stages of development does so invisibly. Cuénot was working on color inheritance in mice and noticed that in crosses between two heterozygous yellow mice, two-thirds of the offspring were yellow instead of the predicted half.

If you're a yellow mouse it's best to pair up with a mouse of a different color—otherwise you'll produce 25 percent fewer offspring. Lethal genes or, more correctly, lethal alleles are only able to exist in heterozygous combinations, and only if they're recessive or incompletely dominant. Recessive lethals express no phenotype in a living animal (if they're paired up with a dominant allele, that's the one that's expressed, and if they're homozygous, well—they're not called lethal for nothing). Dominant lethals are lethal whether inherited from one or both parents. There are, however, many interesting and desirable traits in exhibition breeds that are incompletely dominant and lethal only in homozygous form.

The Japanese bantam or Chabo, for example, is an ancient chicken breed with various geographical varieties and a rich cultural history.

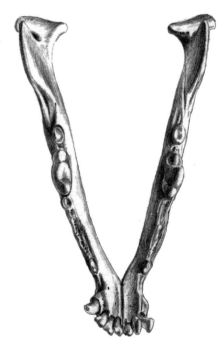

Underdeveloped or absent teeth are a characteristic of several breeds of hairless dog, including the Chinese crested, though it appears to cause them little, if any, inconvenience. Teeth and hair share a common developmental pathway, which is the reason why both are affected by the same gene action. The fully furred "powder puff" form has normal teeth, as the gene that causes hairlessness isn't present.

They are among the few bantam breeds that were not created as a miniature version of a larger counterpart. While the diminutive body size is a result of selective breeding, the disproportionately short wings and legs were initially caused by a form of dwarfism affecting the limb bones only, further shortened by centuries of selection.

In Chabos, and some other poultry breeds, this trait is caused by an allele known as the creeper gene and is always lethal in its homozygous form. It's not uncommon for an equivalent phenotypic result to be caused by two or more different genes, and a very similar form of disproportionate dwarfism, called Cornish lethal, also occurs in poultry and produces exactly the same shortening of the limb bones. Both are characteristic of particular recognized breeds, but other than that the only distinction between them is in the way the genes are expressed in the skeleton. The difference is in the fibula—the thin, spiky bone that extends part-way down the shin bone or tibia from the knee (the one that makes a convenient toothpick after a roast chicken dinner). Apart from being somewhat shortened, this bone is unaffected by the creeper gene, whereas under the influence of Cornish lethal it's much more substantial and attached to the tibia at its lower end, giving the legs a thickened, chunky look. Cornish lethal, as the name suggests, is also—lethal.

Another lethal allele occurs in the Chinese crested, a delightful little dog with two recognized forms. One is known as the powderpuff and is covered from head to tail in luxurious long fur—this is the homozygous recessive allele combination. The other, the heterozygous combination, carries one recessive allele for long fur and one partially dominant allele for hairlessness. The result is a charismatic animal with a hairless body and exuberantly plumed paws, head, and tail. Two copies of the allele for hairlessness, however, never result in live births.

Another interesting genetic feature of this (and some other hairless dog breeds that share the same allele) is their teeth. In the heterozygous animals premolars or molars can be missing and the canine teeth point further forward like tiny tusks. These breeds hardly seem affected by their physical idiosyncrasies, however. They have no problems eating and are vivacious and long-lived dogs that appear to enjoy life to the full.

Critics of selective breeding may be forgiven for thinking it rather perverse to deliberately propagate traits that are known to be lethal. However, lethal alleles can and do survive under natural conditions too, and the reason for this is exactly the same as it is under domestication: the losses within the affected populations are offset by the advantages offered by the trait in its heterozygous form.

For an example in nature we only have to look to our own species. In many human populations with an ethnic origin in malarial regions, there's a common allele that gives immunity against malaria by altering the structure of red blood cells. However, any individual unlucky enough to inherit this useful trait from both their parents will have sickle-cell anemia, a debilitating disease that can strike during childhood and often proved fatal before it was identified and controlled by modern medicine. And to a domesticated animal, the advantage need only be that fanciers wish to preserve it.

The fact that one characteristic—like hairlessness—is often associated with another, seemingly unrelated trait—like toothlessness—had not escaped Darwin, although he knew nothing of alleles or loci. In the opening pages of *On the Origin of Species* he remarked on this correlation in hairless dogs, and also on the relationship between deafness and blue eyes in cats. These "free gift" genetic relationships, called pleiotropic effects, can affect the evolutionary fitness of an animal if an advantageous trait is coupled with one that has negative consequences. However, under different environmental conditions one might tip the balance in favor of the other.

In wild animals there's usually no indication that any correlation exists and, even in domesticated animals, it's not until an alternative allele suddenly appears that it's possible to determine which strings are being pulled at any given locus. Think about the last time you blew a fuse in your car. It probably affected a whole range of seemingly unconnected things, from headlights to the horn, but when the car's functioning normally (unless you start messing around with the fuse box) you can't tell which is affected by which. Car horns and headlights may not seem to have much similarity to one another, but they're all part of the car's electrical system and are all a result of the way the car was wired up when its prototype was manufactured. Thus it's to the prototypes of living things—to the embryonic developmental stages—that we have to turn to begin to understand the action of genes. Although hair and teeth seem unrelated, they're both formed at a similar time and place in the developing fetus, so an allele that affects one also affects the other. It's equally possible that a single phenotypic effect might be the result of the

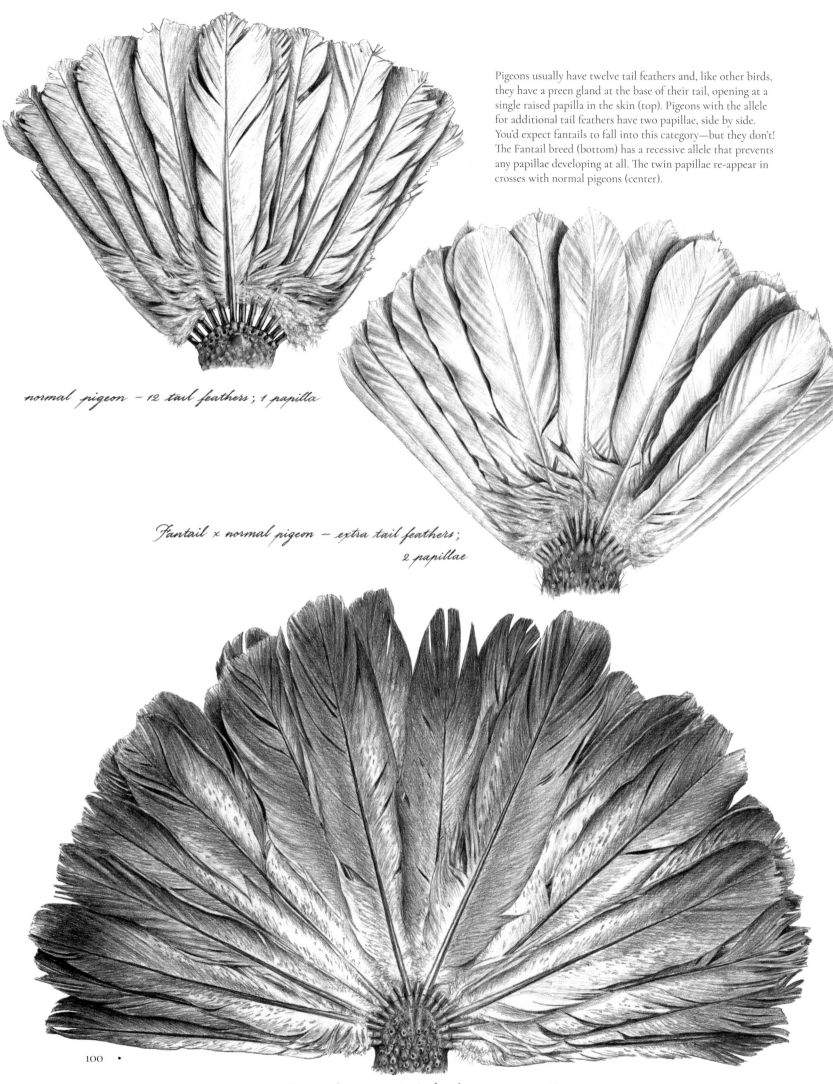

Pigeons usually have twelve tail feathers and, like other birds, they have a preen gland at the base of their tail, opening at a single raised papilla in the skin (top). Pigeons with the allele for additional tail feathers have two papillae, side by side. You'd expect fantails to fall into this category—but they don't! The Fantail breed (bottom) has a recessive allele that prevents any papillae developing at all. The twin papillae re-appear in crosses with normal pigeons (center).

normal pigeon – 12 tail feathers; 1 papilla

Fantail × normal pigeon – extra tail feathers; 2 papillae

Fantail – extra tail feathers; no papillae!

combined action of two or more genes, even at loci on different chromosomes. It's only in this, developmental, context that the widely diverse relationships between genotype and phenotype, causes and effects, can begin to make sense.

Pigeons usually have twelve tail feathers, arranged symmetrically in six opposite pairs from a central point. In domesticated pigeons there's an allele that results in the production of extra tail feathers, and in extreme cases this can result in effectively having two or even three rows, one behind another. One of our own birds possessed over forty tail feathers.

Just above the tail's upper surface is the preen gland. This consists of two oval-shaped fatty bodies beneath the skin, opening at a single raised papilla. (The fatty bodies are poorly developed in pigeons, which rely mostly on specialized feathers called powder down for preening, but they still possess the surface papilla.) Now here's the interesting bit: most pigeons with multiple tail feathers have a double opening of the preen gland—two little papillae instead of one. It seems that, like the hair and teeth in the previous example, the instruction to the cells in the ectoderm to produce more feathers also duplicates the preen gland opening.

The pigeon breed most famous for its extra tail feathers is, of course, the fantail. Extra feathers alone don't make the fantail breed, but fantails do obviously have many extra tail feathers. Interestingly, instead of having two or even just one preen gland papilla, fantails (along with one or two other breeds with normal, twelve-feather tails) have . . . none. There seems to be no explanation for this; it's simply a case of this recessive allele being inadvertently transferred to the breed at some point in its history. Cross a fantail back to a "normal" pigeon and the twin papillae reappear.

Some of the most skilled animal breeders in history—men like Robert Bakewell and John Sebright—were bringing about revolutionary improvements to commercial and exhibition breeds in the eighteenth century when nothing was known about the science of inheritance. More impressive still are the advances in selective breeding of livestock made during the Roman period, though many of these achievements in agriculture were undone during the Dark Ages that followed. It doesn't take an understanding of post-Mendelian genetics to make an expert animal breeder, any more than it takes a physicist to be an excellent cook. To Darwin and his colleagues in the pigeon fancy, the highest pinnacle that could be reached through selective breeding was the creation of the almond pattern in English short-faced tumbler pigeons, shown on the opening page of this chapter. The advanced combination of genetic traits needed to create a good specimen still poses a considerable challenge for modern breeders. Despite the not-insubstantial difficulties, fanciers with no knowledge of genetics have for centuries succeeded in breeding this enigmatic bird, already reverently described in John Moore's *Columbarium* of 1735—the first treatise devoted to domesticated pigeons.

Here's how to "make" an almond-patterned tumbler from scratch: You need to start with an English short-faced tumbler, then add homozygous dark checker and heterozygous recessive red in equal proportions, not forgetting homozygous kite to give the bronzy sheen. Add a sprinkling of grizzle if required and, last but not least, the crucial ingredient—a gene known as "stipper." After the numerous generations it takes to combine these elements you now have a pigeon that may (or may not) be successful in exhibitions—but only for two or three seasons at most. Stipper, which produces the black flecks in the pale feathers that make this pattern so distinctive, also causes the flecks to gradually become larger with each successive molt. Within a few years the tonal balance of the whole bird is entirely changed.

No one creates almond-patterned birds from scratch anymore, though neither is it simply a case of mating one to another. The stipper gene is lethal if inherited from both parents (it's probably comparable with the blue-merle or harlequin coat pattern in collies and great danes), so you need to outcross at every pairing. Finally, if all these obstacles weren't enough, the stipper gene is also sex-linked.

Remember at the beginning of this chapter I was careful to say that "*virtually* every characteristic has its counterpart on its chromosome partner"? Well, "sex-linked" alleles are the exception. In most animal groups, one chromosome pair is different from its counterpart in the opposite sex and is effectively just a single chromosome with a small and nondescript partner. In birds it's the female that has the mis-matched chromosome pair, with a normal matching pair in the males. In mammals it's the other way around. This means that any allele, dominant or recessive, that happens to be on the normal-length chromosome of a mammal will be expressed in the male. Or, to put it another way, a male can't be heterozygous for a sex-linked trait.

moult 1 *moult 2* *moult 1* *moult 2* *moult 3*

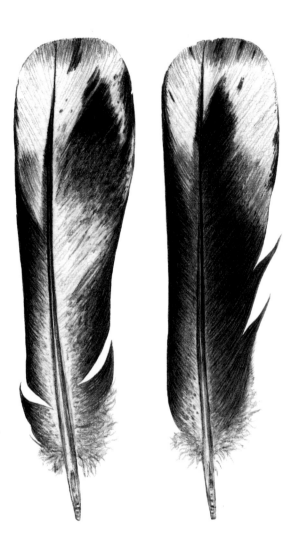

The reason why the almond pattern in pigeons is so difficult to create is mostly due to a troublesome gene called "stipper" that produces the distinctive black flecks on the pale feathers. Apart from being sex-linked and lethal in its homozygous form, the effect of stipper is accumulative. With every molt, the black flecks enlarge a little, changing the tonal balance of the entire bird.

Probably the most well-known example of a sex-linked characteristic is the tortoiseshell pattern in cats, which are always female. Although this might seem confusing (remembering that sex-linkage in mammals is usually associated with males) it's the ginger color that is sex-linked. Ginger is co-dominant with black, so only female cats (which have two copies of the sex chromosome) can have one allele for each, resulting in a mixture of ginger and black fur.

We left Darwin at the end of the last chapter cobbling together his account of inheritance by pangenesis—the transmission of microscopic gemmules in the body fluids from one generation to the next, modified by changes accumulated during each lifespan. Natural selection rests on the assumption that variations can be inherited, but as yet there was no concrete hypothesis for how this could happen, save the irrefutable evidence that it does.

In *The Variation of Animals and Plants under Domestication* Darwin had considered every imaginable example, from the simplest all-or-nothing inheritance of cow horns to the complexity of the almond pattern in tumbler pigeons. Not surprisingly he had failed. By the end of what he later described as four years and two months of hard labor, when his interests had already moved on to other things, he wrote in a letter to his friend Joseph Hooker, "If I try to read a few pages I feel fairly nauseated . . . the Devil take the whole book"!

Pangenesis was put to the test by Darwin's precocious half cousin Francis Galton in a series of experiments involving blood transfusions between different-colored rabbits. Galton had initially been an enthusiastic advocate of the gemmules theory, but his results, published in the *Proceedings of the Royal Society* in 1871, revealed that not a single rabbit produced unexpected-colored kits as a result of the transfusion. Darwin wriggled and squirmed in a most unbecoming manner, responding in the journal *Nature* that he'd never specified that gemmules would be carried *in the blood*. A few years later Weismann (of the mouse tails) proved that the sex cells are immune from the influence of the body cells, seriously discrediting the belief in the inheritance of acquired characteristics and leaving evolutionary theory without its central core.

At this point in the story the drums are of course rolling and the trumpets beginning to sound in anticipation of the rediscovery of Mendel's work. Surely it would provide everything science was waiting for—a simple and elegant mechanism to match the simplicity and elegance of Darwin's theory of natural selection. The time was right. Heredity was the hottest topic for scientific discussion, as evolution had been half a century before. Old journals were sought out and re-examined. Among them was an obscure local journal, written thirty-five years earlier in German containing a paper about experiments in plant hybridization.

Three scientists independently recognized the implications of Mendel's research. But none recognized its magnitude. Instead of illuminating a triumphant path for evolutionary research into the twentieth century, the rediscovery of Mendel's work smoldered into one of the most bitter and puerile controversies in the history of modern science: Does evolution proceed gradually, by small steps, or by giant leaps?

II
Inheritance

6. "Natura non Facit Saltus"

6 ~ "Natura non Facit Saltus"

In 1791 in Dover, Massachusetts, a lamb was born that, by a happy combination of circumstances, was destined to live for many years, father many lambs of its own, and become one of the most celebrated sheep in science. This lamb had two things in its favor: it belonged to a man of cunning good sense and enterprising character, and it was born with four very, *very* short legs.

The breed of the sheep is of no importance here; any breed can unexpectedly give birth to a dwarf, but the trait was later christened "ancon" after the Greek word for elbow (a reference to the animals' rather crooked forelimbs) though more down-to-earth people called them "otter sheep." Ancon is, in fact, a comparable mutation with the chabo chickens discussed in the last chapter, and with dachshunds and basset hounds and other disproportionate dwarfs that will feature later in this book. It's the limbs only that are shortened, which makes the animals appear long-bodied, though the rest of the body is largely unaffected.

The owner of this particular sheep, a man named Seth Wight, was, as I said, unusually savvy even for a farmer and immediately realized the benefits of propagating not just one but a whole flock of short-legged animals that would be unable to jump anything but the most modest walls and fences—thereby saving a small fortune in the maintenance of field boundaries. Within a few years the plan had succeeded and a small but thriving population had become established. So remarkable were they that they gained the attention of the scientific community on both sides of the Atlantic and earned the especial interest of Charles Darwin.

After about a hundred years the original ancon strain eventually became extinct, perhaps as a result of the introduction of cheaper fencing materials, or just by bad luck. However, ancon sheep had become sufficiently famous that when the mutation occurred again, in Norway in 1919 and yet again in Texas in 1962, it was identified with the famous Massachusetts flock and studied in detail. A decade or so ago ancon sheep bones—of the tiny, slender-limbed unimproved type of animal—were discovered in an archaeological dig in Leicestershire, England, dating to the Tudor period of around 1500. Who can guess whether these physically compromised beasts were ever viewed as a potential asset in those early years of the Tudor Enclosures?

It's actually likely that the trait occurs, or has remained present but unexpressed (ancon is recessive, so you need to cross two carriers together to get any actual ancon lambs born), rather more frequently than science has recorded. Husband photographed the Border Leicester sheep pictured overleaf, happily grazing in a field of normal, long-legged Border Leicesters, while on holiday in England several years ago. Then there's "Stumpy," who made the headlines in New Zealand by giving birth to apparently normal twins in 2011. I suspect that Stumpy's owners have had a few surprises since then.

Carefully documented museum collections are a vital resource for studying variation: between geographical races, between sexes, ages, and (often overlooked) the slight variations between individuals. Darwin was adamant that evolution progresses by the accumulation of countless, imperceptibly tiny steps—these same slight variations—over vast time periods.
These piglets, each with precisely recorded data, were collected by Willem van Heurn, mentioned in chapter 2.

'ancon' *unimproved* *modern commercial*

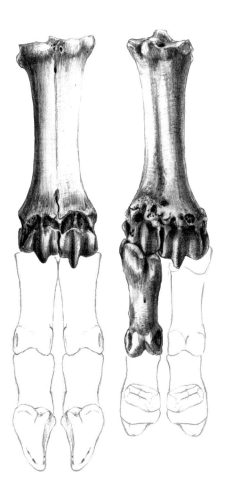
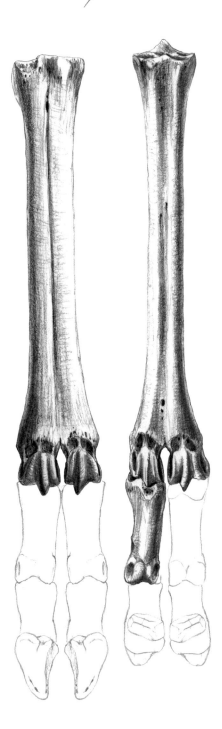
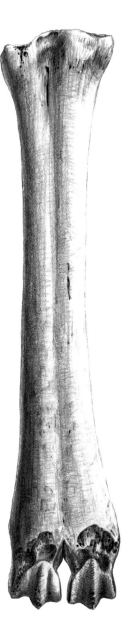
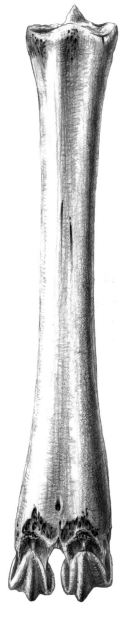

The earliest recorded bone specimens from a sheep with disproportionate dwarfism. "Ancon sheep," as they would become known, isn't a breed; it's a mutation that can happen in any variety. This particular animal was of the tiny, "unimproved" type, from the English Tudor period. The equivalent foreleg bones from a normal unimproved sheep, and a modern commercial sheep, are shown for comparison.

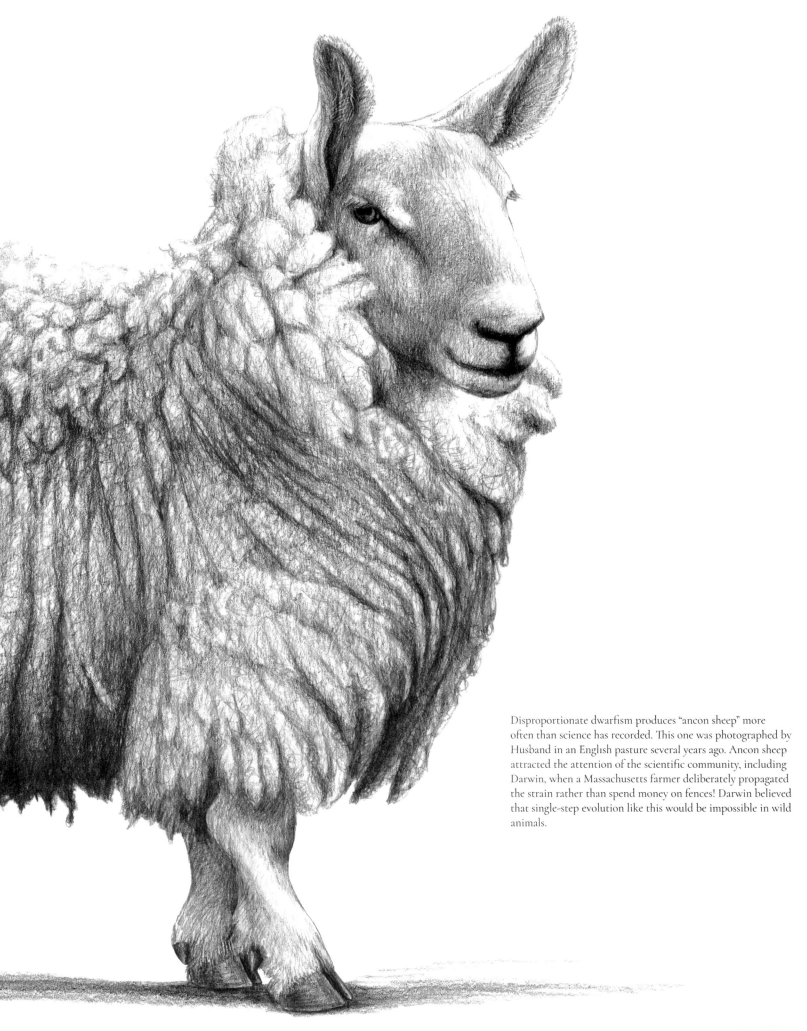

Disproportionate dwarfism produces "ancon sheep" more often than science has recorded. This one was photographed by Husband in an English pasture several years ago. Ancon sheep attracted the attention of the scientific community, including Darwin, when a Massachusetts farmer deliberately propagated the strain rather than spend money on fences! Darwin believed that single-step evolution like this would be impossible in wild animals.

One of Darwin's many excellent habits was to take particular notice of exceptions that contradicted his prevailing theories, rather than sweep them under the carpet as many scientists do. In artificial selection he had found an analogy with how he believed evolution must progress in nature—by small heritable variations that influence the breeding success of certain individuals over others, gradually accumulating in overall change. Yet he recognized in the ancon sheep an example of a new form of animal becoming established in a single step, in no way resembling either of its parents, or intermediate between them.

Such sudden aberrations are, as Darwin well knew, not infrequent under domestication. They were then known as "sports"—a rather disrespectful term implying that they were mere whimsies and not of any scientific importance. Breeders throughout history have relied on the occasional occurrence of sports, displaying unusual color, structure, or fur or feather type, to use as the founding stock for new commercial or exhibition strains.

Feathered feet, for example, is a thing a bird either has or doesn't have. Without wanting to spoil any of the surprises I have in store later in this book, I'll just say that feathers didn't extend down the leg and toes one at a time,

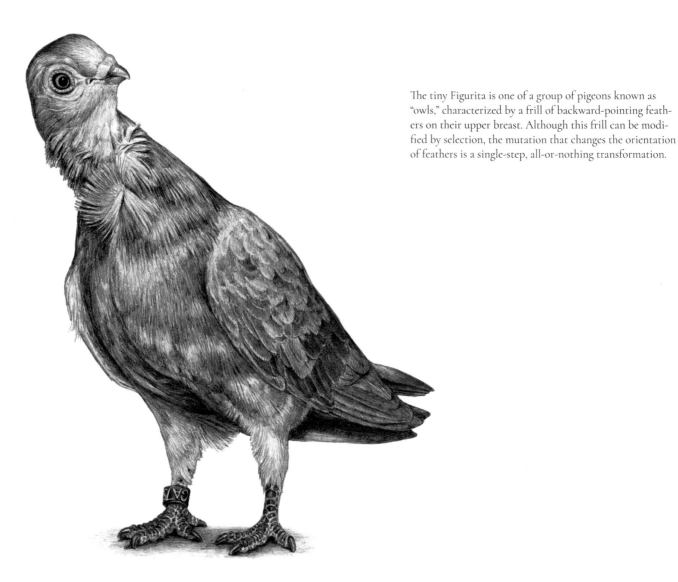

The tiny Figurita is one of a group of pigeons known as "owls," characterized by a frill of backward-pointing feathers on their upper breast. Although this frill can be modified by selection, the mutation that changes the orientation of feathers is a single-step, all-or-nothing transformation.

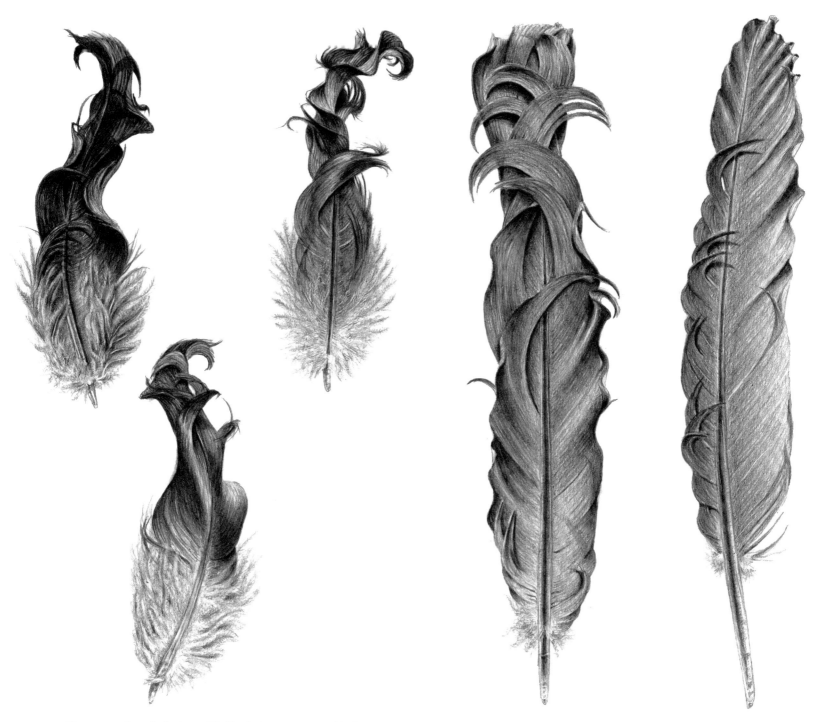

The apparently curly feathers of Frillback pigeons are caused by irregularities in their microstructure, preventing the barbules from lining up to form a continuous flat vane. Although the degree of curling can be changed by selection, the mutation causing these irregularities is another all-or-nothing trait.

generation by generation. They appeared spontaneously—though they've been much developed by further selection. Similarly, the reversal in the direction of fur or feathers, like the little whorls or rosettes on Abyssinian guinea pigs, the strip of backward pointing hair on a Rhodesian ridgeback dog, the ruffs on a Jacobin pigeon (there's one pictured in chapter 1), and the little ridge of feathers down the front of the group of fancy pigeons known as "owls" (there are countless more examples) all arise suddenly in a single step. Gradual selection can accentuate and order these features, but it can't make them appear in the first place.

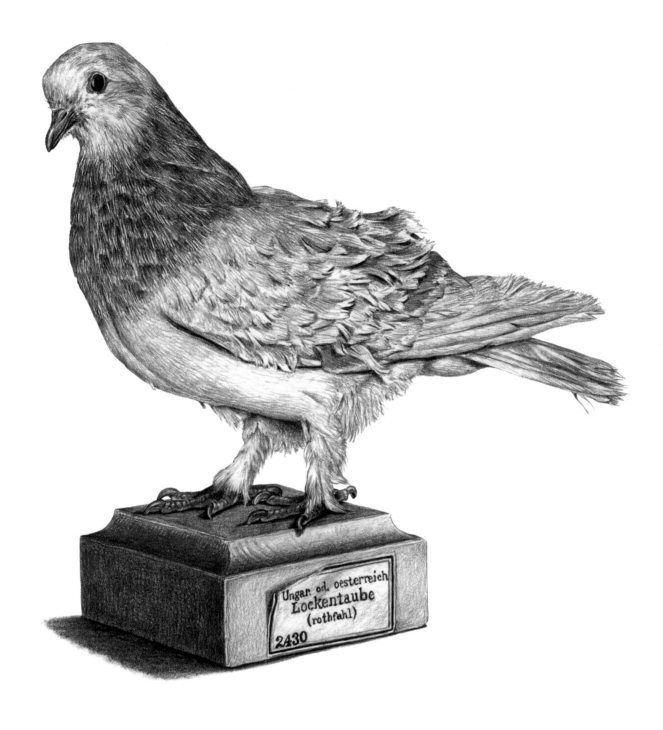

Frillback pigeons, to give another example, have feathers that curl at the edges. This appears to be the result of unequal growth in the feather's microstructure, causing a misalignment between adjoining barbs, a bit like gathering up too much material while sewing and ending up with a rippled piece of cloth. Husband and I tested this by crossing Frillbacks with birds carrying the silkie mutation in which the hooklets that connect the barbs together are dysfunctional. Sure enough, several generations later, the would-be frillback feathers lacked curls, confirming our suspicion that it's all down to the way the barbules connect—the feathers themselves are not intrinsically curly. Darwin kept Frillbacks too, though his birds would be very poor examples by modern standards. Once again, the degree of curling has been greatly exaggerated by selective breeding, but the presence of curled feathers can only be achieved through a spontaneous mutation.

Many mutations, going undetected or unappreciated, disappear, perhaps never to be seen again. Husband once bought a feathered-footed budgerigar from a pet shop—something seldom ever seen—presumably offloaded as an unwanted freak. Unfortunately it was in poor health and died before he had a chance to breed from it. Again, in a pet shop, he discovered a new color mutation—grizzle—in a Barbary dove. This time his breeding attempts were far more successful and the descendants of this bird are now thriving and spreading their grizzled genes over half of Europe.

Such mutations happen randomly and can be utilized, or discarded, according to taste. Some situations simply cry out for the occurrence of a certain mutation. The trait for non-molting in sheep, for example, enabled entire fleeces to be removed at once by shearing, which launched the cottage industry for wool production into a thriving international trade. For others, the time may just not be right. They might be kept as interesting curiosities, or fail to even be noticed.

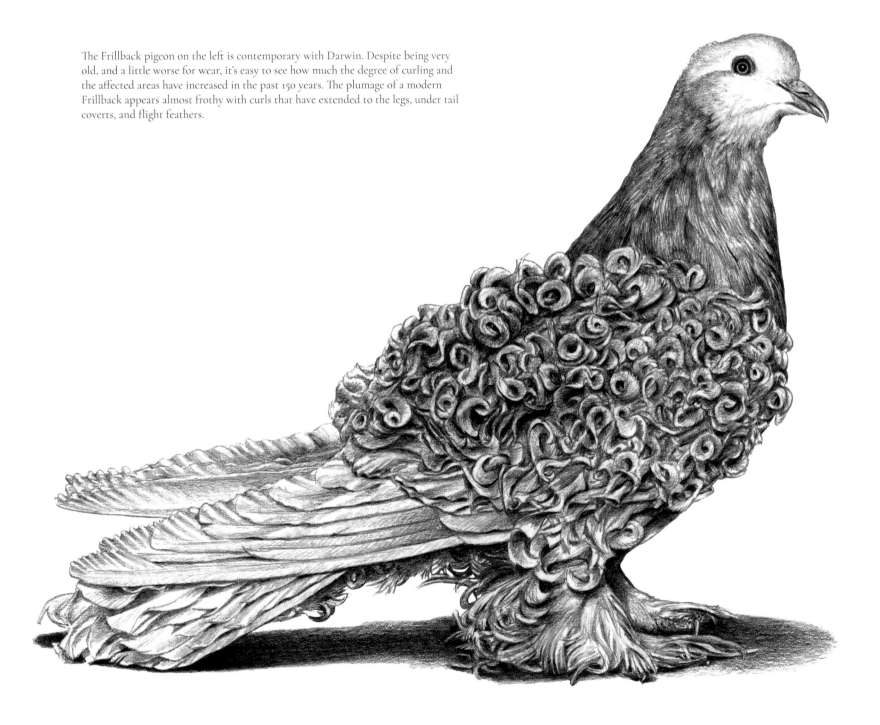

The Frillback pigeon on the left is contemporary with Darwin. Despite being very old, and a little worse for wear, it's easy to see how much the degree of curling and the affected areas have increased in the past 150 years. The plumage of a modern Frillback appears almost frothy with curls that have extended to the legs, under tail coverts, and flight feathers.

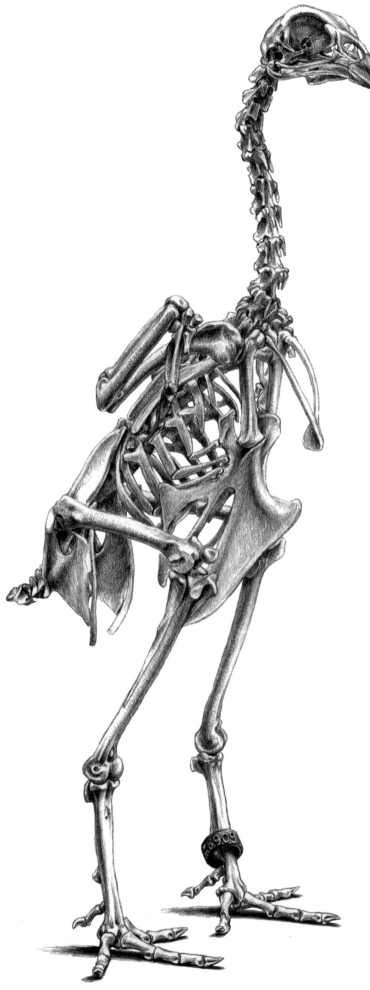

Although Darwin recognized a metaphorical parallel in the way domesticated animals and their wild counterparts change over time, the possibility that a sport as exaggerated as an ancon sheep could be favored under natural selection seemed too improbable. He flatly refused to accept the occurrence of the rumpless (tailless) Ceylon junglefowl mentioned in chapter 1, for example, though its extinction might have given strength to his argument that such "monstrosities" wouldn't survive in nature.

Darwin was quite right in assuming the gradual accumulation of minute differences to be the norm. This type of slow selection favors almost imperceptible modifications in structures already in existence. The principal opponents to Darwin's evolutionary theory were academics who refused to accept that evolution could have progressed so slowly and denied the existence of deep time. Darwin therefore wasn't going to lend support to them by openly favoring the possibility that there might be some bigger evolutionary steps mixed in. Again and again in *On the Origin of Species* he repeated the Latin adage "natura non facit saltus" (nature does not make leaps). So determined was he to stress this point that his chief public advocate, Thomas Henry Huxley (the man nicknamed "Darwin's Bulldog"), warned him against appearing too gradualistic for fear of alienating his less extreme supporters.

Real novelty is, in fact, *exceedingly* rare in evolution. Most adaptations in wild animals are merely new uses put to existing structures, and those existing structures may be common to such a wide range of animals, going so very far down the evolutionary tree, that they no longer bear any resemblance to one another. They may even have deviated from their original purpose, like the forelimbs of whales evolving from those of terrestrial mammals, returning to the aquatic existence shared by the earliest ancestors of all tetrapods—the lobe-finned fishes that swam the oceans around 390 million years ago.

In domesticated animals that have a shorter evolutionary history, derived structures (and behaviors too) are less difficult to identify, though they too may be very much changed from their original purpose. Take pouter (or cropper) pigeons, for example. The many varieties of pouters are some of the most outlandish of all birds, as you'll remember from the illustration in chapter 1. An excited one can look

Posture is one of the things that can be radically changed through a series of imperceptibly tiny steps. There are only so many things that a body can do, however, and again and again we see familiar patterns emerging across a range of species. This remarkably upright bird is a Ko shamo, a former fighting chicken breed from Japan.

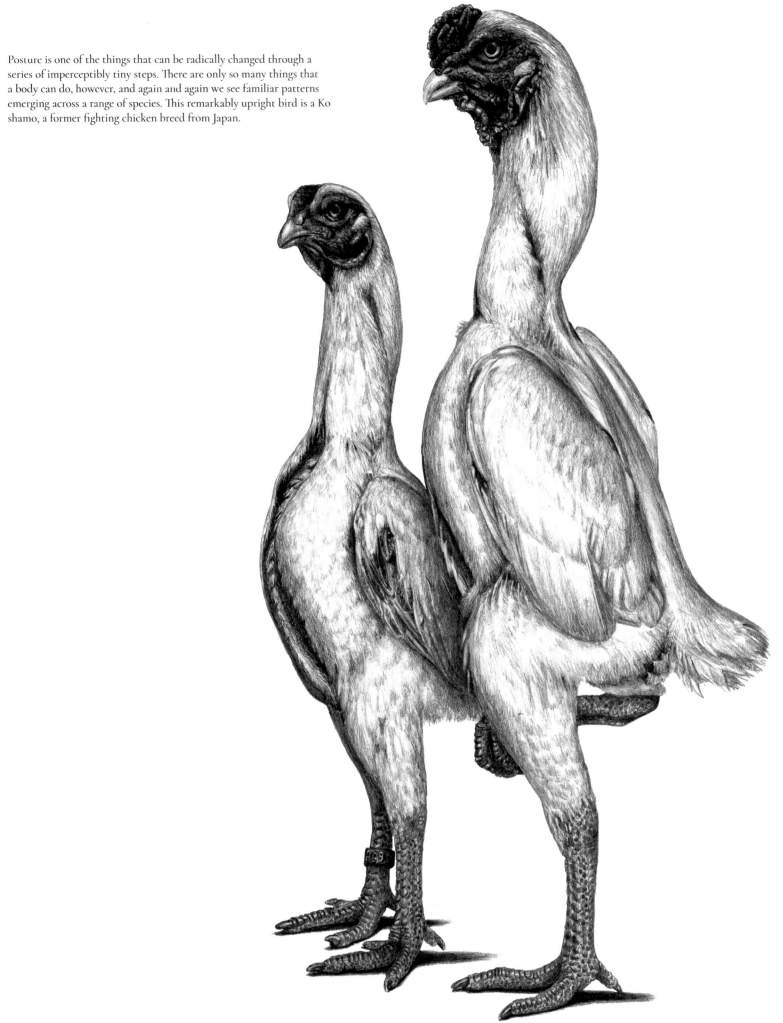

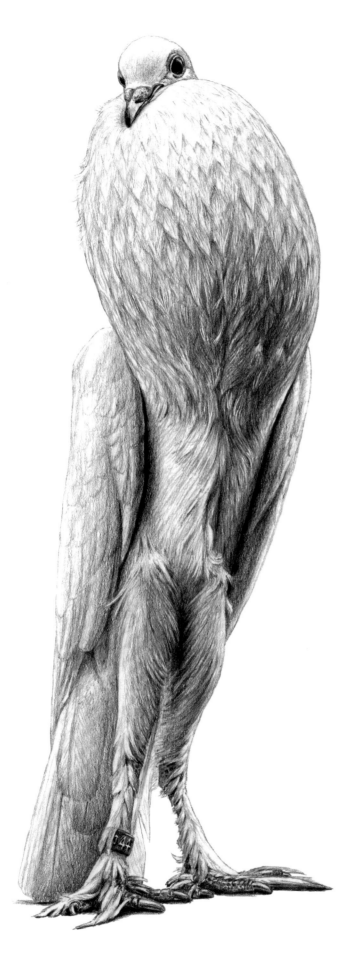

as though it has a fully inflated balloon stuck in its throat. But pouters are simply doing what every other pigeon does, wild or domesticated: they're inflating their crop with air in courtship display. The only difference is that, over countless generations of pouter ancestors—almost all the way back to normal dovecote pigeons—certain breeders have favored individuals with the largest crops and the most excitable behavior.

Gradual selection on minute differences is also accountable for changes in posture and, once again, behind the appearance of extreme diversity is a pattern of repeated forms and combinations. In ducks, pigeons, chickens, and even canaries there are breeds with near-vertical postures, as well as horizontal ones. The Runner duck is an obvious example. Lesser known is the remarkably erect Ko shamo, a rare breed of fighting chicken from Japan. Then there's the English pouter pigeon, and its tiny counterpart (one of the creations of John Sebright) the Pygmy pouter, not forgetting the old-fashioned style of exhibition Fantail pigeon discussed in chapter 2. The posture of this type of fantail, with its head held low behind its back, is remarkably similar to that of the Serama, the diminutive bantam chicken discussed in chapter 4.

Erect posture is often accompanied by slenderness of form. In the case of the pouter, the rib cage and breastbone have contracted almost to a cylindrical tube, and the knees (which in birds are usually tucked out of sight on either side of the rib cage) are clearly visible beneath the body. The Hollecropper pigeon on the other hand is a horizontal version of a pouter, with the neck curved backward, exactly like the rather spherical modern Fantail.

The now outdated fashion for Yorkshire canaries was to produce a bird so upright and slender that they were said to be able to fit through a wedding ring. Presumably this would have been a wedding ring of a chunky-fingered man, and I very much hope that nobody actually tried. (The current requirement for Yorkshire canaries is to be "carrot-shaped.")

Unusually—and perhaps the difference is that canaries are perching birds rather than terrestrial ones, with different requirements of balance—there are several canary breeds in which the head is extended forward and downward instead of backward, and again we see slight variations on a general theme. At one end of the scale is the Scottish fancy, whose head

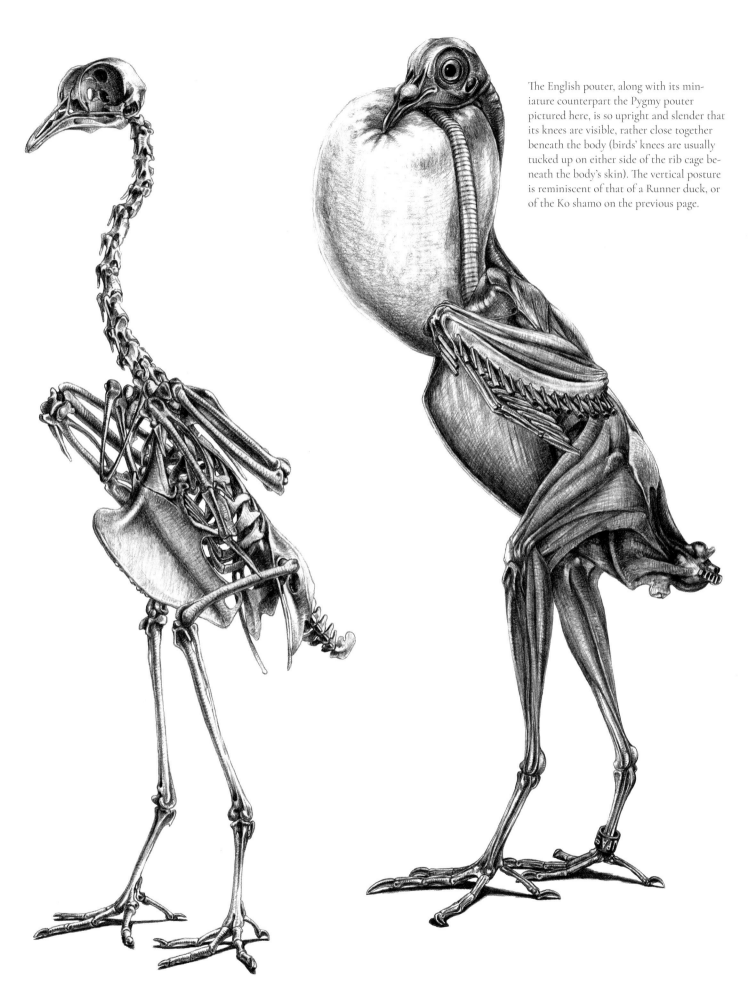

The English pouter, along with its miniature counterpart the Pygmy pouter pictured here, is so upright and slender that its knees are visible, rather close together beneath the body (birds' knees are usually tucked up on either side of the rib cage beneath the body's skin). The vertical posture is reminiscent of that of a Runner duck, or of the Ko shamo on the previous page.

and tail both curve inward in a delicate crescent-moon shape; at the other end are the very extreme Gibber Italicus and Giboso Español. What is certain is that the appearance of all these breeds has changed, is changing, and will continue to change.

Some of the first serious experimentation into inheritance in animals (as opposed to plants) was conducted on the comb shape of chickens by English biologist William Bateson, who began his work in the years leading up to the rediscovery of Mendel's research. It was Bateson who later coined the term "genetics" from the Greek word *genesis*, meaning "origin."

As we shall soon see, inheritance in chicken combs is not as straightforward as the characteristics in pea plants selected by Mendel, so it's likely that he would have struggled to clinch the basic laws that make Mendelian inheritance such an elegant foundation. Mendel had wisely selected clear-cut, all-or-nothing characteristics to study, and (by as much luck as judgment) his results were neatly segregated into the same precise types without any intermedi-

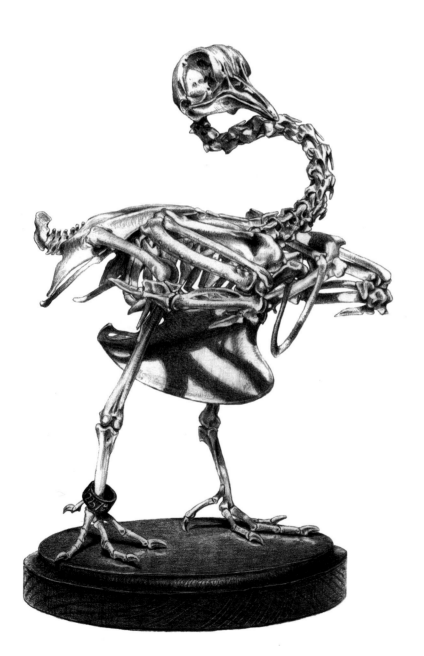

The Hollecropper is a pouter on a horizontal axis. With its neck curved backward, crop inflated, so that its head rests in the center of its back, it's similar in its spherical proportions to the modern exhibition Fantail discussed in chapter 2.

ate forms. Bateson's results likewise emerged as a pattern of identifiable types, although they revealed a number of additional complications.

Simplest of all chicken combs is the upright, blade-like single comb, with a series of spikes along the top edge. The number of spikes is highly variable and is controlled by a completely different, "comb-roughening" gene that produces varied effects according to the comb type it acts on. This is the comb shape of the principal wild ancestor of all domestic chickens, the Red junglefowl.

If you remember from the previous chapter, different alleles occupy the same location—or locus—on a given chromosome and represent alternative sets of genetic instructions. Single comb is another example, like horns in cattle, in which the wild-type is recessive to an allele occurring only under domestication. This dominant version is the rose comb.

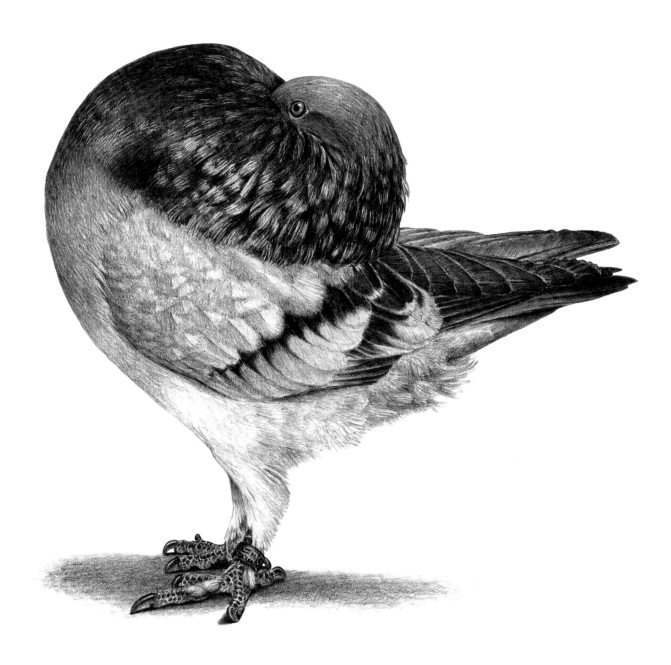

The first problem that might have confused Bateson is that the comb-roughening gene that adds spikes to a single comb radically alters the appearance of a rose comb. Rose combs are flattened rather than upright so the comb-roughening gene can produce a varying number of projections over its entire surface. Take away the influence of comb roughening, however, and its surface is entirely flat and smooth. Rose combs also either follow the contours of the head or stick upward at the back in a series of raised spikes. The amount of variation between different breeds and even individuals is considerable and, to complicate matters further, fertility problems in rose-combed strains tilt the ratio of offspring from crosses in favor of single-combed birds, making them a statistical nightmare to fathom.

A third comb type is known as pea comb. It tends to be quite small and is divided into three longitudinal sections. Pea-combed birds also have a dewlap of loose skin beneath their chin and their wattles are much reduced in size. Pea comb isn't an additional allele on the single-/rose-comb locus but occupies a different part of the genome altogether, so it's possible to have both sets of comb-shape instructions acting at once—with the additional instruction for comb roughening thrown in!

When you have the gene for a rose comb acting in conjunction with a gene for a pea comb you get a fourth comb type, the walnut comb. Because of the pea-comb element, walnut-combed birds have small wattles too, and in the case of Silkie fowl (there's a recognized Silkie breed in addition to the generic silkie feather mutation), the rose-comb element might contribute little spikes at the back.

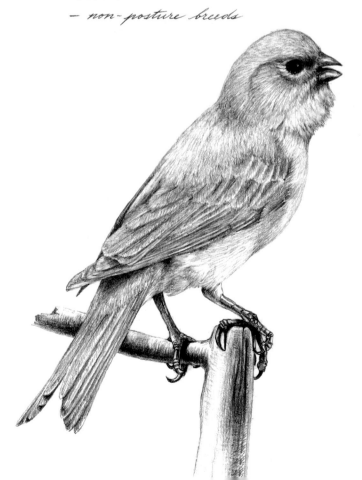

'Normal'
— non-posture breeds

From the standard finch shape typical of the many singing and color canary varieties, a handful of breeds have been created, by gradual selection, with a range of rather more unusual postures. The crescent-moon-shaped Scotch fancy, the carrot-shaped Yorkshire (formerly much more slender and less top-heavy), and the very extreme Gibber Italicus are just a few.

In "silkies" the comb does indeed look exactly like half a walnut, while in the Malayan fowl it's rather smooth with tiny bristle-like feathers growing out of it—rather like the surface of a strawberry. This, unsurprisingly, is the strawberry comb—even though it's technically a walnut!

Yet another comb type is the duplex comb, which branches into two at the front of the head, and often occurs in crested breeds. There are two forms, controlled by different alleles of the same gene. The simplest is a V-shaped comb—just two fingers of flesh pointing up like a pair of snail horns in front of the crest. The other (in fact there are two very similar versions of this one) produces a many-fingered cup shape exactly like the paired antlers of a moose.

Remember the seemingly unconnected characteristics that can be affected by the same gene? Well, here's another example. Chickens with a duplex comb also have a different structure to their nostrils, which are raised above the level of the bill. Even the skull is different, as these birds lack the bony bridge that arches above the nostril openings on a normal bill. Although the raised nostrils are genetically associated with the duplex comb, they're also present in breeds that have no comb at all—like the Polish, and the Breda, fowl. That's because of yet another gene, one with an allele for comblessness that overrides the instructions from the comb-type genes. But even though this prevents the development of a duplex (or any other) comb, it doesn't prevent the associated effect of raised nostrils.

Mendel's 1866 paper on the hybridization of pea plants was simultaneously re-discovered at the turn of the century by three botanists working independently in three different countries: Hugo de Vries in the Netherlands, Carl Correns in Germany, and Erich von Tschermak in Austria, sixteen years after Mendel's death and eighteen

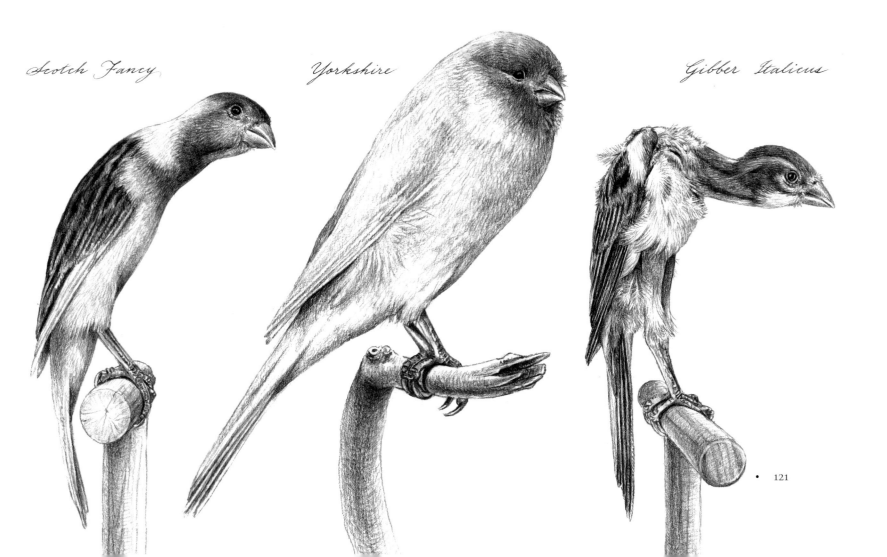

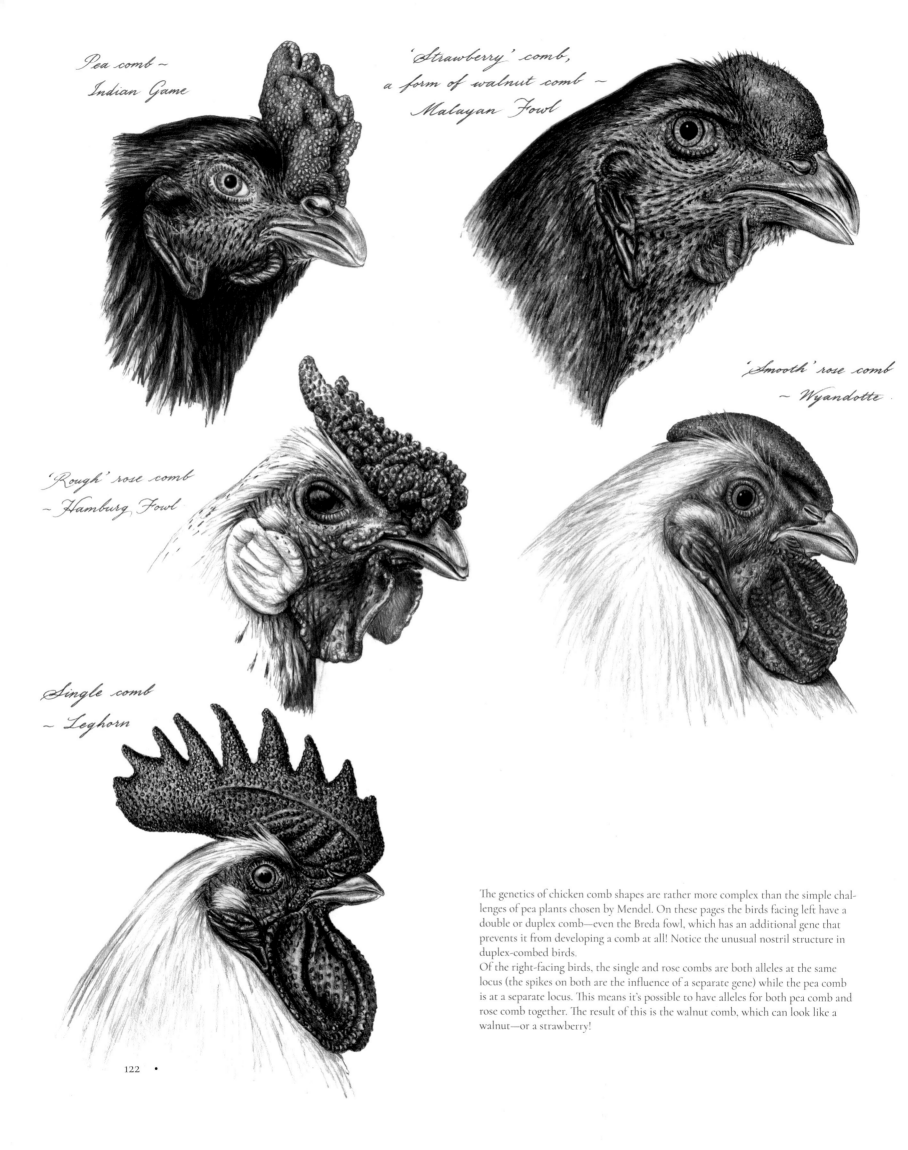

Pea comb ~ Indian Game

'Strawberry' comb, a form of walnut comb ~ Malayan Fowl

'Smooth' rose comb ~ Wyandotte

'Rough' rose comb ~ Hamburg Fowl

Single comb ~ Leghorn

The genetics of chicken comb shapes are rather more complex than the simple challenges of pea plants chosen by Mendel. On these pages the birds facing left have a double or duplex comb—even the Breda fowl, which has an additional gene that prevents it from developing a comb at all! Notice the unusual nostril structure in duplex-combed birds.
Of the right-facing birds, the single and rose combs are both alleles at the same locus (the spikes on both are the influence of a separate gene) while the pea comb is at a separate locus. This means it's possible to have alleles for both pea comb and rose comb together. The result of this is the walnut comb, which can look like a walnut—or a strawberry!

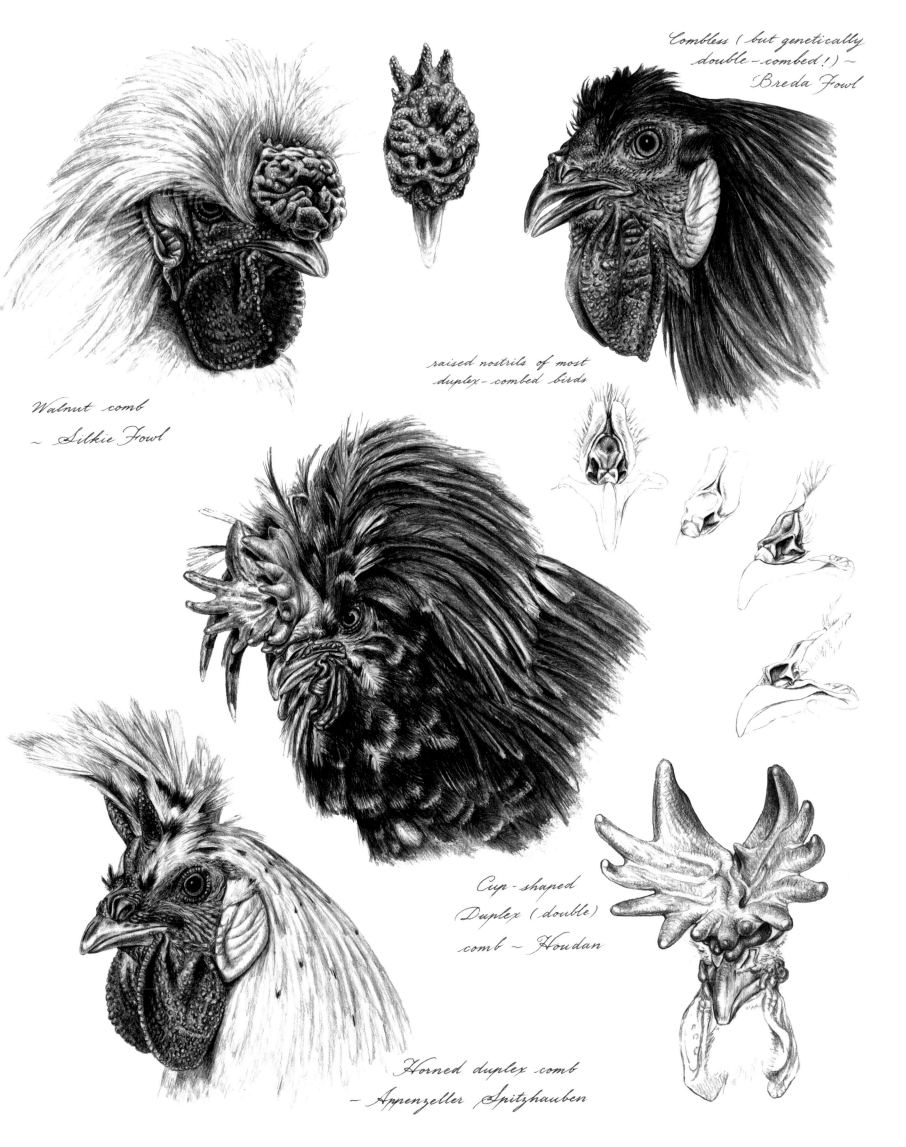

years after Darwin's. Bateson, valiantly struggling meanwhile with the complexities of chicken combs, could justifiably have been peeved to discover that someone else had already accomplished what he sought, but instead he embraced Mendel's achievements with open arms, translated his paper into English, and remained a stalwart champion of his work. Over the succeeding decades he and other "Mendelists," including, in America, eugenicist Charles Davenport and Thomas Hunt Morgan (who conducted groundbreaking genetic research using fruit flies), threw themselves enthusiastically into understanding the multiple exceptions and permutations of the basic Mendelian Laws.

But finding a pattern to the inheritance of clearly definable characteristics under controlled experimental conditions appeared to contrast sharply with the gradual, imperceptible changes in nature advocated by Darwin's natural selection—changes moreover that Darwin had insisted do not progress in leaps. Wouldn't Mendelian inheritance surely produce an erratic and jerky evolutionary pathway instead of a smooth transition through time? The more vehemently the followers of Mendel attacked Darwin's gradualist approach, the more bitterly the followers of Darwin, headed by English mathematician Karl Pearson, attacked the "saltationists"—those who maintained that nature does indeed "facit saltus."

Space in this book is too precious to waste in relating the petty politics of the two opposing sides, or how viciously they hacked and slashed at one another in print. Suffice to say that the advancement of science that should have sprung from the union of Darwin's natural selection with the newly discovered laws of inheritance—to be known as the modern synthesis—may conceivably have been delayed by several decades.

It's probable that Darwin's followers were far more radical in their defense of gradualism than Darwin himself would have been. He, as a naturalist and animal breeder, with finely tuned observational skills, would have had a greater understanding of the sort of variations that are possible—at the very least under domestication. He would have appreciated that not all hypothetical paths might lead to the end result observable in nature. Take the following example.

I recently opened an evolution textbook and noticed a series of illustrations of a pigeon keeper (I think it was supposed to be Darwin) in his loft, surrounded by birds. The first picture showed blue-gray pigeons of the wild-type pattern including one individual that was a slightly paler gray than the others but with the same markings just visible in a muted form. The second showed several, even paler pigeons. As the pale pigeons in the series increased in number, so they gradually increased in paleness. The final illustration showed a happy Charles amid a flock of pure white pigeons.

Imagine that these were wild pigeons and not domesticated ones and this would be the gradualist account of how white pigeons evolved, and you could apply the same reasoning to swans or polar bears or any other white animal. They were very attractive illustrations, though unfortunately quite incorrect.

Paler markings can indeed occur through mutations—such as ino or dilution that affect the intensity or distribution of melanin granules. These muted colors are often referred to as isabelline.

There's a story behind that name that's worth telling, even though it has nothing to do with Darwin or pigeons. Allegedly, in 1601, the Infanta Isabella Eugenia of the Spanish Netherlands rather foolishly vowed not to change her underwear until the Siege of Ostend was over, thinking it would last a few days at most. The siege lasted for *three years*, and the term refers to the color of her garments after this time. When historians discovered that the word was first used in 1600, however, just before this siege took place, the story was conveniently transferred to another Spanish queen and a different, much shorter siege. Judging by the pale color alone, the latter seems more likely.

Anyway, dilution mutations are not cumulative. No matter how many generations you breed, the offspring will never, ever increase in paleness. Complete whiteness in pigeons requires a different mutation—a specific form of leucism that affects the entire plumage in one single step.

Another enormous leap that categorically has no middle ground is the direction of spirals—the difference between clockwise (dextral) and counter-clockwise (sinistral). Spirals occur again and again in nature: in the arrangement of leaves around a plant stem, in the shells of mollusks, and in the horns of sheep, goats, and antelopes.

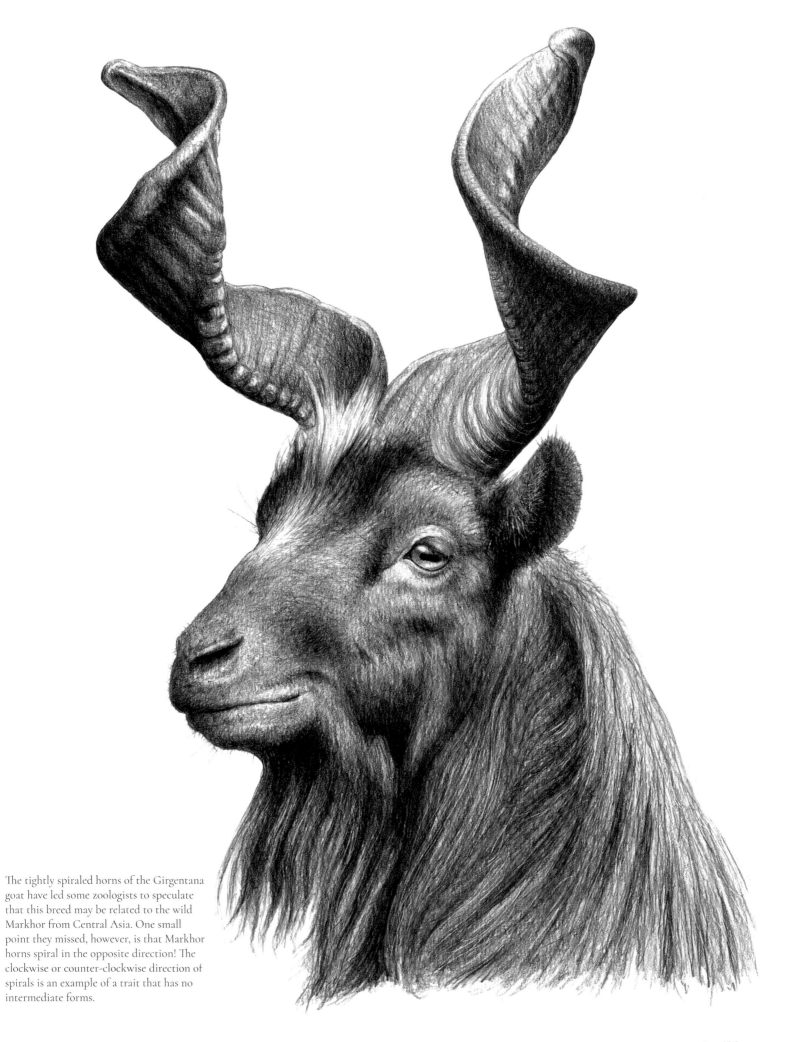

The tightly spiraled horns of the Girgentana goat have led some zoologists to speculate that this breed may be related to the wild Markhor from Central Asia. One small point they missed, however, is that Markhor horns spiral in the opposite direction! The clockwise or counter-clockwise direction of spirals is an example of a trait that has no intermediate forms.

The direction of spiraling is usually pretty consistent in related animal groups, especially in the case of gastropod (spiral-shelled) mollusks, which rely on the compatibility of their shell shape in order to reproduce. Think how awkward it feels to shake hands with someone using their opposite hand to yours—that's the closest you'll get to knowing how it feels to have sex with a sinistral snail. Nevertheless, nearly 10 percent of gastropod species do spiral in the opposite direction, along with some comprised of a mixture of dextral and sinistral individuals.

In case you're wondering how these animals could breed in the first place, remember that recessive genes can multiply in a population before they're ever expressed, so the first sinistral gastropod born may well be shortly followed by a second and a third. While there's obviously no evolutionary advantage in being reproductively incom-

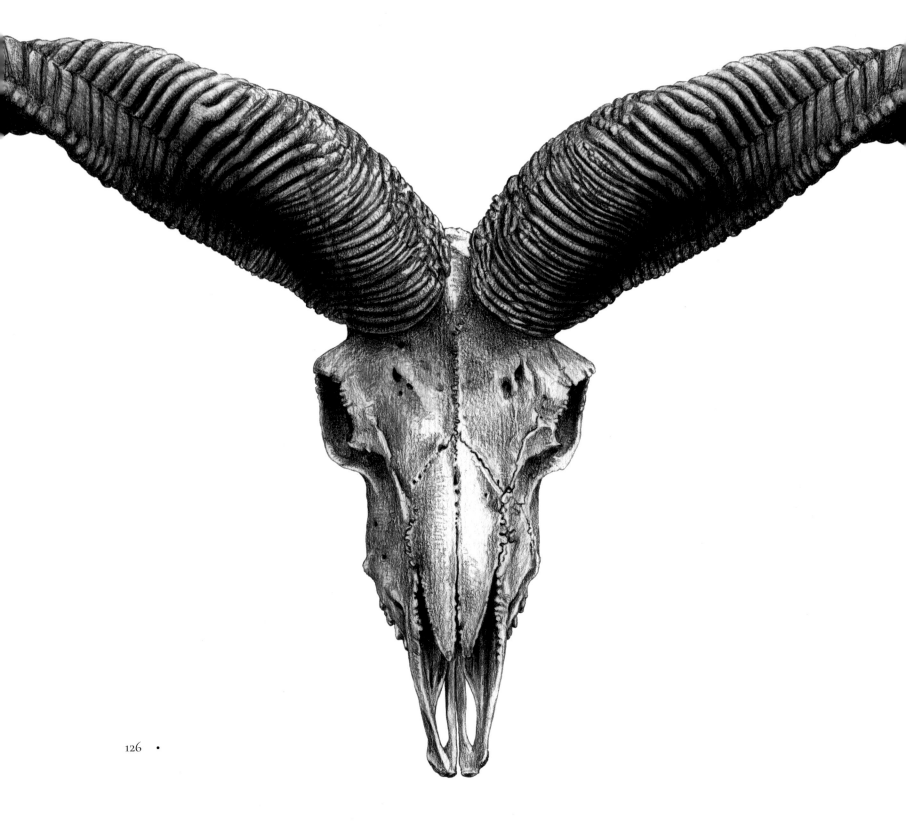

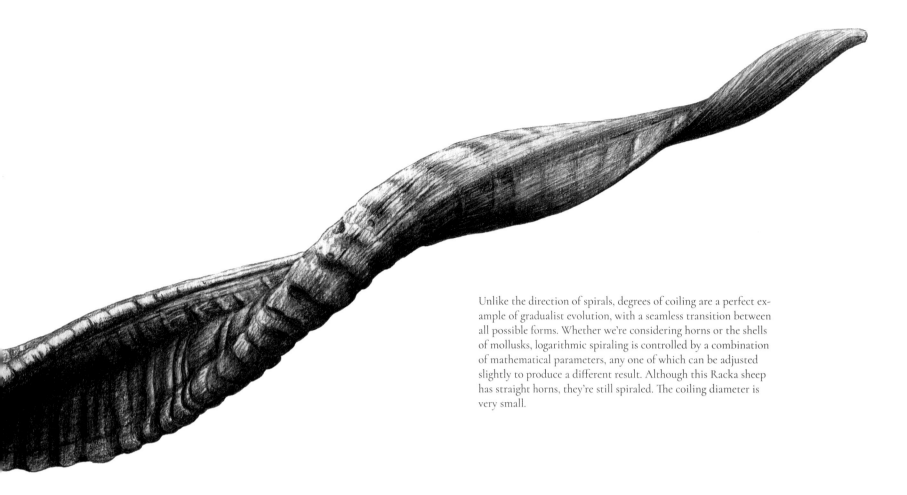

Unlike the direction of spirals, degrees of coiling are a perfect example of gradualist evolution, with a seamless transition between all possible forms. Whether we're considering horns or the shells of mollusks, logarithmic spiraling is controlled by a combination of mathematical parameters, any one of which can be adjusted slightly to produce a different result. Although this Racka sheep has straight horns, they're still spiraled. The coiling diameter is very small.

patible, there's a lot to be said for being in such a minority that competition is virtually eliminated, which lends support to the saltationist argument.

Goat horns usually curve gracefully backward from the forehead without any obvious spiral at all, but in one rare (and magnificent) breed—the Girgentana, from the Mediterranean island of Sicily—the horns are erect and tightly spiraled along their central axis, very much like the Markhor, a wild goat species from Central Asia.

It took only one man, Austrian zoologist Leopold Adametz, to claim that Girgentana goats must surely have descended from markhors—based solely on their superficial horn shape—for other zoologists to flock together in agreement. No one seemed to notice that the horns of markhors, like those of spiral-horned antelopes—eland, kudu, blackbuck, bushbuck, and so forth—spiral in one direction while the horns of all domesticated goats and sheep spiral in the other.

There's a sheep breed too, the Racka sheep from Hungary, with straight but tightly spiraled horns and these most certainly did not descend from markhors. All sheep horns are, in fact, spiraled, but when the spiral is especially loose the horns appear to be just gently curved. Increase the lifespan of these animals, however, and you'd eventually see the horn's true potential.

Spiraling of the sort that occurs in nature (called logarithmic spiraling) has been studied at length, not only by zoologists, but by mathematicians, philosophers, physicists, and artists. It's complicated stuff and well beyond my arithmetic capabilities, but a spiral is basically controlled by three distinct parameters, which could equally be genetic parameters. Tweak one of these just a little and you'll get a different configuration—perhaps a more loosely spiraled horn. Make another change and the horn curls more closely toward the head. Eventually you've gone from a straight line to a tight coil. It's theoretically possible to map out every variation of any logarithmic spiral that could ever exist. This has, in fact, been done. It's called the Museum of All Possible Shells, but it matters not

whether it refers to mollusks or horns. Every hypothetical intermediate is accounted for. Some of these animals exist. The majority don't. They may have existed once as intermediate forms on their way to evolving into the species that we recognize today. Some that exist now may cease to exist or may be the intermediate forms toward the species we'll recognize tomorrow. Or they may never come to exist at all. The message here is that this is gradualist evolution at its finest.

The followers of Mendel appreciated that gradual Darwinian inheritance could work in small populations, but they couldn't envisage this having any influence on evolution above the species level. One major hurdle was, and still is, the sheer impossibility for the human mind to comprehend the depths of time over which evolution has taken place. In a way, saltationism mirrors the early nineteenth-century belief in catastrophism—that the landscape of today was formed by a series of sudden cataclysmic geological events instead of gradual change by the continuous action of forces still at play. There certainly have been bursts of rapid evolution in geological history, but these are still the accumulation of thousands of tiny changes spanning millions of years, rather than an overnight transformation through a single gene change. Even during long periods of apparent evolutionary stasis, natural selection continues to work unabated by removing the less efficient variants.

In one of my former incarnations I was a curator of the second-largest ornithological reference collection in the world. There were three floors of bird skins alone, amounting to around 750,000 specimens arranged taxonomically in long rows of cabinets resembling the warehouse scene at the end of *Raiders of the Lost Ark*. These are the parts of museums that the public doesn't usually see, but periodically we'd take groups around on tours of the collections. People's reactions were varied, but one question that you could guarantee would be asked was, "Why do you need so many?"

The answer is that no matter the number of specimens a museum holds, it's far short of what's needed to provide a large enough sample size for every potential research project. Any taxon can be divided and subdivided countless times: different sexes, different ages, breeding and non-breeding plumage, worn, fresh, or partially molted plumage, different time periods or different geographical locations and—all too often underestimated—the slight, natural variation between individuals. It is individuals that are the all-important single units that make up populations and the bottom line where evolution begins.

As Darwin repeatedly stressed, the more familiar you become with animals, the better you're able to appreciate subtle differences. To an onlooker at a dog show, a row of competing black labradors may look identical. The show judge will be able to spot their relative faults and merits, but to a dog's owner the question of individual recognition would never even come into question. Similarly, every miniscule difference that might give one individual even a tiny selective advantage in the struggle for life, counts. Over time the accumulated differences can make a significant evolutionary impact.

Mendel and his followers had, for the sake of clarity, deliberately selected traits with no intermediates. But infinitesimally tiny variations are controlled by genes too, and each is subject to the same laws. Indeed, just as a single gene can influence many seemingly separate traits, a single trait—like height or facial characteristics—can be influenced by the action of hundreds of genes. Together they produce the continuous smooth transition that Darwin's followers maintained was necessary for natural selection.

Even traits that were originally caused by a major mutation, like the legs of an ancon sheep, can be modified by the action of other genes. Who knows whether the short legs

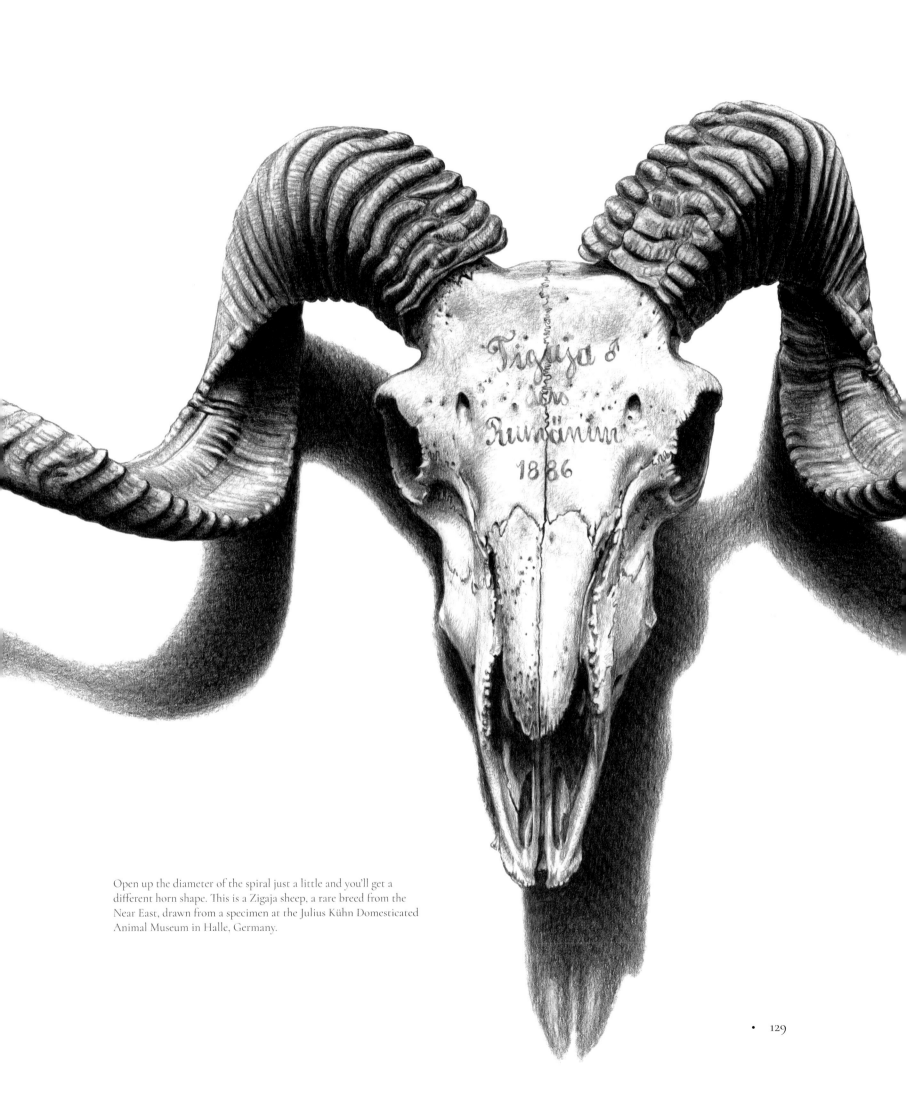

Open up the diameter of the spiral just a little and you'll get a different horn shape. This is a Zigaja sheep, a rare breed from the Near East, drawn from a specimen at the Julius Kühn Domesticated Animal Museum in Halle, Germany.

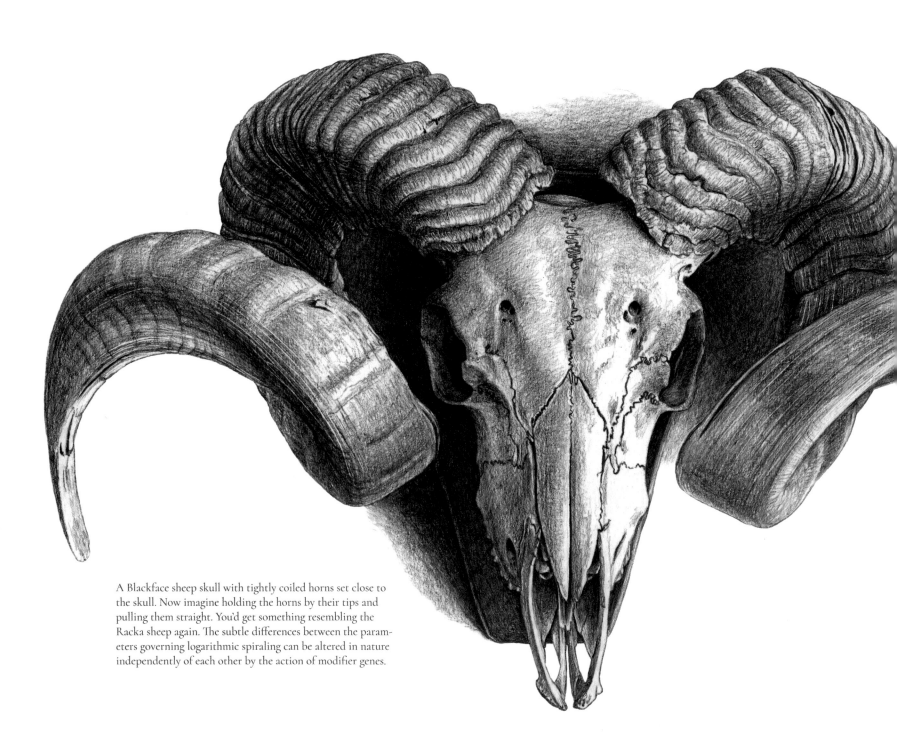

A Blackface sheep skull with tightly coiled horns set close to the skull. Now imagine holding the horns by their tips and pulling them straight. You'd get something resembling the Racka sheep again. The subtle differences between the parameters governing logarithmic spiraling can be altered in nature independently of each other by the action of modifier genes.

of otters and other mustelids may not have been given a head start by a similar mutation? Or major leaps in phenotype may be just the action of many small steps working as one. Collectively these genes are known as modifier genes, but in reality virtually any gene can influence or modify the effect of another. Although it's almost impossible to write about genetics without falling into the habit of mentioning genes "for" this or that, as I'll stress again and again in the remainder of this book, there are no genes with exclusive control over individual traits—only whole genomes that work together in varying degrees of harmony. If a community of genes works well together, the more successfully it—and the animal or plant it inhabits—will withstand the pressures of natural selection. Variation in the gene community is inevitable, but whether the changes bring disaster or advantage, or have no effect whatsoever, all depends on how well they are suited to their ever-changing surroundings.

Mendelian inheritance, then, *can* produce subtle results as well as major phenotypic change—the sort of results that, over time, and in the right environment, could blossom into the endless diversity of life on Earth. While the long-overdue modern synthesis marked the acceptance that all changes, large and small, are inherited according to the same genetic laws and principles, the debate over saltation, however, was far from ended.

III

VARIATION

7. The "M" Word

7 ~ The "M" Word

Mutation; mutant; monstrosity; monster; deformity; freak—you can almost hear the barrel organ and the booming voice lyrically cajoling passers-by to roll up and see the two-headed lamb or the bearded lady. The word conjures up images of mad scientists conducting illicit experiments; creatures with too many body parts, or body parts in the wrong places, pickled in jars. Even the X-Men superheroes of Marvel comics are social pariahs. "Mutation," it turns out, is a dirty, politically incorrect, word. The sort of word to get doors slammed in your face. If only I'd known that when I began this book and embarked on what I thought would be the pleasant task of contacting animal fanciers to ask for help (things would go well until I mentioned the "M" word). In fact I wasn't asking about six-legged puppies or two-headed lambs, and certainly not about bearded ladies. I was asking about yellow canaries, black cats, fantail goldfish, and fluffy guinea pigs. I might equally have been talking about elephants, ostriches, curlews, or crabs.

For all their sinister implications, mutations are nothing more or less than the alleles I talked about in chapter 5. Just random typos in the transcription of DNA in the sex cells that may, or may not, bring about a changed phenotype in succeeding generations. They're the origin, not just of the differences between domesticated animals and their wild ancestors, but of all the diversity that exists and has ever existed on the planet—between individuals, races, species, families, orders, and every division that human taxonomists have applied to the organization of life. It's mutations that put the eyes on a peacock's train, mutations that created the colossal sauropod dinosaurs, mutations that allow palatable butterflies to mimic toxic ones, and mutations that resulted in a brain with the capacity to ask "how?"

Sexual reproduction combines and shuffles these alleles, churning out an unlimited supply of new phenotypic variations to fuel the fire of natural selection. But the original source of all this variation is in random errors.

Even the great John Sebright (who's mentioned frequently throughout this book)—gifted animal breeder though he was—was quite incorrect when he boasted that he could produce any given feather in three years, but it would take him six years to produce a head and beak. All selection is on pre-existing variation, and variation is random. Darwin, who would never know the complexities of DNA replication or the nature of mutations, nevertheless recognized that variation is the fuel for natural selection and not a product of evolution. Contemplating his pigeons he reflected that it would be impossible to imagine creating a Fantail unless the idea was first suggested by the animals themselves, that is, by the sudden appearance of a bird with extra tail feathers or an upright tail: "Man can never act by selection except on variations which are first given to him." It's only by removing unwanted intermediates—by destroying a large percentage of the variation itself—that adaptive evolution and eventual speciation are possible. If that sounds unpleasantly destructive, think of it as a flat and featureless landscape that has to be partially eroded away to form the Grand Canyon, or a block of marble that has to be chipped away to reveal the Venus de Milo inside!

 Happy as a dog with two tails! This conjoined puppy is the sort of animal usually associated with the term "mutation." In fact it's not the result of a heritable genetic mutation at all—just an unfortunate accident of cell division in the developing embryo.

These duplicated calf skulls, complete with two sets of teeth, are joined at their base and would presumably have been attached to a single, and perfectly normal, calf's body.

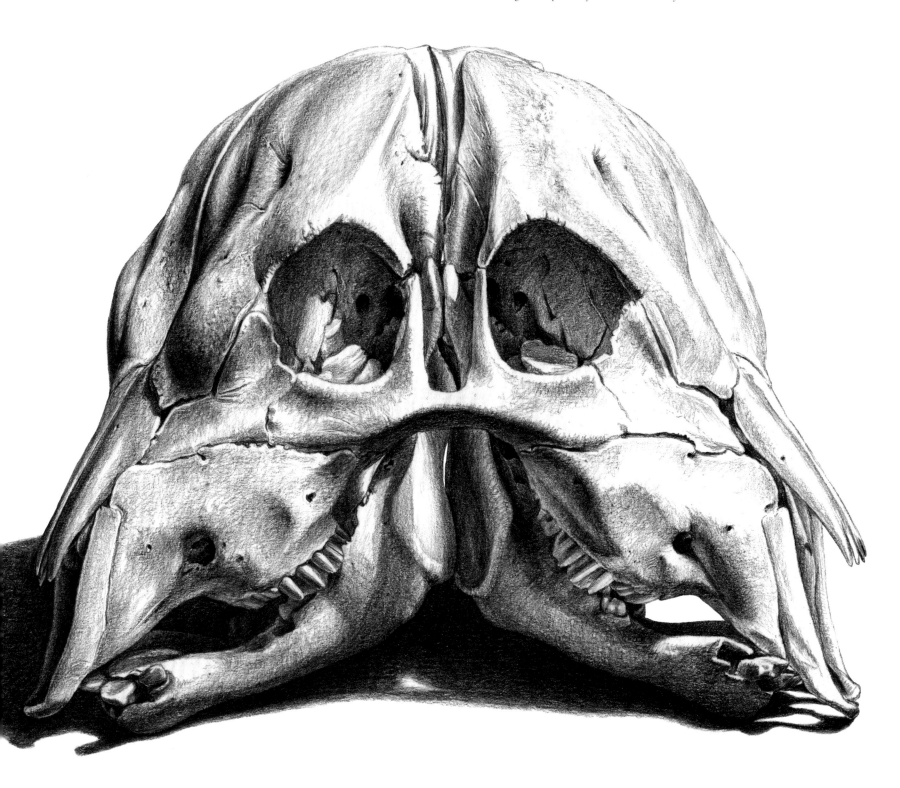

This lamb (or should it be lambs?) has two fully formed bodies attached to a single deformed skull. One of the forelimbs is lying across the back of its twin. Even if macro-mutations like this were genetically heritable, they would almost certainly not be favored by natural selection!

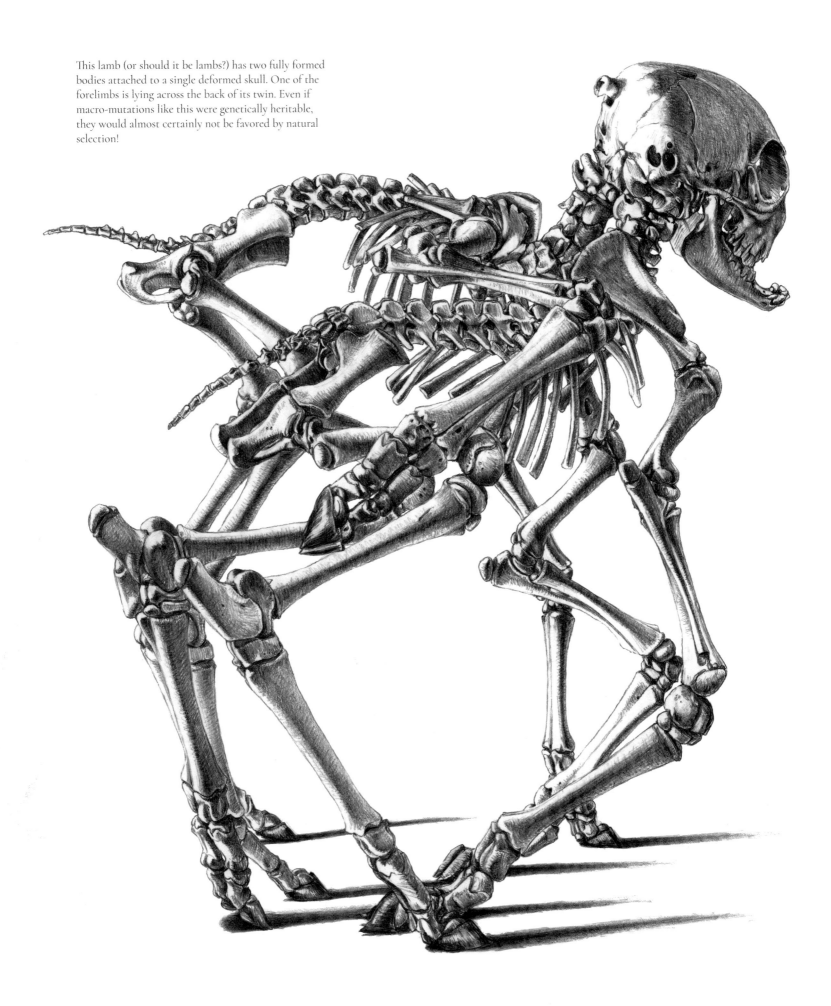

Despite having two additional limbs joined at their base, and a twisted and partially duplicated pelvis, this domesticated Mallard nevertheless survived to adulthood. We'll never know whether it reproduced during its lifetime, but it's very likely that any offspring would have been completely normal. Such conditions are not usually heritable.

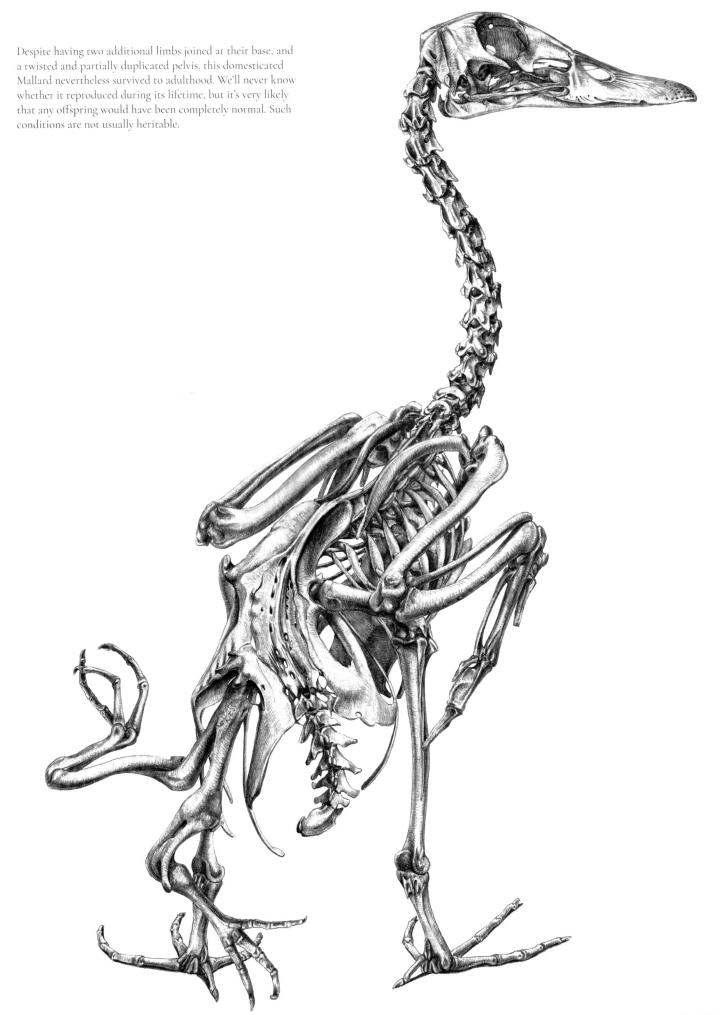

It's true that there are plenty of mutations that result in what people would term "monsters." The puppy at the beginning of this chapter is from our own collection and has two forelimbs and two sets of apparently normal hindquarters, complete with two little tails. The calf pictured would have had a single, probably quite normal body attached to its twin skulls. The lamb is divided at the neck to give two complete bodies with eight legs between them, attached to a single (deformed) skull. In the duck, which survived to adulthood, the two extra limbs are connected at their base, giving the appearance of a single additional limb with two feet, though each lacking the full complement of toes. The pelvis is also twisted and partially duplicated.

The most famous example, in humans, is that of Chang and Eng Bunker, the original Siamese twins, joined at the sternum by a narrow band of skin and cartilage. Chang and Eng were two individuals with their own independent characters. They lived for nearly sixty-three years and between them fathered twenty-one perfectly normal children. They were definitely not monsters.

Although these are exactly the sorts of examples that are conjured up by the "M" word, they're not heritable genetic mutations of the sort evolutionists talk about. They're embryological accidents—the result of abnormal cell division or the effects of toxins on the mother during pregnancy. Mutations can happen in any cell, but only those occurring in sex cells, the gametes, can be inherited and thus have any evolutionary significance. Although epigenetic studies have revealed short-term hereditary changes, especially in relation to diet, once the gametes of the two sexes combine to form a new embryo, nothing that befalls them, not even in the early stages of cell division, has so far been proven to be heritable in a long-term evolutionary sense beyond a few generations.

Examples like these were exactly the sorts of mutations that William Bateson thought to be a source of variation in nature. The idea was taken up by German geneticist Richard Goldschmidt who, in his 1940 book *The Material Basis of Evolution*, coined the now famous term "hopeful monsters." Although he appreciated the importance of gradual variation for short-term changes within species, he thought that only major mutations could bring about speciation itself.

The problem is there's such a weight of accumulated tiny steps—with the imperceptible action of modifier genes gradually shaping, accentuating, adapting, and re-shaping organisms to different ends over countless generations—that the question of whether the initial change was a large one or a small one is lost in the depths of time.

Large phenotypic change doesn't necessarily require a major genetic mutation. It may only take a simple genomic step, just the flick of a switch, to re-channel a developmental pathway in a new direction. For example, only a single gene change was needed to lengthen the fingers of the ancestor of bats. Even adding the webbing between them may have been a relatively simple genetic step. (Webbing exists in all embryos but the skin cells are usually programmed to self-destruct after the digits have developed.) However swiftly these proto-wings may have formed, you can bet that it would have taken eons of accumulated tiny tweaks to make them as aerodynamically refined as they are now.

Some parts of the genome are more susceptible to mutation than others. There are rigorous—and I mean *rigorous*—spell-checks built in to prevent any mistakes from happening. Nevertheless there are a number of different things that can go wrong. Point mutations can substitute a single base pair for another (each DNA strand is made up of millions of base pairs), or delete or insert a new base pair. Copy number variations, in contrast, can result in whole sequences of DNA being repeated over and over, resulting in the potential for traits to become rapidly exaggerated within surprisingly few generations. This is believed to have been a contributory factor in the rapid changes in the shape of dog skulls over the last hundred years, for example, in the Bull terrier skulls discussed in chapter 2. Elements called transposons (better known as jumping genes) can move around the genome creating havoc by "cutting and pasting" lengths of DNA from one location to another.

The miniscule percentage of DNA that codes for proteins is particularly resistant to change. This doesn't necessarily mean that mutations in these areas don't occur but that these areas influence such a wide range of physiological functions that mistakes would simply wreck the machinery. Most mutations occur in the non-coding areas—the parts rather arrogantly referred to in the 1960s and 1970s as "junk DNA." Here the spell-check is generally much more relaxed. The most successful changes subtly control and re-channel the actions of genes, enabling their influence to be independently put to additional uses without affecting their other functions.

It might sound paradoxical to attribute the wonders of life on Earth to copying errors. Nature appears to be flawless in the products of adaptation, so how can diversity be based on anything less? But it's important to remem-

ber that the efficiency of the "spell-check" is itself a result of natural selection. Just the right proportion of errors, in just the right parts of the genome, is allowed through to ensure the constant supply of new variation. Any more and the heritability of advantageous variations would be undermined; any fewer and there'd be insufficient variation to cope with changing environmental conditions. The genomic spell-check is only as (in)efficient as it is because natural selection keeps it so.

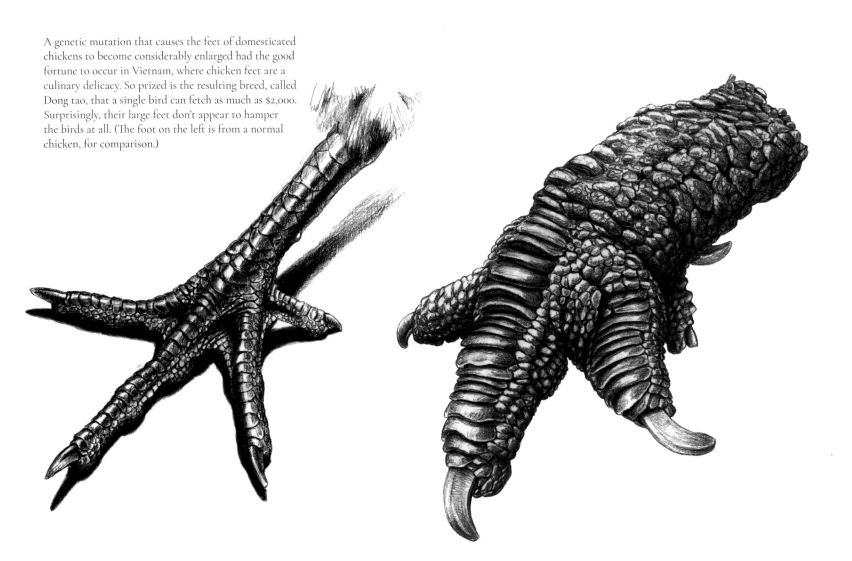

A genetic mutation that causes the feet of domesticated chickens to become considerably enlarged had the good fortune to occur in Vietnam, where chicken feet are a culinary delicacy. So prized is the resulting breed, called Dong tao, that a single bird can fetch as much as $2,000. Surprisingly, their large feet don't appear to hamper the birds at all. (The foot on the left is from a normal chicken, for comparison.)

The majority of mutations either are harmful—and by harmful I mean that the animal will never even make it past the embryonic stages—or have no phenotypic effect at all. Natural selection responds solely to the phenotype—how genes are outwardly manifested—so neutral mutations can be passively accumulated in the genome without exerting any obvious evolutionary influence. As long as an animal survives long enough to reproduce, the mutation has been successful. Even the mutations that do result in phenotypic change needn't necessarily be advantageous to be passed on. As long as they don't cause any *disadvantage* they can hitchhike their way through generations of animals, baffling biologists conditioned to search for adaptations in everything. Not everything, however, is an adaptation.

Once an animal is born, the question of whether or not a mutation is beneficial depends largely on its environment. Think of the polled cattle in chapter 5. Animals that exist, that live, eat, breathe, and reproduce are obviously well adapted to their environment already, with their physiology finely balanced to give maximum performance for the minimum energy expenditure (remember there are two parts to that equation—there's no such thing as a free lunch); so any major variation will almost certainly bring a disadvantage.

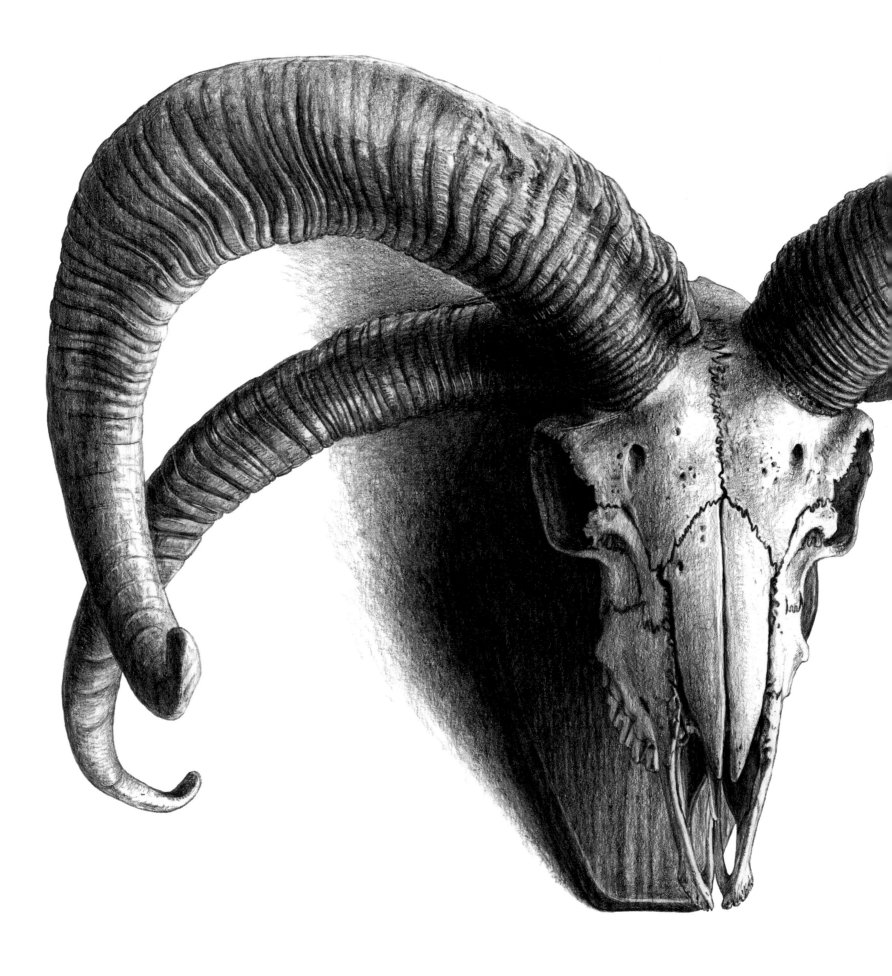

Although several recognized sheep breeds are known for their multiple horns, this is a trait that can occur in any breed, merely through a single-step mutation causing the developing horn bud to divide. The conformation of sheep horns, or even of their skull, is often insufficient to identify particular breeds. This one could be any number of possible alternatives.

It's when the conditions change that slight differences come into their own. This is why the fossil record shows long periods of stasis punctuated by periods of rapid evolutionary change. It's not necessarily because of an accelerated mutation rate or the sudden occurrence of macro-mutations, but due to a change in environment (including the genetic and ecological environments) allowing just a few more of the steady stream of new variations to squeeze through the net. Mutations, variations, traits—whatever you choose to call them—exist because they can.

Under the right circumstances some changes in environment prove especially fertile ground for certain mutations to flourish. I'm talking particularly, of course, about animals under domestication. Being favored by an animal fancier provides the perfect environmental conditions for success—just as perfect as having a thick coat at the onset of an ice age.

For example, one mutation, which causes the feet of domesticated chickens to become considerably enlarged, had the good fortune to occur in Vietnam where chicken feet are a culinary delicacy. So prized is the resulting breed, called Dong tao, that a single bird can fetch as much as $2,000. Unsurprisingly, I wasn't able to procure a specimen of my own, and for once had to resort to making my illustration from a photo! There are lots on the Internet. There are several films of live birds on the Internet too, and I was surprised to see that the birds don't seem handicapped by their large feet in the slightest and behave just as normal large chickens do.

Although in Vietnam Dong tao is now a recognized breed, this mutation could equally have occurred in any chicken, or could be outcrossed to any other. Many so-called new "breeds" of domesticated animal are really nothing more than an existing breed with a new trait, or with a trait that's been introduced from another strain. The fact is that varieties that can interbreed are assemblages of different characteristics that can be put together in any combination. Don't fall into the trap of seeking to define domesticated animals as you would wild species from a field guide, looking for specific identifiable characteristics. Their traits might be modified by selection, but they're seldom exclusive to any particular recognized variety.

Four-horned sheep are a good example. Manx loaghtans, Jacob sheep, and Navajo churro are all sheep breeds with four (or more) horns, a straightforward mutation that causes the horn buds to divide early in development. There are no particular differences between the horns, or even the skulls, of these animals, however, and the mutation can occur in any sheep regardless of their bloodline. Meanwhile there are no recognized goat breeds with four horns—but that doesn't stop four-horned goats from being born from time to time.

Belted Galloway cattle are another case in point. The one distinctive thing about this rugged Scottish beef animal is the unusual pattern: black (or more rarely brown) at both ends with a white band around the middle. It's the belt that gives them their name—ordinary Galloway cattle are solid-colored. Anyone seeing a cow patterned this way immediately pronounces it as a Belted Galloway. But this pattern is caused by a certain type of leucism that can be bred into any cow, regardless of its breed or color. The original belted cows were the Lakenvelders or Dutch belted cattle. "Laken" is the Dutch word for bed sheet, and "velder" is an Old Dutch term referring to skin, so the name literally means "a white sheet over the skin." The pattern isn't exclusive to cattle, however. It also occurs in pigs, in goats, and in mice. (The chicken breed of the same name is only superficially similar.) It would be a sad loss if Lakenvelder cows, now critically endangered, became extinct; they're beautiful animals with a rich cultural history dating back many centuries. But it would be more tragic still if the belted mutation itself disappeared, maybe never to return in cattle.

Another ancient Dutch breed defined by its unique genetic trait is the Hookbill duck, and it's only by uncanny good fortune that I'm able to use the word "is" and not "was." If a duck with a hooked bill sounds freakish to you,

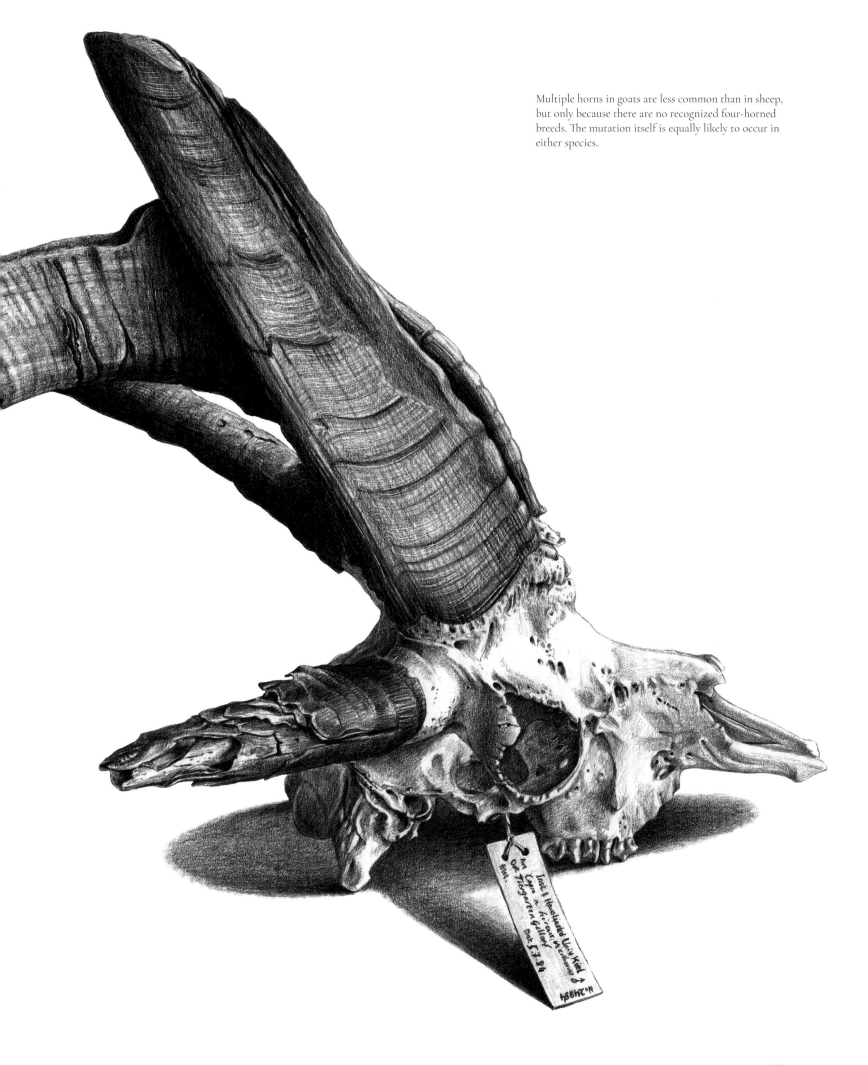

Multiple horns in goats are less common than in sheep, but only because there are no recognized four-horned breeds. The mutation itself is equally likely to occur in either species.

consider curlews, or even flamingos. The cause of all three (along with Scandaroon pigeons and Bull terriers) is probably due to the timing of cell growth in the developing embryo, with the upper surface of the mandibles being activated slightly earlier than those on the lower surface, causing a downward curve. A wild population of ducks (and I speculate here) might find this advantageous for foraging among boulders, just as Wrybills in New Zealand use their sideways-curved bill. Or they might not. Either way, domesticated ducks don't need to. As long as they can reproduce, that's all that matters.

There's a long tradition of duck keeping on the canal systems of the western provinces of the Netherlands. With a canal virtually on every doorstep, birds could be allowed to forage freely, swim and fly where they pleased, graze on other people's land, and return home to lay eggs and be eaten. The white breast, so characteristic of domesticated ducks in the Netherlands, was a sign to hunters not to shoot them, mistaking them for wild mallards as they flew overhead. Whether the first duck with a downward-curved bill appeared spontaneously in the Netherlands or whether it was imported from the Dutch colonies in Indonesia is unknown, but by the seventeenth century Hookbills were one of the most popular breeds, recorded for all time in the paintings of Jan Steen and Melchior d'Hondecoeter, and in the *Ornithology* of Francis Willoughby. These paintings very nearly became all that remained of the Hookbill. By the early twentieth century, the demand for duck eggs had diminished in favor of commercially produced chicken eggs, and the breed was kept only by a hard core of dedicated fanciers. The last few birds in their former stronghold of North Holland probably perished during the devastating Hunger Winter in the final years of World War II when people starved by the thousands. And that was thought to be the end of the Hookbill duck. Then three elderly birds were discovered on a remote farm and, after much perseverance, some fertile eggs were finally procured. All the Hookbills alive today, on both sides of the Atlantic, are their descendants.

If you're a fan of Old Master bird paintings you'll probably have noticed more than one rendition of ducks, geese, or chickens with feathery pom-poms on their head. They're cute, and even slightly ridiculous, and from their external appearance alone don't do much to support my argument that "domesticated animals aren't just for kids." But there's a great deal more to them than that—above and below the surface.

A central message of this chapter, which I'll repeat again and again, is that genetic mutations are universal and are just as likely to occur spontaneously in wild populations as they do in captivity. A group of three wild Canada geese, almost certainly a family group, was shot at Pie Island, North Carolina, in 1913, all of which had a tuft of feathers on their head identical to those found in domesticated ducks and geese. (The various domesticated varieties of crested geese are all descendants of Greylags, in the genus *Anser*—the gray geese—so its occurrence in wild black geese of the genus *Branta* is worthy of note.)

Even major mutations may not be as well-developed when they first occur as they are after generations of natural or artificial selection, honed by the gradual shaping of modifier genes. In general, the older and more well-established the variety, the more exaggerated the trait will be, having been subjected to centuries of selective breeding. Thus the strains of chicken and duck with the largest crest also happen to be the most ancient ones.

In chickens the crested variety is the Paduan fowl, which also bears a set of unrelated feathery facial appendages called a muff and beard in place of the usual wattles. There's also a version without these, called Polish fowl. (The names are misleading as both are actually old Dutch breeds—neither Polish nor Italian!) And the crested duck is called a . . . Crested duck! (Don't confuse them with the wild species of the same name, from Patagonia.)

Lots of wild ducks have crests of course—think of Wood ducks, Tufted ducks, or Hooded mergansers—and very elaborate they are too, particularly when used in courtship displays. But there's one fundamental difference: these crest feathers are clearly feathers that "belong" to the head. Their pattern and structure are continuous with the other head feathers: smallish, rather fine, narrow, and elongated. Now look at the crest of a Crested duck or Polish fowl. They clearly don't fit with the rest of the head. The feathers are far, far larger than the surrounding ones, slightly curled, and even colored differently. In fact in structure, size, pattern, and color they most closely match the feathers of the lower back and flanks in both chickens and ducks.

In chickens there's a clear distinction between the pointed crest feathers of males and the neat rounded feathers in hens, both of which correspond with the plumage of the rump and flanks in both sexes. In ducks, or rather drakes, that have retained the wild-type iridescent green head of the Mallard, the difference in feathers is even more obvious. These birds have crests of large curled feathers of finely vermiculated gray, identical to their flank feathers.

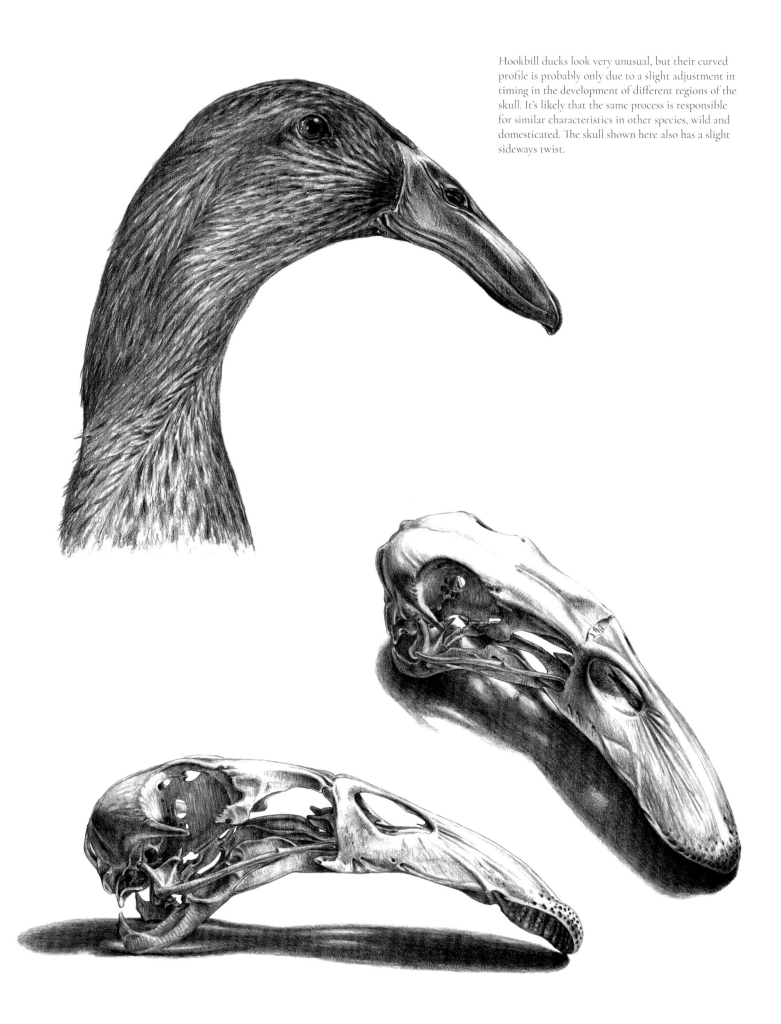

Hookbill ducks look very unusual, but their curved profile is probably only due to a slight adjustment in timing in the development of different regions of the skull. It's likely that the same process is responsible for similar characteristics in other species, wild and domesticated. The skull shown here also has a slight sideways twist.

If you're a fan of Old Master bird paintings you'll probably have noticed more than one rendition of ducks, geese, or chickens with a feathery pom-pom on their head. They're cute, and even slightly ridiculous. But there's a great deal more to them than that—above and below the surface.

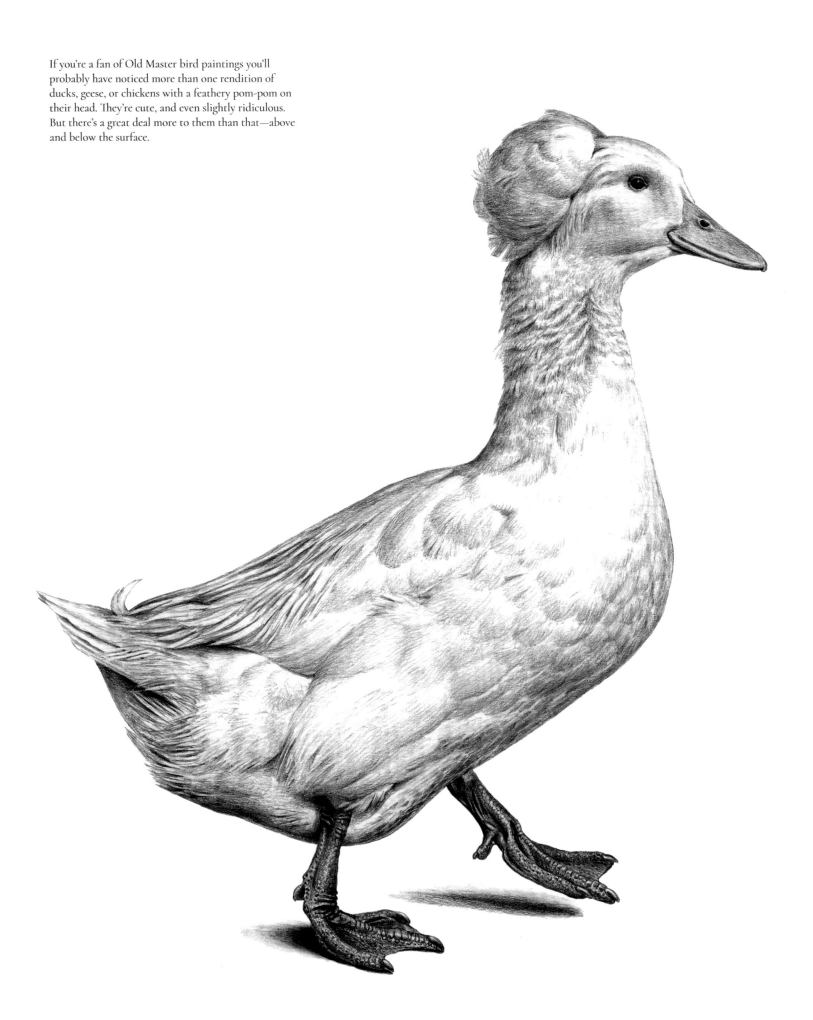

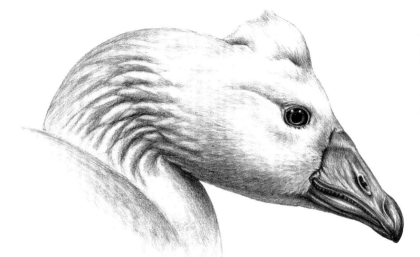

Crests occur in geese as well as in ducks, though in ducks a longer history of deliberate artificial selection for the trait has made it more pronounced. In both cases it's characterized by a feathered fatty lump covering a hole in the skull's surface. This is a Roman, one of the few crested goose breeds.

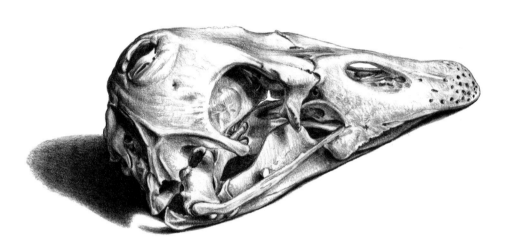

Even when the drakes go into their late summer "eclipse" plumage and take on the brown striped markings of females, their crest likewise takes on the markings of female flanks.

This is where the similarity between crested chickens and ducks ends, but if the pom-poms weren't peculiar enough, things get even stranger when you delve beneath the feathers. Underneath the Polish or Paduan fowl's crest the skull extends into a large raised dome of wafer-thin bone—a hollow "vault" into which the brain grows from below. The bone at the top of the skull develops gradually as young birds mature, in a process called ossification, in this case building upward and inward from the edges, exactly like constructing an igloo, eventually closing in completely to form a smooth rounded surface. Interestingly, Darwin recorded that these vaults had, in the previous century (in Germany at least), occurred only in female birds, the males failing to hatch or dying as young chicks. By Darwin's time they already occurred in both sexes, suggesting that the male deaths were due to the action of another associated gene that had by then been bred out, rather than to the genes responsible for the vault itself. Although the vaults in Paduan/Polish fowl are enormous in both sexes, we've noticed that the much smaller vaults of Breda fowl are indeed better expressed in females.

Remember that I mentioned in the previous chapter that many crested breeds also have a double, or duplex, comb, and that duplex combs are genetically associated with raised nostrils? From the illustrations of Polish/Paduan and Breda fowl you can clearly see that the bill is missing its bony bridge above the nostril openings. Before its connection to comb type was realized, this feature was thought to be a genetic side effect of the crest.

We'd already examined the skulls of numerous crested chickens, so when we boiled up our first crested duck head I was fully expecting to see the same raised dome. Instead there's a large hole in the skull. Not the hole where the neck's attached but higher up at the back of the braincase. And protruding from the base of the hole were long bony tendrils that curved into where the pom-pom would be.

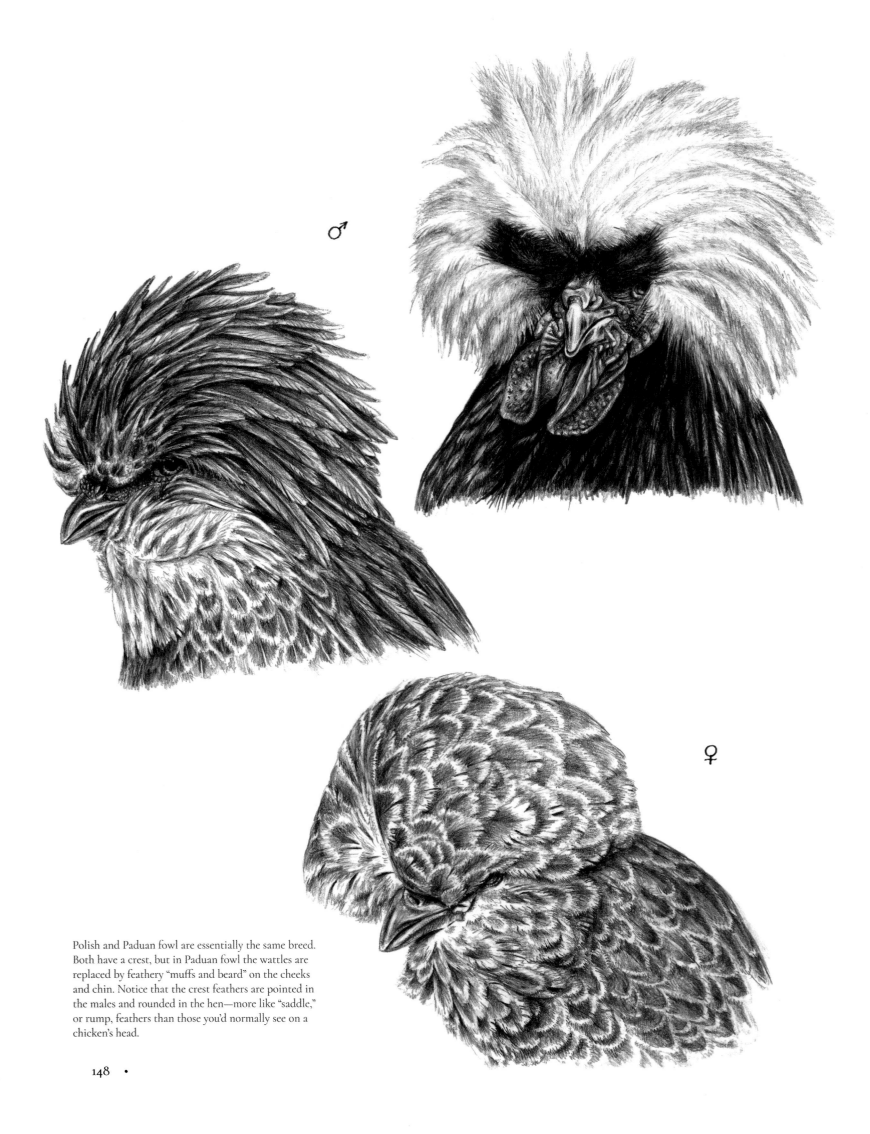

Polish and Paduan fowl are essentially the same breed. Both have a crest, but in Paduan fowl the wattles are replaced by feathery "muffs and beard" on the cheeks and chin. Notice that the crest feathers are pointed in the males and rounded in the hen—more like "saddle," or rump, feathers than those you'd normally see on a chicken's head.

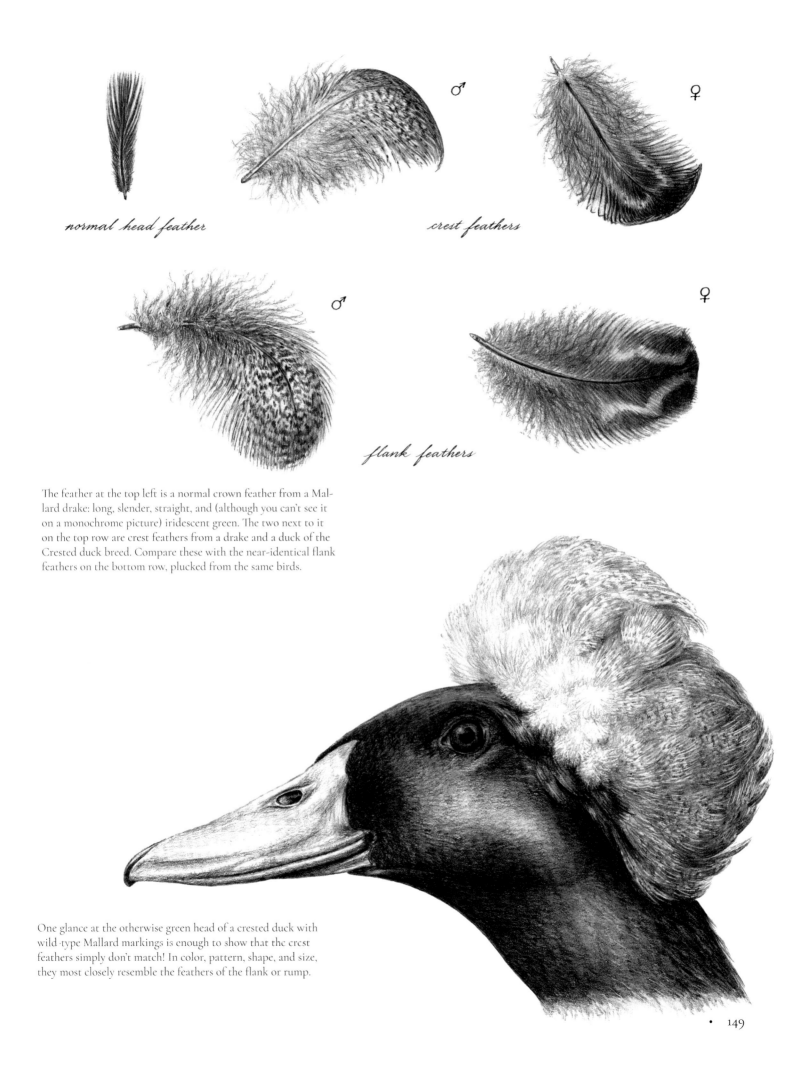

The feather at the top left is a normal crown feather from a Mallard drake: long, slender, straight, and (although you can't see it on a monochrome picture) iridescent green. The two next to it on the top row are crest feathers from a drake and a duck of the Crested duck breed. Compare these with the near-identical flank feathers on the bottom row, plucked from the same birds.

One glance at the otherwise green head of a crested duck with wild-type Mallard markings is enough to show that the crest feathers simply don't match! In color, pattern, shape, and size, they most closely resemble the feathers of the flank or rump.

• 149

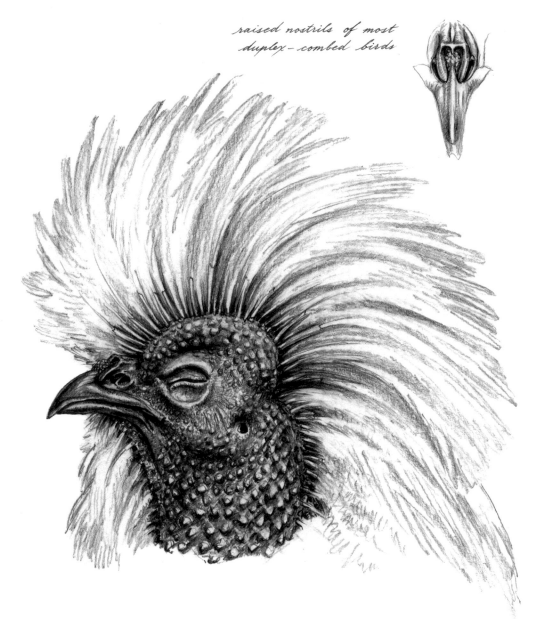

raised nostrils of most duplex-combed birds

If the feathers of crested poultry weren't strange enough, the crests are even stranger on the inside. Crests in chickens conceal a raised bony "vault" into which the brain grows from beneath. The skull completes its development for a prolonged period after hatching, the vault gradually building up from the edges, rather like constructing an igloo.

Having now read stacks of scientific papers on the subject and prepared the skulls of dozens more crested ducks, we know a little more about the phenomenon but, most importantly, we know that there are many more questions left unanswered.

The majority of crested duck skulls just have the hole (without the tendrils), which closes up gradually as they mature. The largest holes belong to the youngest ducks. The bony tendrils—called osteophytes—can take virtually any form. They're a show fault in exhibition birds and judges give the pom-pom a thorough handling to detect their presence. They can project out of the skull or inward into the braincase. They can fork or branch, and are sometimes not attached to the skull at all but develop as independent bodies. Some are large and flattened, and sometimes they even appear to bear rudimentary bony joints. Very rarely (and this is potentially significant if you consider the flank-like feathers of the crest) fully formed legs with little webbed feet have been found protruding from the skull of embryos and even of tiny ducklings. Despite examining all the unhatched eggs we could procure, however, we never had the good fortune to see this firsthand.

The pom-pom itself is formed from a pad of fat on the surface of the skull. Ideally it should be positioned in the middle, though in many birds it protrudes over to one side or the other. Fat not only comprises the pom-pom but, in the overwhelming majority of crested ducks, there's also a large fatty deposit embedded in the brain itself, considerably increasing the overall brain size, though reducing the volume of actual brain tissue. Regrettably, when the bones of the skull become fully developed, this fatty area applies pressure on the brain, resulting in poor coordination

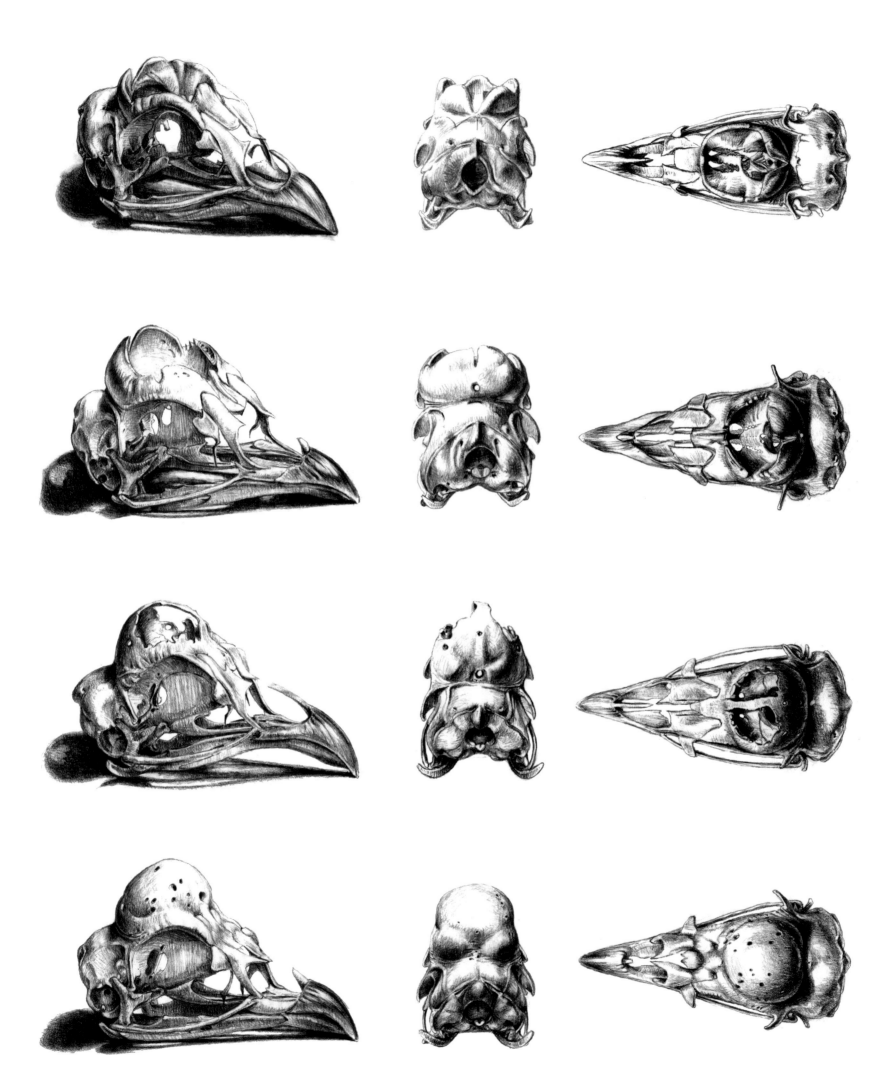

when birds are stressed, though at other times they can appear quite normal. Although neither the hole nor the osteophytes appear to affect the birds, there's a clear correlation between those with the largest fat bodies within the skull and the most impaired co-ordination.

All these factors together present a strong case for ceasing to breed crested ducks in the future, though this would mean the extinction of a fascinating, not to mention culturally important, variation. Additionally, there are similarities between these fat bodies and those found in diseased human brains, for example, in patients with Parkinson's disease, so crested ducks may hold the key to understanding and even curing these conditions. How should we weigh the case for animal welfare in this situation? Thankfully we don't have to. The fat bodies found within the skulls of crested ducks are apparently entirely independent of the crest itself, so perfectly healthy birds can be

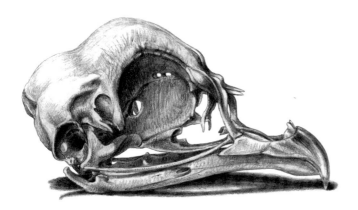 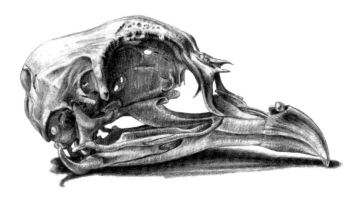

Darwin recorded that the vaults of Paduan/Polish fowl had, in the previous century, occurred only in female birds. By Darwin's time they already occurred in both sexes, as they do now. We've noticed that the much smaller vaults of Breda fowl are indeed better expressed in females (left) than in males (right). Notice, too, the missing bone above the nostril openings. Before its connection to comb type was realized, this feature, underlying the characteristic raised nostrils, was thought to be a genetic side effect of the crest.

bred that still tick all the boxes on the show bench. A simple and harmless test: placing the birds on their back and timing how long it takes for them to stand up again is all that is needed to select the healthiest individuals. Within just a few generations of selective breeding from birds that "pass" the test, significantly healthier, and presumably happier, crested ducks have been bred, with the additional advantage of a far higher hatching rate—a positive result commercially, for the fancy, and for the welfare of the birds.

If Crested ducks and Polish/Paduan fowl possess the most bizarre single trait, the prize for the best *assemblage* of traits has to be split between two chicken breeds. I'll start with the lesser-known of the pair, the Aracauna.

The only agreed-upon definition of an Aracauna is that it should lay blue eggs. They're strange birds in all their various forms, and what little is known of their history is as exotic and strange as the birds themselves. They were even once (mistakenly) named as a separate species, *Gallus inauris*, meaning "earring fowl," for reasons that will become apparent. The common name comes from the Aracauna region of southern Chile where the birds were discovered, living among the indigenous Mapuche people, by Spanish aviculturist Salvador Castelló in 1914. It's still not known when, or by which route, the ancestors of these birds arrived in the southernmost tip of South America from the Far East. The British strain that has ear tufts and a tail (Aracaunas are one of the "rumpless" chicken breeds discussed in chapter 1, but there are different strains: with and without a tail) is said to have derived from a Chilean ship wrecked off the coast of Scotland—but there are lots of shipwreck stories like this and probably only a small

proportion of them are true. The ear tufts are lethal in their homozygous form so presumably the Chilean population, running around the native villages in a semi-wild state, would have been comprised of tufted heterozygous birds along with homozygous recessive individuals with no tufts. The tufts are more than just decorative feathers; they're small flanges of feathered skin just in front of the ear opening and even the bones beneath them can be strangely distorted. There's a great deal of individual variation, sometimes biased more toward one side than the other. The tuft feathers too, like the Polish and Paduan fowl crests just described, are more typical of flank feathering than the plumage of the head.

There are many different combinations with/without a tail and/or ear tufts. The only thing all these variations on a theme of Aracauna have in common is the color of their eggs. No other unrelated chicken breed, not even any of the wild species of junglefowl, lays blue eggs. It's so unusual that it's even been suggested that their ancestors must have hybridized with tinamous—an ancient and totally unrelated bird order of the Americas! (If you've never seen a tinamou egg, add it to your "list of things to do before you die.") The inheritance of the unusual egg color was studied by Reginald Punnett, a colleague of Bateson and best remembered for his tables showing the outcomes of genetic crosses—the Punnett Square. Punnett discovered that the blue-green color is dominant over white—the color of the eggs of wild junglefowl species—but shares dominance with brown, to produce olive-colored eggs. So if your own Aracaunas lay olive eggs it's a clear indication that they're descended from outcrosses with another breed.

Sharing first place for the strangest assemblage of chicken traits is the Silkie fowl—a veritable collection of genetic idiosyncrasies. Not only does it carry the silkie feather mutation, but it has five toes, feathered feet, a crest, a walnut comb, and melanistic skin. Contrary to popular belief, the bones are not black, but they are covered by a black membrane of connective tissue, which is colorless in most animals. The black skin is independent of the feather color, just as the dark skin (and tongue) of chow dogs doesn't affect their fur color. Black-, red-, buff-, and white-feathered "silkies" all have black skin.

Beneath the feathery crest of crested ducks there's a fatty lump covering a hole in the rear of the skull. From our investigations it appears that, in the majority of birds, this hole gradually closes up with age; the youngest birds (top) having the largest. Most crested duck skulls lack the bony protuberances, called osteophytes, shown on the following pages.

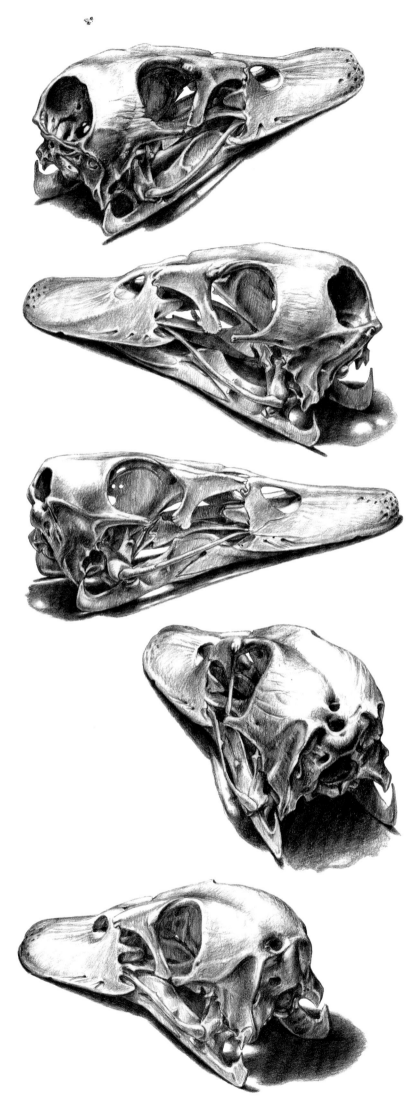

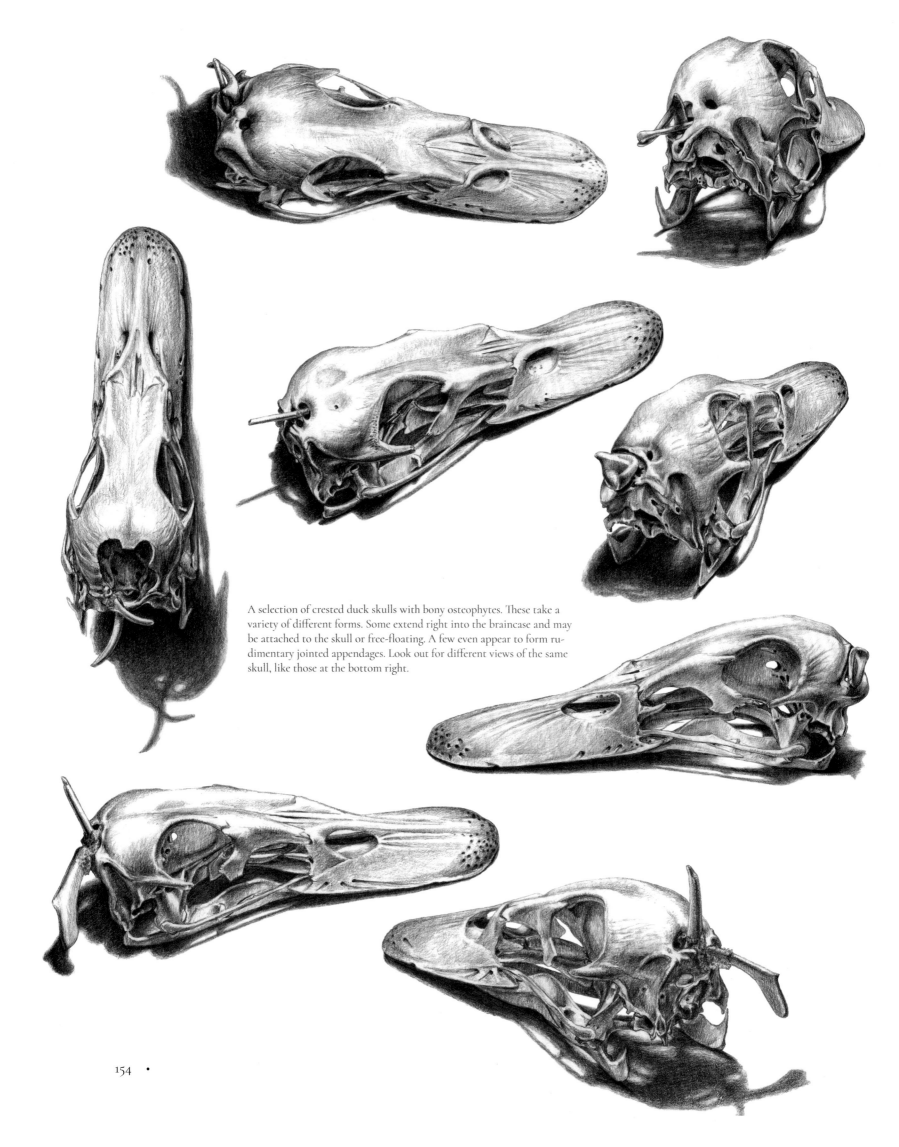

A selection of crested duck skulls with bony osteophytes. These take a variety of different forms. Some extend right into the braincase and may be attached to the skull or free-floating. A few even appear to form rudimentary jointed appendages. Look out for different views of the same skull, like those at the bottom right.

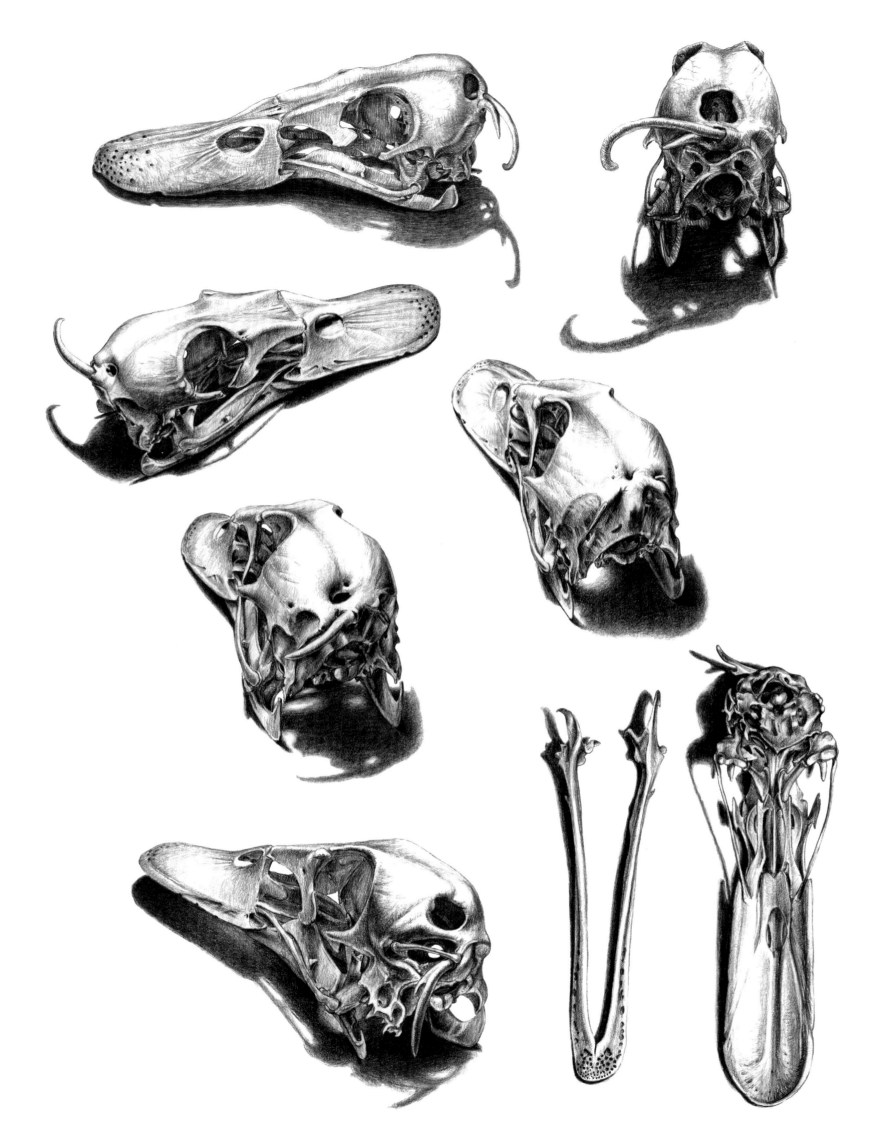

Achondroplasia—disproportionate dwarfism—affects the development of the limb bones. It's been recorded in a variety of animal species, wild and domesticated, though in domesticated breeds, like this Dachshund and the Chabo mentioned earlier, the limbs have been further shortened by selection. Who knows if short-legged wild animal groups like mustelids evolved by tiny steps all the way, or if they were given a head start by achondroplasia?

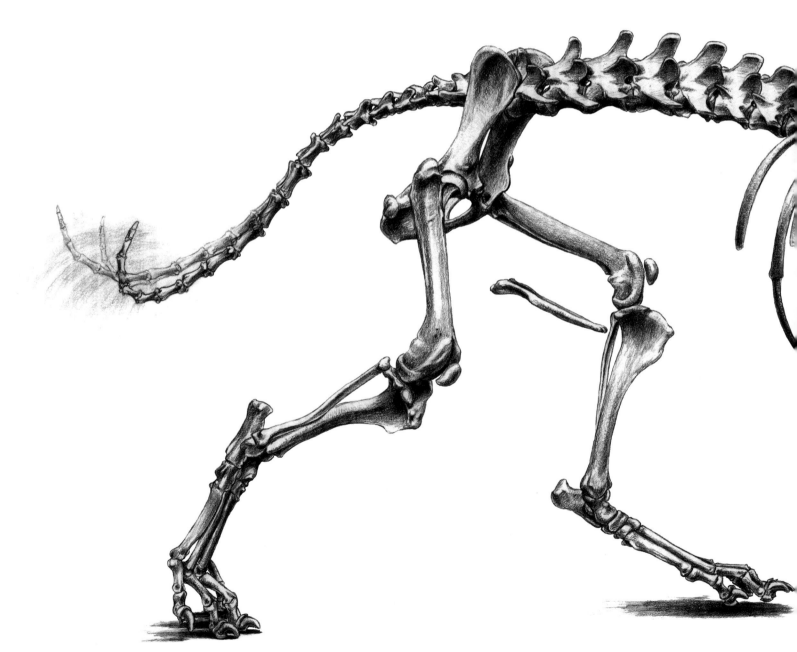

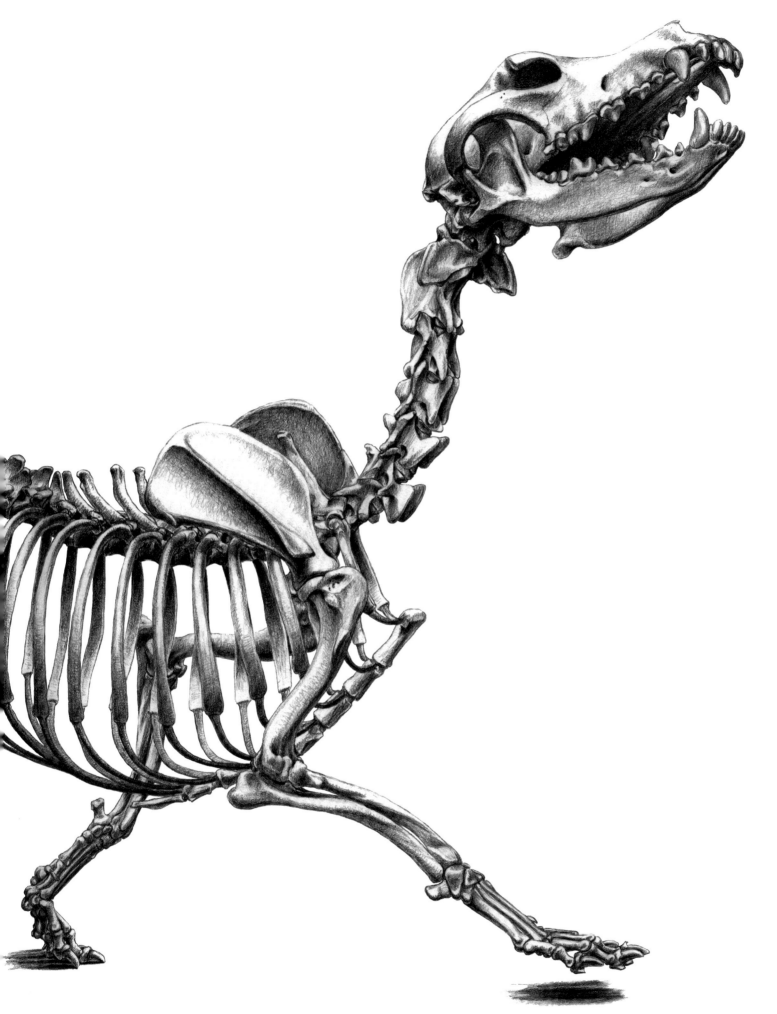

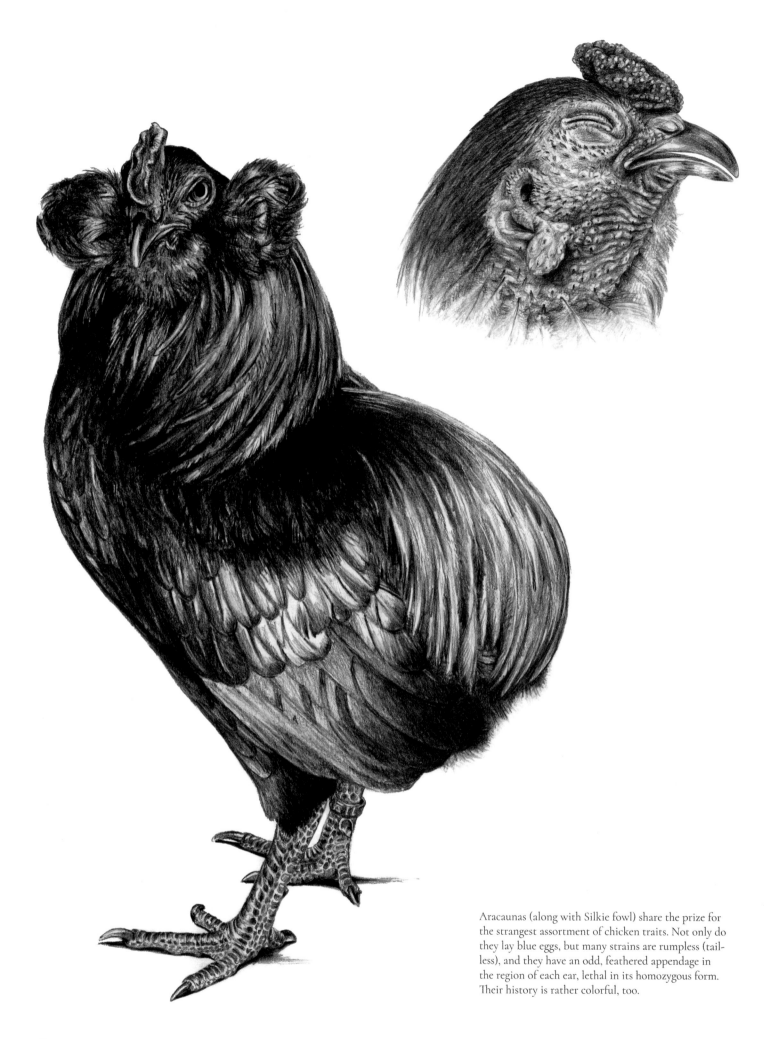

Aracaunas (along with Silkie fowl) share the prize for the strangest assortment of chicken traits. Not only do they lay blue eggs, but many strains are rumpless (tailless), and they have an odd, feathered appendage in the region of each ear, lethal in its homozygous form. Their history is rather colorful, too.

All of these traits can and do occur in other chicken breeds and, while outcrossing is likely to account for much of this, the mutations can equally occur spontaneously anytime, anywhere, and even across a range of species. Or, they may never occur again.

This is why it's so important to preserve rare breeds of livestock—not for their historical or cultural importance alone but because they represent irreplaceable richness in genetic diversity, not just for their species but for the entire animal kingdom.

The purpose of this book is to make an analogy between natural and artificial selection, not to make claims for the course of evolution. It's one thing to assert that the same mutations that occur under domestication also occur in wild animals, and entirely another to argue that these same mutations might have been favored far back in their evolutionary history by natural selection. It's obvious that a trait that causes fatty deposits to press against the brain couldn't be considered a good thing. However, many of the traits we see in nature would appear to be a handicap too. For example, if a duck's crest happened to be favored under sexual selection then the disadvantages might be outweighed by reproductive success.

I've already playfully (but not altogether frivolously) suggested that the mustelids—the otters, weasels, badgers, and the like—might have been given an evolutionary head start from a mutation that shortens the limb bones. As yet there's no fossil evidence of intermediate forms to prove otherwise. We've already looked at several different examples (and there'll be more to come) showing that this sort of dwarfism (called achondroplasia) affects tetrapods—four-limbed animals—of all kinds; it's even been recorded in wild foxes and recently in a wild Asian elephant. As I've stated again and again, however, it's important to remember that the short legs we see in exhibition dachshunds and basset hounds have been considerably modified by selective breeding; these animals are a world away from the lithe, athletic though short-limbed hunting dogs they once were. So when I speak of a head start, I mean just that—a step in the right direction, not a sudden overnight transformation.

The short, velvety fur of rex rabbits, lacking directional guard hairs, has either never occurred or never caught on in wild rabbits. It's an ornamental trait that would be dismissed by most biologists as a frivolity of domestication. But a similar fur type allows moles to move smoothly backward and forward in their rather more constricted underground tunnels without even turning around. Rex fur, like achondroplasia, is a single-step mutation.

There are many more examples throughout this book, some factual, others more speculative, of potential common causes between the traits of wild and domesticated animals. Some scientists argue that it's futile to make these types of comparisons because such artificial things could never survive in the wild (the term "freaks" is implied, if not used). For all the achievements of the modern synthesis, the battle between gradualists and saltationists is still raging. The "hopeful monster" still raises a head from time to time (it apparently has many heads as well as multiple limbs) and has it immediately lopped off by a gradualist knight. I'm not qualified to compete on such a battlefield and can only read, make observations, ask questions, and think.

History is written by the victors. All *we* ever get to see are the winners in nature—those whose physical form is best fitted to their current environment, whose ancestors happened to be in a certain place at a certain time and combined their genes in one of many possible ways. We can also get a hint, through fossil evidence, of organisms that have already succumbed to changing conditions and are now extinct, but these are nevertheless still victors; they existed. The course of evolutionary history on Earth is only one of countless possible alternatives that may have come about had circumstances been different. Indeed, if it were possible to rewind time and start over again under identical conditions, it's fairly certain that evolution would take a different trajectory each time. Domestication allows us to see a few of the mutations that might have hypothetically been favored in one of these alternative timelines. And selective breeding allows us to explore their genetic and developmental frontiers.

There are of course ethical issues involved in pushing these boundaries to their full capacity, and equally there's a certain amount of moral outrage about selective breeding in general. Some would even label all domesticated animals as monsters. To say that it's not about right and wrong is not the same as saying that it's right. Nevertheless, my response to anyone complaining, "Look what humans have done to the Pekinese" is to reply, "Look what flowers have done to Sword-billed hummingbirds"!

III

VARIATION

8. COMMON THREADS

8 ~ Common Threads

During my ascension from the humble rank of girlfriend (eager to impress) to the lofty station of "wife of Hein van Grouw" (useful for proofreading scientific papers), I learned a lot about color aberrations. It's Husband's favorite subject, after his pigeons.

Melanins, I discovered, are by far the commonest pigment, but birds can also have carotenoids, psittacin, turacin, and porphyrins, as well as structural colors. I learned that melanins come in brown as well as black, but that black melanins can also be mutated to a different sort of brown. I learned that pigment can be diluted in different ways, and that melanism doesn't necessarily make animals darker. I could distinguish leucism from albinism and learned that although albinism is common, albinos have such atrocious eyesight they don't usually live long (although albino mammals generally fare better than albino birds). Most memorably, I was indoctrinated with the mantra "there's no such thing as a partial albino."

I'd learned all these things about color aberrations in wild animals, and yet I vividly recall my surprise on discovering that white ferrets, black cats, golden goldfish, blue budgies, and yellow canaries—virtually every ornamental variation in coat color or plumage in all domesticated animals—are a result of the same handful of processes. Somehow I'd always assumed that domesticated animals just "came" in these colors and, I'm ashamed to say, I'd never given it further thought.

In fact most of the colors of animals, aberrant or otherwise, can be explained by the same principles, even in cases where the molecular details aren't yet known. Many color morphs in wild animals are, likewise, color aberrations. The only difference is that these individuals comprise such a high percentage of the population that they're recognized as distinct forms: the melanistic races of Bananaquit on islands off the coast of Venezuela, for example; "Polish" Mute swans, with the mutation that makes black melanin brown (though you can only recognize them from their leg color or as cygnets, because the adult plumage is white!); or the pale brown "spirit" Black bears on the northwestern coast of British Columbia. Polish swans, incidentally, share a similar mutation with chocolate labrador dogs, and spirit bears with golden labrador dogs. The pale coloration of spirit bears even gives them a selective advantage when hunting fish.

Indeed, the color aberrations of today may well be the races or even species of tomorrow, just as the species of today may well have been the aberrant forms of yesterday. Every evolution textbook mentions the dark phase of Peppered moth that fared so well on the soot-covered tree trunks of post-industrial England in the nineteenth century, or the different hues of Rock pocket mice against the varied backgrounds of beach and desert. Rather more inexplicable is the indication that present-day dark-phase Vermilion flycatchers and even melanistic feral pigeons in urban environments thrive better than their normal-colored counterparts. Perhaps even (and this is pure conjecture on my part) the blind, white, cave-dwelling forms of the Mexican tetra fish are descendants of albino individuals that were not hampered by the poor eyesight resulting from pigment loss.

 Heritable changes in skull shape are the result of subtle adjustments in timing during embryonic development. It can happen across a range of animal groups and can result in shortened, lengthened, upturned, or downturned jaws. Compare this Persian cat skull with the bulldogs, Niata cow, and even with the Short-faced tumbler pigeons pictured elsewhere in this book.

 Myriad different colors can be produced by the combined effects of just two or three pigments. Change or remove just one, and all the other colors will be affected too, just like using overlapping layers of watercolor in a painting. This is a Gouldian finch, not a true finch but one of a group of tiny waxbills popular for their bright plumage. Still greater color variety is achieved by structural elements in the feathers, producing a range of optical effects.

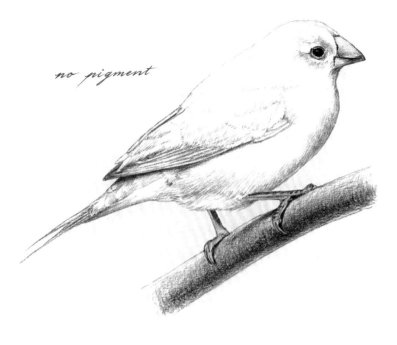
no pigment

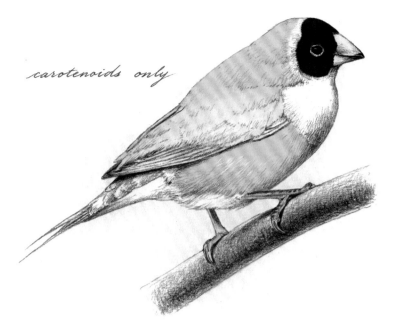
carotenoids only

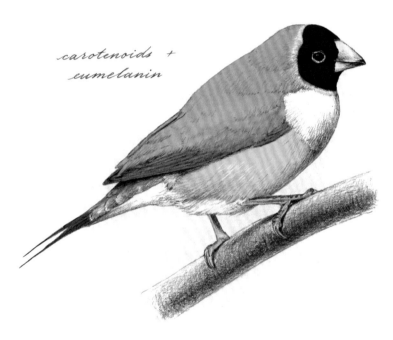
carotenoids + eumelanin

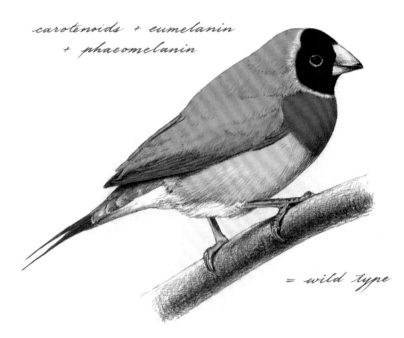
carotenoids + eumelanin + phaeomelanin

= wild type

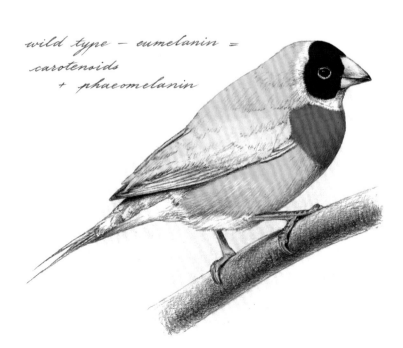
wild type − eumelanin = carotenoids + phaeomelanin

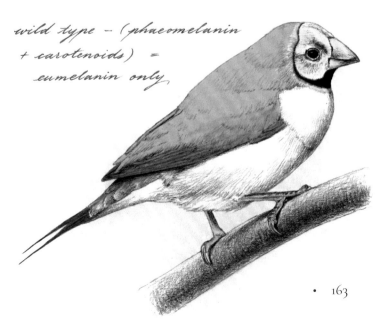
wild type − (phaeomelanin + carotenoids) = eumelanin only

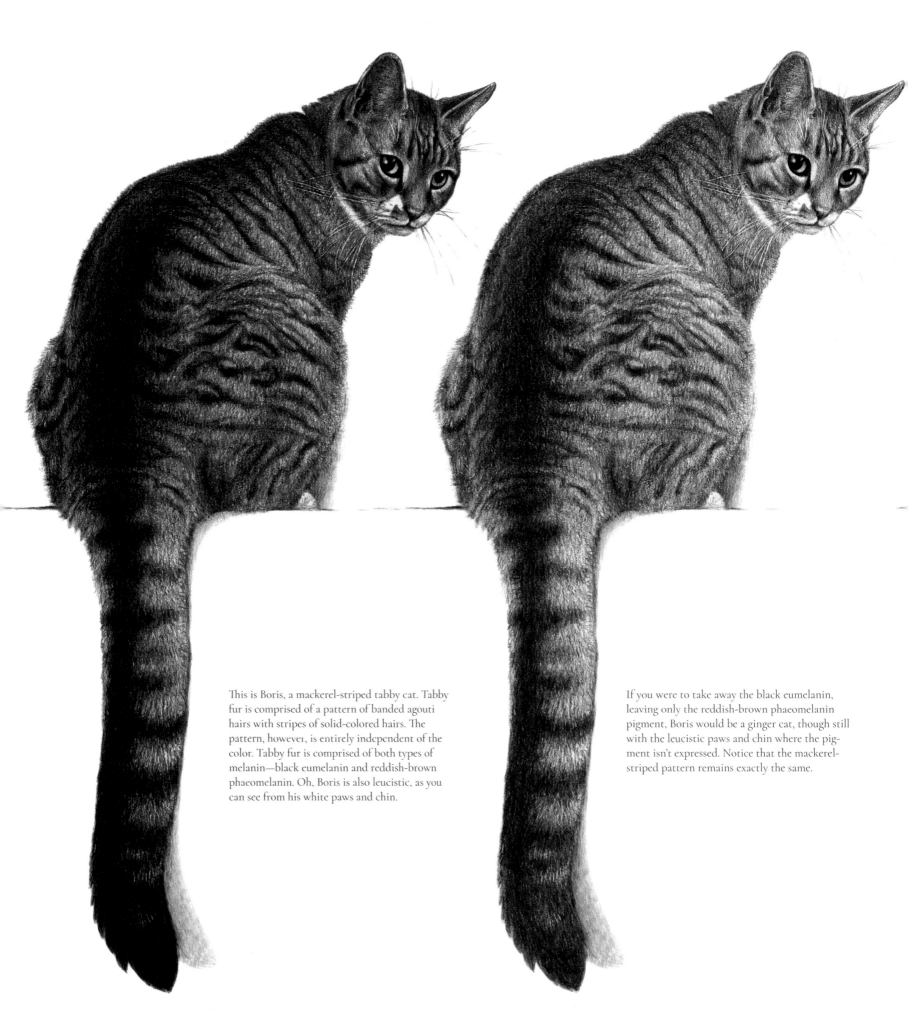

This is Boris, a mackerel-striped tabby cat. Tabby fur is comprised of a pattern of banded agouti hairs with stripes of solid-colored hairs. The pattern, however, is entirely independent of the color. Tabby fur is comprised of both types of melanin—black eumelanin and reddish-brown phaeomelanin. Oh, Boris is also leucistic, as you can see from his white paws and chin.

If you were to take away the black eumelanin, leaving only the reddish-brown phaeomelanin pigment, Boris would be a ginger cat, though still with the leucistic paws and chin where the pigment isn't expressed. Notice that the mackerel-striped pattern remains exactly the same.

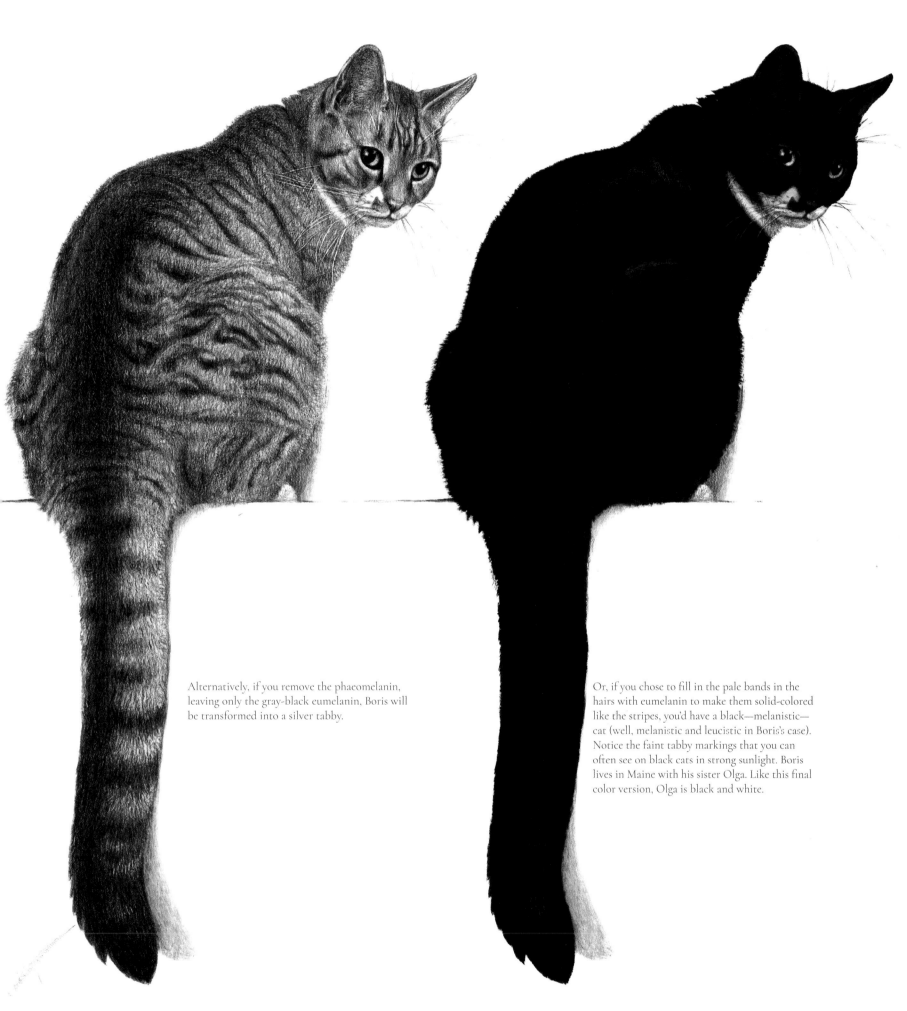

Alternatively, if you remove the phaeomelanin, leaving only the gray-black eumelanin, Boris will be transformed into a silver tabby.

Or, if you chose to fill in the pale bands in the hairs with eumelanin to make them solid-colored like the stripes, you'd have a black—melanistic—cat (well, melanistic and leucistic in Boris's case). Notice the faint tabby markings that you can often see on black cats in strong sunlight. Boris lives in Maine with his sister Olga. Like this final color version, Olga is black and white.

One of the difficulties of interpreting the causes of animal colors is that the same mutation can express itself differently in different species, and the same pigment can take on different appearances depending on its concentration and distribution. If you've ever been shocked to discover that the ten-gallon vat of "white" wall paint you just bought looks positively pink next to your white doors, you'll know that the appearance of colors depends on the colors next to them, even when both are apparently lacking in color. And of course, if you've overpainted one color with another, you'll know that unless your second layer is very thick, the underlying color will show through. Remember the green, blue, and yellow budgerigars in chapter 4? Even in animals, the combination of two colors produces a third, just like the semi-transparent layers in a watercolor painting or a silkscreen print.

But let's look at an example. The many species of waxbill, diminutive seed-eating songbirds of the family Estrildidae, though arguably not truly domesticated, are very popular with bird keepers because of their exotic patchwork of brightly-colored plumage. In just one tiny bird, carotenoid pigments producing vibrant patches of red, yellow, and orange rub shoulders with the blue-gray, reddish-brown, or intense black of melanins or are overlain by them to create maroon or forest green. I was never a great fan of waxbills (and even less a fan of color varieties in captive exotics) until I visited the European championship bird show in 2015, and was entranced, particularly by the Gouldian finches. Until then I'd imagined color changes as being subtle and rather messy and hadn't fully appreciated the flick-of-a-switch transformations that could result from a tweak of pigmentation.

Gouldian finches, *Erythrura gouldiae*, were described and named by ornithologist John Gould, whom we've met elsewhere in this book. A first glance at the scientific name suggests that Gould appears to have committed the cardinal sin of naming a species after himself. However, the feminine ending *-iae* instead of *-ii* indicates that it's named after a woman—his wife, Elizabeth. Three pigments—carotenoid and two types of melanin—are responsible for their extravagant plumage, and their effects are further enhanced by structural elements (like those in the blue of budgerigars) that give the optical effect of additional colors. Although the startlingly red face is the most recognizable characteristic of Gouldian finches, the black-faced form, which has black eumelanin pigment overlaying and completely masking the bright red carotenoid, is the most numerous of three color morphs occurring in wild populations (there's also a yellow-faced form). Unsurprisingly, the red-faced variety is most popular with bird keepers, and this is the one we'll be focusing on in the following "let's color a Gouldian finch" exercise.

We'll start with a white canvas and add one pigment at a time. We've already mentioned the red carotenoid in the face. Carotenoid on the body is expressed as yellow and it's distributed over the wings, mantle, nape of the neck, belly, and flanks but ends abruptly in a sharp line beneath the breast. A bird with only carotenoid will be neatly patched in yellow and white but with a vivid red face. Now add eumelanin. This is the gray-black form of melanin, and in a Gouldian finch it covers the yellow on the wings, nape, and mantle to give green plumage but also covers the previously white areas of the rump and edges of the face, which, due to the structural elements already mentioned, now appear blue. On the chin, and in a narrow band surrounding the red face, the eumelanin is densely concentrated as a rich jet-black. There's no eumelanin on the breast—this remains white, waiting for the final pièce de résistance. And here it is: a vivid patch of rich purple phaeomelanin, the sister pigment of the blue-black eumelanin. Phaeomelanin doesn't usually appear purple; it generally shows as a warm reddish-brown, but as I mentioned, there are other influences at play here. Behold—your completed Gouldian finch! You can also remove pigments or add them in a different order to create more variations. Take away the carotenoid, for example, to leave the melanins, and the composition will move to the blue end of the spectrum. Or you can remove the eumelanin, changing the colors to purple and yellow.

Notice that although the colors can be changed, the arrangement of the colors—the pattern—remains the same. For a really perfect example of how fur or feather color is independent of pattern you need look no further than to the striped coat of tabby cats. In fact the only definition of a stripe is that each of the individual hairs within the stripes are solid-colored while in the unstriped areas each hair has one or more pale bands across it, giving a finely mottled appearance to the coat. The banded hair is called agouti patterning and it's common to a whole host of mammals from mice to monkeys (as well as being the wild-type color of most domesticated mammals).

Tabby-patterned fur comes in two (arguably three) basic forms: broad dark stripes and blotches, or narrow stripes (called mackerel, after the fish) that are sometimes broken into spots. Although there's a great deal of

Remarkably similar traits occur independently in different species. Polled or hornless versions, for example, exist in every domesticated animal that has horns in its wild state—like this Border Leicester sheep (above) and Nubian goat (below).

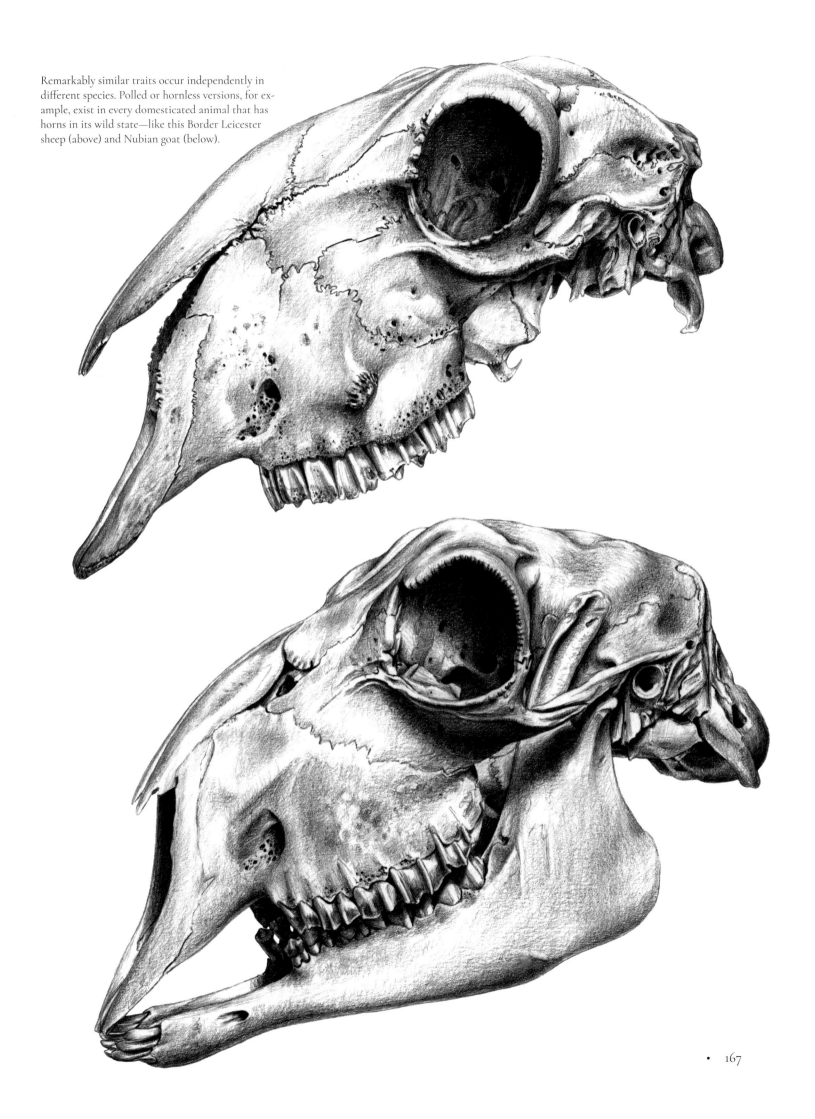

Dewlaps in geese are another trait that has risen independently in the domesticated relatives of different wild species. The bird on the left is a Toulouse goose, one of many breeds descended from the wild Greylag goose, while the bird on the right is an African goose, one of only two purebred descendants of the wild Swan goose.

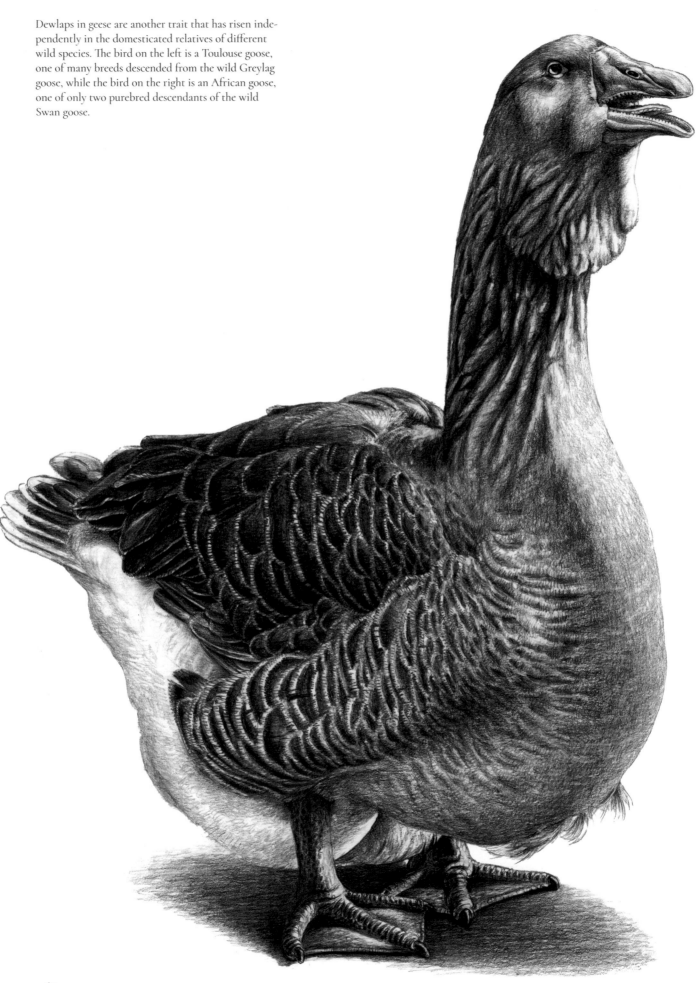

168 •

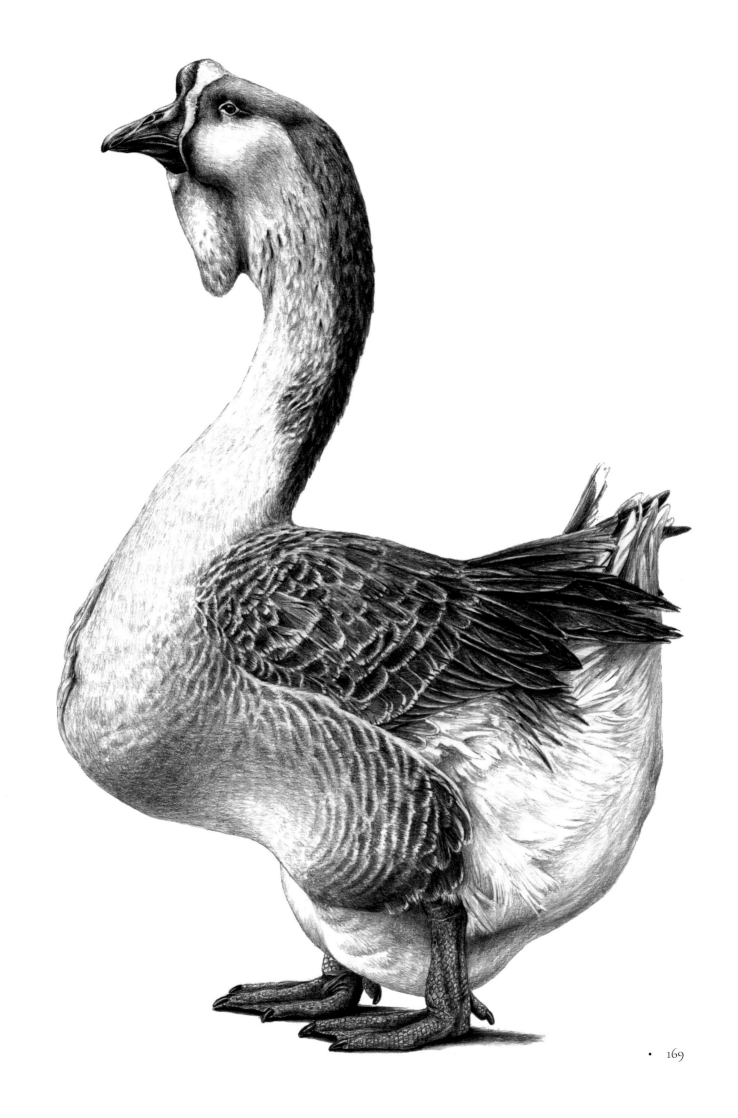

The mutations resulting in "double muscling" effectively switch off the processes that regulate the growth of muscle cells, allowing them to grow or proliferate unchecked. It occurs in a wide variety of animal species and, of course, brings obvious advantages for the meat industry—though not always for the animals themselves. Commercial broiler chickens have such a high body mass in proportion to their skeleton that their mobility is severely restricted.

individual variation, crossbreeding between the two forms produces one or the other type of pattern, never an intermediate between them. This extends to coat patterns in wild animals too, and, as in domesticated animals, mutations occur that result in new forms. In 1926 a Cheetah with broad dark stripes and blotches instead of the usual fine spots was seen in Rhodesia (now Zimbabwe) and described as a new species, *Actinonyx rex*—"King cheetah." But king cheetahs are not a separate species, just an aberrant variation, and the gene that's responsible for the blotchy pattern is none other than the one that produces the equivalent markings in tabby cats.

The cat pictured is called Boris; he's a mackerel tabby with the usual blackish stripes against a grayish-brown background. Boris is also leucistic, which you can tell from his white chin and paws. The coat is a mixture of both types of melanin: phaeomelanin (which, if you remember, is usually reddish-brown) and eumelanin. However, swap the eumelanin for 100 percent phaeomelanin and Boris would be a ginger cat—still with agouti-marked hairs, still with the identical pattern of stripes, and still with that cute white chin and paws. Or, if you remove the phaeomelanin, leaving only the gray-black eumelanin, Boris will be transformed into a silver tabby. Alternatively, if you chose to fill in the pale bands in the hairs with eumelanin to make them solid-colored like the stripes, you'd have a black cat (well, black and white in Boris's case). Yes, black cats are nothing more than tabby cats with the spaces filled in. The distribution of the melanin granules is never quite a perfect match, however, which is why it's often possible to see the markings in black cats—including black panthers—in strong light.

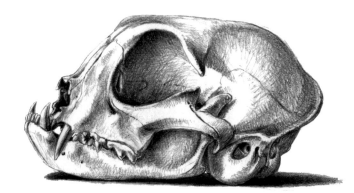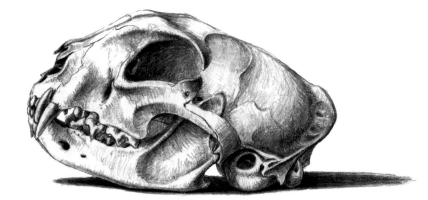

A Persian cat skull (left) and the skull of a normal cat (right) for comparison. The term "brachycephaly"—literally meaning "short head"—refers to the overall result of the mutation. It can occur in a wide variety of animal types and be accentuated through continued selection for individuals with the shortest head. The Persian shown here is less extreme than the one at the opening of this chapter.

Patterns can be disrupted when an existing pigment oversteps its boundaries, in the case of some forms of melanism, or when melanin pigment cells are absent from certain areas, as in leucism. Many people associate leucism and albinism with being white, but this all depends on whether other pigments are present.

The green and black striped plumage of wild canaries, for example, is the result of a combination of different intensities of melanin with yellow carotenoid. Leucistic animals lack melanin pigment cells in all, or part, of their skin. So if you remove the melanin you'll be left, not with a white canary, but with a yellow one. In canaries, leucism doesn't affect the plumage all at once, as it can in pigeons, but in patches, giving what's known as a variegated canary. It generally affects the extremities first, as these are the areas least likely to be reached by the pigment cells migrating outward from the neural crest that runs along the spinal region of the developing embryo, so the yellow patches on a canary are usually fairly symmetrical. It's estimated to have taken breeders around a hundred years to create true-breeding, uniformly yellow canaries. White canaries can only be achieved by removing the carotenoid as well.

Albinism is an entirely different thing. Albinos lack the enzyme needed to synthesize melanin at all, which is why their fur or plumage, skin, and eyes are all completely devoid of it (the pink eye color is from the blood vessels showing through)—and why there's no such thing as a partial albino. However, albinos can still express other pigments. Albino canaries are not recognized as a color variety but, on the rare occasions that they spontaneously occur, they too are yellow.

Melanins are, and have probably always been, the central players in the coloration of animals. Millions of species in existence and billions more that have existed in the past share the capability to manufacture melanins. They may not actually take advantage of this, and the necessary parts of the genome may even have been switched off in some lineages, but the capacity for it is there, surprisingly unchanged over eons.

Despite the breathtaking diversity of animal forms, the range of phenotypic possibilities that can be achieved is nevertheless limited and falls within established parameters. Again and again the same traits crop up in different species, families, and even classes, and, although they might be the result of slightly different gene actions, the developmental pathway produces comparable results.

For example, in cattle, sheep, and goats the instruction for developing horns has independently been switched off, producing polled (or hornless) animals, a trait that, as we have seen, gives some populations a selective advantage. Domesticated goose descendants of both ancestral wild species develop remarkably similar dewlaps, seen in the African goose (descended from the Swan goose) and the Toulouse goose (descended from the Greylag). Many pig and goat breeds have a pair of fleshy wattles on the underside of their neck.

In chickens, pigeons, cattle, sheep, and even dogs and humans, a range of similar naturally occurring mutations can effectively switch off the processes that regulate the growth of muscle cells, allowing them to grow or proliferate unchecked. It's also been introduced experimentally in rabbits, mice, and goats in the laboratory, and in pigs, by gene editing, in commercial piggeries. The popular term for this, "double muscling," is rather misleading, as the number and arrangement of actual muscles are unchanged; they're just much larger than usual. In most animals the trait is incompletely dominant, so the effect is more extreme in individuals carrying two copies of the gene. Heterozygous whippet dogs, for example, generally perform better than normal dogs on the racetrack even though they're barely distinguishable from them visually, while homozygous animals, called "bully whippets," are aesthetically disfigured by their enormous muscles and are poor runners.

Double muscling has obvious advantages for the meat industry, particularly in commercial poultry farming. Broiler chickens are able to gain sufficient muscle for the table early on in their post-hatching development and be ready for slaughter before they're even two months old. Sadly, it's not so great for the chickens, as their high body mass in proportion to their skeleton restricts their mobility and even makes standing difficult. The bird pictured here is the same individual, raised to adulthood, whose skeleton is shown in chapter 3. (Don't worry, even though she's shown here in a living posture, I can guarantee that she wasn't alive when we removed her skin!)

In the last chapter I talked about Hookbill ducks and mentioned that the rates and timing of bone growth in different regions of the skull may account for, not just their downward-curved bill, but also the comparable skulls of Scandaroon pigeons and Bull terrier dogs. If, instead of increasing the rate of skull growth on its upper surface you decrease it, or halt its development early, the muzzle (or bill, in the case of birds) will be shortened and upturned instead, producing what's termed a brachycephalic skull. We've already mentioned Middle white pigs, English bulldogs, and the Niata cattle observed by Darwin in Uruguay during the *Beagle* voyage. The principle applies equally to Persian cats and to short-billed pigeon breeds such as the Short-faced tumblers.

Another trait shared widely by birds and mammals of a range of species is achondroplasia—the disproportionate dwarfism that we've already looked at in such diverse animals as dogs, sheep, and chickens, which results from changes in the timing of limb development. It's also appeared in cats on at least four occasions worldwide since the 1940s; the latest occurrence, in the United States, giving rise to the now established breed, the Munchkin—named after the little people from *The Wizard of Oz*. (Incidentally, I believe the Munchkins were played in the 1939 film mostly by proportionate, not disproportionate, dwarves and children. Who knows—if the breed had originated in Britain it may have suffered the fate of being named "Oompa Loompa" of *Charlie and the Chocolate Factory* fame—a more accurate description if you compare it with the 1971 movie, though a terrible name for a cat!)

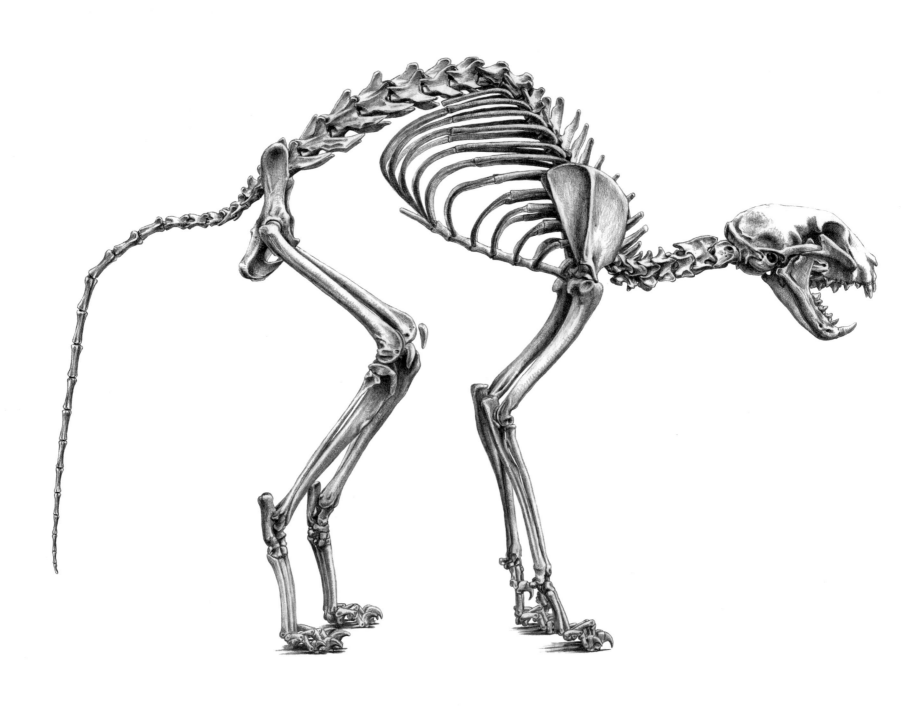

Another species for the list of disproportionate dwarves! The cat on the right is a relatively new breed called a Munchkin, though the mutation is known to have occurred in cats on at least four occasions. As you can see, only the long bones of the limbs are affected; the rest of the skeleton is entirely normal. It doesn't appear to hamper the animals in any way, however—Munchkins are just as active and athletic as any other cat.

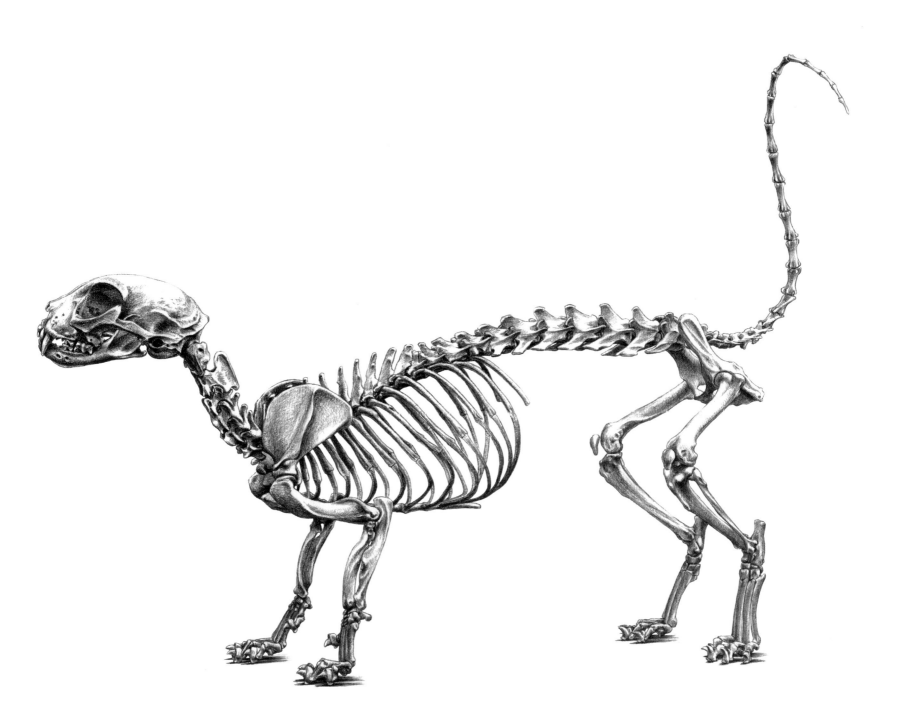

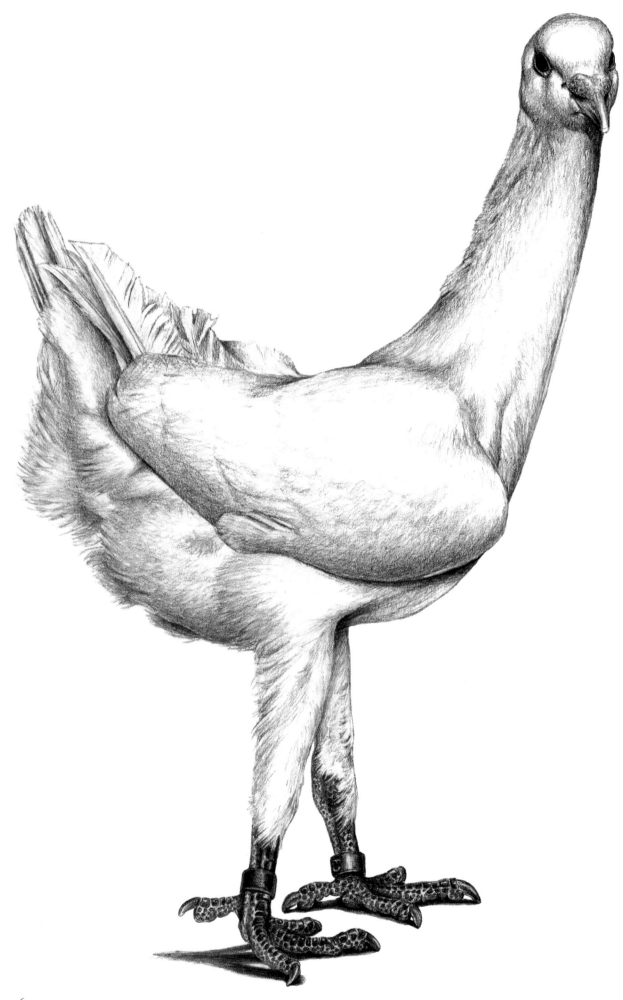

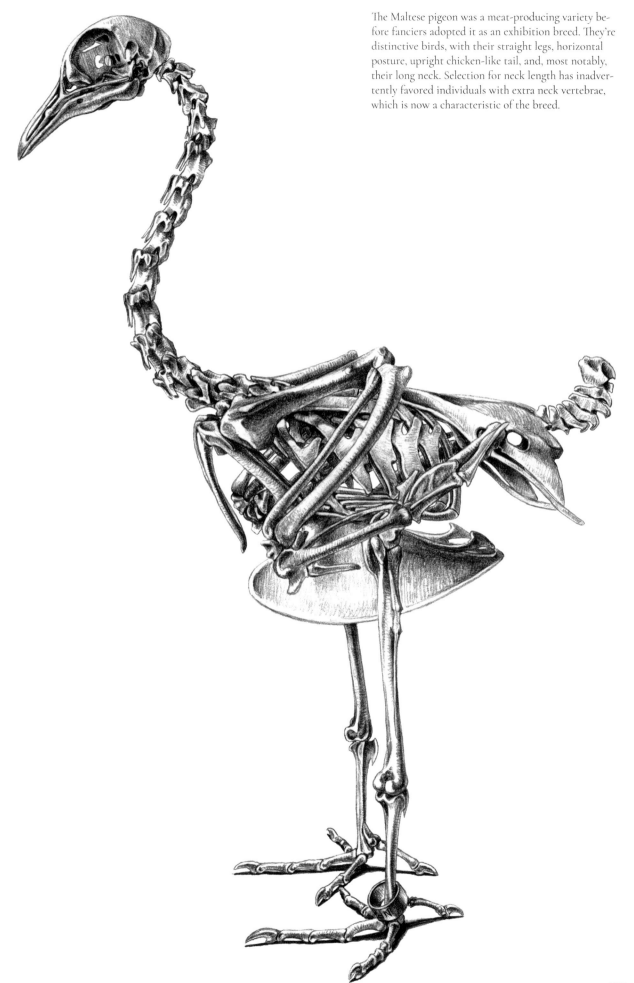

The Maltese pigeon was a meat-producing variety before fanciers adopted it as an exhibition breed. They're distinctive birds, with their straight legs, horizontal posture, upright chicken-like tail, and, most notably, their long neck. Selection for neck length has inadvertently favored individuals with extra neck vertebrae, which is now a characteristic of the breed.

There's a lot of controversy facing the Munchkin breed, with several major cat fanciers' associations refusing to recognize it on grounds of animal welfare. Husband and I had the pleasure of visiting one of the few European breeders, and spent a whole day just playing with cats and kittens, watching them chasing each other around the house and doing all the things that normal cats do. I can honestly say that they didn't appear to be in the least bit compromised by their short legs. I only wish all my book-research days were as enjoyable.

The similarity between shared traits often gives the appearance that animals are related, when they're simply the result of adaptation to a similar environmental niche—things like the wings of bats and birds, for example, or the counter-shaded pattern of auks and penguins. These are analogous traits, the result of what's known as convergent evolution. Likewise, adaptation might alter anatomical features so that they barely resemble those of their closest relatives. If features were inherited from a common ancestor, they're said to be homologous. Separating homologous structures from analogous ones was for many decades, before the advent of molecular genetics, the taxonomist's primary tool for working out relationships between animals. For example, the skulls of the saber-toothed marsupial (well, borhyaenoid to be precise) predator *Thylacosmilus* and the saber-toothed cat *Smilodon* could easily be mistaken for members of the same family. Both share all the analogous adaptations seemingly for ripping through the throat of large prey. But they're about as distantly related as two mammals can be. Only a few homologous features of the skull, teeth, and pelvis conclusively identify marsupials and their lineage from placental mammals (besides the pouch, of course; but pouches don't make it into the fossil record). Similarly, the group of birds known as vangas, from Madagascar (like Galapagos finches, and the honeycreepers of Hawaii), have adapted a range of bill structures superficially resembling a plethora of different families and are only gradually, one by one, being attributed to their correct taxonomic group.

Many pigeon breeds have a habit of shaking their neck. This breed, the Stargard shaker, however, also has a curiously shaped neck—very long, and with the bend in the "wrong" place . . .

It's ironic that one of the first proponents of the idea of homology also happened to be one of the chief opponents of Darwin's theory of evolution by natural selection: Richard Owen. Sadly best remembered for his famously unpleasant personal character, Owen was nevertheless a comparative anatomist of unsurpassed brilliance. In his small but groundbreaking book, *On the Nature of Limbs*, published in 1849, Owen highlighted the parallels between the forelimbs of quadrupeds and the wings of bats, pterosaurs, and birds and even went a step further to compare them with the fins of fishes. He made observations about the sequence of loss of digits and limbs, and formulated a theory about animal structure as a series of repeated units corresponding to each vertebral segment. It's difficult to imagine how someone who rejected the idea that animals evolved from a common ancestor could interpret their shared structures with such accuracy and flair. In many ways Owen was a herald of the very, very modern science of evolutionary developmental biology, better known as "evo-devo."

While phylogenetics is concerned primarily with separating out the fine twigs in the uppermost branches of the evolutionary tree, evo-devo examines diversity from the perspective through the other end of the telescope; from the trunk of the tree. To do this it's not necessary to search for "missing links" in the fossil record, or even to map the entire genome of existing animals, but to look at the course of development from egg to embryo.

I still remember, as a child at school, my biology teacher reciting the words "ontogeny recapitulates phylogeny." In my head I hear it spoken very slowly, syllable by syllable, in a Welsh accent. The recapitulation theory, popularized by German naturalist Ernst Haeckel in the mid-nineteenth century, rested on the observation that all developing embryos in their early stages look alike. After this generic period, with a little imagination and a good deal of artistic license Haeckel convinced himself, and others, that he could make out the appearance in sequence of at least four groups of "lower animals" in order of increasing complexity—a fish, a salamander, a tortoise, a bird, and so forth—all fully developed. The highest pinnacle was, of course, the human form.

Ontogeny—the course of development of a fertilized egg—does not recapitulate phylogeny, at least not in the literal sense that Haeckel proposed. It does, however, mirror the course of evolutionary history in other, more profoundly beautiful, ways. Compare it with a painter mapping out large areas of tone on a canvas with broad strokes, methodically tightening as the painting progresses and only at the end working with the finest of sable-hair brushes.

. . . which is because it has, on average, two more vertebrae than most other pigeon breeds. These additional bones give extra length at the "head end" of the neck, shunting the neck's natural S-shaped curve further down toward the body.

• 179

The body plan is mapped out like this—arranged roughly into repeated segments, each then subdivided into regions and honed, in ever-increasing detail, to its specific purpose. Gradually, a collection of cells that has the potential, at least in theory, to become a *T. rex* or a hummingbird, a mouse or a man, takes on the identity of a particular family of animals, a particular genus, a species, a race, an individual. It's in the developing embryo that genotype is translated into phenotype. This is where identical cells carrying identical sets of instructions are differentiated into distinct types, each with a specialized purpose: brain cells, liver cells, blood cells; bone, skin, hair, eyes. By the time an animal is born the greatest adventure of its life is already over.

It's a general evolutionary principle that it's easier to lose appendages than it is to gain them. Once the tetrapod—four-limbed—body plan had been set, in the mid-Devonian period around 390 million years ago, anything arising from that lineage would be pretty much restricted to having four, or fewer, limbs, and five or fewer digits on each limb.

Because of the intricacy with which all the developmental processes combine, mutations that result in truly novel complex structures (like the extra pairs of limbs that enable mythical horses to fly) couldn't just spontaneously appear. You'd have to go right back to the beginning of evolutionary history and start again, and then six-limbed animals would be the norm and hardly worthy of note. It's not the six limbs that are problematic. It's the fact that the wings of flying horses are required to be functional and adapted for different purposes from the existing limbs. It takes more than just wings to turn a horse into a flying horse—there's the entire skeletomuscular system, not to mention the physical constraints of weight and wing loading. Most importantly, it's no good having the genetic instructions to build these extra appendages if the required developmental processes aren't there to see the job to completion. In order to build something complex you need to have built things nearly as complex in the past.

On the other hand an additional body part that's a basic copy of a serially repeated existing structure—like a vertebral segment—can be achieved relatively easily. You only have to look at snakes to see what repeated segments can achieve. Body segments in vertebrates are comparable with segments in arthropods and are among

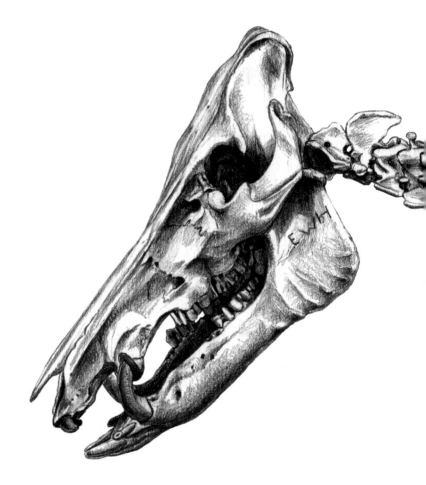

The Wild boar, the ancestor of all domesticated pigs, typically has nineteen vertebrae, though evidently the number varies between individuals. Of course, no one actually selects for animals with extra bones—just those that produce the offspring with the highest meat yield, which amounts to the same thing.

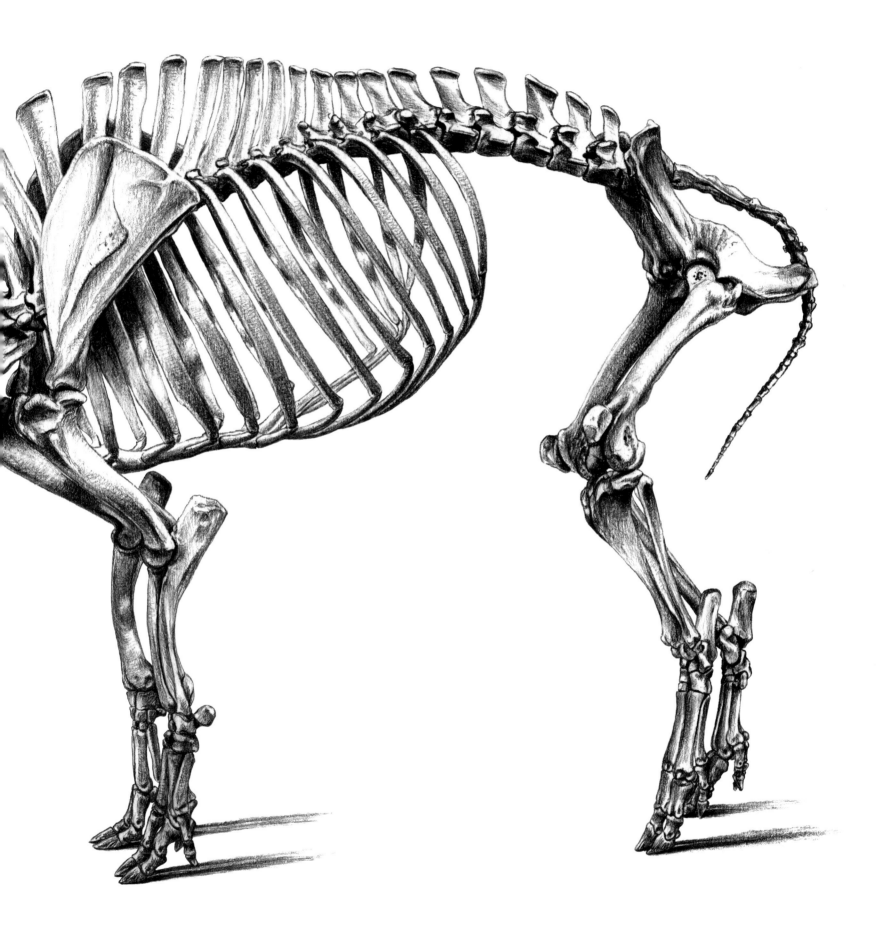

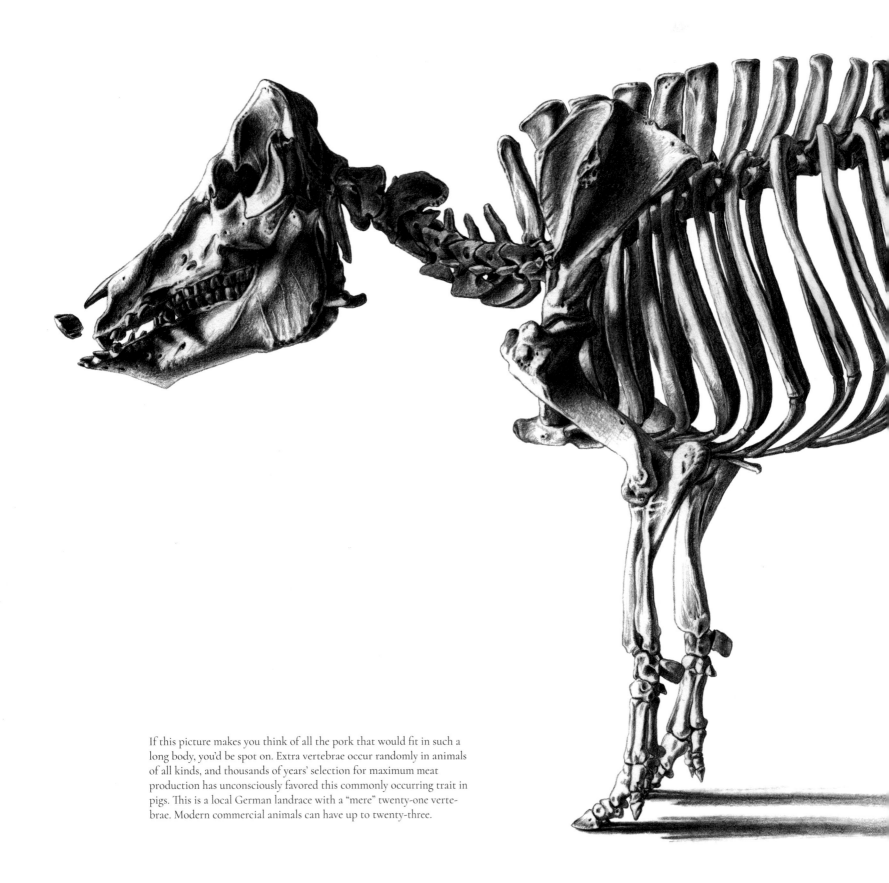

If this picture makes you think of all the pork that would fit in such a long body, you'd be spot on. Extra vertebrae occur randomly in animals of all kinds, and thousands of years' selection for maximum meat production has unconsciously favored this commonly occurring trait in pigs. This is a local German landrace with a "mere" twenty-one vertebrae. Modern commercial animals can have up to twenty-three.

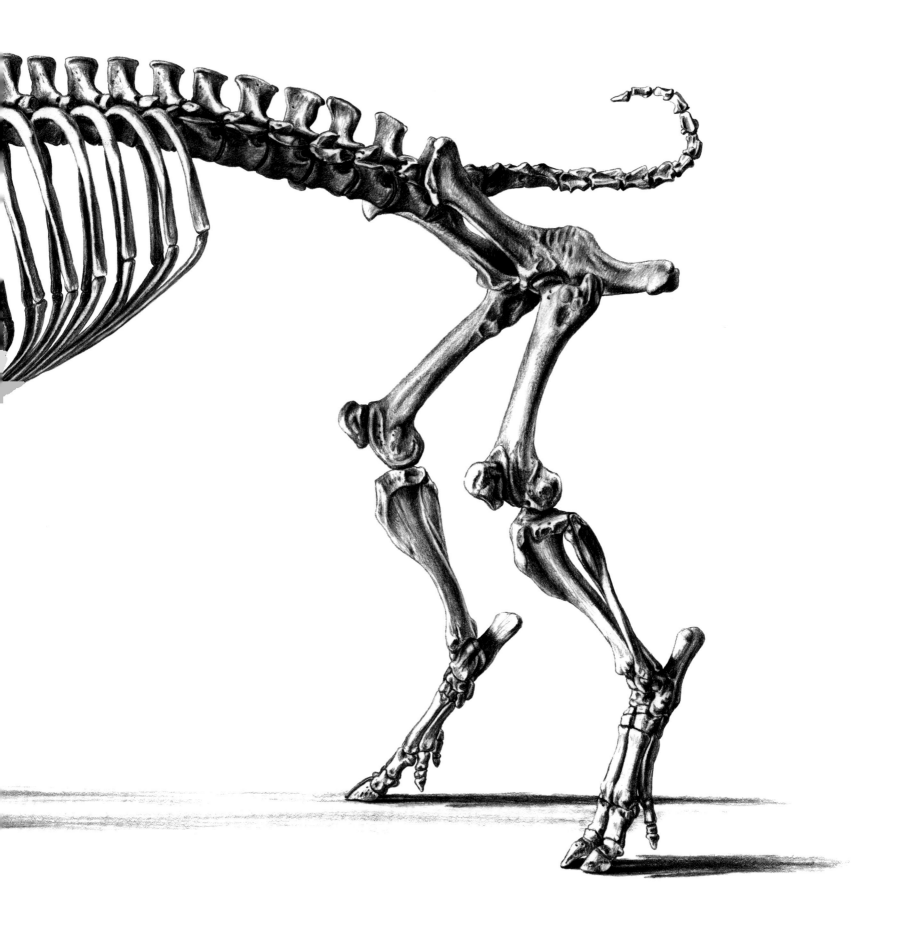

· 183

the first things to be laid down in the developing embryo, dictated by the same basic genetic tool kit—the exact same genes—used throughout evolutionary history.

In birds the number of vertebrae is highly variable between families. Long-necked birds have more vertebrae than short-necked birds. Swans, nevertheless, have many more neck vertebrae than do flamingos. Both have a long neck, but in flamingos the length is achieved by elongation of each bone, giving it a more angular curve like a dot-to-dot puzzle. If you consider that virtually all mammals, whether they're bats or giraffes, have seven neck vertebrae (the only exceptions are manatees, which have fewer, and sloths, which may have fewer or more) the capacity for variation in bird necks is quite remarkable. More remarkable still is that extra vertebrae can also occur *within* bird species, and it happens with surprising frequency.

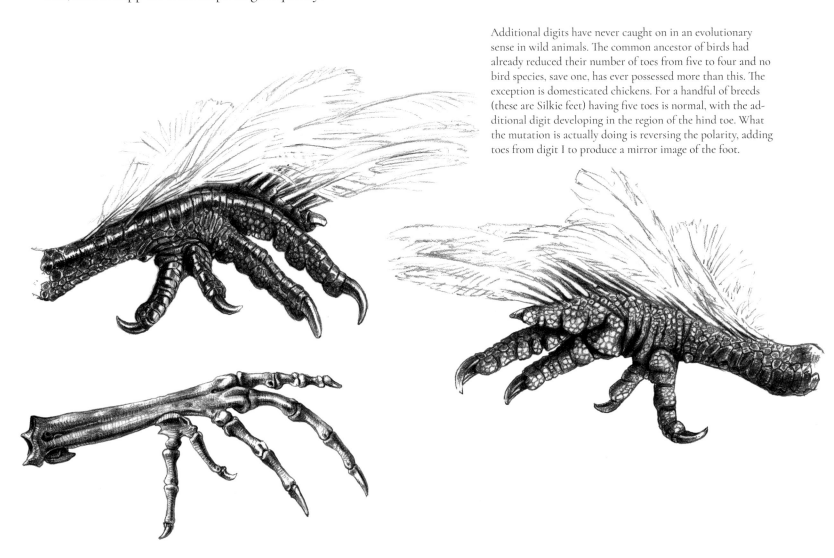

Additional digits have never caught on in an evolutionary sense in wild animals. The common ancestor of birds had already reduced their number of toes from five to four and no bird species, save one, has ever possessed more than this. The exception is domesticated chickens. For a handful of breeds (these are Silkie feet) having five toes is normal, with the additional digit developing in the region of the hind toe. What the mutation is actually doing is reversing the polarity, adding toes from digit I to produce a mirror image of the foot.

Certain fancy pigeon breeds, selectively bred for their long neck, have thirteen neck vertebrae—one more than breeds of a more normal conformation. This is all the more astounding when you consider the very short time period in which this has taken effect. One, the Maltese—a variety peculiar for its horizontal back, upright, hen-like tail, and queer-looking straight legs—was until recently kept only as a meat pigeon, so the trend for selecting long-necked birds for exhibition has probably taken place in less than a century. Another is the Stargard shaker whose neck is not only longer than average but curves in a different place, further from the head than in other pigeons, giving it a peculiar crooked look. Presumably the extra vertebra in this case was "added" close to the head to account for this idiosyncrasy. Shakers, as their name suggests, share the neck-shaking habits of mookees and fantails discussed in chapter 2, so the unusual neck shape is accentuated by this.

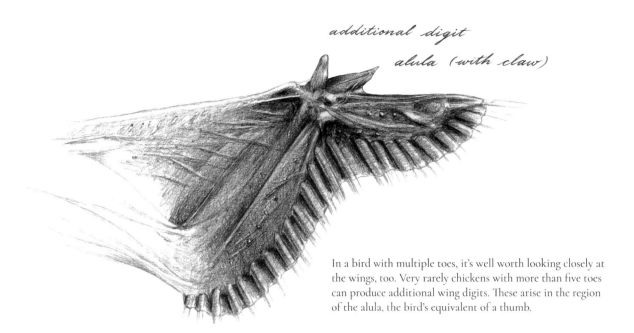

additional digit
alula (with claw)

In a bird with multiple toes, it's well worth looking closely at the wings, too. Very rarely chickens with more than five toes can produce additional wing digits. These arise in the region of the alula, the bird's equivalent of a thumb.

Animals aren't selected for their skeleton, of course—only for their external appearance, and no amount of selective breeding can induce bones to multiply or decrease in number. But the fact that this can occur so swiftly suggests that extra bones appear quite regularly, just waiting for an environment that will favor their existence.

For many people there's not much in life more favorable than a nice bacon sandwich. Pigs have been kept for meat for thousands of years, so when mutations occur that add a bit of length to the body, no one complains. While changes in the number of *neck* vertebrae have associated harmful genetic effects in mammals (which accounts for their standard number in all but the most sedentary species), vertebrae in other areas of the spine can, and do, increase or decrease more freely. Over time domesticated pigs have acquired up to four additional vertebrae to their original complement of nineteen possessed by their ancestor, the Wild boar. The old German landrace pig pictured here is only modestly long-bodied, with a mere twenty-one vertebrae, compared with modern commercial breeds! That amounts to quite a lot of extra pork.

Like limbs, digits too seem to be firmly opposed to increasing in number on an evolutionary level, regardless of commonly occurring heritable mutations that result in extra ones. Although the first tetrapods "experimented" with multiple digits (*Acanthostega* had eight fingers on each of its forefeet), the common ancestor of all living tetrapods had five digits on each limb, and pretty much everything since then has kept to the same pattern (though there are plenty of examples where the number has been reduced). One exception is the ichthyosaurs—dolphin-like marine reptiles that swam the Mesozoic seas—which could have as few as two or as many as ten fingers on each of their immense paddle-like forelimbs and up to thirty individual bones in each digit. Pandas, elephants, and moles have extra digit-like structures, but these are modified sesamoid bones—floating bones embedded in tendon or muscle—and not true digits. In domesticated animals and humans, however, polydactyly—additional fingers and toes—is relatively common, indicating that it probably also occurs regularly in wild populations and is simply not favored by natural selection.

The common ancestor of birds had already reduced the number of digits on its hind limbs to just four, and no bird species, save one, has ever possessed more than this. The exception is the domesticated chicken. Five toes

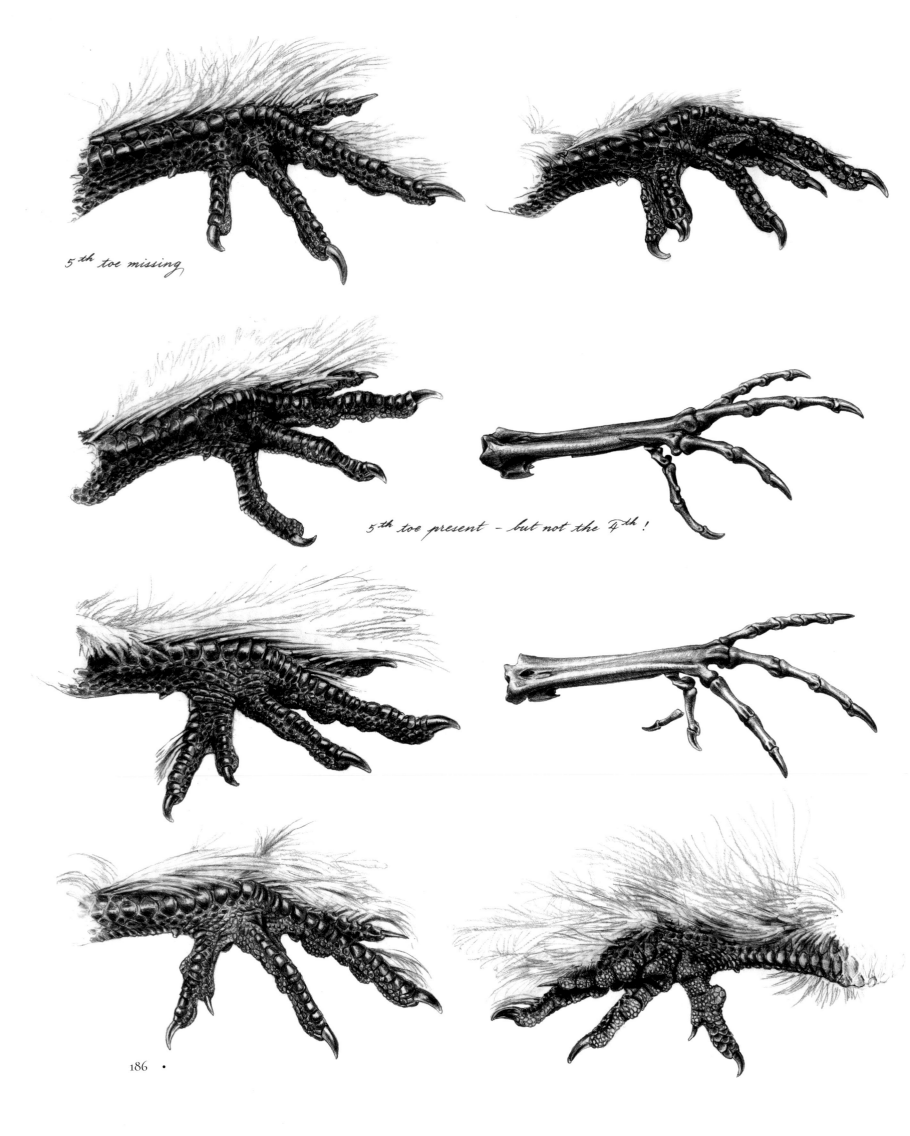

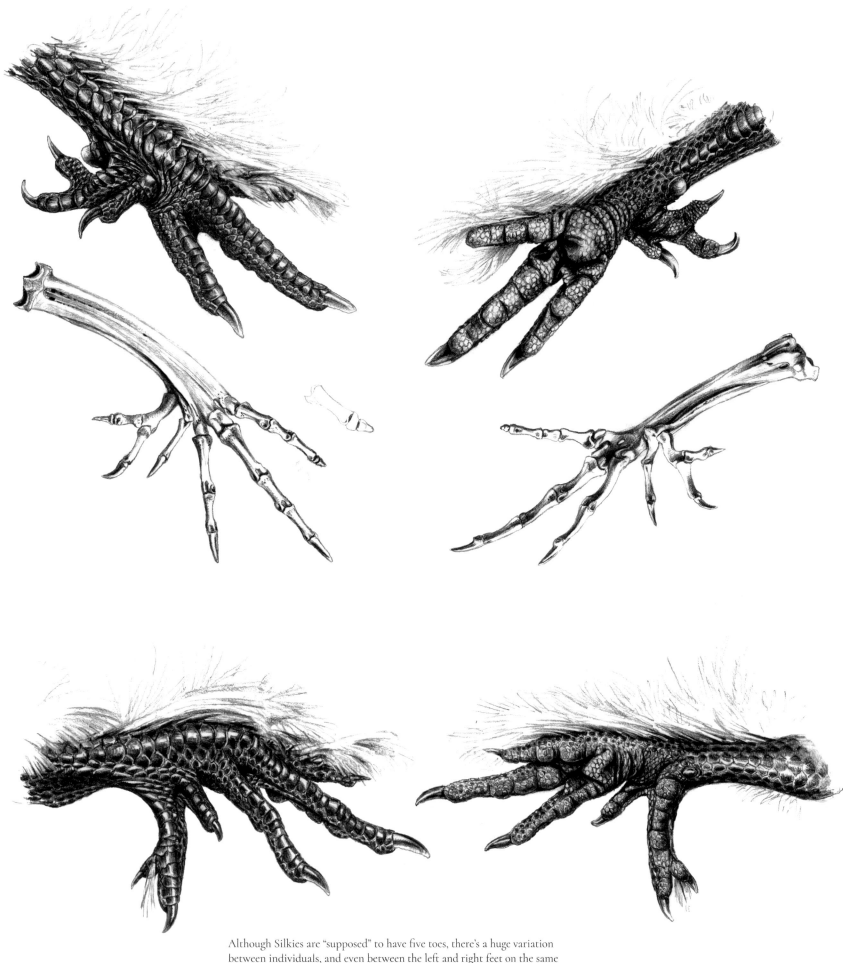

Although Silkies are "supposed" to have five toes, there's a huge variation between individuals, and even between the left and right feet on the same bird. They can have four toes like a regular chicken, or four toes with an extra bone in the hind toe. Or the fifth toe can branch off from the hind toe anywhere along its length. There may even be a sixth or seventh toe.

are present in just a handful of breeds including the Dorking, Silkie, Houdan, Sultan, and Faverolle, but, as I've stressed many times, traits can easily be transferred from one breed to another, so the specific varieties are of little consequence.

The fifth toe develops in the region of digit I, the hind toe, on the inner edge of each foot. The gene responsible is one of the "tool kit" genes that establishes and maps out the basic body plan of all animals in the developing embryo—the equivalent of the large brushes used by our painter early on in his work of art. The result of this particular mutation is that it reverses the polarity, adding toes from digit I to produce a mirror image of the foot. There's a huge variation between individuals, and even between the left and right feet on the same animal. They can have four toes like a regular chicken, or four toes with an extra bone in the hind toe. Or the fifth toe can branch off from the hind toe at its tip—sometimes just a double nail. There may even be a sixth or seventh toe. Extra, extra toes, that is, more than five, are thought to be due to an allele of polydactyly called duplicate polydactyly that delays the switching off of the embryonic cells, so they just go on producing more and more toes.

In a bird with multiple toes, it's well worth looking closely at the wings, too. Very rarely duplicate polydactyly can produce additional wing digits that, again, arise in the region of the first digit, the alula—the bird's equivalent of a thumb (in fact there's some controversy about whether the alula of birds is actually digit I or II). I was once shown a photograph of a kestrel chick, newly fledged but unable to fly, that had an extra hind toe on one foot and several toes growing from the tarsus of the other leg. It also had additional digits growing out of one wing, which presumably were the cause of its inability to fly. The bird had been taken to a wild bird hospital and euthanized, but unfortunately no one thought to preserve the body. Wing digits are of course well known in some birds, most famously in Hoatzin chicks, which actively use them to clamber around in the reeds. These are not additional digits, however, just claws on the tips of the longest finger and alula, which are unusually mobile.

Symmetry between limbs isn't really that surprising. Just like repeated vertebral sections, forelimbs and hind limbs are what are known as serial homologues; they're copies of the same basic structure that are differentiated only at a later stage of development.

Just as bird wings can develop claws, birds' feet can develop feathers. Owls, grouse, and even some swallows and martins have their tarsi and the upper surface of their toes covered in short, loose-textured contour feathers. But no wild bird has, or has ever had, fully formed, asymmetric quill feathers on its feet to rival the flight feathers of wings. This is a distinction shared by only two groups of animals, or rather the same group of animals separated by an abyss of time and very different circumstances. One is a lineage of theropod (predatory) dinosaurs called Microraptoria; the other, also a theropod dinosaur, is the domesticated pigeon.

Yes, you read that correctly. It was in 1868, the same year that saw the publication of Darwin's *Variation under Domestication* (and 150 years before the publication of *this* book), that his chief supporter, Thomas Henry Huxley, "Darwin's Bulldog," having examined the newly discovered fossil of *Archaeopteryx*, dared to voice the radical opinion that birds evolved from theropod dinosaurs. But it wasn't until the last few decades that a series of remarkable fossil finds in the Liaoning province of China turned almost everything we thought we knew about birds upside down. We discovered that birds *are* dinosaurs. One by one, features that had been mistakenly assumed to be adaptations to flight and unique to birds, were found to have been shared with their dinosaur ancestors. Most unexpected of all was the possession of feathers.

Exciting as these discoveries were, skeptics argued that it still didn't shed new light on bird evolution. Most of these finds, including spectacular "four-winged" fossil dinosaurs from the genus *Microraptor*, were from the Cretaceous period, while *Archaeopteryx* had been found in older rocks laid down in the late Jurassic period. Then, in 2009, an exquisitely preserved fossil of a feathered and very, very bird-like dinosaur was found, pre-dating *Archaeopteryx* by at least ten million years. It too had feathered legs (though not as wing-like as those of the later *Microraptor*), as well as asymmetric quill feathers on perfectly formed wings. It was named *Anchiornis huxleyi* in honor of Huxley. Incidentally, its preservation was so pristine that it's even been possible to decipher the color and markings of its plumage from fossilized remnants of pigment cells. You guessed it—they were melanins.

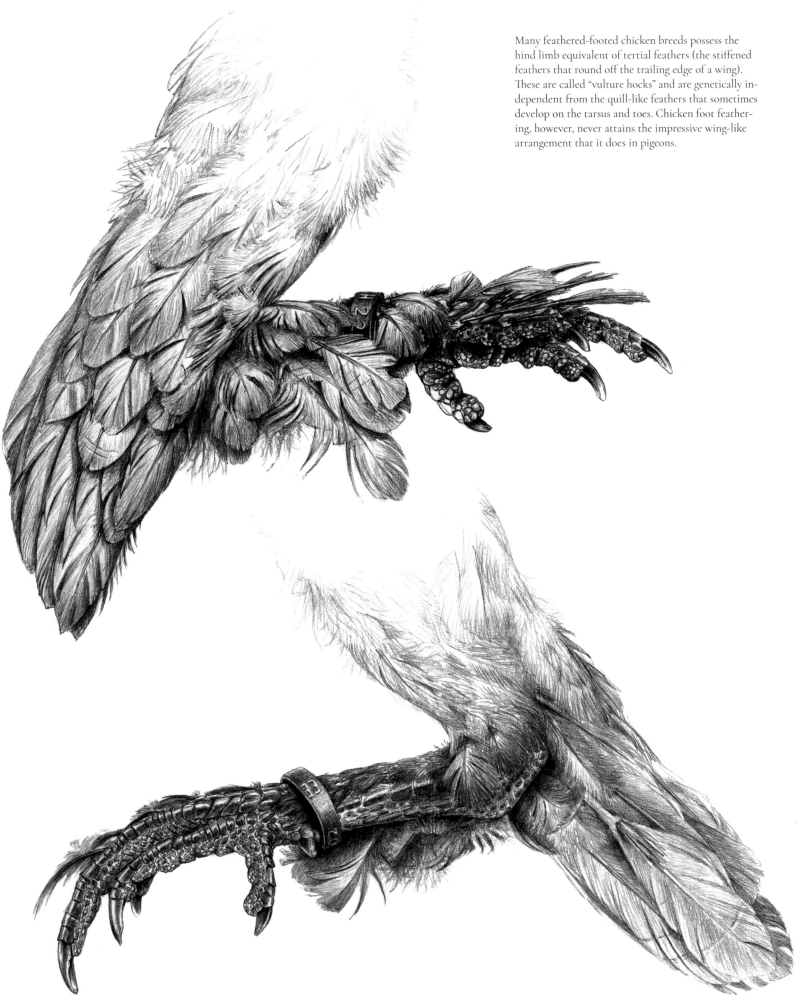

Many feathered-footed chicken breeds possess the hind limb equivalent of tertial feathers (the stiffened feathers that round off the trailing edge of a wing). These are called "vulture hocks" and are genetically independent from the quill-like feathers that sometimes develop on the tarsus and toes. Chicken foot feathering, however, never attains the impressive wing-like arrangement that it does in pigeons.

Pigeons show a remarkable capacity to develop fully formed quill feathers on their feet, perfectly comparable with the flight feather groups arranged along the hand and forearm of their wings. Even the feather color distribution reflects this symmetry between the forelimbs and hind limbs. Producing this spectacular "hind wing" (called "muff" feet by fanciers), however, isn't just a simple matter of gradual selection . . .

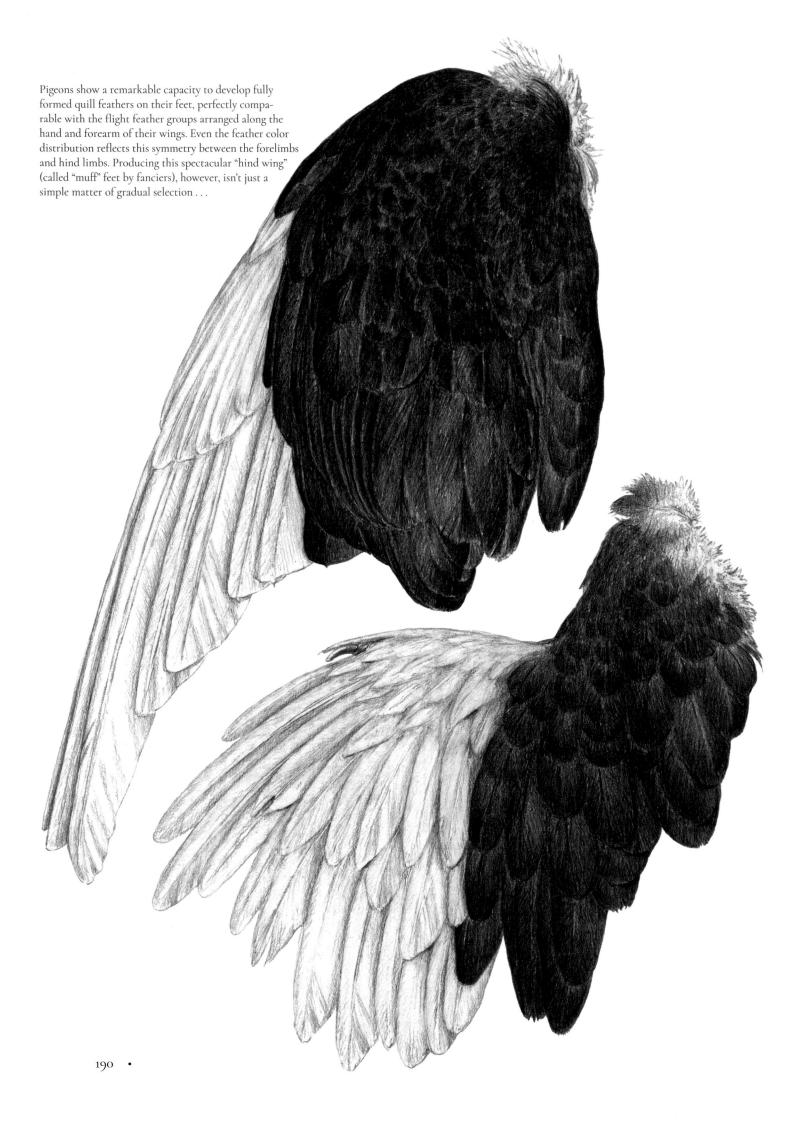

NORMAL SLIPPER GROUSE

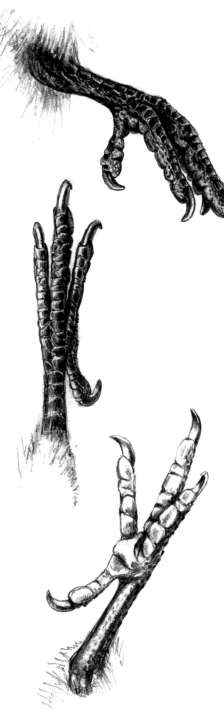
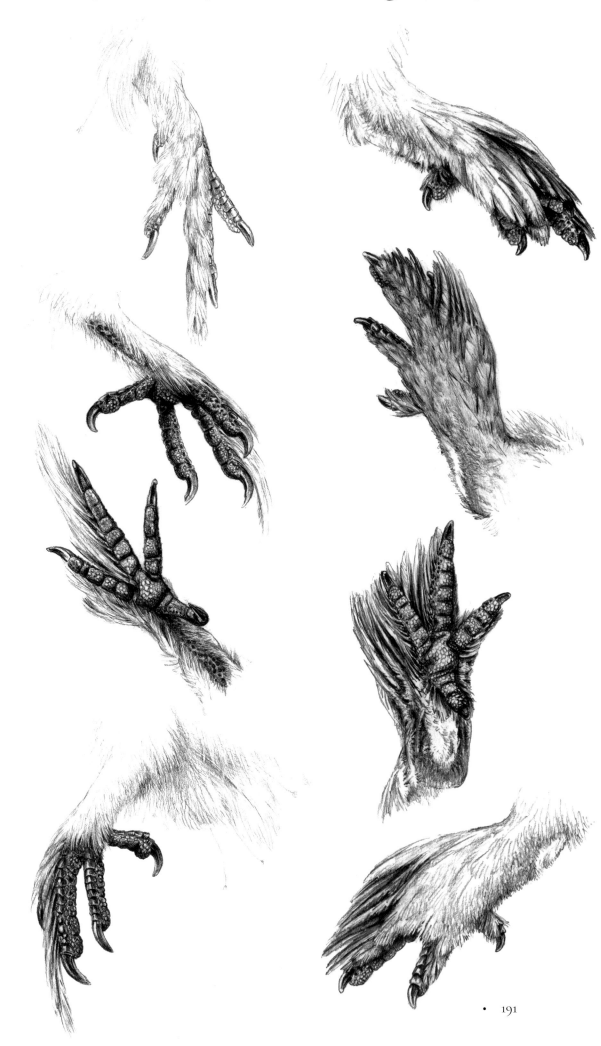

. . . to begin with, the normal pigeon foot is unfeathered. The feathered-footed varieties fall into two distinct and very modest types: "grouse" feet, which have a dense covering of short feathers, and "slipper" feet, with much more scanty, though longer, feathers. It's only by combining these two types that you'll get a bird with fully formed muff feet, and only after a great deal of further selection to perfect their appearance.

The quill groups on a "muff" foot correspond exactly with the arrangement and structure of flight feathers on a wing, with the underlying skeletal positions shifted to retain the wing's conformation. The innermost of the forward-pointing toes, digit II, gives rise to feathers that correspond with the wing's alula. It's the central and outer toes that bear the equivalent of primary feathers that on a wing would be arranged along the digits and hand. The pseudo-secondary feathers, meanwhile, grow from the tarsus.

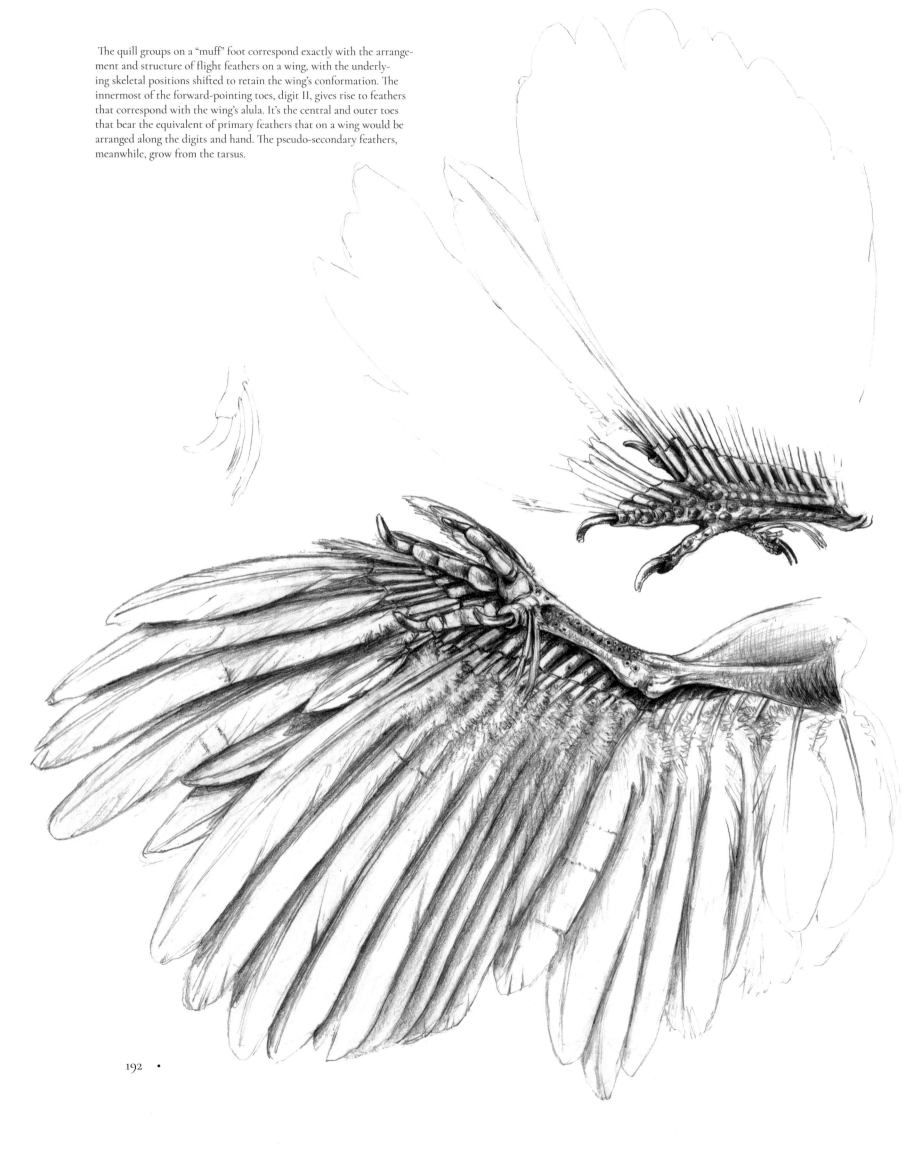

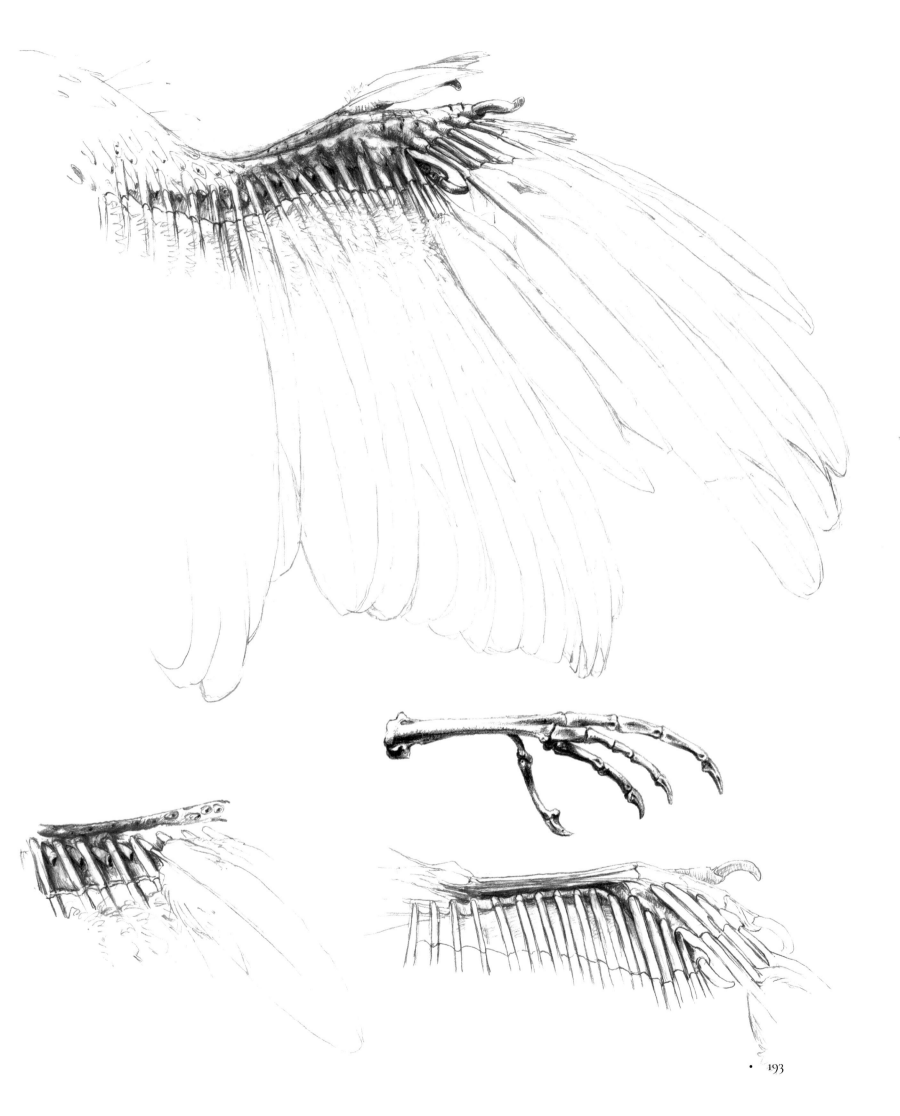

It almost sounds foolish to suggest that a "man-made," ornamental show bird like this Bokhara trumpeter pigeon can provide answers to such profound questions as the evolution of birds. No wild bird has, or has ever had, fully formed, asymmetric quill feathers on its feet to rival the flight feathers of wings. This is a distinction shared by only two groups of animals, or rather the same group separated by an abyss of time: domesticated pigeons and theropod dinosaurs.

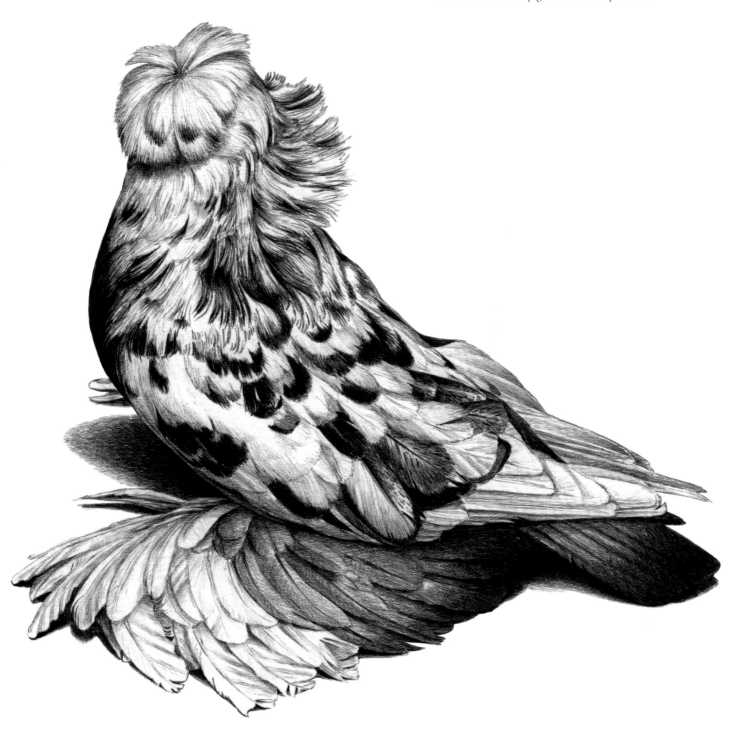

Microraptor is thought to have used its four "wings" for gliding or leaping rather than flapping flight, with its hind limbs angled downward and only slightly outward. Indeed, the skeletal structure of non-avian dinosaurs strongly suggests that they were incapable of powered flight. Flapping flight in *birds* generates a huge amount of heat that is usually lost through the unfeathered areas of bare skin: the spaces between their feather tracts, the sides of their bill, bare areas on their face, and, especially, through their feet. For birds, whose feathers provide super-efficient thermal insulation, keeping cool is as much of a problem as staying warm. Experiments with normal pigeons, with unfeathered feet, have shown that birds whose feet are artificially covered, quickly become overheated during prolonged flight. So it's possible that the trend for foot feathering in dinosaurs was incompatible with the thermodynamics of flapping flight that later evolved in birds, perhaps explaining why feathered feet in wild birds is generally rather rare.

Feathered-footed pigeons, although they fly exceedingly well when they have the chance, don't use their feathered hind limbs to any aerodynamic advantage. These are fancy pigeon breeds that aren't usually permitted to fly at liberty at all and are certainly never flown for competition. The wing-like plumage of the feet is all the more remarkable in that it arises from a combination of two very different, and very modest, foot-feather types. Breed together a bird with "grouse" feet, which have a dense covering of short feathers over tarsus and toes, and a bird with "slipper" feet, with much more scanty, though longer, feathering, and you'll get a bird with "muff" feet—fully formed hind wings. Even the distribution of pigment between wing and foot feathers shows exact symmetry.

The quill groups on the foot correspond precisely with the arrangement and structure of flight feathers on a wing, with the underlying skeletal positions shifted to retain the wing's conformation. The innermost of the forward-pointing toes, digit II, gives rise to feathers that are the equivalent of the wing's alula (a noteworthy observation if you recall the controversy over which wing digit this is). It's the central and outer toes that bear the equivalent of primary feathers that on a wing would be arranged along the digits and hand, while the pseudo-secondary feathers grow from the tarsus. Both primary and secondary equivalents are closely attached to the bones, as they would be on a wing, though the tarsus lacks the tiny raised "quill knobs" present along the forearm of pigeon wings (and the wings of many other bird groups) where the secondary flight feathers are attached. There's even the equivalent of tertials—the stiffened feathers that round off the trailing edge of a wing—arising from the tibia, the shin bone, just above the ankle; on a wing these would be just above the elbow. Many feathered-footed chicken breeds also possess these—called "vulture hocks"—though their foot feathering never attains the spectacular wing-like arrangement that it does in pigeons.

Domesticated, fancy pigeons; it almost sounds foolish to suggest that a "man-made," ornamental show bird can provide answers to such profound questions as the evolution of birds from non-avian dinosaurs. Yet the step that distinguishes scaled legs from feathered ones, forelimbs from hind limbs, is likely just a small one—not a difference in the genes themselves but in the regulation of genes—the way they're expressed, or in the timing of the respective developmental processes. This is why distantly related groups share so many of the same traits; why the same basic tool kit of genes has been so little changed throughout evolutionary history; why such different animals as chimpanzees and humans—and even mice—are genetically so similar. There's a dinosaur in the genome of every bird, though the developmental paths may be switched off and long disused. The revelation in modern biology is not the differences between animals, but the similarities they share.

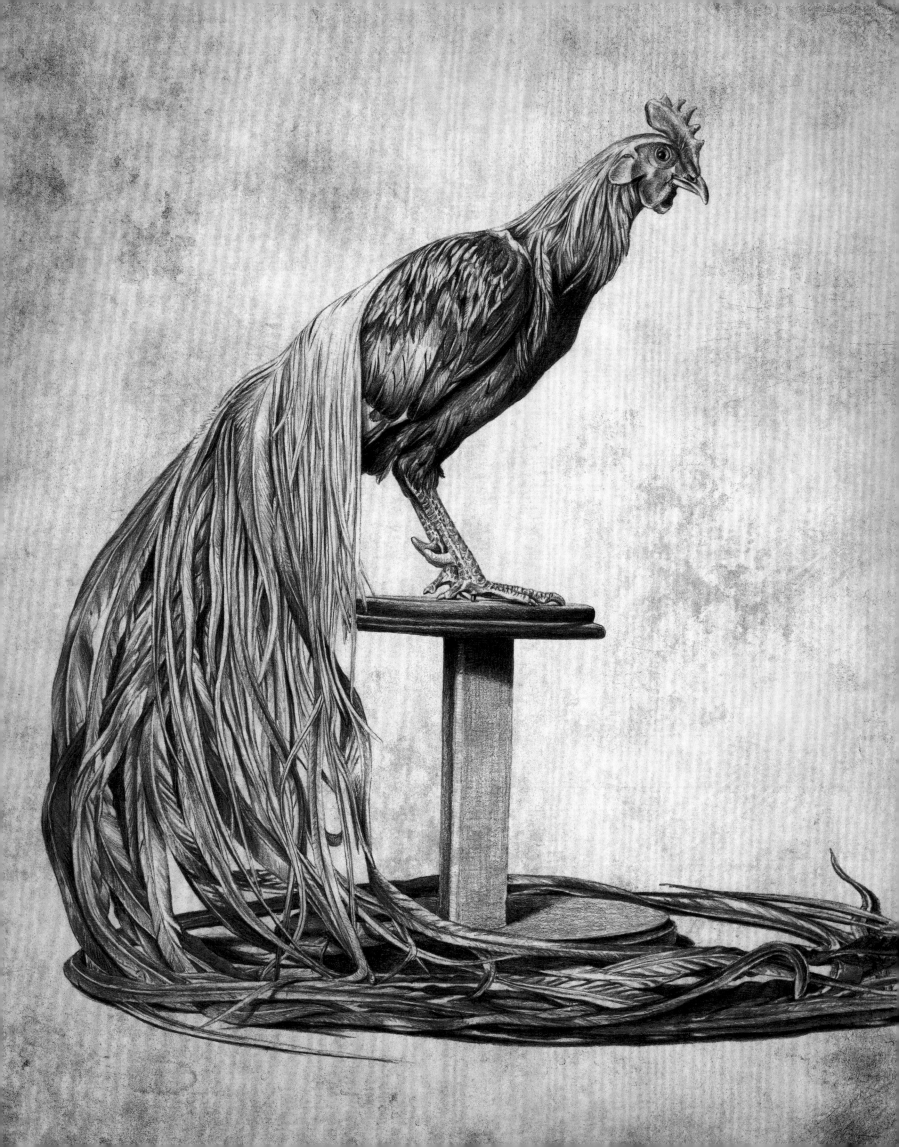

III
Variation

9. Terms & Conditions Apply

9 ~ Terms & Conditions Apply

As a young child I was especially fond of the Walt Disney musical *Babes in Toyland*. It wasn't one of Disney's finest moments, but I loved it. I still have the LP record of the soundtrack, the cover much battered and dog-eared from incessant handling. At the end of the story the action takes place in a toymaker's workshop where the toymaker's apprentice has invented a machine that can produce toys on demand. All the toymaker has to do is press a few buttons to select the desired combination of features and a tin soldier in a scarlet uniform, or a blue-eyed, blond-haired doll, would pop out. I won't tell you what happens next (everything goes wrong, of course), but notwithstanding, the machine itself was a pretty handy invention.

Many people believe that genes work a bit like that. Genetics is a mysterious world of impenetrable jargon so it's easiest to think in simplified terms of genes "for" blue eyes or blond hair as though they're buttons that can be pressed with guaranteed results. And often the results *are* guaranteed. As we've already seen in chapter 5, there are laws of inheritance, and there are known exceptions to the laws; as long as you know the genotype that went in, the phenotype that comes out should theoretically be easy to predict.

However, as you've already made it this far through this book, you may have guessed that, in practice, things are rather more interesting. There are no buttons, even metaphorical ones. The process of building bodies is organic, not mechanical, and highly susceptible to other influences. Even the word "gene" is a rather abstract concept as it can refer to sections of DNA of varying lengths, each with a multitude of different functions. The DNA strand itself doesn't relate to eyes or hair or any other body part; it's comprised of just four chemical bases that, in certain combinations, dictate the production of twenty amino acids, which in turn build proteins. The net result might be that the activities of certain types of cell are switched on or off at a given point in the developing embryo, and, yes, this might result in blond hair or blue eyes. Or it might not. Genes only give the *potential* for a certain outcome. Achieving this potential depends on the genes' environment. As they say in the small print of advertisements, "terms and conditions apply."

For genetic instructions to be carried out effectively they need to be in tune with their surroundings. For perfect results, this will be the environment in which they evolved. First there's the genetic environment. Genes work in teams, and need to be able to cooperate with the genes they interact with, rather than hampering or conflicting with them. Then there's the physiological environment. The right machinery and chemistry need to be in place to have the required effect. Incompatible combinations result in dead embryos, unhatched eggs, or cells that fail to develop or develop abnormally. Finally there's the external environment, which encompasses everything from parental care, light levels, soil type, to—most importantly—nutrition. All of these things play a vital role in switching gene action on and off, controlling development of the embryo, and influencing the body's biology throughout life.

The capacity to grow a twenty-seven-foot-long tail is something that not just any chicken can do. It requires a specific combination of genetic traits and environmental conditions. The Onagadori is designated a special natural monument in its native Japan, and is the most aesthetically remarkable of the group of poultry breeds known as "longtails." This stunning mounted specimen was presented by the Tokyo Museum to the British Museum in 1887.

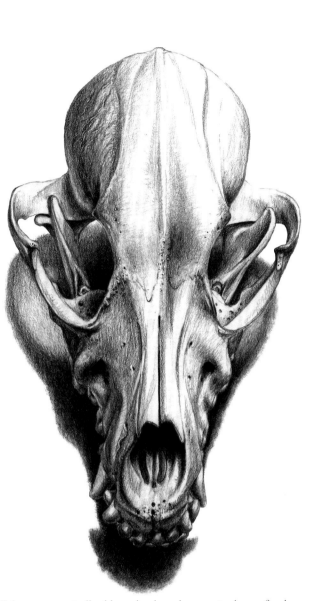
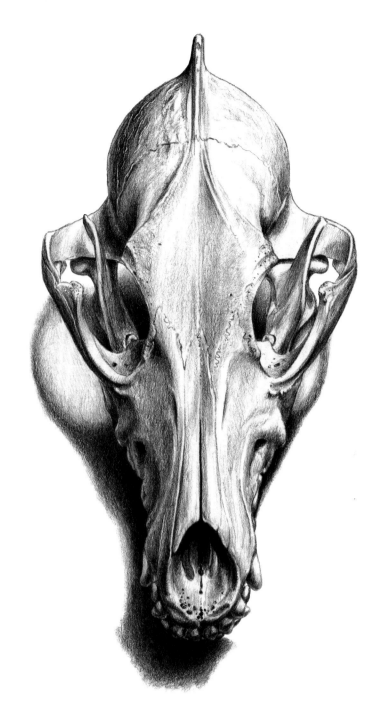

All dogs are genetically able to develop a bony sagittal crest for the attachment of jaw muscles—but only if they're big enough for the muscles to reach the midline. Although the Standard dachshund on the right has a well-developed crest, the Miniature dachshund (left) could never have developed one, because volume and surface area don't decrease at the same ratio. In other words, small animals aren't just scaled-down versions of big ones.

Sometimes the inherited potential to develop a certain structure is denied by the body's environment. Skull shape, with its close bond between form and function, particularly in carnivores, is a good example. The bony sagittal crest that runs along the upper surface of the cranium is an anchor point for the jaw muscles on either side, and develops only after birth. If the jaw muscles get especially rigorous use, the sagittal crest will be enlarged to accommodate them. However, here's the interesting bit: reduce the size of an animal by selective breeding and after a certain point the jaw muscles simply can't extend all the way to the midline. This is because the overall volume of an animal and its surface area don't decrease at the same ratio, and it explains why toy dog breeds have apple-shaped heads without a crest. Increase the size of the animal once more, and a crest would develop.

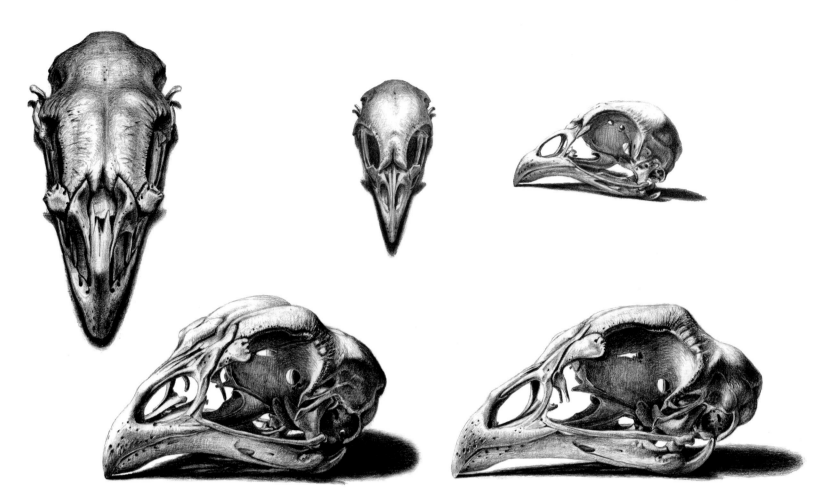

These large skulls belong to Malayan fowl—the largest chicken breed—while the small ones are from Seramas, the smallest. Their shapes are entirely different. Because a skull needs to accommodate the structures within—the brain, eyes, tongue, and other organs that can't be reduced at the same rate—proportional size reduction simply isn't possible.

Similarly, organs like the brain and eyes are also unable to undergo a comparable size reduction, which is why the skull shape of the largest (Malayan) and the smallest (Serama) chicken breeds are so proportionally different, and why many tiny pigeon breeds have bulbous-looking eyes in raised sockets. They're not created like that intentionally; it's just part of being small.

Very rarely certain traits will only be expressed if they're inherited from one or the other parent, in a phenomenon known as genomic imprinting, which has nothing to do with the sex-linked genes discussed in chapter 5. The best-known example is the Callipyge sheep (its name means "beautiful buttocks"!) descended from a single ram named Solid Gold whose ample hindquarters caught the attention of its owner and saved it from slaughter. Disappointingly for the owner, the meat is over-lean and apparently rather tough and unappetizing, but at least his efforts drew the attention of the scientific community to a fascinating mutation. While either sex can carry the trait, it's only expressed in animals that have inherited it from their father.

To move on to the external environment, no domesticated animal is more sensitive to its subtleties than sheep. They have an uncanny connection with the climate, soil, vegetation, topography, and geology. And yet they're so ubiquitous you'd think they'd thrive virtually anywhere. Well, sheep, in general, can. But individual populations

attain their full productivity only under very particular circumstances—the environment in which they evolved that productivity. Take Merinos, for example. In the early nineteenth century the Spanish merino was universally heralded as the finest wool-producing sheep in the world, but attempts to introduce the breed into Britain consistently failed. Merinos—animals of hot, dry, lowland pasture—just don't produce good-quality wool in the English climate, and certainly not in Scotland or Wales. Nevertheless, there's no shortage of sheep in any of these countries and few of them look significantly different from merinos.

The British Isles has a lot of different environments and it's no coincidence that it has a lot of different sheep breeds too. Ancient landraces can often gain more nutrition from poor pasture than improved strains would be able to. One population—from North Ronaldsay, in the Orkney Islands off northeast Scotland—is able to survive on a diet that consists mostly of seaweed. In upland areas Scotch blackface sheep give a marginally poorer yield in meat and wool than a competing hill breed, the Cheviot, but under the challenges of true mountainous terrain it's the blackface—with the advantage of being able to eat heather—that gives the best commercial return.

Northern, high-altitude ewes tend to do well if crossed with more southern, lowland rams. These crosses always improve stock, whereas crosses in the opposite direction would not. So British farmers have developed a unique, stratified system of sheep husbandry in which mountain ewes are brought down to lower pastures to cross with and improve hill breeds, and their crossbred offspring are again crossed with lowland strains. It's not just about providing animals with what they need, but about converting their requirements into commercial gain, ensuring the best possible productivity from the nation as a whole under the most diverse environmental conditions.

The influence of the environment superficially doesn't sound that surprising. We all watch nature programs on TV and are used to colorful examples of adaptation to inhospitable conditions, usually resulting in animals that are phenotypically transformed as a result of natural selection. There's a fine line between the influence of the environment on achieving an animal's full genetic potential, however, and adaptations that are expressed in its permanent phenotype. Camels and zebu, for example, retain their fatty humps even when well nourished for generations in captivity in non-arid climates. Good, commercially productive sheep, meanwhile, look pretty much identical whether they're reared on mountain or desert. It's adaptation at the most subtle level—not just a matter of whether an individual can survive under certain conditions but whether its metabolism—affecting things like muscle, fat, and bone development, hair growth, and milk yield—is functioning at its full capacity.

Some climatic influences produce rather more quirky results. Cats, mice, guinea pigs, gerbils, and rabbits all come in "pointed" varieties, that is, their "points" or extremities have colored fur in contrast with their much paler body. There's no continuity between the names: Himalayan guinea pigs, Californian rabbits, Siamese cats—the trait is comparable between all species and, just like any other color variety resulting from a genetic aberration, it can easily be transferred from one breed to another.

Although the trait is an allele that shares a locus with albinism, they're not albinos despite often having pink eyes. Whereas albinos are unable to synthesize melanin at all, in pointed animals melanin expression is triggered only at low temperatures. And the only parts of a mammal's body that are consistently colder are the extremities: the ears, nose, feet (including the paw pads), and tail (except for guinea pigs, that is, though if they had a tail it too would be colored). It's important to remember that these are not white animals that develop darker points in cold weather; they're animals whose natural color is suppressed unless a certain low temperature is reached. This is why there are chocolate points, seal points, lilac points, and so on: it all depends on the animal's underlying color.

In the warmth of the womb the kits are completely white, but shortly after birth all the extremities begin to show color as the melanin cells become activated in those areas. Pointing occurs when hair is actually growing, in every molt cycle throughout life. A decrease in temperature may produce an increase in the dark area, and removing fur during the colder months (for example, if an animal is partially shaved for surgery) will stimulate the regrowth of darker fur in that area. So don't have your show cat castrated in the winter or you'll end up with a darker rectangular patch of fur on its belly until the following molt!

This sounds as though it would be a useful trait in a wild animal adapted to colder climates—camouflaged for the greater part, but with heat-absorbing dark areas on the extremities that expand as the temperature drops. Strangely,

although it's present in such a wide range of domesticated mammal groups, it seems never to have caught on in an evolutionary sense in wild animals, though it's certainly occurred. Several species of bat have been reported with the mutation, as well as a Chacma baboon (christened Snowball) at the Tuli Game Reserve in Botswana. Perhaps the mutation has never appeared in a climate in which it might be advantageous, or maybe the frequent occurrence of reduced pigmentation in the eyes outweighs the benefits.

In almost all species, pointing inhibits the production of both forms of melanin: the gray-black eumelanin and the reddish-brown phaeomelanin—resulting in a body color that's white, or at least a very pale form of the color of the points. However, a new mutation, originating in Peru, has recently been discovered in guinea pigs which, instead of inhibiting melanin expression, *adds* extra eumelanin to the extremities, leaving the rest of the coat (and eye color) unaffected. This gives fanciers the option to combine any existing coat color with darker point markings.

Pointing is well known in mammals, but until recently had been overlooked in birds. Then, several decades ago, Husband noticed an unusual color pattern occurring in his Barbary doves: white plumage on all but the extremities. These birds are naturally a pale beige color so the markings were subtle, but consistent enough to arouse his interest. So he waited for the winter and plucked a few white feathers as an experiment. Sure enough, these grew back beige. Birds lose heat from different areas than do mammals. For example, you'd be wasting your time looking for a dark-tipped tail. Feathers don't feel the cold; the fleshy part of a bird's tail is tucked up close to the body and sheltered from the elements by a thick covering of feathers, so the tail remains unaffected. Birds lose heat from the head, the wrists and elbows of the wing, the feet, and even the upper breast overlying the center of the crop (full crops push the skin outward and can get a bit chilly), so if you want to spot pointing mutations in birds, these are the areas you need to look at. Since then Husband has found examples of pointing in many other bird species, in living birds as well as in museum collections, wild and domesticated.

There's no better example of the influence of the environment on gene expression than the story of the red canary—a tale, set against the backdrop of pre-war Germany, of the dedicated efforts of two bird fanciers, Hans Dunker and Karl Reich, to breed a canary with red plumage. The story has been brilliantly told by Tim Birkhead in his book *The Red Canary*, a wonderful combination of science and history that I can't recommend highly enough. The outcome (and my apologies to Tim for the spoiler) was that even after decades of selective breeding involving thousands of birds, the creation of a truly red canary was possible only when color supplements were added to their diet. This might sound a dismal account of total failure were it not for one triumphant achievement. By hybridizing canaries with an entirely different species, the Red siskin, Dunker and Reich managed to introduce the "red factor"—the genetic potential for the yellow carotenoid pigment in a canary to change color in response to the right environmental cue. It was only on the last leg of the enterprise that they failed, by thinking solely in terms of genetics and not recognizing that with a carotene-rich diet, the red factor can turn the growing plumage red.

It's not just domesticated birds that can be transformed by color supplements. Wild birds can too, and many depend on them for their reproductive success. Think of flamingos. They naturally gain all the pigment they need to keep them pink in the wild from the shrimp they feed on. Zoos don't feed birds on microscopic shrimps, and for many years captive flamingos were a washed out grayish-white color and wouldn't breed. Then color food was discovered, and changed everything.

Color derived from food makes perfect sense as a message of sexual selection. It clearly advertises the ability of the prospective partner to be able to support itself, and the more intense the color, the more likely it is to be able to support its family too. Useful indicators like this make those partners more attractive, to the point that they become favored unconsciously, simply because they're attractive. If a bird is in ill health, the color fades too—an instant turn-off to would-be mates.

The orange color of the bill of white domesticated ducks is also a product of carotenoids in their diet. (In fact this is also true of wild mallards and domesticated ducks of other colors, but in these cases the orange is partially disguised by gray-black melanins.) One notable exception comes from my home town of Aylesbury, in the English county of Buckinghamshire, famous for the Paralympic Games, the Friars music venue, and—ducks. Aylesbury ducks are a large, white, meat-producing breed with orange legs and a pink bill. This is the result of a mutation that prevents ducks from absorbing pigment, so their bill and skin remain pink, even though their legs, controlled by

Traits that are expressed to their full only under certain environmental conditions are not the same as adaptations to particular environments—like the humps and dewlaps of zebu, or the humps of camels. Zebu and camels have humps even after generations in captivity in non-arid climates.

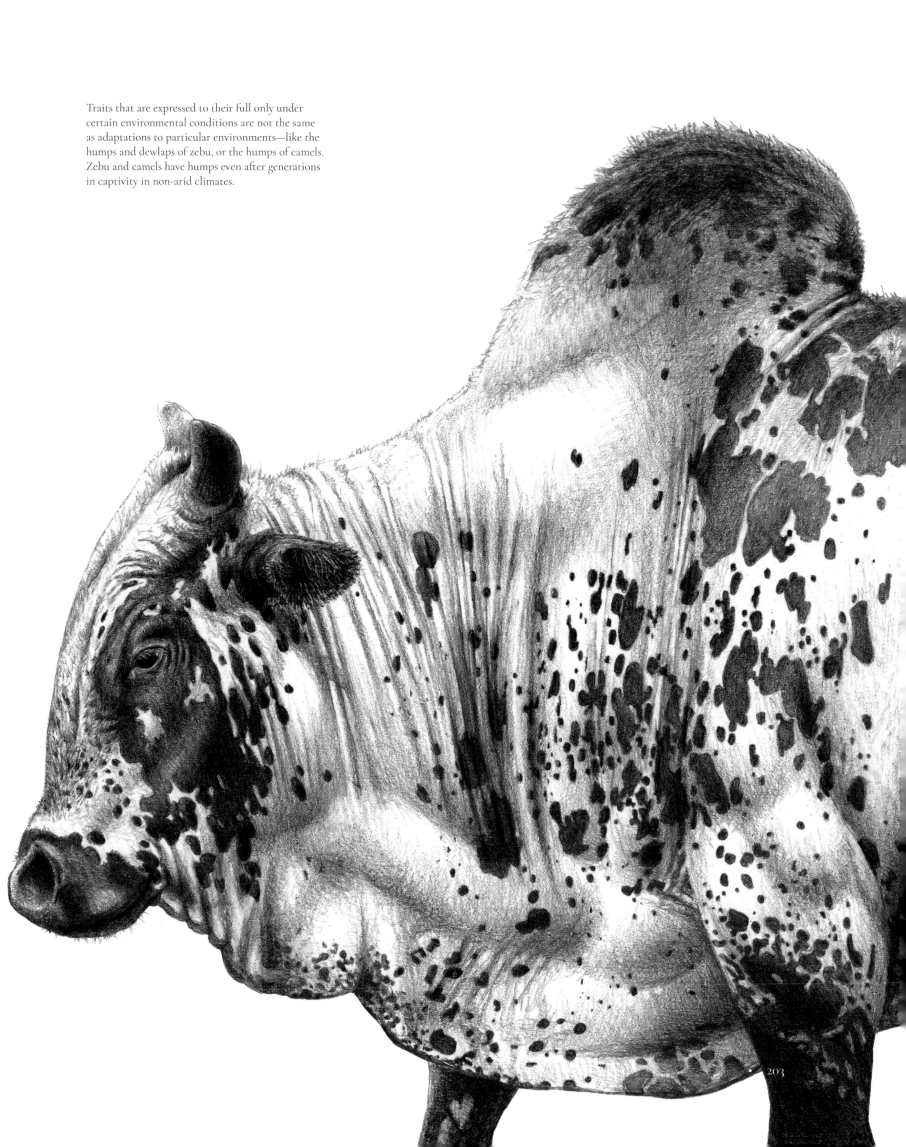

The expression of melanin pigment in "pointed" animals, like Himalayan guinea pigs and Siamese cats, is temperature dependent. Only the extremities (the points)—the ears, nose, feet (including the paw pads), and tail—are sufficiently cold for color to be expressed. Guinea pigs don't have a tail, but if they did, it too would be colored.

a different gene, are orange. Many people believe that the pink bill itself is dietary, resulting from the chalk-rich streams running down from the nearby Chiltern Hills, attributing this as the reason why attempts to create similar ducks in other areas have failed. They're wrong. The only way to produce a pink-billed domesticated duck is to genetically block the deposition of carotenoid pigment. Put another way, all white ducks would have a pink bill were it not for the influence of carotenoids in their environment.

If red canaries take the prize for the best genes-plus-environment story, the prize for the most impressive result has to go to the Onagadori rooster, designated a special natural monument in its native Japan, and the most aesthetically remarkable of the group of poultry breeds known as "longtails." The stunning mounted specimen at the opening of this chapter was presented to the British Museum by Tokyo Museum in 1887.

The capacity to grow a twenty-seven-foot-long tail is something that not just any chicken can do. The genetics are complicated and involve a combination of factors that influence the number of feathers, rate of feather growth, and, most importantly, a slowed or even halted molt cycle. Some of these traits show intermediate dominance, so you get a less extreme result from heterozygous pairs, and each can influence different feather groups. The multiple possibilities for genetic combinations explain why there are so many different longtail breeds. Some even possess the additional trait of extended-crowing.

The term "longtail" is something of a misnomer. With the exception of the central pair, the actual tail feathers of roosters are relatively short and rigid and are usually hidden beneath the long, curved covering feathers known as sickle and saddle feathers. It's these that really give longtails (and roosters in general) their impressive appearance. Onagadoris molt the majority of their tail feathers annually, just like any other bird, but the central pair (known as *kougai* in Japanese) along with one or two broad and flexible additional pairs on either side of them (called *kouge*) are retained for three to four years. Interestingly onagadoris have an extra pair of sickle feathers (*urao*) beneath their tail, and these too are molted only after three to four years. The outermost three pairs of sickle and saddle feathers are also molted annually, but the innermost (the *utaibane*, *sho-utaibane*, and *ofuku*)—once the bird attains adult plumage—are never molted again, continuing to grow indefinitely. The crowning glory is the central pair of non-molting, spiraled saddle feathers—the *uwayore*.

Even with the required genes, however, the creation of a really good onagadori is a matter of skill and cultural heritage acquired over centuries of dedicated practice. It takes a protein-rich diet to attain the optimum rate of feather growth and a very special environment to prevent or delay the onset of molt. Birds usually replace all their feathers every year. There are some exceptions, including the Green junglefowl *Gallus varius*, which molts every eighteen months (suggesting a sprinkling of *G. varius* in the chicken genome along with the *G. sonneratii* element discussed in chapter 1). Either way, retaining feathers for three to four years, or even for life, is a very un-birdlike thing to do.

A range of stimuli can initiate molt: changes in day length, sudden stress, diet, and, most of all, sex. The most prized onagadori roosters therefore live an austere, monastic life. They're traditionally kept in tall enclosed towers called *tombaku* where their exposure to light can be closely monitored. (It's ironic that this form of husbandry is unpopular in the West, on animal welfare grounds, while billions of chickens are meanwhile kept in much more enclosed conditions in battery farms worldwide!) Although there are lots of strains of longtail outside of Japan, many of which claim to be pure onagadoris, it takes *tombaku* rearing to express the full genetic potential of these birds and to separate the impostors from the real thing.

The capacity for chickens to grow long feathers has other uses besides its aesthetic appeal. Feathers of this kind are perfect materials for the art of fly-tying. As the name suggests, fishing flies are intended to resemble . . . flies; in fact a range of aquatic insects eaten by fish. But it's not enough to just look like insects—they need to behave like them too. There are dry flies, for example, with short, bristly feather barbs that will settle momentarily on the water's surface without breaking through—just like a resting caddisfly or stonefly. Then there are the softer, denser feathers used to make wet flies or saltwater flies—sinkable flies resembling aquatic larvae or drowned insects.

Poultry geneticist Tom Whiting, of Whiting Farms in Colorado, creates birds of specific feather types suitable for fly fishing. He very kindly sent me some examples of hackle and saddle feathers—marvelously slender and

Pointing isn't only a "mammal thing." It also occurs in birds, though it's easily mistaken for other color aberrations. Birds lose heat from different areas than do mammals, so the colored points occur in different places: the head, the wrists and elbows of the wing, the feet, and even the upper breast where the crop pushes against the skin. Husband first discovered this in his Barbary doves and has since found evidence for it in many other bird species. The single dark feather in the wing was the replacement "test" feather, plucked to see what color would grow back!

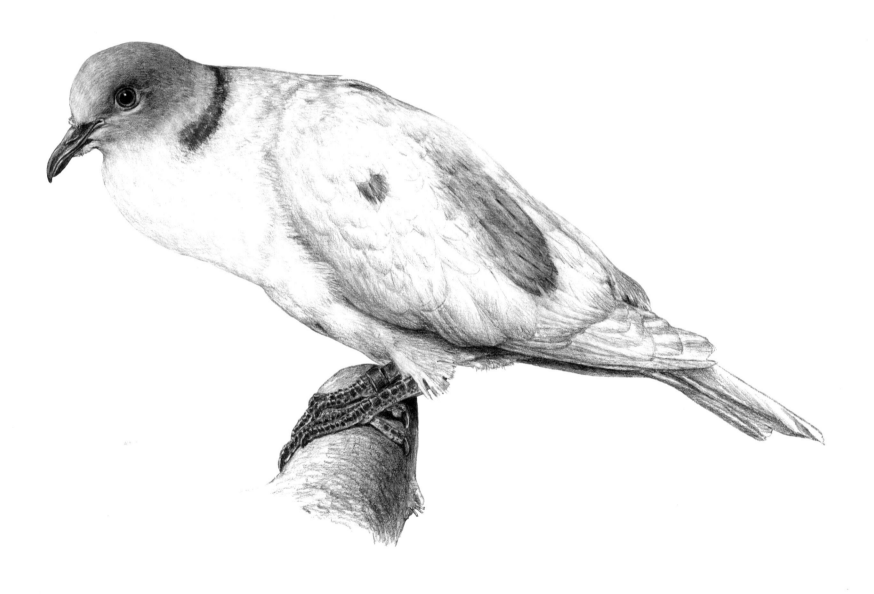

flexible things, almost slippery to the touch, like fine cord—and allowed me to bombard him with questions about his methods.

Once again, success depends on maintaining just the right balance between genetics and the environment. Whiting Farms birds have all been selectively bred to produce saddle and hackle feathers of the required length and flexibility under precise conditions of carefully controlled day length. There's no "right answer" to this—what's important is consistent selection of the birds that are most productive within this environment. The system works so well that the difference is immediately obvious when new birds are brought in from elsewhere. One of the central messages of this chapter is that optimum performance (and this applies to wild as well as domesticated animals) isn't only about attempting to find the best conditions for productivity, but about creating animals that reach their full potential in response to those conditions.

To continue on the chicken theme, roosters of all chicken breeds can usually be distinguished from hens by their feather shape: their aforementioned long, curved, central tail feathers, the cascade of sickle-shaped tail coverts, the saddle of pointed feathers with fringed edges that hang down from the rump, and the very similar hackle feathers of their neck forming a sort of cape around their shoulders. Female feathers are, by comparison, neat, short, broad, and rounded, and mostly lack the structural colors that are so splendid in males. But they do have a subtle beauty of their own, and this is particularly well expressed in feathers that bear the pattern known as "lacing"—that is, a silver-white or gold feather, edged with black. Lacing looks lovely on rounded-feathered females but doesn't suit the pointed feathers of males at all. To make a really fetching pair of laced fowl you'd need a matching rooster with female-type feathering. And for that you'd need two things—a mutation that gives female-feathering in males, and a genius among animal breeders who'd know what to do with it. That genius was John Sebright.

I've mentioned Sebright several times already in this book, but now the moment has arrived to introduce his namesake, the Sebright bantam, an entirely ornamental breed, useless for egg or meat production, but very pretty to look at—especially in pairs. Just like a master chef who can skillfully add a little bit of this and a little bit of that to create a perfect dish, Sebright combined a pinch of Nankin bantam, a sprinkling of Hamburg, and a precious ingredient that he happened to notice strutting around a Norfolk farmyard in the shape of an unusual game cockerel with the plumage of a female.

You could argue that the "henny feathering" mutation works independently of environmental influences. It conforms to Mendelian rules and reliably shows itself in crosses whenever you'd expect it to. The expression of the trait does, however, fluctuate in response to changes in hormone levels, which, in my opinion, qualifies it as an excellent illustration of my point in this chapter—that the phenotype of animals is not simply the result of pressing a few genetic buttons.

The hormonal system is an unfathomably complex science involving a mass of interconnecting chain reactions, any of which can be altered significantly by a single trigger. In this case the henny-feathering trait converts, by a circuitous route, excess male hormones in the skin into female hormones, which is why the feathers are affected and nothing else. Although Sebright roosters have the plumage of females, there's no reduction in male sexual desires or any of the qualities that *are* influenced by testosterone. They have the larger comb and wattles typical of roosters, they develop spurs, they're belligerent toward other males, they're amorous with females, and they crow. Sebrights nevertheless have a reputation for fertility problems in some strains, but this is probably connected with the complicated genetics of their rose comb rather than a result of their female-type feathering.

Interestingly, Darwin tells of a Sebright bantam hen that became diseased in her ovaries in her old age and assumed the plumage characteristics of a "proper" cockerel—with long, pointed saddle and hackle feathers and long sickles. He interpreted this as the underlying characteristics of the original breed, lying latent for sixty years since its creation. But there's a more likely explanation.

Research strongly suggests that in several bird groups, including gamebirds and ducks, male-type feathering develops independently of the presence of male hormones. Estrogens are the name of the game, and it's the presence

of these female hormones that dictates whether a bird develops male or female plumage. So when the production of estrogens breaks down—in old age, or as a result of illness—females revert to their default, male plumage instead.

Apparent sex change in birds—especially in gamebirds—is actually quite a common occurrence. The mythical cockatrice—half fowl and half serpent—was assumed to be the offspring of a "sex-changed" chicken. "Sex-changed" chickens in ancient China were purported to be a good omen foretelling the birth of a baby boy while, in Europe's dark past, these birds were tried in court for crimes against God and summarily executed.

The most celebrated example, however, was a pied peahen belonging to a Lady Tynte in the late eighteenth century. After raising several broods of chicks, at the ripe old age of around eleven years the peahen amazed her owner by developing the lavish plumes of a peacock, finally adding spurs in her/his third year after transformation and dying shortly after. The bird was immortalized by surgeon and naturalist John Hunter in a paper published in the *Philosophical Transactions of the Royal Society of London* in 1780 titled "Account of an Extraordinary Pheasant," which provoked considerable interest from the scientific community. And after its death the peafowl's infamous gonads were preserved in spirit in the museum of the Royal College of Surgeons in London—the Hunterian Museum.

However large a cockerel's comb is, a standard single comb almost always stands upright in a healthy bird. Strangely, there are chicken combs that are expected to be floppy and to hang over sideways like an empty rubber glove, and these are always in the females, even though their comb is smaller. It's a characteristic feature of the White leghorn breed, and in cases where elderly hens with dysfunctional ovaries undergo a "sex change," you guessed it—the influence of testosterone asserts itself and the floppy comb becomes upright!

The phenomenon of gender reversals, added to the knowledge we've gained of henny-feathering, is still helping scientists understand the subtle interplay of hormones that affect bird plumage—not just in domesticated varieties but in wild species too. The males of many duck species, for example, molt into an inconspicuous female-like eclipse plumage for a few months every autumn while they're replacing their flight feathers and are vulnerable to predators. It's thought that this could be a henny-feathering response to seasonal fluctuations in hormone levels, embedded by millennia of natural selection to fulfill a seasonally beneficial function.

While some bird groups have default male-type plumage that's moderated by estrogens, in other groups it's known to be the other way around: they're influenced by testosterone instead. One of the few bird species whose extravagant male plumage is known to be wholly influenced by testosterone is a little sandpiper called a Ruff. In the breeding season male ruffs—transformed into something resembling feathery puffballs on stilts—engage in elaborate communal courtship displays called leks. There's a hierarchical system between males, with higher-caste individuals (who get most of the girls) sporting a decorative ruff of reddish-brown feathers, while in subordinate males the ruff is white. These manage to get in a quick copulation here and there when the alpha males aren't looking. Unlike similar communal display strategies in birds and mammals, where the lower-caste males at least have a hope of becoming an alpha male someday, the white-ruffed individuals are genetically stuck with their status for good. But it gets even more interesting. Regular observations of what appeared to be lesbian copulation in ruffs have revealed a third male form—a male ruff in female plumage! These "wolves in sheep's clothing" can sneak past the displaying males and have a field day among the females; indeed their comparatively enormous testes have shown them to be very sexually active. Perhaps (and this is pure speculation) this high level of testosterone is somehow responsible for producing the female plumage in certain individuals, in a similar way to the henny-feathering in Sebright bantams. These birds, called *faeders*—meaning "ancestral fathers"—are thought to represent the ancestral-type males that may have retained a small but important niche, a niche wholly dependent on the presence of a sexually competitive lekking system to give them a back door to sneak through.

To remain on the theme of chicken feathers, or in this case the lack of them, it's time to return to the Naked-neck fowl, which I mentioned briefly in chapter 5. There's also a Naked-neck tumbler pigeon, which I'll discuss shortly. As both are, by pure coincidence, from the Transylvania region of Romania they're the brunt of all sorts of vampire-related jokes. We keep both.

Just like the henny-feathered Sebright, Naked-neck fowl have also made scientists sit up and pay attention. This time it's all to do with thermoregulation. Feathers are arranged in a precise pattern of tracts across the body, with spaces in between vital for losing excess heat. Although the layout of the tracts is comparable in virtually all birds,

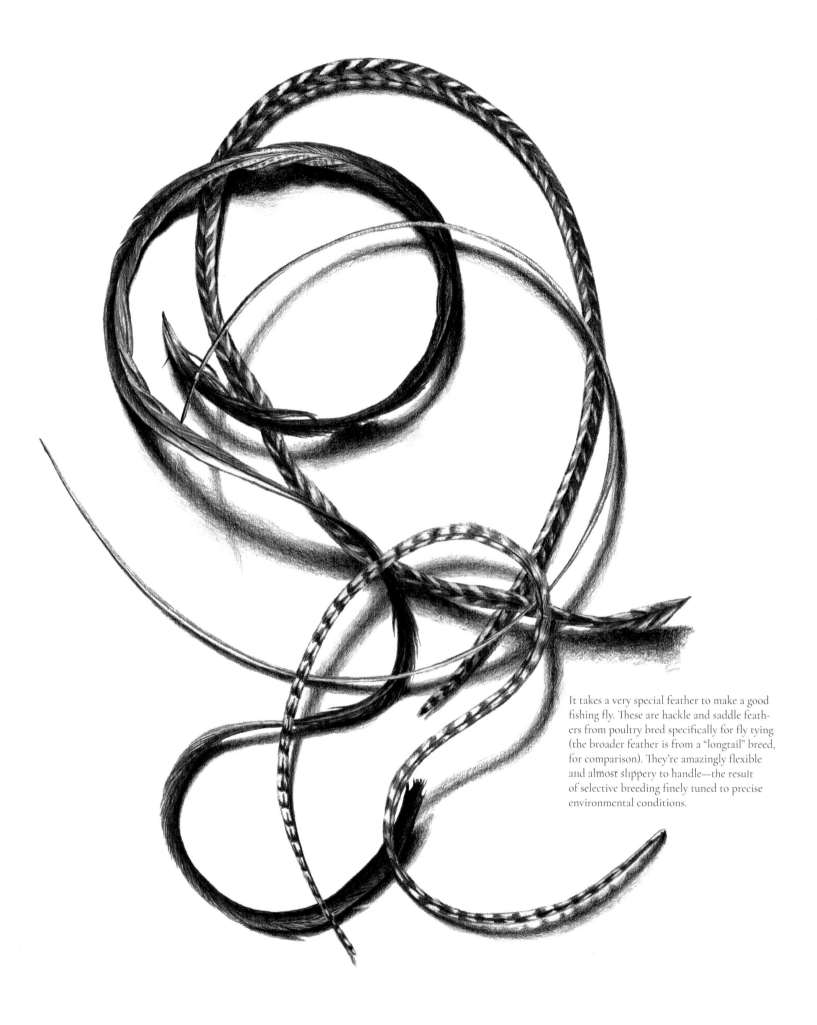

It takes a very special feather to make a good fishing fly. These are hackle and saddle feathers from poultry bred specifically for fly tying (the broader feather is from a "longtail" breed, for comparison). They're amazingly flexible and almost slippery to handle—the result of selective breeding finely tuned to precise environmental conditions.

Sebright bantams are an entirely ornamental breed combining a beautiful laced feather pattern with a mutation called "henny-feathering" that gives male birds the neat, rounded feathers of females. Excess male hormones in the skin are, via a complex chain reaction, converted into female hormones, which is why the feathers are affected and nothing else.

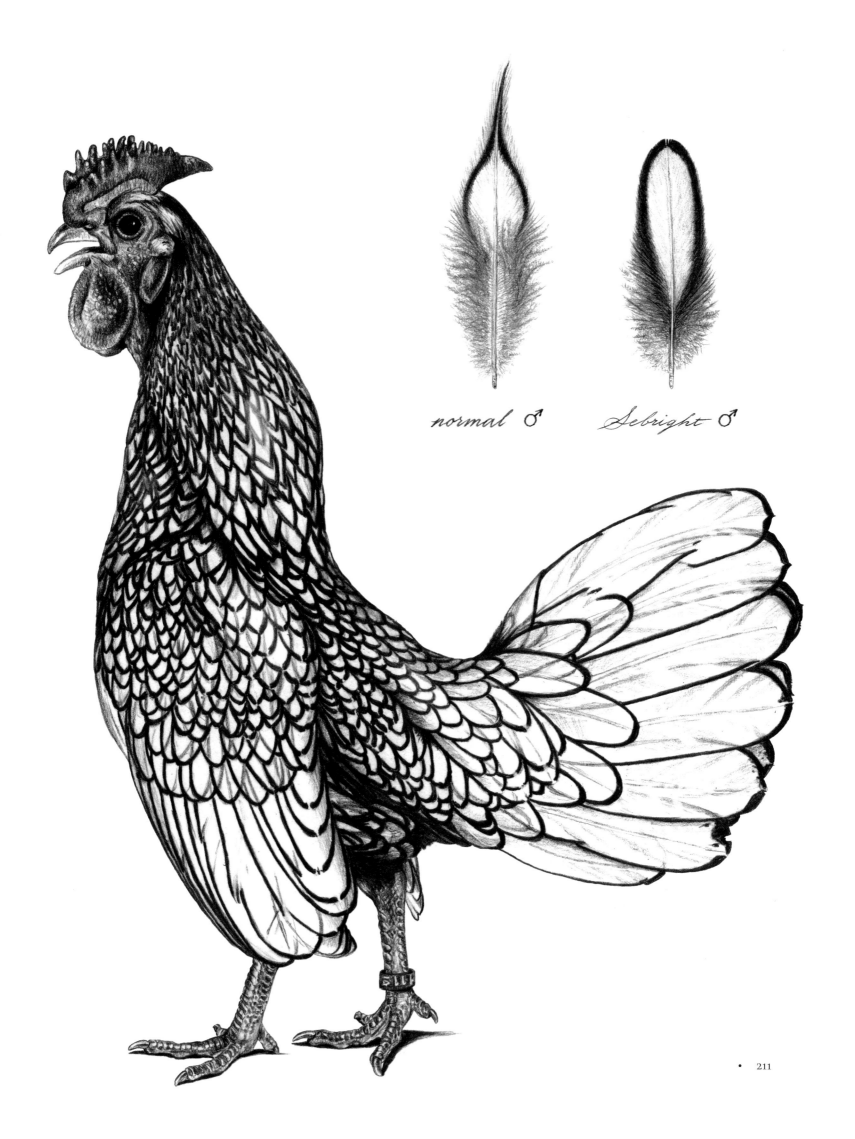

normal ♂ Sebright ♂

their shape differs between groups, with birds inhabiting hot climates generally having larger spaces. The spaces are widest, and the feather tracts narrowest, on the neck region, and it's the neck that's the best place for heat loss because of the major blood vessels running so close to the surface of the skin. Birds with a completely bare neck—like ostriches and vultures—are especially efficient at losing heat, and it's likely that they reached this stage in exactly the same way as Naked-neck fowl, in a single step.

The neck skin of all birds is thought to contain a substance, derived from Vitamin A, which is highly sensitive to the reduction of feathering elsewhere on the body. When a mutation occurs that amplifies the extent of feather reduction then the chemistry in the neck region is activated and the feather follicles are prevented from developing. Remember that mutations are random, so it can happen anywhere, in any climate—even in Romania. It's all down to natural selection to favor this trait if it proves beneficial in a hot climate—or to artificial selection if fanciers find it worthy of perpetuating.

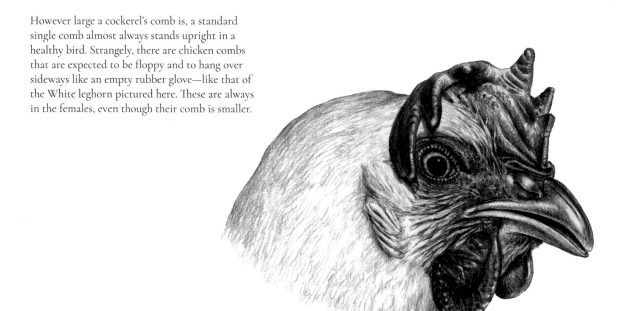

However large a cockerel's comb is, a standard single comb almost always stands upright in a healthy bird. Strangely, there are chicken combs that are expected to be floppy and to hang over sideways like an empty rubber glove—like that of the White leghorn pictured here. These are always in the females, even though their comb is smaller.

Some commercial poultry farmers in the tropics have developed this trait further to produce completely naked chickens. Arguably this is for animal health reasons, though its economic advantages in saving the costs of plucking machines, feather disposal, and air-conditioning may also have had some influence!

Except for their bare neck, naked-necked pigeons and naked-necked chickens have nothing in common beyond their country of origin. Unlike the chickens that never develop neck feathers at all and don't even have feather follicles there, naked-necked pigeon squabs grow normal feathers all over—and then the neck feathers drop out. But here's the really interesting bit: only if the feathers are red or yellow. (I don't mean the bright red and yellow caused by psittacin or carotenoids, but the colors that result from reddish-brown phaeomelanin in its pure and dilute forms.)

The naked neck trait isn't restricted to the single recognized breed: the Romanian naked-neck tumbler—it can spontaneously occur or can be bred into any pigeon of any variety or color. But you'd never know it until it gets passed to a red or yellow one. It can be quite alarming when your apparently healthy young pigeons shed all their

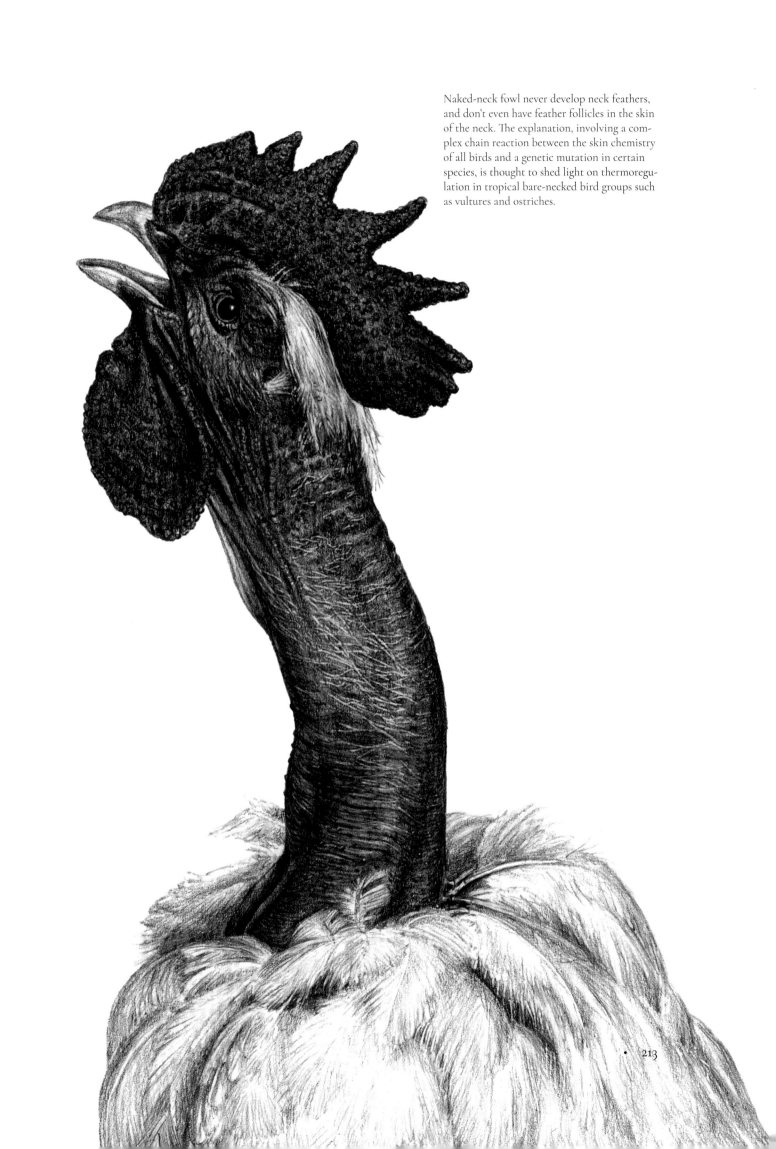

Naked-neck fowl never develop neck feathers, and don't even have feather follicles in the skin of the neck. The explanation, involving a complex chain reaction between the skin chemistry of all birds and a genetic mutation in certain species, is thought to shed light on thermoregulation in tropical bare-necked bird groups such as vultures and ostriches.

neck feathers at once. When the mutation first appeared outside Romania it wasn't unusual for broods to be culled, in the belief that they had some strange disease.

It's impossible for birds possessing only gray-black eumelanin, or a leucistic bird lacking pigment, to express the trait for a naked neck. Only phaeomelanin is affected. Even birds with leucistic patches on their neck lose the red feathers and not the white ones. We don't yet know, however, if albino pigeons that are genetically red are affected in the same way. Neither do we know with certainty whether pigeons that have both melanin pigments (breeds like Archangels and Gimpels) are affected in the same way, though we've been told that spontaneous naked neck mutations have occurred in these breeds. This is an experiment on Husband's "to do" list (after he's finished creating Naked-necks in orange!).

Remember the stipper gene that gradually darkens the feathers in almond-patterned pigeons? Well, there's also a process, or a range of processes, that produces the opposite effect—progressive graying. It's common in dogs and, as we're all too painfully aware, also in humans. But graying doesn't only occur in old age. Many gray horses (horses are termed "gray" even if they appear white) begin their life as horses of a different color and are fully transformed by the time they reach adulthood. Less understood is its occurrence in birds.

Progressive graying can usually be attributed to death of the melanin pigment cells, and begins with a spattering of pure white hairs or feathers that increase in number with each successive molt. But in poultry and pigeons with a mottled or grizzled pattern, the feathers themselves become progressively whiter—the exact opposite of the stipper effect—beginning with white tips or flecks that become larger or more numerous with each feather generation.

Many of the wild birds that we see with white feathers—birds that are mistakenly described as "partial albino" (impossible) or leucistic (these are rather rare)—are birds with one or another form of progressive graying. Because only a small percentage of a population survives to old age, and young birds may have not yet begun losing pigment, the proportion of individuals with the *potential* to develop progressive graying at some point in their life is probably very high indeed. Some species, and even certain sexes, appear to be more susceptible than others. Some are more likely to go gray in an urban rather than a rural environment, and at present it appears that at least some forms are not inherited.

One bird species that is definitely affected by a heritable form of progressive graying is the canary. In yellow canaries of course the results are invisible, as the mutation only affects melanin. However, in green canaries, if the gene is present, the dark feathers of young birds will be replaced with feathers edged with yellow, the amount of yellow increasing over successive molts as the melanin recedes. Finally the result will be a uniformly yellow canary.

Canary fanciers responded to this by producing a breed that shows the transitional plumage to its full beauty—each dark-centered, yellow-edged contour feather overlying the next to give the impression of scales. The breed was called the Lizard.

Another "breed" closely associated with the Lizard was the London fancy, unseen since the end of World War I and the Holy Grail of canary fanciers. Indeed, London fancies *were* Lizard canaries in all but appearance and could be hatched from the same brood. Instead of the scaly pattern of yellow-edged feathers, however, they exhibited a uniformly yellow body contrasting sharply with the green-black wings and tail. The answer is, quite probably, in the rapidity of progressive graying.

Songbird fledglings need to be able to fly as soon as they leave the nest, so they need to develop functional, grown-up flight feathers as early as possible. These wing and tail feathers are, in most species, kept until the late summer of the following year. However, the fluffy juvenile body plumage is replaced a month or so after fledging, which results in plumage of two generations present at the same time. This is precisely how bird ringers age birds. Now introduce a mutation for rapid progressive graying causing the second generation of body feathers to lose all their melanin during this post-juvenile molt. You've created—for one year only, before the wings and tail too are replaced with plain yellow feathers—a bird with yellow body plumage and darker wings and tail: a London fancy.

Feathers grow from follicles in the skin, each follicle producing a succession of feathers throughout the bird's life, like a sausage machine. Although the color, pattern, and even the structure of a bird's plumage change throughout its life, the feathers all come from the same follicles, which are just re-programmed to behave differently in response to the action of hormones. Developing feathers have a blood supply until they're fully grown, then the blood

Naked-neck tumbler pigeons, unlike Naked-neck fowl, do have feather follicles in their neck, and even grow feathers there! But if the feathers contain the reddish-brown phaeomelanin pigment, they drop out before they're fully developed. It's impossible for birds possessing only gray-black eumelanin, or a leucistic bird lacking pigment, to express the trait for a naked neck, although they may carry it.

supply is withdrawn and the feather is effectively dead while the follicle cells undergo a rest period. (The longtail chickens described earlier are unusual in that some of their feathers retain their blood supply and, like human hair, continue to grow.) It's only when the old feather is shed that the cells will be stimulated to produce a new feather. Clipping a feather off won't make it grow a new one, but pulling it out will. Most birds replace all their feathers once a year and, even though they do it gradually and are never left featherless, it's a debilitating process that renders them temporarily vulnerable. Natural selection has timed the molt to occur when this will pose least risk to a bird's overall reproductive success.

 Molting usually begins when the days begin to shorten at the end of the breeding season (remember I mentioned that sexual activity and day length trigger molting to commence) and is finished by the fall. But there's a paradox here: if you don your bright new breeding plumage several months too early it'll be in a sorry state by the

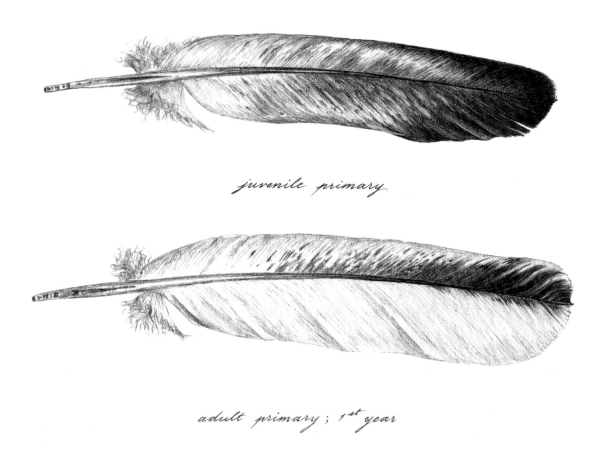

juvenile primary

adult primary; 1st year

Remember the stipper gene that causes the gradual darkening of the feathers in almond-patterned pigeons? There's also a process that results in the opposite effect—progressive graying. In poultry and pigeons with a mottled or grizzled pattern, the white tips or flecks on the feathers become larger or more numerous with each feather generation, eventually resulting in pure white plumage.

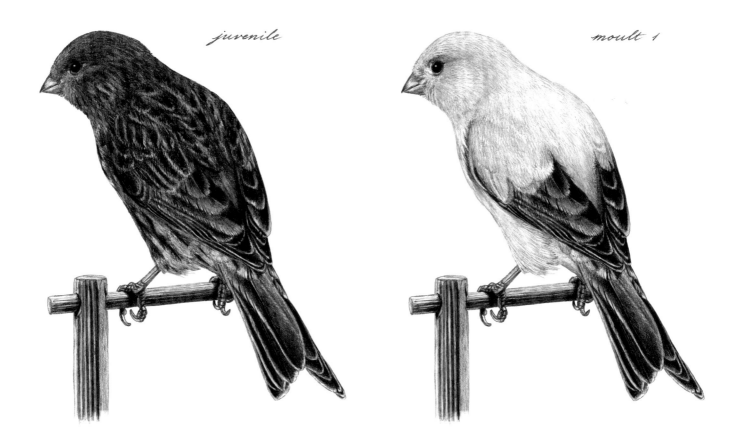

It's very likely that the canary "breed" known as the London fancy—the Holy Grail of fanciers, believed extinct since the early twentieth century—was not a breed at all but a population with the mutation for rapid progressive graying. The dark wings and tail are retained juvenile feathers contrasting with the second-generation body plumage now devoid of melanin.

time the spring comes. Plus you'll be an easy target for predators when there's not much cover to hide in. However, natural selection ensures that the molt is timed, not just to occur when it's least damaging to the bird, but so as the plumage will be at its optimum appearance for attracting a mate several months later. This is because the conspicuous breeding plumage of many songbirds (buntings, finches, and sparrows, for example) isn't composed of fresh new feathers but of the brighter feather-bases that become visible after their subtly colored fringes have abraded away during a winter of wear and tear.

Feathers aren't the only things that require use in order to be useful. Teeth likewise develop in order to be worn, and it's only in a form modified by rigorous use that they can continue to be functional. In many zoo animals fed on artificial diets, the teeth and even the entire skull morphology have changed as a result.

Animals have evolved as part of their environment, under conditions that change them. In order to maintain their maximum evolutionary fitness, natural selection therefore doesn't produce perfect, functional products at the outset. If it did, the perfection would be short-lived. The environment is a reality that can't be escaped so, just like an archer firing an arrow deliberately off-target to compensate for the wind, it's incorporated by natural selection to yield results that work to their best advantage under its influence.

Once in a while, however, the wind changes.

IV

Selection

10. Facets of Fitness

10 ~ Facets of Fitness

In the Welsh market town of Abergavenny, tucked away among the ruins of a Norman castle, is a modest local museum. It houses the eclectic and slightly surreal mix of treasures you might expect from a town steeped in history: Roman artifacts, a World War II air-raid shelter, items of costume, farming implements, the contents of several shops, and a complete Victorian kitchen. In the kitchen, in a wooden, glass-fronted box decorated with imitation flowers and scarcely bigger than a shoebox, is a tiny stuffed dog. Her name is Whiskey and, although she's not the best example of canine taxidermy in the world, she's a very important little dog indeed.

Whiskey is the only existing specimen of a turnspit dog. There are no skins, no skeletons, no photographs, or even that many illustrations. Why would there be? Turnspit dogs were kitchen utensils and you'd no more preserve a likeness of one than commission a painting of a saucepan. They were trained to run in a little wheel, like the ones hamsters seem to enjoy so much, which, by a simple system of cogs and gears, would turn the roasting meat on its spit so that it was evenly cooked all over. If this doesn't sound so bad, bear in mind that the wheel was situated uncomfortably close to the fire and the dogs weren't permitted to pause for a drink of water. If their pace slackened, they could always be encouraged to run a little faster by tossing a few hot coals into the wheel! Throughout centuries of British history, while monarch succeeded monarch; while battles raged in Europe, and the bigger wheels of politics and economics turned the events of the world, people still needed to eat, meat still had to be roasted, and dogs were employed in the kitchens to ensure that it didn't burn.

Turnspit dogs were not breeds in the modern sense. It's misleading to think of working dogs before the late nineteenth century as breeds in the way you'd think of pedigree dogs today. They were generalized types, and several different types of dog could be selected from the same litter of puppies for completely different purposes. Those types unfortunate enough to be considered suitable for the turnspit only needed to be small and short-legged. (Many contemporary reports described them as having crooked legs and a surly temperament, but these were probably qualities gained from a life in the wheel, not necessary to it!) Nevertheless, over many generations, a typical turnspit dog evolved.

I'd seen many photos of Whiskey before visiting Abergavenny museum so I arrived confident that she'd be no different from any other small, short-legged dog—just a badly stuffed one. It's difficult to really get the "feel" of something from a photo. Whiskey, to my surprise, was altogether different from your average mongrel, and much smaller than I'd expected. She was one of the last dogs to run in a turnspit wheel; the breed—or type—was shortly to become extinct, replaced, like many other manual workers of the period, by a mechanical invention that was cheaper to maintain.

 This is Whiskey, the world's only specimen of a turnspit dog, used to run in a little wheel in the kitchens to turn the roasting meat over the fire. Turnspit dogs were just one of many former working animals facing redundancy in the nineteenth century. While some types met extinction, others entered a new and very different evolutionary trajectory as pedigree exhibition breeds.

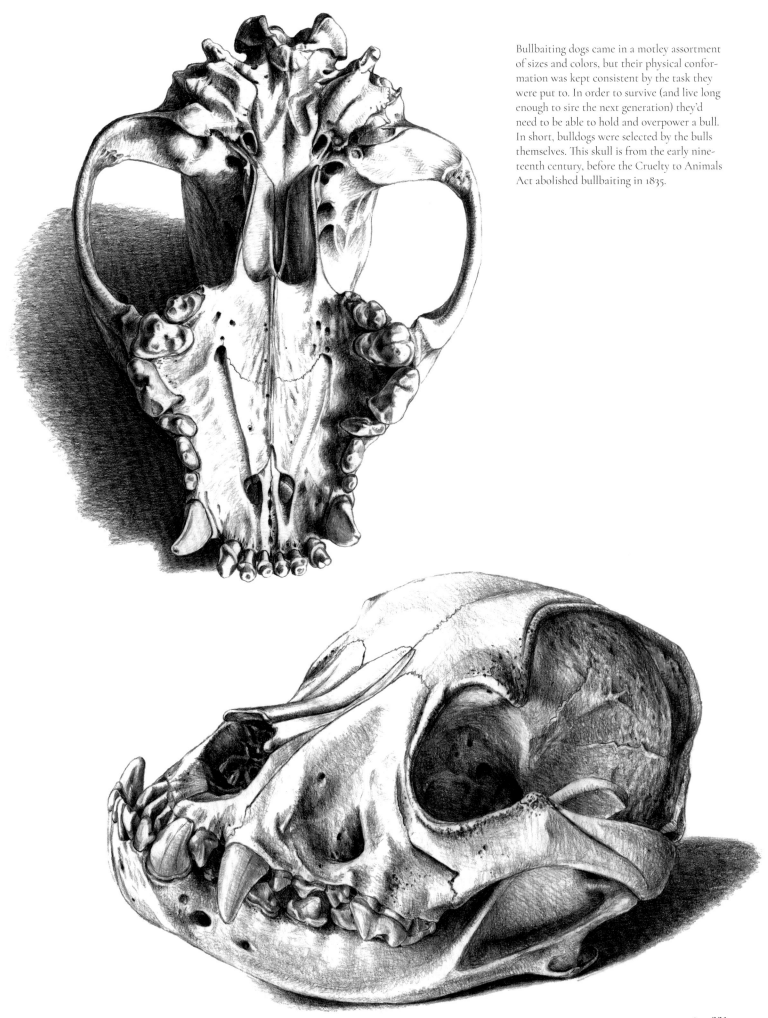

Bullbaiting dogs came in a motley assortment of sizes and colors, but their physical conformation was kept consistent by the task they were put to. In order to survive (and live long enough to sire the next generation) they'd need to be able to hold and overpower a bull. In short, bulldogs were selected by the bulls themselves. This skull is from the early nineteenth century, before the Cruelty to Animals Act abolished bullbaiting in 1835.

Compare the skulls of modern English bulldogs with the early nineteenth-century skull on the previous page. It's hard to believe that they're the same breed, or even the same species. Moving a working breed from a working environment to an exhibition environment is effectively like switching off a thermostat on a heater and watching the temperature creep up, one degree at a time. Even with the best of intentions, change is inevitable.

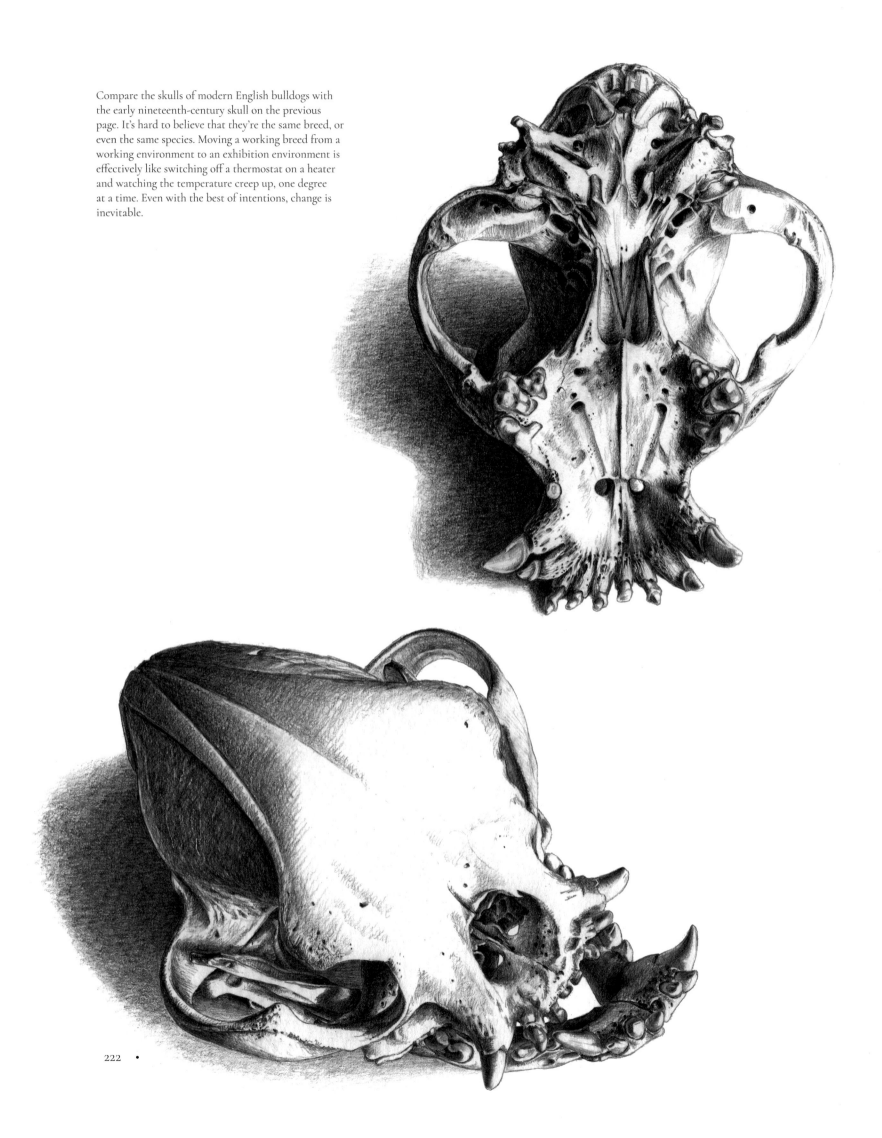

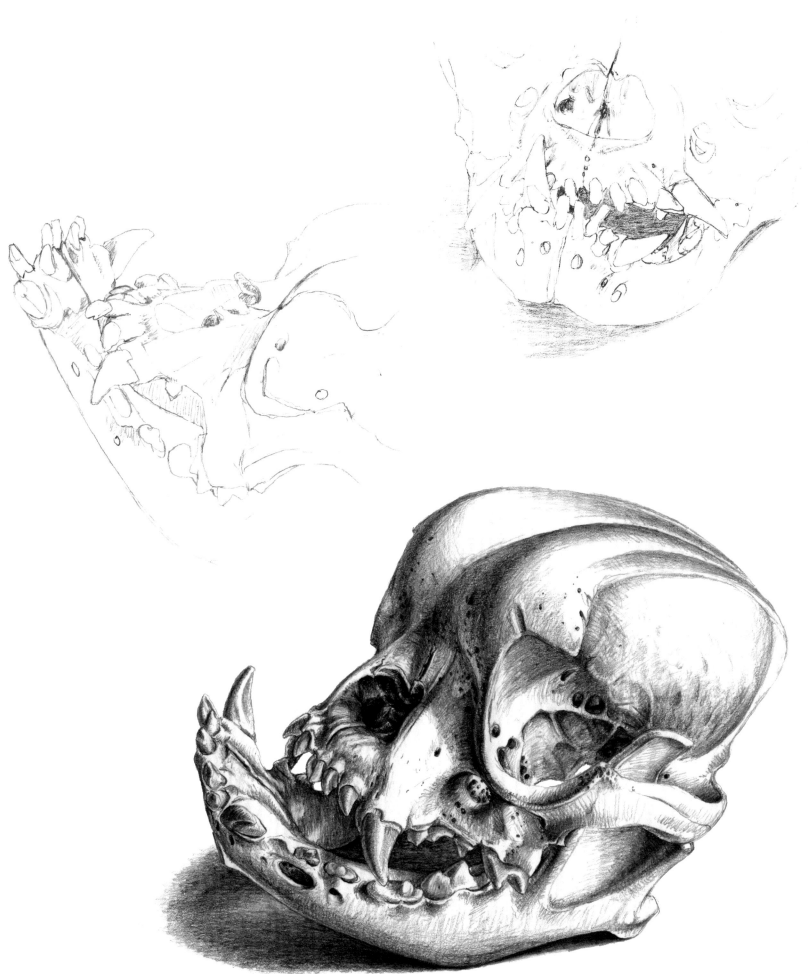

Whiskey and her colleagues were by no means the only domesticated animals facing redundancy as a result of progress. Ironically, one of the chief causes of extinctions of working breeds was legislation passed for the animals' welfare, in particular, the Cruelty to Animals Act of 1835, which brought an end, in England at least, to such sports as bullbaiting and cockfighting—along with the bulldogs and game fowl that took part.

By the time a breed society was formed for the English bulldog in 1874, they'd already been unemployed for thirty-nine years and were in serious trouble. Dog fanciers were slow to see the attraction of what they considered to be ugly, brutish animals, rather too representative of the lower social classes. Even celebrated American lion tamer Isaac van Amburgh, who was impressed by their courage and tenacity, was forced to admit that the bulldog is "rather deficient in its range of ideas."

Working animals are less selected *for* a purpose than *by* a purpose. They're highly specialized products of evolution—as perfectly adapted to their environment as any wild animal in a complex ecosystem. The initial human choice of animal is only the beginning. Ultimately the difference between success and failure lies with the animals' ability to perform the task allotted to them, and the work itself establishes an upper limit beyond which further change ceases to be useful.

For a pre-1835 working bulldog, that meant having a broad, slightly undershot jaw that could grip a bull's muzzle, the energy to be able to maintain its grip against a struggling bull, a nose set back behind the jaws so that it could continue to breathe while holding on, a courageous character, and the agility to dodge the bull's horns. Although there was huge variety in general appearance, all shared the ability to fight and hold bulls. Any pup deemed unsuitable by its human owners would never even be considered. And any marginally unsuitable animal that was pitted against a bull anyway probably wouldn't be siring any pups of its own. In other words, the old English bulldog was created and kept consistent by the bulls themselves.

From the bull's standpoint, by the time you're facing the dogs it's a one-way trip. The bull is at the end of its life regardless of the outcome, so the evolutionary impact on the animals involved would be completely one-sided. Bulls would stay the same, and bulldogs would become better at overpowering bulls to the point where they were efficient and no further. So the physical conformation of old English bulldogs, like many other working types, was probably little changed for centuries, exactly like a stasis situation in nature—evolution appears to stop, though in fact natural selection continues at the same rate, removing the less efficient variants.

Of course as everybody knows, a great many working and former working breeds are represented at shows, and also kept as pets, so you might wonder why I'm talking about extinction. For the answer, compare the skulls of modern English bulldogs with those prior to the mid-nineteenth century. It's hard to believe that they're the same breed, or even the same species. When the environment changes; that is, when there's no longer any work for them to do, the forces that shape working animals and keep them constant disappear. Moving a working breed from a working environment to an exhibition environment is effectively like switching off a thermostat on a heater and watching the temperature creep up, one degree at a time. Even with the best of intentions, change is inevitable.

For animals whose working peers still exist (like guard dogs and gun dogs), their inclusion in the pedigree show world represents a branching point where populations diverged and headed in different directions toward different ends, just like the phylogenetic trees discussed in chapter 2—working animals down one path and changing only very slowly if at all, and exhibition animals down the other, changing rapidly. In cases where the original use of the animal had been banned (like bulldogs) or lost popularity (like turnspit dogs), that branch of the tree might die out entirely, perhaps leaving only a rapidly changing exhibition strain.

Animal fanciers talk a lot about fitness for original purpose. That is to say that breeds created for bullbaiting should still be able to bait a bull *in theory* (even though just about everyone would agree that they shouldn't be given the opportunity in practice). Fitness for purpose—or not—has created a rift between the show and working dog fraternities, with some animosity, especially from the working dog camp. I would argue that it's impossible to maintain fitness for purpose at a theoretical level and you might as well settle for just fitness.

It's unfortunate that the net effect of attempts to restore the appearance of animals like the English bulldog to a period in their history when they were more athletic succeeds only in establishing new minority breeds that compete with, rather than influence, the existing ones. Their presence may even push the existing breed toward greater

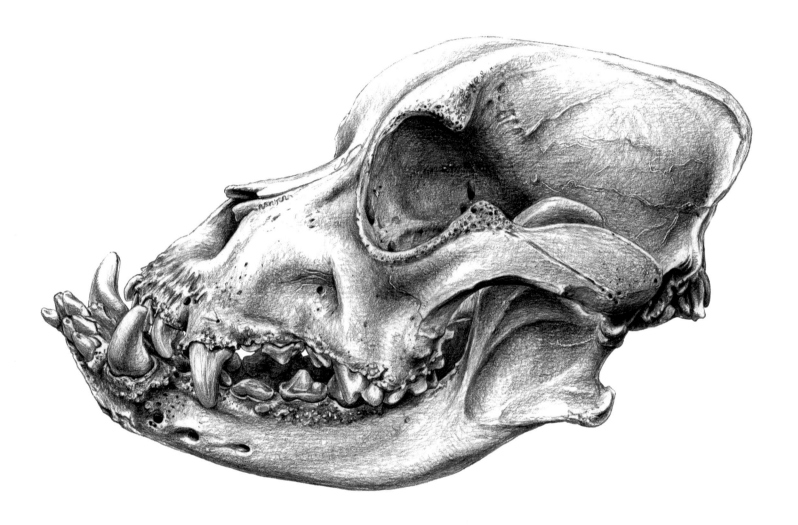

An American dog breeder named David Leavitt successfully re-created a strain of animals with the appearance of the original English bullbaiting dogs though without their ferocious character. You can see, even from this first-generation dog skull, that the conformation is much closer to the desired original type. Leavitt bulldogs are, deservedly, gaining worldwide popularity as pets.

Fighting fowl were another group of working animals that faced redundancy as a result of the 1835 Cruelty to Animals Act. Fortunately for them the passion for cockfighting was replaced with a fashion for poultry exhibitions. Game fowl enthusiasts were divided into two camps. Those who wanted to develop the aesthetic potential of fighting fowl produced the elegant though delicate Modern English game . . .

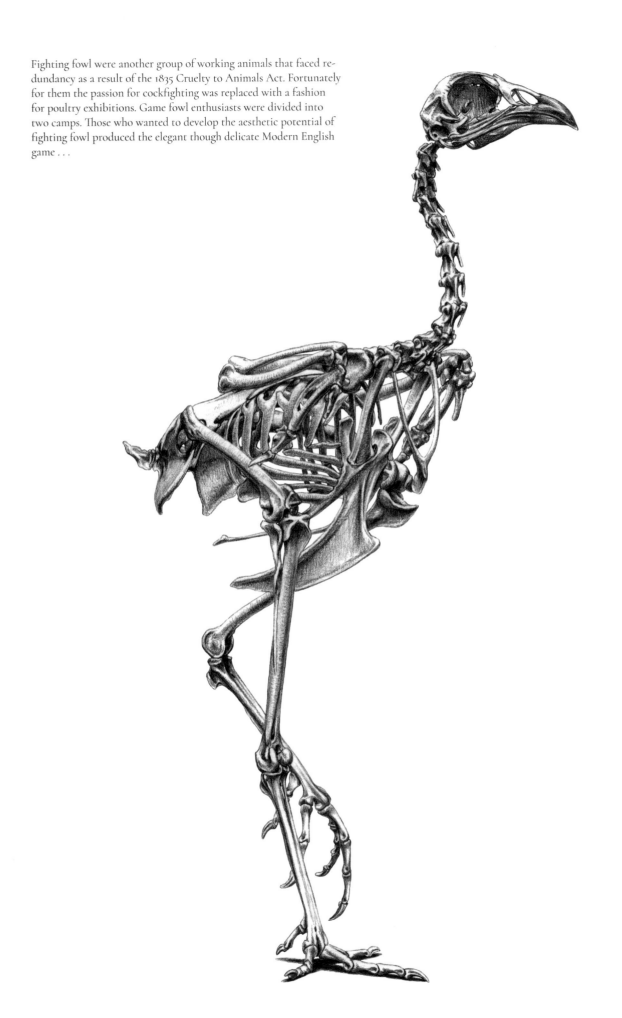

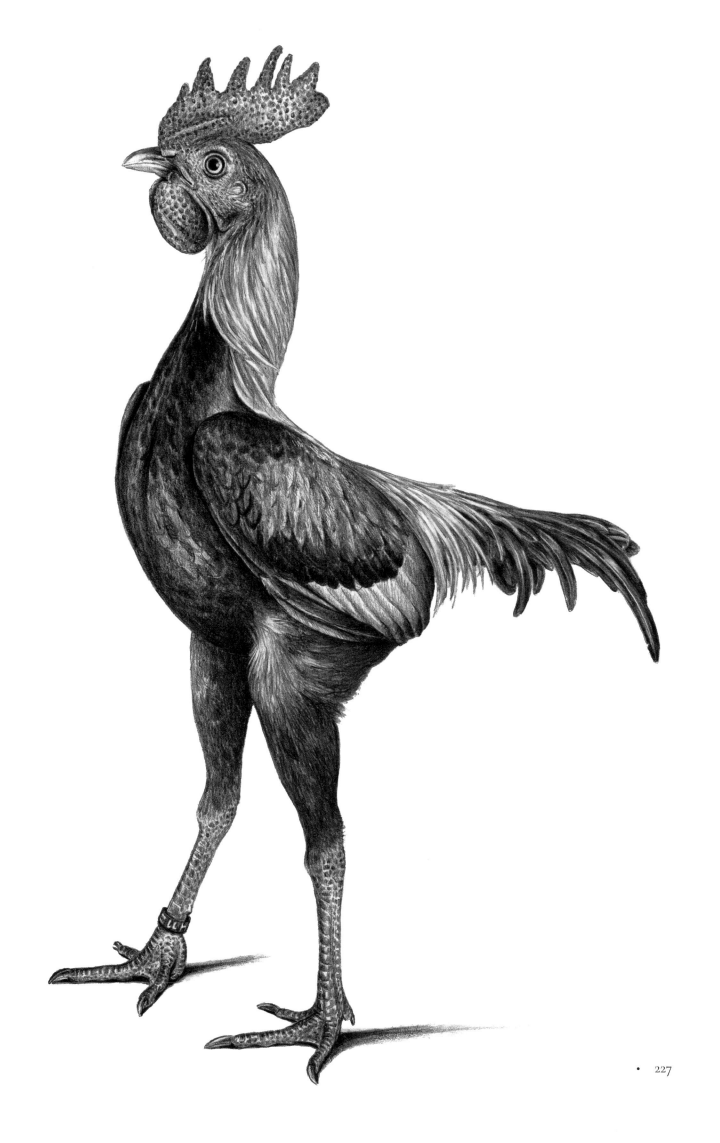

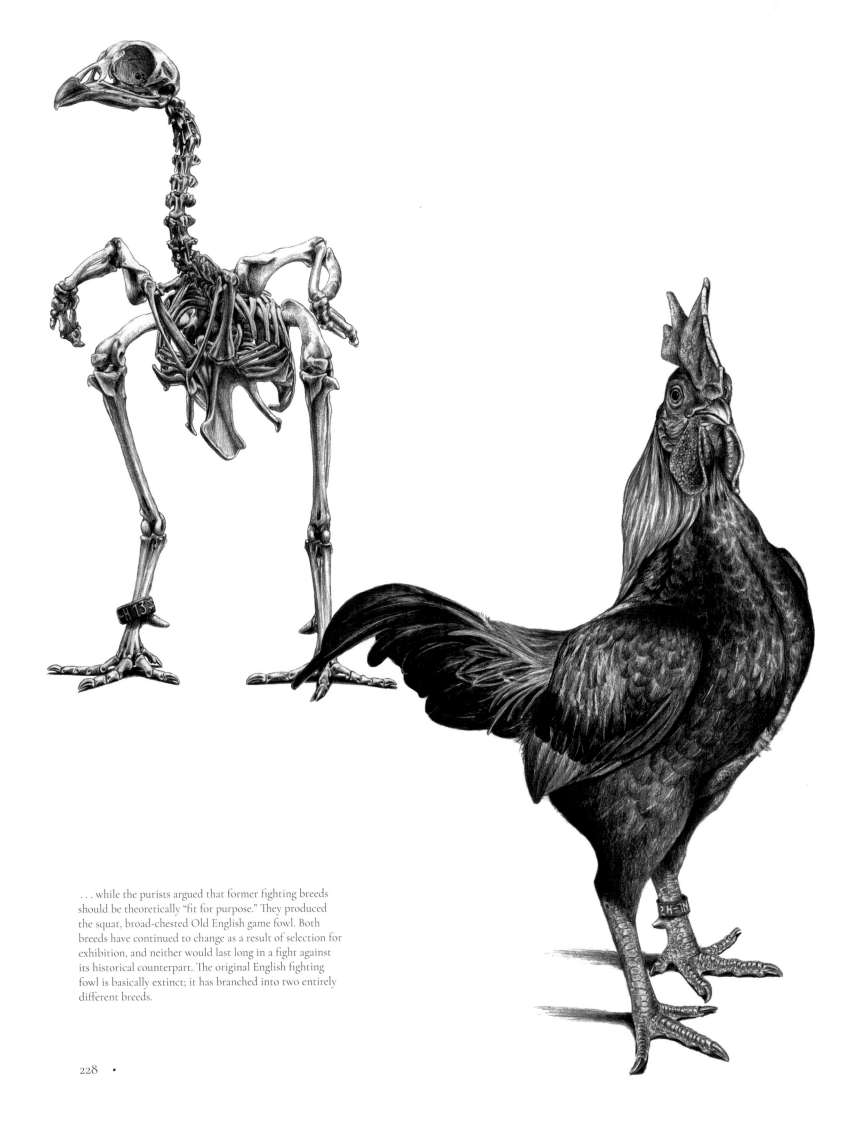

... while the purists argued that former fighting breeds should be theoretically "fit for purpose." They produced the squat, broad-chested Old English game fowl. Both breeds have continued to change as a result of selection for exhibition, and neither would last long in a fight against its historical counterpart. The original English fighting fowl is basically extinct; it has branched into two entirely different breeds.

extremity in order to establish a clear difference, just in the way that two emerging species become reproductively isolated from one another.

An American dog breeder named David Leavitt successfully re-created a strain of animals with the appearance of the original English bullbaiting dogs though without their ferocious character, carefully conducting his research using historical references. He named it the Olde English bulldogge (though he was forced to change the name to Leavitt bulldog to avoid confusion with the creations of other breeders). Although Leavitt bulldogs are, deservedly, gaining popularity worldwide as pets, English bulldogs bred for exhibition unfortunately won't be able to benefit from them, as outcrossing isn't permitted under Kennel Club rules without losing pedigree status. Change in English bulldogs can only come about by amending the breed standard, and by the decisions of show judges, effectively taking the place of the bull by weeding out the unsuitable animals. Thankfully this process has already started.

As with dogs, so also with fowl. The elegant though powerfully built game fowl popular as fighting birds in England prior to the Cruelty to Animals Act no longer exist. Instead we have two fancy breeds resulting from two opposing schools of fanciers: one favoring the aesthetics of the original breed, and the other made up of the purists who want to keep their birds—you guessed it—fit for their original purpose. Both were given different names to avoid confusion. Nearly two hundred years on, the Modern English game is a delicate and slender sylph-like creature that wouldn't last five minutes in a fight against its nineteenth-century counterpart, while the Old English game—at least in continental European fashions—is about as far removed in the opposite direction and rather like a bowling ball on legs. (Both the Old English and Modern English pictured are bantam versions of the larger breeds.)

One rare fighting breed that's on the cusp of evolutionary change is the heavyweight Tula goose that was once popular in many parts of Russia and Eastern Europe. Goose fighting isn't a true blood sport in the same way as cockfighting—the geese seldom if ever actually injure one another—but it is nevertheless banned throughout much of its former range. Tula geese are descended entirely from Greylag stock. They're the bird equivalent of sumo wrestlers, using their immense weight to overcome their opponent. Their large features and deep, rounded bill for gripping make them something of an acquired taste aesthetically and it's unusual to see a Tula goose at a poultry show, though a small number of fanciers are doing their best to perpetuate the breed.

Compare these with another former fighting goose, this time from Germany: the Steinbacher, mentioned in chapter 1. Unlike Tula geese, Steinbachers don't show any obvious adaptations to combat, and have the added advantage of coming in an alternative color known as "blue"—a form of dilution—which makes them very desirable birds for the fancier. Perhaps their fighting style differed from that of Tula geese; or their mixed ancestry from both Greylags and the slender Swan geese gives them their refined appearance. Or perhaps the show Steinbachers and fighting Steinbachers already parted company long ago.

As we've seen with bulldogs and with game fowl, even if Tula geese do earn some popularity as an exhibition breed, under different selection criteria they're certain to diverge along a new evolutionary path or paths, either becoming more butch or more elegant, or even both.

It's no coincidence that the fashion for showing animals sprang up at around the same time that the Cruelty to Animals Act was passed, in the early nineteenth century. People like having a connection with animals, and if they couldn't pit them against one another for sport they'd use them for some other recreational purpose instead. Gatherings in public houses to watch a dogfight or a cockfight would now be replaced with competitions to judge the best dog or rooster from an aesthetic standpoint. Ladies likewise would exhibit their companion dogs in the more genteel setting of the drawing room. Before long, classes were arranged for different types of dog. Dog shows and poultry shows became the hottest new craze, astronomical prices were paid for rare or exotic specimens, and shows were given extra spice by a profusion of cheating and double-dealing. Soon there were active fancies for virtually all domesticated animals.

In addition to new breeds deliberately created by crossing, there were numerous types of animal already available to the growing number of fanciers—many of them working varieties now officially recognized by the newly formed breed societies. There'd be a lot of discussion about what their defining qualities should be and eventually a standard would be written up against which all the animals of that breed would be judged thereafter.

It was all done with the best of intentions and, theoretically at least, seemed to be the perfect way to preserve and maintain the identity of each variety. However, there were a number of flaws in the plan that guaranteed the opposite effect in practice, not least of which were the breed standards themselves. Written descriptions are, by their very nature, rather nebulous and open to interpretation. They can also be updated, which, like a carrot on a stick, effectively keeps the goal tantalizingly out of reach. Ironically, the very system designed to standardize the appearance of animals actually has the effect of "chasing them" in another direction.

The result is rapid evolution, so the explanation is necessarily an evolutionary one. It's competition parallel with the sexual selection of the peacock's train discussed in chapter 3, or with the predator/prey "arms race" between cheetahs and gazelles. It happens when a single ecological relationship applies such pressure on the competing parties that it sends them into evolutionary hyper-drive, stepping up the level of competition at every generation in a runaway process of self-perpetuating change. As long as the most successful animals continue to produce the most offspring within the gene pool, the process will continue unabated. The selective power of breeding for competition really can't be overestimated and must surely be one of the most powerful evolutionary forces in the animal kingdom.

I must here say a few words about the term "natural selection" as it has at least three different applications that can be rather confusing. In its widest sense natural selection can be used, as Darwin intended, to refer to the whole evolutionary process summed up by the equation given in chapter 3: random heritable variation + non-random selection = evolution. Or it can be used specifically to refer to the selection part of the equation, particularly when you want to set it apart from artificial selection. But, as we've seen, selection isn't that straightforward either; there are many facets to evolutionary fitness, with forces sometimes working in opposition to one another.

The third way is to use it to refer to the collective influence of the environment, to distinguish it from the runaway processes of sexual or arms-race selection. In this context, natural selection is a multifaceted network of forces generated by every aspect of the environment, and it influences the entire ecosystem. Runaway selection, by comparison, is rather two-dimensional and acts within species or on specific relationships between species, driving them toward ever-greater extremes.

The two forces (natural selection in this third context, and runaway selection) often act in opposition. Ultimately there's a leveling-out point where runaway selection is curbed by straightforward natural selection in the form of predators or energy requirements. Beyond a certain point individuals will simply not be reproductively successful. For this reason it's tempting to think of runaway selection as a creative, building process to balance the erosive influence of natural selection. It isn't. Runaway processes like sexual selection and predator/prey arms races are just highly specialized forms of the same evolutionary law: that of removing variation.

Domesticated animals—protected from at least some of the ravages of natural selection—have a rather more cushioned existence than their wild counterparts, which means that they're able to be pushed to far greater evolutionary extremes. This begs the question of how far evolution can go. The entire anatomy and physiology of horses, for example, has, over millions of years, become supremely adapted to sustained running at high speeds, and racing has honed that potential in another example of runaway selection. Through selective breeding, the athletic potential of the average racehorse has been significantly raised, closing the gap between the fastest and slowest animals. The net effect is to drive up the level of competition still further.

As is to be expected, Thoroughbred racehorses suffer an increasingly high rate of skeletal injuries, especially on courses with hurdles as opposed to flat races. Fewer track records are being set, and there's a general consensus that racehorses are less hardy than they were fifty years ago. This is only a handful of horse generations—which would be a very rapid decline when you consider that selection should be improving their performance. It's simply not possible to go on breaking speed records indefinitely; at some point an evolutionary plateau has to be reached and it's probable that the Thoroughbred has reached the point where it's impossible to run faster.

Cushioned as they may be, domesticated animals are still subject to natural selection. It's true that stout fences and strict hygiene will deter foxes and bacteria, but foxes and bacteria are nevertheless major causes of chicken deaths. Sheep still die in snowdrifts, and racing pigeons are still killed by peregrines. These aren't necessarily

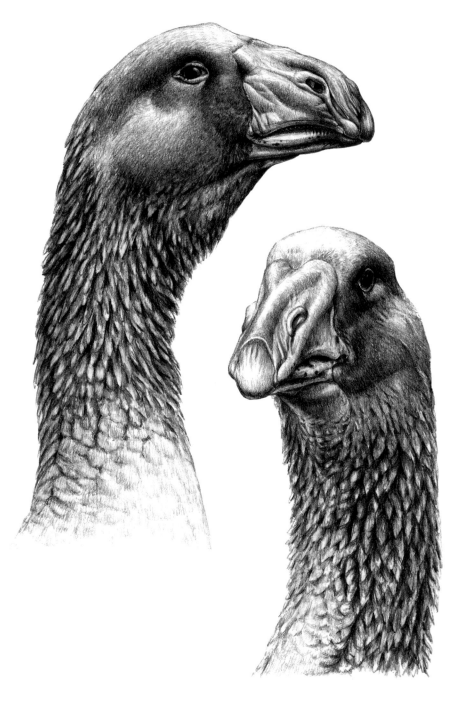

random accidents; the animals that survive, survive because they can. Those that succumb are competitively less efficient. While all this is going on, human owners are independently applying their own artificial selection—sometimes in opposition to natural selection, sometimes in accordance with it. Ever wondered how foxes have that uncanny knack of taking your very best exhibition birds? While this might seem like an infuriating case of Sod's Law, it's more likely that these are the individuals that are most changed—comparatively the easiest prey. The selective influence of predation by foxes and that of the human owner breeding for exhibition are working in opposition. (Okay, there's probably an element of Sod's Law at work too.)

Racing pigeon enthusiasts, on the other hand, want the fastest birds with the best homing instinct. Peregrines (which have been hard at work perfecting the speed and agility of racing pigeons' wild ancestor for thousands of years already) want to eat any pigeon they can catch, so both are effectively working toward the same end—though I've yet to meet a racing pigeon breeder who sees it that way. Peregrines don't want pigeons to be fast and agile, but by polishing off the slower ones they're literally chasing the pigeons of future generations in that direction. Pigeons, meanwhile, although they definitely don't want to be eaten either, inadvertently ensure that only the fastest, most agile peregrines pass on their genes to the next generation too. It's no accident that peregrines and pigeons, especially Racing homers (pictured in chapter 4) with their deep, muscular chest, short tail, and stout pointed wings, share a similar aerodynamic conformation. Once again, it's an arms race.

For Darwin, the apparently conflicting forces of different sorts of selection in nature were still unclear, particularly relating to sexual selection.

One rare fighting breed on the cusp of evolutionary change is the heavyweight Tula goose. Goose fighting isn't a true blood sport in the same way as cockfighting—the geese seldom if ever actually injure one another—but it is nevertheless banned throughout much of its former range. Even if Tula geese do gain popularity as an exhibition breed, they're certain to diverge along a new evolutionary path or paths, either becoming more butch or more elegant, or even both.

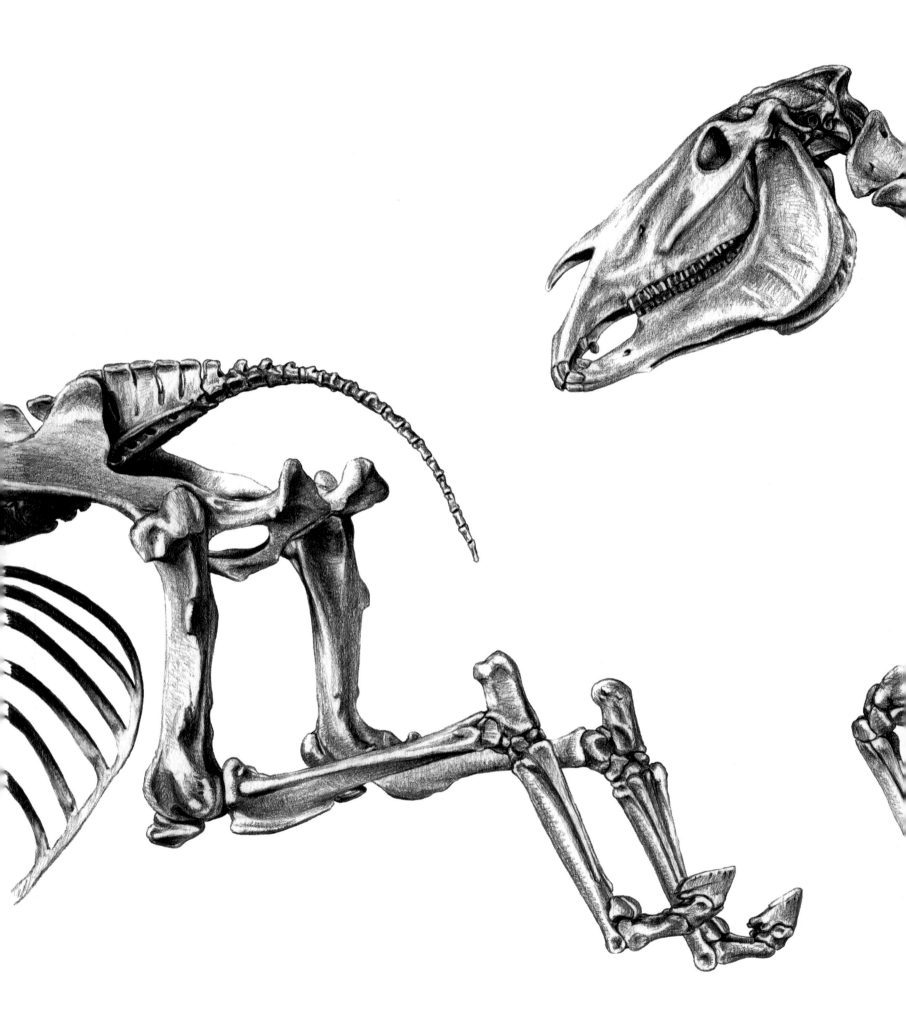

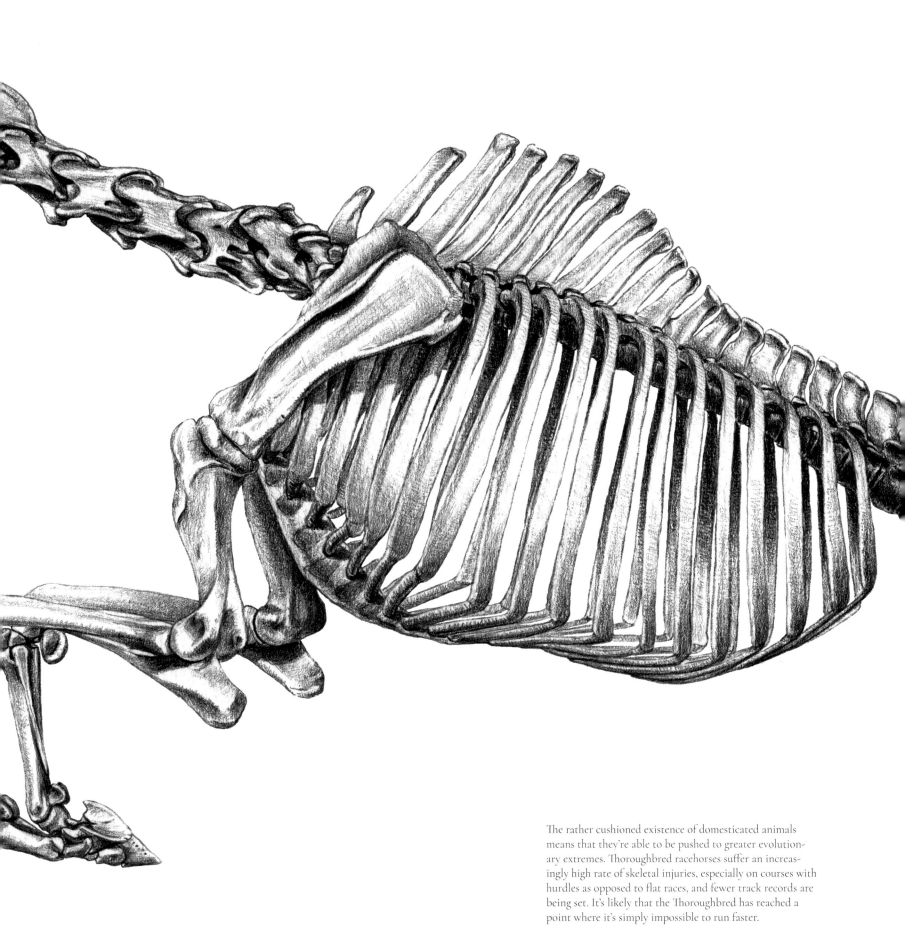

The rather cushioned existence of domesticated animals means that they're able to be pushed to greater evolutionary extremes. Thoroughbred racehorses suffer an increasingly high rate of skeletal injuries, especially on courses with hurdles as opposed to flat races, and fewer track records are being set. It's likely that the Thoroughbred has reached a point where it's simply impossible to run faster.

For example, the brightly colored plumage of male birds of many species seemed to contradict everything he'd come to understand about the struggle for survival. Such lavish adornments are indeed tantamount to carrying around a large sign saying "EAT ME." Although Darwin was aware that the disadvantages would be offset if they resulted in an increased number of offspring, he wasn't ready to understand how such a vortex of non-adaptive traits could come about. (This revelation—that the process is driven by female preference—would have to wait for the work of Ronald Fisher in the 1930s.) "The sight of a feather in a peacock's tail," Darwin complained, "whenever I gaze at it, makes me sick!"

Darwin recognized a distinction between what he called "conscious" artificial selection to create and improve breeds, and "unconscious" selection, meaning an undirected preference for attractive, tractable, productive animals. But what he was actually observing was the equivalent to the very fastest runaway processes in evolution compared with normal environmental natural selection. Serious competitive breeders, just like peahens, chase ever-elusive goals.

The major distinction between natural and artificial selection is that natural selection lacks foresight, acting only on the qualities that are beneficial to a single individual within its immediate environment. Every single step must offer an advantage, and be competitively successful. Artificial selection, by comparison, can plan ahead, even anticipating the genotype of subsequent generations.

Imagine a stone carver chipping away at a block of marble. He's constrained by the proportions of the marble, which is fortunately quite large, as his tools allow him only to chip away and not to cement bits on. Now there are different approaches he can follow. He can make it up as he goes along, according to what "works." Or he can plan it in advance, being careful to leave enough marble intact in the places where he wants his subject's arms and head to go. Both are processes of removal—he's not sticking on any extra bits of stone—but one course of action is with deliberate direction, whereas the other is undirected. (Being undirected is *not* the same as being random.) This is the difference between unconscious and conscious artificial selection. In fact, most of the directed planning that the stone carver does in artificial selection is done at the very end—millions of years of natural selection have already set the parameters. Of course this analogy is purely metaphorical. The stone carver in evolution is simply a remover of things that don't work as well as others.

Figuring out the selective forces at work in the creation of a breed far removed from its wild ancestor is often something of a challenge—especially because, just as in nature, it may have been adapted and counter-adapted to different ends over long periods of time. Darwin was particularly puzzled by the origins of the Indian runner duck—then known as "penguin ducks" because of their upright posture. Modern exhibition Runner ducks have the shape and stature of a wine bottle (which is probably why they're a particular favorite of mine), quite perpendicular to the horizontal posture of a mallard. They're ancient. Carvings of them are alleged to feature on the walls of the ninth-century temple of Borobudur in Java, so the reason for their gradual rotation through 90 degrees will never be known for sure. People therefore guess. And the guesses usually involve a conscious decision to create ducks of that shape, rather than the shape being the incidental outcome of an unconscious selective pressure.

The methods of husbandry in their native Indonesia (the "Indian" part of their name is generic, loosely referring to anything Eastern) have probably changed very little over the centuries. They're caged at night, and every day they're led out into the rice paddies in vast flocks to feed. They're trained to follow a colored rag tied to the end of a bamboo pole, like a party of tourists following their tour guide. Their height makes them easily visible above the tall vegetation so it's often assumed that the upright posture was selected for this reason. However, rice grows rather higher than the height of a mallard so it would have taken quite some foresight to begin deliberately selecting *marginally* more upright individuals with that end in mind. Another suggestion is that taller birds would have been able to reach insects better than shorter ones but, again, unless the slight difference in food intake affected their reproductive capacity (remember these are captive birds and wouldn't usually starve) this would have little effect on selection. Maybe taller birds would be able to spot approaching predators? But they'd also be spotted by them.

To me the most logical evolutionary path was not by deliberate selection for appearance, but by unconscious selection for sustained walking. Wild mallards originally evolved for swimming and dabbling in shallow water, not for marching long distances. Drovers nevertheless lead vast flocks of Runner ducks, again following the pole adorned with its conspicuous rag, on journeys lasting up to several months. Slower birds that hindered progress would be

the ones that were more vulnerable—they'd be a nuisance and, being tired, would be easier to catch by both predators and the drovers for their evening meal. Gradually the gene pool of ducks (I like the idea of a pool of ducks) would become populated with more upright birds with a posture better suited to long journeys on foot.

However, anyone who's seen vertical exhibition Runner ducks outside of Indonesia will agree that they walk rather clumsily, with small strides. The clue here is "outside of Indonesia." The rather less upright ducks that still forage in the rice paddies are at their optimum performance and have probably looked the same for centuries, barely resembling the birds kept for exhibition. Once again, it's all down to differences in the type of selection—on the one hand functional, self-stabilizing adaptation, on the other, a runaway process of self-perpetuating change.

For Darwin the Runner duck problem wasn't just the selection pressures that created them, but the identity of their original wild ancestor. After measuring hundreds of duck bones and getting nowhere it was the curly tail feathers that eventually clinched it. Among all wild duck species only mallards have curled central tail feathers, so it seemed logical that any domesticated duck with a curly tail, even as unusual as a Runner duck, would probably (though not necessarily) be descended from a mallard.

Darwin was intrigued by Runner ducks, especially by the identity of their original wild ancestor. It was the curly tail feathers that eventually clinched it. Among all wild duck species only Mallards have curled central tail feathers, so it seemed logical that any domesticated duck with a curly tail, even as unusual as a Runner duck, would probably (though not necessarily) be descended from a Mallard.

Natural selection in its broadest, Darwinian sense is, as I've stressed throughout this book, an irrepressible force, highly sensitive to the slightest change. It's startling how quickly a relaxation in selection pressure, or even an unconscious shift in the emphasis of selection, can take effect. Selection for improved meat in sheep, for example, was invariably bought at the cost of compromised wool production. Darwin gives the account (originally observed by his colleague William Youatt, a veterinary surgeon) of two flocks of sheep belonging to neighboring farmers, Mr. Buckley and Mr. Burgess. Both flocks were derived solely from purebred stock procured from Robert Bakewell's famous strain of New Leicester sheep and yet, within fifty years, they had diverged so much in appearance that they resembled two altogether different varieties. This isn't an isolated example, and I'm certain that many animal fanciers today have similar stories to tell.

Husband has two bird-keeper friends in the Netherlands, both of whom keep a rare pigeon breed from Turkey called a Kumru, one of several breeds known as "laughers". (We keep them too, and they really are a delight.) Instead of cooing rhythmically like other pigeons, laughers laugh. In fact it's rather like the sound of a troop of hysterical gibbons sharing a joke. In their native Turkey, Kumrus are selected solely for their frequency of laughing. The sound itself is the result of a single-step mutation and isn't subject to much further change, but selection can result in birds that laugh constantly, a loft of them encouraging one another and keeping up a steady stream of whooping and giggling all day. Husband's two friends both started out with very vociferous birds imported directly from Turkey. While both men enjoyed the sound, one of them continued to breed only from the birds that called most consistently, while the other rather liked the pattern of white markings on the face and he allowed his bias toward the most

attractive individuals to influence his selection. When Husband visited again after a few years that loft was silent for much of the time, while the other friend's pigeons continued to drown out all other sound from dawn to dusk.

Visit a fancy pigeon show and you'll see countless different ornamental varieties described as "rollers" and "tumblers." There are also "highfliers" and "ringbeaters." Just like the exhibition varieties of homing and racing pigeons discussed in chapter 4, these are performance breeds in name only. For a performing roller or tumbler pigeon, the task is to fly high in the air in a tight-knit flock or "kit," then fall from the air, regaining flight after several seconds. To a trained eye the effect is impressive. Once again, it takes unwavering selection for a task to produce a bird capable of performing it to a consistent degree of excellence. Slacken selection for even just a few generations and emphasis on certain behaviors over others will likewise slacken.

Performance flying has been practiced for centuries. (In the Far East it was once popular to attach tiny whistles that resonate in the wind as the birds fly.) Although there are still plenty of flying breeds kept for performance, these tend to be of entirely different strains than those developed for exhibition. The fancies, too, have largely separated, with different communities of racing, performance, and exhibition fanciers.

Pigeons are highly sociable, so it's not unusual to attract birds from other flocks that then return with them to their own loft, so a pigeon fancier can lose or gain birds in this way. Deliberately attracting a neighbor's birds—then selling them back to him—is all part of the fun, and several breeds, known collectively as "thief pigeons," which are irresistibly attractive to the opposite sex, have been developed specifically for this purpose. Husband tells me there was a pet shop in The Hague in his youth where owners could buy back their own birds, and I'm sure there are still shops like this in other cities where pigeon flying is popular.

Pigeon theft hasn't always been conducted with such harmless good humor. In Spain and Italy during the Middle Ages and onward—especially in the city of Modena—feuding gangs of *triganieri*, described by a contemporary as "a company of loose livers, given up to gaming and pigeon flying," lost no opportunity to intimidate their rivals by killing the stolen birds and publicly exhibiting their corpses, or even attaching a vial of gunpowder and a lit fuse to a bird and releasing it back with its rightful owner's flock!

Looking at the modern exhibition Modena pigeon it's difficult to imagine their tyrannical history. They look rather like a dumpy chicken, with straight legs set far apart, a horizontal body, and a short upright tail. Show standards favor large birds, so the size of the modern exhibition Modena far exceeds that of the original diminutive fliers, placing an excessive amount of weight on their skeletal frame. But their performance requirements are minimal. The attraction of exhibition Modenas is their color. Already by the end of the nineteenth century they came in 152 colors and they now have more varieties than almost any other pigeon breed.

It's important to remember that 99 percent of an animal's aptitude for a task is already inherent in its wild ancestor. Wolves track prey for miles, surround it, and often fight rivals. So humans are only tweaking these traits to different ends by producing dogs that specialize in tracking, herding, and fighting. By selective breeding, they're not only accentuating the instinct for the desired traits but suppressing opposing instincts. Pointer dogs aren't intentionally pointing out game for their owners. They're merely prolonging the hesitation that all dogs, wild and domesticated, take before a pounce—without ever pouncing.

In another example, some chicken and duck breeds are better layers than others. It's a bird's natural instinct to go broody and begin incubating eggs, but by selecting for hens that are less inclined to sit, you're effectively producing a strain that will continue to lay eggs every day without ever attempting to incubate them. Laying breeds are produced by selecting the hens that are potentially the worst mothers!

The forces of nature—the climate, eating and being eaten, courtship and baby animals, the complex interactions of different life forms and the structures they build—these are things we take an interest in, that we watch on the Discovery Channel or outside our windows, and about which we nod in agreement that evolution is indeed a marvelous thing. A TV program about tiny mutations probably wouldn't get that many viewers. For this reason it's easy to forget that the *selection* element in natural selection is only half the equation. Selection doesn't generate diversity; it only removes it. As miraculous as selection is, it can only work on the variations that are available, and, in order for a variant form to be successful, it has to occur at the right time and place, in an environment that will allow it to flourish.

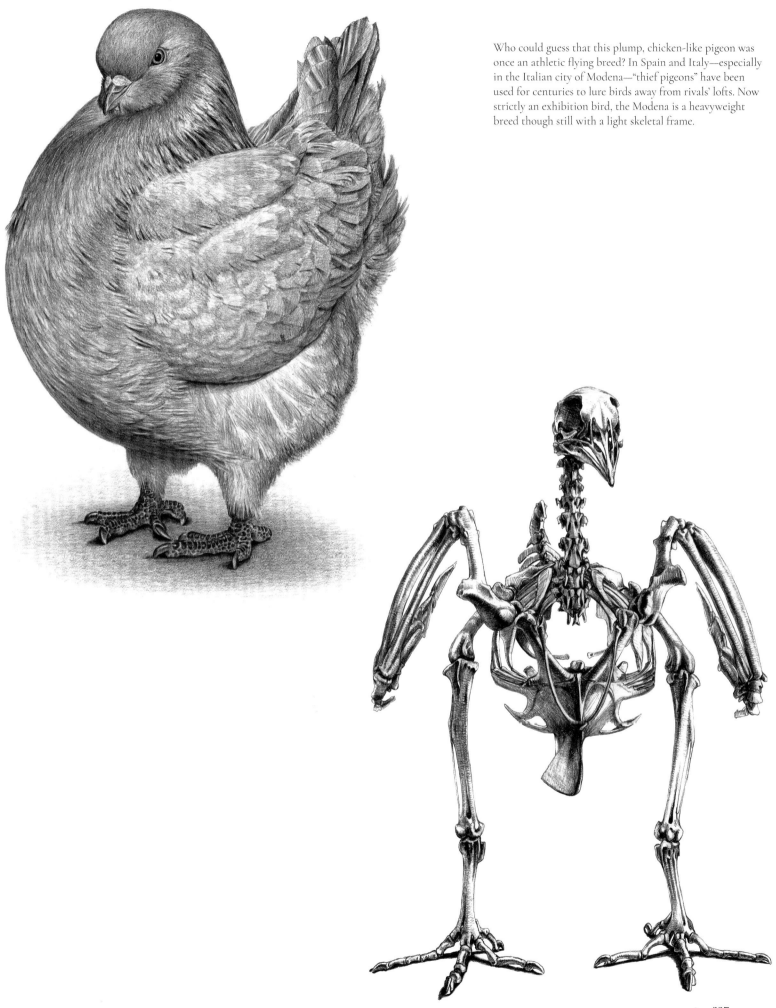

Who could guess that this plump, chicken-like pigeon was once an athletic flying breed? In Spain and Italy—especially in the Italian city of Modena—"thief pigeons" have been used for centuries to lure birds away from rivals' lofts. Now strictly an exhibition bird, the Modena is a heavyweight breed though still with a light skeletal frame.

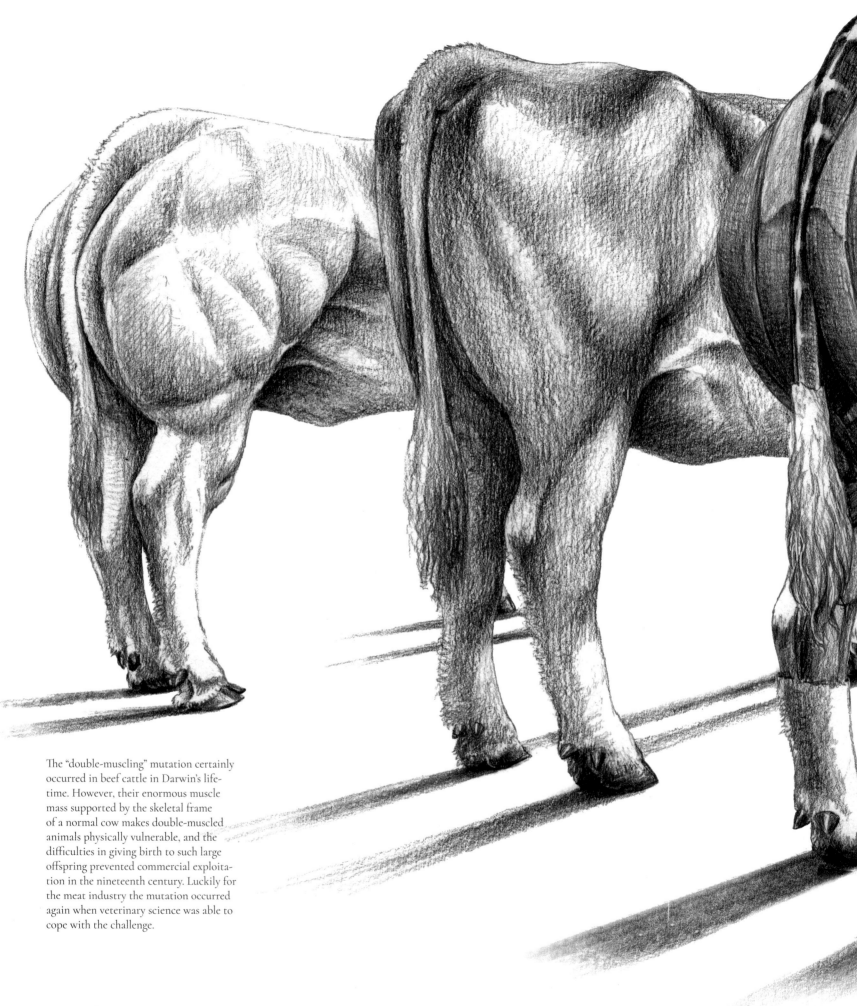

The "double-muscling" mutation certainly occurred in beef cattle in Darwin's lifetime. However, their enormous muscle mass supported by the skeletal frame of a normal cow makes double-muscled animals physically vulnerable, and the difficulties in giving birth to such large offspring prevented commercial exploitation in the nineteenth century. Luckily for the meat industry the mutation occurred again when veterinary science was able to cope with the challenge.

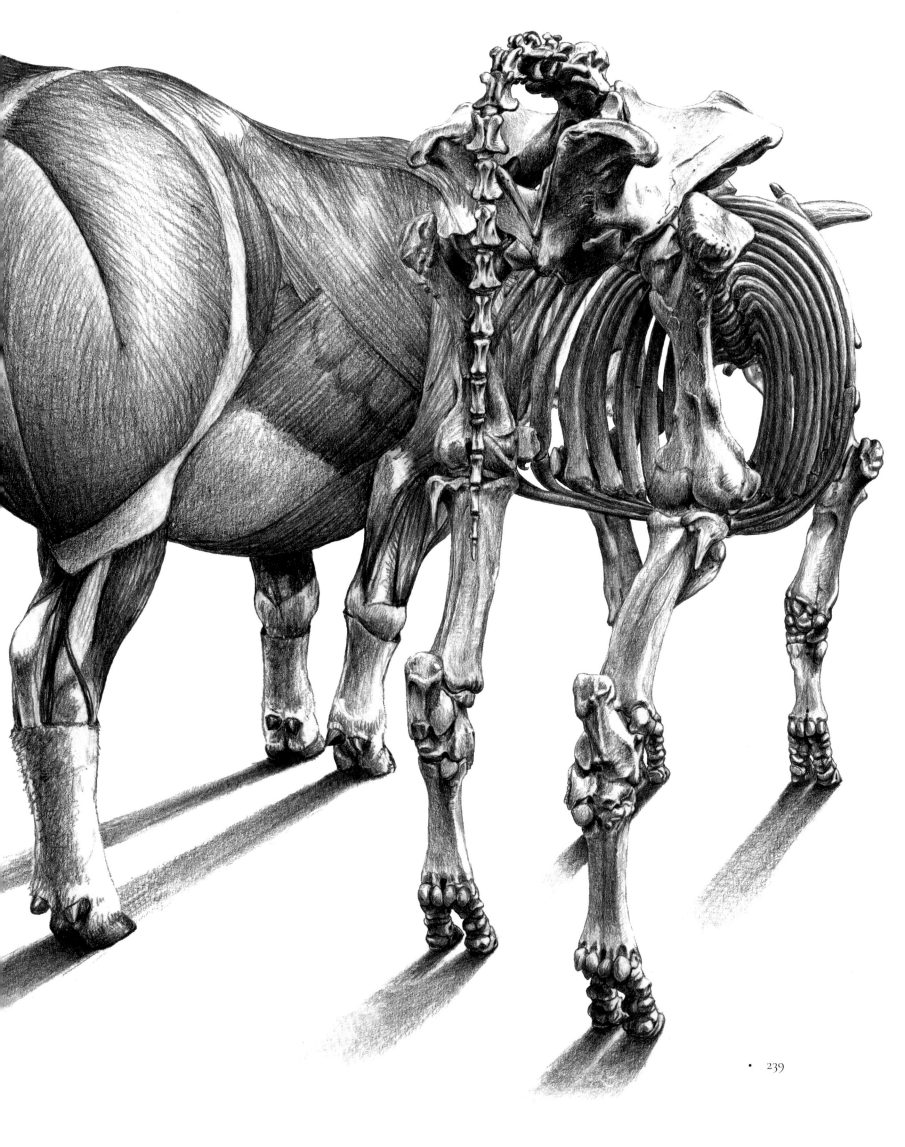

No one could deny that both of these goldfish varieties—the Tosakin on the right, and the Bristol shubunkin on the left—are beautiful. But while the gorgeous iris-flower shape of the Tosakin's tail ideally needs to be seen from the traditional viewpoint—looking down from above—it takes a side view—as seen through a glass aquarium—to really appreciate the full glory of the Shubunkin. Glass aquaria are, however, only a recent development in the cultural history of goldfish breeding. How many beautiful variations were missed before the time came for fish to be viewed this way?

The "double-muscling" mutation discussed in chapter 8 certainly occurred in beef cattle in Darwin's lifetime, and agriculturalists were quick to recognize its potential. However, the time simply wasn't right. Their enormous muscle mass supported by the skeletal frame of a normal cow makes double-muscled animals physically vulnerable, and the difficulties in giving birth to such large offspring prevented any commercial exploitation in the nineteenth century. Luckily for the meat industry the mutation occurred again when veterinary science was able to cope with the challenge.

We visited a farm in Belgium where the semen of double-muscled Belgian blue bulls was used to inseminate normal cows to produce beef cattle. The technology was state of the art. When cows are ready to give birth, sensors responding to their hormonal changes automatically alert a veterinary surgeon who would be on hand at the right time to perform a caesarian. Unnatural as it is, there are far fewer casualties from this method than from natural births, even of normal-sized calves.

For a less commercial, more aesthetic example you only have to look underwater. The question is—how? It took a surprisingly long time before the underwater world was enjoyed from a fish's perspective. Before the latter half of the nineteenth century illustrations of aquatic life invariably portrayed it uncomfortably hauled up onshore, while more imaginative renditions of fishes or extinct marine reptiles put them writhing at the water's surface among the waves. Human imagination simply hadn't envisaged underwater animals in any other way. Even as the materials and technology became available to build watertight glass tanks, they were fashionable initially in the form of Wardian cases—tiny, enclosed, self-sustaining gardens for plants only. It wasn't until the craze for keeping ferns had run its course that the aquarium ascended to prominence.

Nevertheless, keeping freshwater fish in ponds and shallow ceramic bowls had been practiced for centuries, particularly in China where color aberrations in the wild silver-bronze colored Prussian carp led to the development of the domesticated goldfish. Further mutations resulting in a double tail that fans out on either side, a rounded body, or large globular eyes could be easily appreciated from above—particularly in animals kept in shallow bowls. Some varieties actually look better when viewed this way. The beautiful Tosakin, for example (a Japanese breed), has a double tail attached along its upper edge to form a single curled fin, extending in a semicircle around the body in the shape of an ornamental iris flower. (The Tosakin was almost wiped out during the World War II air strike on Japan in 1945 and an earthquake the following year. Its continued existence is due solely to the determination of a single fancier who managed to locate six fish in a restaurant, of all places. Fortunately the restaurant owner was willing to trade the fish in exchange for a bottle of Japanese potato vodka—*shōchū*!)

But there are many fancy goldfish traits, such as the absence of the dorsal fin, a deep or hunched body, or an exquisitely shaped single tail, along with many colors and patterns, which can only be fully appreciated when viewed from the side, in a glass aquarium. Domesticated goldfish owe their rich diversity to the changing ways they've been viewed throughout history. Or, to look at it another way, who knows how many wonderful and beautiful goldfish mutations had been overlooked prior to the nineteenth century; how many potential new varieties emerged and disappeared unseen, simply because human culture was not yet ready for them?

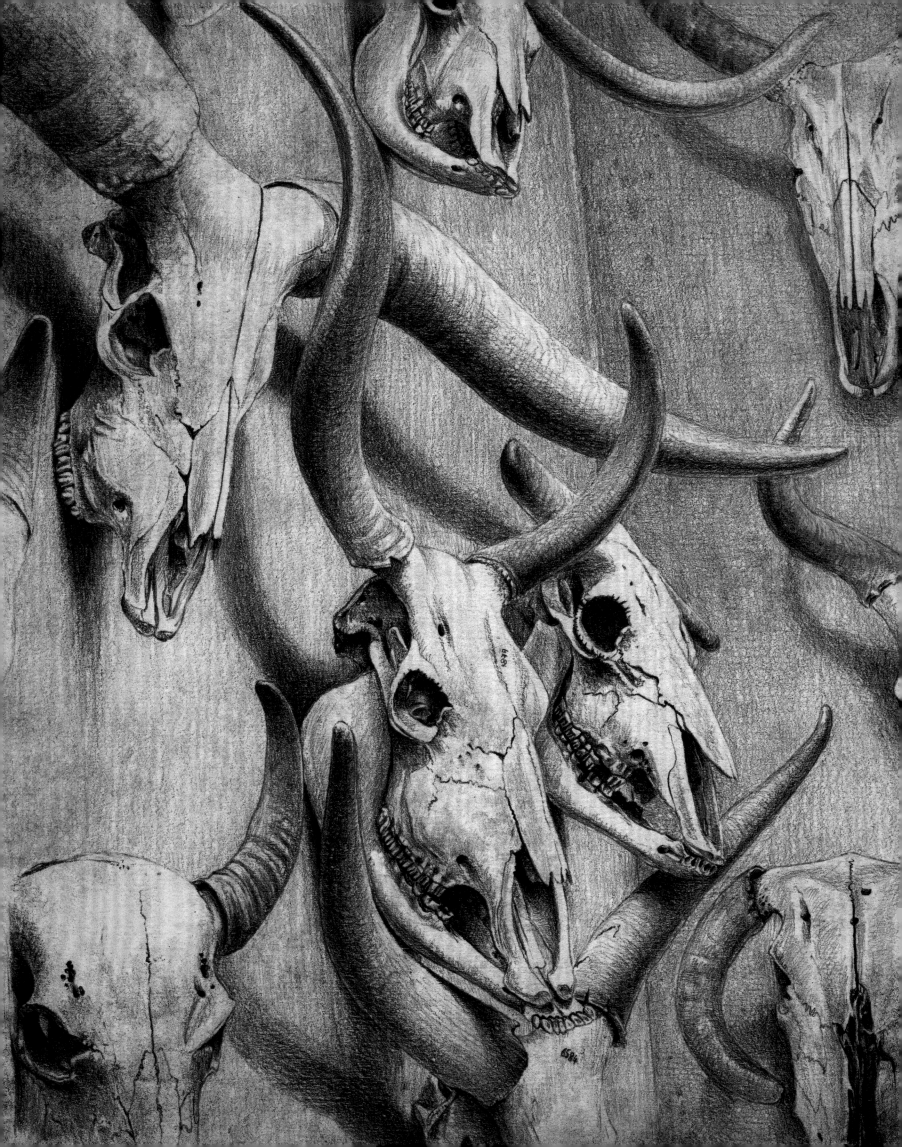

IV
SELECTION

11. ISLANDS OF ALL KINDS

11 ~ Islands of All Kinds

So said the cat, and he was Manx
"Oh, Captain Noah, wait!
I'll catch the mice to give you thanks
And pay for being late."
And so the cat got in, but oh,
His tail was a bit too slow!

And this, according to the *Girls' and Boys' Own Magazine*, published by the Detroit Free Press in 1927, is why the Manx cat has no tail. It's a good story. Making a last-minute dash for the Ark as the rain starts, the gangplank already being drawn up, the cat has to blag its way past Noah but pays the price for its tardiness by having its tail cut off by the closing door.

Another explanation, from 1845, claims that Manx cats are the hybrid offspring of cats and rabbits, giving rise to the fictional "cabbit." And a third, as you may remember from chapter 4, maintains that simply losing their tail by accident can cause normal cats to give birth to tailless kittens.

I like the Noah version best. Part morality tale and part "just so story" with an extra pinch of salt (I love all tales about ships and the sea); the account of the Flood has to be everyone's favorite Bible story. Of course, if you recall August Weismann's experiments on mice, you'll know that no matter what befalls the tail of animals causing them to become separated from their body, heritable taillessness is a result of a random mutation. Although it was to remain tailless forever after, the Manx cat still lives on, especially on the island from which it gets its name: the Isle of Man, halfway between England and Ireland in the Irish Sea.

Asking why something is as it is—why the leopard has spots or the elephant its trunk—is a very commendable practice, especially if you're interested in evolution. However, the answers are rarely as straightforward as we'd like. Things like spots and trunks may be well adapted for particular purposes, but they exist because the ancestors of leopards and elephants had set the path for them, and originally these and all the other structures in nature—things like feathers and flowers—may have had a very different function from what they have now. It's also true that many non-adaptive traits are favored in domesticated animals by human owners purely for aesthetic reasons. Or there might be no reason whatever. Different sorts of animals exist *because they can*. Not everything in nature is an adaptation.

 In countless tribal communities across the whole African continent, herdsmen take enormous pride in maintaining their particular cattle strains, each with a very specific horn shape, color or pattern, and each of vital cultural significance and value. Islands, as oases where individual traits may flourish, come in many different forms.

Take Mulefoot hogs. Instead of having the usual cloven hooves of other pigs, Mulefoots (no, not "mulefeet") have a single hoof like that of a horse (or a mule). It's caused by the partial fusion of the bones of the two central digits, which are covered by a single nail instead of two, sometimes dented in the middle where the digits join. Mulefoots were originally kept in the swamplands of the Mississippi River Valley, so it was natural (though entirely erroneous) to assume that the resulting broad "toe" is an adaptation to living on marshy ground. It isn't. Although Mulefoots are the only animals in which this trait has been established in a recognized breed, the mutation—called syndactyly—is random, and can happen in virtually any vertebrate. Except horses!

On my latest visit to Crufts Dog Show I spent my entire day at the British Kennel Club's excellent annual exhibit Discover Dogs. It's actually intended to help people choose a pedigree puppy, but I took advantage of the opportunity to interrogate lots of dog fanciers about the history and development of their chosen breed, and generally make a nuisance of myself. One of the things I learned was that not even expert breeders are immune from the temptation to assign adaptations to just about every feature.

Newfoundland dogs famously have webbing between their digits. They also happen to be inordinately fond of water. Whether their webbed feet are an adaptation to swimming or not, we shall probably never know. Darwin certainly thought so, and described the process by which the skin between the toes might increase a little with each generation, giving a competitive advantage to dogs in a watery environment. (Darwin was possibly quite wrong about the gradual evolution of webbed feet. At least in ducks it's caused by a single genetic switch that turns off the process of cell death between the digits in the developing embryo.) I'm rather more skeptical. Although they may indeed help Newfoundlands swim, I don't believe that webbed feet would have made a sufficient difference to their performance to affect either their survival by natural selection or their selection by humans.

Either way, there are a lot of breeds whose webbed feet can't be attributed to swimming. From the nice people at Discover Dogs I learned that salukis—sight hounds of the deserts of the Middle East—evolved webbed feet for running on sand, and another breed that I've now forgotten evolved them for clambering over rocks. I was also told that the French herding dog the Beauceron and its close relative the Briard had evolved double dewclaws on their hind feet for agility and ease of movement over rough terrain. Dewclaws are a form of polydactyly—the development of additional digits. In the hind feet of dogs they're rarely attached by more than a flange of skin and usually have no independent movement, so it's highly unlikely that a dog breed would have evolved them for a particular purpose.

Whenever traits like these occur regularly, and independently of artificial selection, you'll hear people attempting to pass them off as adaptations—putting two and two together to make five. (I even read—on the Internet of course—that dalmatians evolved their spotted coat for camouflage!) What's far more likely is that traits like dewclaws and webbed feet were present in the founding community of individuals and became established as a result of a fairly limited gene flow with other populations. To return to Manx cats, then, taillessness doesn't have to have a reason.

Non-adaptive traits can, nevertheless, tell us something about the animal's environment. Instead of asking why Manx cats have no tail, a better question might be, "Why are there so many tailless cats on the Isle of Man?" And to this, the simple, and correct, answer is, "Because it's an island."

Again, there are a number of stories on this subject, and many of them involve shipwrecks. I hinted earlier how often shipwrecks are invoked as a means of explaining the unexpected presence of animals in certain places. Well, Manx cats have more than their share. There's a choice of at least three. One involves ships of the Spanish Armada wrecked off the island's southwest coast. Another, from the north, actually includes an eyewitness account of a "rumpy cat" swimming ashore! However, whether by shipwreck or spontaneous mutation, the presence of a consistent ratio of tailless cats within the island's cat population isn't a matter of how they came to be there but how the population has remained stable.

There's a big difference between cats that have lost their tail and cats, like this one, that are genetically tailless. Instead of asking why Manx cats have no tail, a better question might be, "Why are there so many tailless cats on the Isle of Man?" And to this, the simple, and correct, answer is, "Because it's an island."

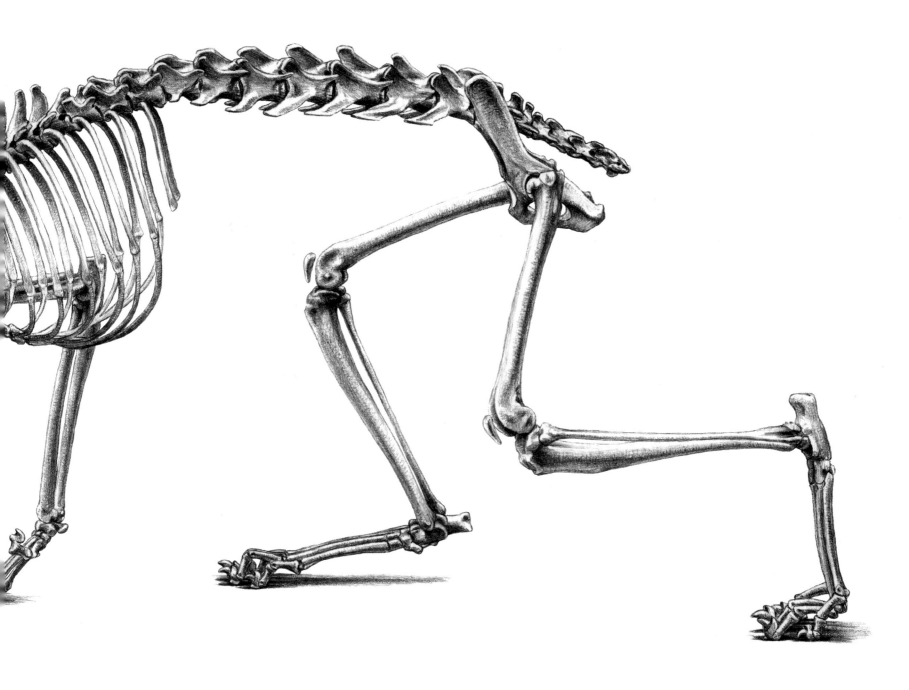

Instead of having the usual cloven hooves of other pigs, Mulefoots have a single hoof like that of a horse or mule. It's caused by the partial fusion of the bones of the two central digits, which are covered by a single nail instead of two. Although Mulefoots are the only animals in which this trait has been established in a recognized breed, the mutation is random, and can happen in virtually any vertebrate.

I touched on this in chapter 5 when I talked about the surprisingly successful sheep with stunted horns on the St. Kilda archipelago. Islands, surrounded by sea, quite literally cut off any chance of populations interbreeding with others. So, as long as they're not negatively influencing the animal's reproductive success, the alleles that are present (however they came to be there), whether dominant or recessive, remain—passed down through the generations in a consistent ratio. Harmless, non-adaptive traits like vestigial horns, fused or webbed digits, or the lack of a tail—that would quickly be dispersed in a population with no boundaries—can make you a big fish in a small gene pool within the confines of an island.

The chance of a genetically tailless cat escaping a shipwreck isn't as unlikely as it might at first sound. Cats were useful additions to ships' crews and fulfilled a vital role in eliminating mice and rats from around the stored cargo and rations. In such an unpredictable environment, where so much depended on luck, unusual cats appealed to the superstitious nature of sailors.

Especially popular were cats with additional toes. It's unknown whether the mutation arose in England, or New England, or somewhere aboard ship in between, but polydactyl cats became plentiful around the ports of the eastern coast of North America (especially around Boston) and southwest England and Wales, where their descendants still thrive. There are designated names for the local strains, like the "Boston thumb cat," the "Ithacat" from Ithaca, New York, and "Cardi-cats," from Cardigan in Wales. The pedigree Maine coon breed has a high prevalence for the trait, reflecting the nautical heritage of Maine, and the big-footed look suits the huge, fluffy breed perfectly.

Perhaps the most famous polydactyl cat was Snow White, the cherished pet belonging to writer and adventurer Ernest Hemingway that was given to him by a sea captain during his travels. Hemingway would, I think, have been comforted to know that Snow White's polydactyl genes have been passed to many generations of cats still inhabiting his home, now run as a museum and cat-haven, in Key West, Florida—and amused to know that a gene for polydactyly, *Hw*, has been named after him![†]

It's easy to see how a localized trait can be contained on an island or in a seaport, but not all islands are surrounded by water. Any population cut off from others can be considered an island in all but coastline. In the Transvaal in South Africa, for example, a local population of feral dogs was discovered in the early twentieth century that comprised an unusually high proportion of individuals with a heritable condition known as short-spine syndrome. This is a common condition that retards the development of the spine, especially in the neck region, though the limbs and skull are completely normal. Because the animals spend much of their time sitting in a baboon-like posture, with their forelimbs extended, they were christened "baboon dogs."

Short-spine syndrome occurs in a wide variety of animal species and, although it's shocking to see, it appears to cause no actual harm to dogs, beyond some restriction in movement. It's a random mutation and has nothing to do with breeding practices. There are many perfectly happy and healthy short-spined dogs kept as pets by compassionate owners unwilling to have them destroyed. Two were even immortalized on canvas by Swedish artist David Klocker Ehrenstrahl in the seventeenth century. What's interesting about the Transvaal population is that baboon dogs were able to maintain a consistent foothold within their community over many generations.

I've spent countless hours trying in vain to locate a skeleton of a baboon dog that I could illustrate in this book. Although I found two very old photographs, of poorly assembled skeletons, I wasn't able to find out their location. But if you Google "baboon dog" you'll see photos of live ones, along with some contemporary pet dogs with short-spine syndrome.

There's nothing like a six-foot-high wall to isolate a population—especially one that joins up at both ends. But instead of being walled in, the animals I'm about to discuss were walled out. They were the little Hebridean sheep that I mentioned briefly in chapter 9, and they were walled off the interior of the island of North Ronaldsay in the Orkney Islands in 1832 to prevent them from interbreeding with the newly imported sheep of improved breeds. Who knows how many animals died of starvation, but a tiny percentage that were able to metabolize seaweed survived. Now the whole population is comprised exclusively of animals able to digest seaweed. Although they may

[†] I'm pleased to say that the Ernest Hemingway Home, its human custodians, and all 54 cats survived the ravages of Hurricane Irma, which devastated the Florida Keys during the production of this book. I told you polydactyl cats are lucky!

Many dog breeds have webbed paws, but this isn't necessarily an adaptation to swimming—or to any other environmental challenge. Harmless traits like this may simply have been able to gain a foothold in an isolated population, making them big fish in a small gene pool.
(I'd intended to show a Newfoundland paw here, but they're too furry to properly show the webbing!)

look no different from normal Hebridean sheep, their entire foraging/ruminating behavior has changed, from a routine dominated by daylight hours to one dictated by low and high tides. But the wall is crumbling. It would be a sad end indeed if this genetically unique population, after all, lost its defining character.

Water and walls are effective means of isolating populations geographically, but there are more ways to prevent interbreeding than actual physical boundaries. Pedigree animals prevented from crossbreeding with other varieties of the same species are as genetically isolated as an inhabitant of the most remote oceanic island. Originally, any animal with the right appearance could be "bred up" to pedigree status within a few generations. Once the breed has become well established, however, many registries revert to a "closed book" system that prevents new strains from being added to an existing pedigree register, restricting any further movement of alleles into or out of the population.

It was only recently that I realized what a back-to-front understanding I had of pedigree dog breeds in relation to mongrels, and I suspect that the error is quite a common one. As a child, for my family, affording a pedigree dog was out of the question. The next best thing was a crossbreed, but even these cost money to buy. So we settled for a mongrel "free to a good home" and throughout the dog's life tried to convince ourselves (and others) about which breeds were "in there." In fact the likelihood was that our dog was from a long line of mongrels that had never mixed with pedigree aristocracy. The hugely diverse appearance of what we call mutts or mongrels—especially the feral dogs that are to be seen hanging around human habitations the world over—is the ubiquitous and original *dog*—probably little changed for many thousands of years. It was from this soup that animals were drawn to be put to different uses depending on their conformation and character, and these that would later evolve into genetically isolated pedigree dogs with their own distinct appearance. It was not the other way around.

The principle of non-adaptive traits establishing themselves in isolated populations applies equally to wild animals as domesticated ones (though in wild animals it's more difficult to be sure whether a trait might be the result of some previous adaptation, or that an apparently isolated population might be a remnant of a much larger one). In some cases however, it's plain to see evidence of variant forms gaining a stable foothold, especially when it's supported by historical data. For example, in the Faroe Islands in the North Atlantic, over many centuries a consistent ratio of around 10 percent of wild ravens were leucistic birds with an attractive pattern of black and white

feathers (at least, that is, until they were hunted to extinction by collectors in the nineteenth century). The Faroese white-speckled raven was so celebrated as part of the islands' culture that it even appeared (posthumously) on their postage stamps. Similarly, on Lord Howe Island, off the coast of Australia, the extinct Lord Howe Island gallinule is thought to have possessed the mutation for progressive graying discussed in chapter 8. Birds that started out in life with the purple coloring common to the many races of Purple swamphen would, within a few molts, have plumage comprised entirely of white feathers.

As soon as we think about islands in an evolutionary context we think of the Galapagos archipelago, five hundred miles off the coast of Ecuador in the Pacific Ocean, and famously visited by Charles Darwin during the voyage of the *Beagle*. The Galapagos finches, as I mentioned in chapter 2, made little impression on Darwin at the time (it took the genius of John Gould back in England to identify these widely disparate little birds as closely related species). But he did notice differences in the mockingbird and giant tortoise populations on separate islands and questioned how they came to be so unalike one another and yet so generically similar to animals found on the mainland.

What makes the Galapagos so special is that the islands are of geologically recent origin, thrown up by volcanic eruptions deep beneath the ocean. So they offered up a fresh blank canvas for life to arrive and swiftly fill the available niches, giving a rare opportunity for Darwin and the rest of us to witness evolution in action. So recent are some of the islands that the initial stages of colonization can be observed firsthand, where featureless landscapes of black lava, spewed up in viscous folds that spread in undulating ripples, provide fissures and furrows for sparse patches of vegetation. In time, these barren expanses of bare rock will likewise be transformed into living, thriving ecosystems.

With the exception of the marine life, all non-human colonists on the Galapagos and similar volcanic archipelagos arrived by accident from the mainland or other populated landmasses, blown off course, or washed ashore on floating vegetation. Once populations were established there was little or no movement between the different islands, so each developed in isolation from its neighbors. Like Farmer Buckley's and Farmer Burgess's sheep

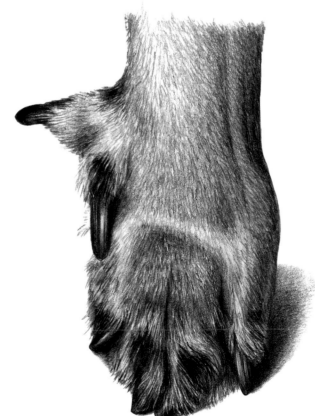
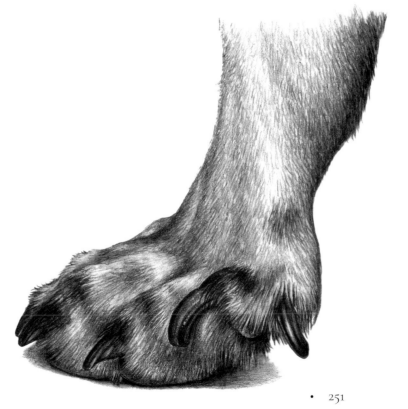

When specific animal breeds have a certain physical trait, like the double dewclaws on this Beauceron (a herding dog from northern France), it's tempting to assume that it must be an adaptation to its lifestyle. As long as a trait brings no disadvantage, however, it doesn't need to be beneficial to become established in a population.

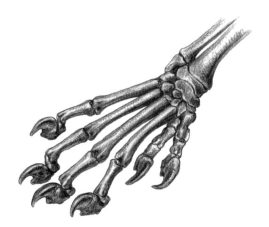

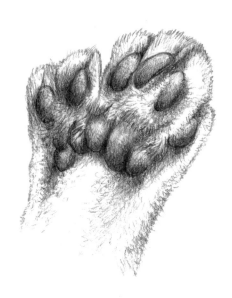

It's no coincidence that cats with extra toes are especially common around seaports on either side of the North Atlantic. Anything that unusual would have been a good omen to superstitious sailors! Whether the mutation first occurred in England or New England, or somewhere aboard ship in between, the relative isolation from inland cat populations allowed it to proliferate in these areas.

discussed in the last chapter, each population evolved along separate trajectories in different directions, eventually diverging into what human taxonomists would term separate species.

If you've visited the Galapagos, and were paying attention, you might have noticed the presence of goats on many of the islands. They're a bit of an embarrassment, and the tour companies do their best to divert attention away from them. On the tour I was on, one of the Ecuadorian guides was seen surreptitiously leaving the boat armed with a rifle during the night, and appeared again twenty-four hours later with a supply of fresh meat, though he refused to say where it came from!

Goats were deliberately introduced to the Galapagos, and countless other oceanic islands, by centuries of sailors very sensibly providing a self-perpetuating food supply for themselves and other travelers in the future. They had no way of knowing the damage these alien mammals would wreak on the fragile ecosystems. You can read about the folly of introductions elsewhere; I'm going to speak in defense of the goats, or at least of the evolution of the goats.

As I've stated throughout this book, natural selection is an irrepressible force. Just like the tortoises and the mockingbirds, the goats too may have changed from their original appearance. It's highly likely that they've diverged into different island forms according to the local topography and vegetation. On the tiny island of Arapaoa off the coast of New Zealand, for example, the descendants of the goats released by Captain James Cook during the voyage of the *Endeavour* in 1773 are now recognized as a distinct breed (and a very attractive one, too)—the Arapawa goat—which is in critical danger of extinction. Although we can't argue with the fact that island goats are unfortunately in the wrong place, perhaps we should take a second look before we jump in blindly to annihilate them.

A trend common in many isolated populations is a change in overall size—with large animals becoming smaller in all their proportions, and small animals, under the same conditions, becoming larger (though bearing in mind the discrepancies discussed in chapter 9 between changes in surface area and overall volume, and between different organs). The skeleton of a Netherland dwarf rabbit pictured here, for example, is almost an exact scaled-down model of that of its wild ancestor, the European rabbit. The reduction in size happens comparatively faster than the reverse effect (in evolution, it's generally easier to lose matter than to gain it). There have been dwarf elephants, dwarf ground sloths, and even dwarf dinosaurs. Unlike the single-step mutations for dwarfism that frequently occur in domesticated animals, the process is thought to be a gradual one. It would be interesting to know if the introduced island goats are gradually diminishing in size.

One island introduction that happened long, long ago—way before Captain Cook or the Spanish Armada; before the fall of Troy, the building of Stonehenge, or the birth of Moses—was the introduction of dogs to Australasia.

It's easy to think of Dingos in Australia, and the similar but distinct Singing dogs of New Guinea, as nothing more than introduced aliens—feral populations of domesticated animals barely worthy of scientific study. If that wasn't bad enough, they're a placental mammal, which sets them apart from the rest of the Australian fauna.

Australia is also an island—albeit a very, very big one. It became separated from the southern super-continent Gondwana before the evolution of placental mammals, which is why all the endemic mammals there are marsupials and their close relatives (i.e., they give birth to a semi-developed fetus that completes its development within a safe pouch of skin outside the body), or monotremes—the egg-laying platypus and echidnas. There are endemic marsupials on other continents, but no endemic placental mammals in Australasia.

Four thousand years may not be much in geological terms, but, for an introduced predator, a new continent can offer a vast spectrum of evolutionary possibilities. In New Guinea and Australia both genetically isolated populations have undertaken unique journeys, becoming part of ecosystems and exploiting niches never encountered by any dog before (except their marsupial equivalent, the Thylacine). Arguably the genome of both has now sufficiently diverged from that of its canine ancestors in Bronze Age Asia to qualify their status, not just as distinct races, but as separate species.

But separate species they will never be. More recent human settlers in Australasia have continued to bring their dogs with them. Although dingos and singing dogs have come a long way since their arrival down under, they're still capable of interbreeding with modern domesticated dogs, and do so readily. They've even been deliberately used in the creation of new breeds, like the Australian cattle dog. Whereas it's fine to enhance the dog genome with elements of dingo, when the process works the other way around, every generation from then on will be affected. Pure, wild dingo populations may only exist in the remotest areas—or may no longer exist at all.

We know by now that natural selection works on the principle that more individuals are born than can pass on their heritable traits to the next generation and that, on average, it's the competitively less efficient individuals that are removed.

We also know by experience that (as the saying goes) "shit happens." Sometimes adaptation and efficiency make no difference at all. Things like volcanic eruptions, bushfires, and hurricanes (or a biblical Flood) are the sort of non-selective agents that can indiscriminately remove a random chunk of genetic diversity. And, the smaller and more isolated the original population, the more significant the impact. It's important to think, not in terms of individuals in this context, but of the alleles they carry. The effect isn't just the loss of potentially useful alleles but also the altered ratios of the remaining ones, as the random change in allele ratios in different populations of the same species will divert their subsequent evolution along different trajectories. Even if the number of individuals recovers, the population will never regain its former composition of allele frequencies.

After a random reduction of genetic diversity like this, a population is said to have gone through a genetic bottleneck. In a diminished gene pool, the few harmful alleles that might have had a minimal influence in a large population can suddenly represent a substantial percentage of the total diversity. While you can rely on natural selection to remove negative traits that affect reproductive fitness, there are many more that exert their influence later in life, after the reproductive damage is already done. Also, whereas dominant alleles express themselves in an animal's phenotype no matter what, and are therefore easy to eradicate if they're harmful or unwanted, there's no way to tell if a recessive allele is present until it combines with another. By this time an undesirable trait might be well on its way to spreading through an entire population.

There's barely any breed of dog kept in Britain during the early twentieth century that hasn't gone through a genetic bottleneck. This sad fact hasn't escaped the many critics of the pedigree system who would pin the blame exclusively on unscrupulous inbreeding for profit. This has arguably had a part to play; however, I'm not referring to deliberate inbreeding here. I'm talking instead about war—probably the major cause of loss of genetic diversity in all domesticated animals.

During World War II in particular, the keeping of fancy animals for exhibition was considered an indefensible luxury. With barely enough food for the human populace, maintaining a collection of meat-eating animals like dogs wouldn't make you any friends. Large kennels were ordered to disband, kennel staff was no longer available, and breeders were faced with the heartbreaking necessity of having to have the majority of their animals destroyed. At the outbreak of war, in London alone, 750,000 pet animals were put to sleep by animal charities in the space of just one week, and the number killed by their owners was probably much higher. Newly recognized breeds, or those represented in only small numbers, fared the worst. The Sussex spaniel, for example, was reduced to just eight individuals. The fact that we still have Sussex spaniels, and many other breeds that were threatened with extinction during those awful years, is due to the determination and self-sacrifice of fanciers whose efforts should be applauded.

I've already told the stories of how the world nearly lost the Hookbill duck and the Tosakin goldfish, and how all living representatives of these breeds stem from just a handful of animals. The only way to restore genetic diversity to a population (beyond waiting for new mutations to occur) is to outcross with other populations. Within the pedigree system for dogs and other animals for which the stud books are closed, however, outcrossing threatens to undermine the whole system and presents a very real dilemma for the fancy.

Before you rush in and condemn the practice of inbreeding per se, think back to islands, the central theme of this chapter. The Seychelles magpie-robin, now numbering several hundred birds inhabiting five islands, was reduced in the 1970s to just sixteen individuals. At the same time the now thriving Mauritius kestrel population was down to a mere four birds. Many island species in general, the descendants of a few half-drowned waifs that arrived by accident on floating bits of vegetation, are, by their very nature, inbred. Whenever any deleterious results of inbreeding express themselves in the phenotype of wild populations they're removed by natural selection. So, inbreeding isn't intrinsically a bad thing, as long as inferior individuals are ruthlessly weeded out and prevented from reproducing.

The legendary Robert Bakewell was just one of many agriculturalists striving to improve the productivity of livestock to feed the rapidly expanding human population in eighteenth-century England. He was notoriously secretive in his methods, but openly swore by the practice of breeding "in and in," meaning that he adopted a system of close inbreeding, coupled with ruthless culling. In this way he transformed the appearance and productivity of the animals he worked with to produce the Dishley longhorn cattle and especially his famous New Leicester or Dishley sheep. Bakewell was a true master of selective breeding and his skill would have rivaled that of any modern-day farmer, even with all their technological wizardry thrown in. His sheep in particular have had a lasting success; their great value lay in their improving influence on virtually every animal they were crossed with and their genes are carried in countless modern breeds worldwide.

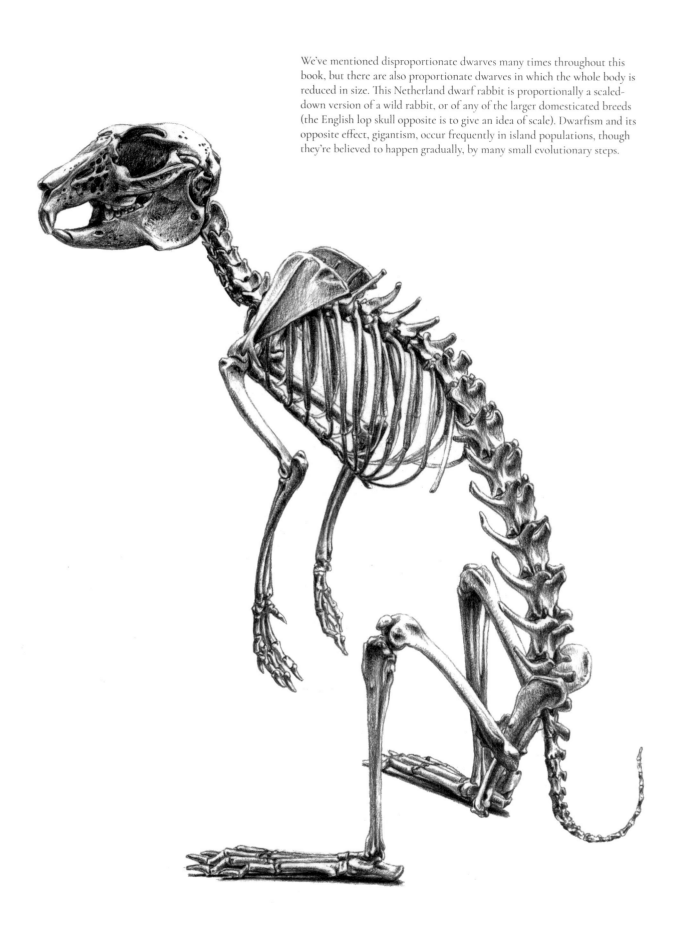

We've mentioned disproportionate dwarves many times throughout this book, but there are also proportionate dwarves in which the whole body is reduced in size. This Netherland dwarf rabbit is proportionally a scaled-down version of a wild rabbit, or of any of the larger domesticated breeds (the English lop skull opposite is to give an idea of scale). Dwarfism and its opposite effect, gigantism, occur frequently in island populations, though they're believed to happen gradually, by many small evolutionary steps.

It was the influence of Bakewell that inspired a younger generation of agriculturalists to attempt with shorthorn cattle what he had achieved with longhorns. A handful of highly skilled cattlemen from the north of England produced astounding results. They had an eye for selecting the qualities in their breeding stock that would produce much-improved offspring, with higher milk and meat yields and a consistent conformation. You've probably seen the idealized cattle type from old paintings: a rectangular body, with thin legs and a small head. It's ironic that much of the founder stock of many of today's purebred strains were beasts with no known history, "discovered" on roadside verges and poor smallholdings in just the same way that a talent scout might hang out in seedy back street clubs looking for star quality. This wouldn't be permitted under the modern closed-book system, but as I explained, at that time any strain could be upgraded to pedigree status after several generations.

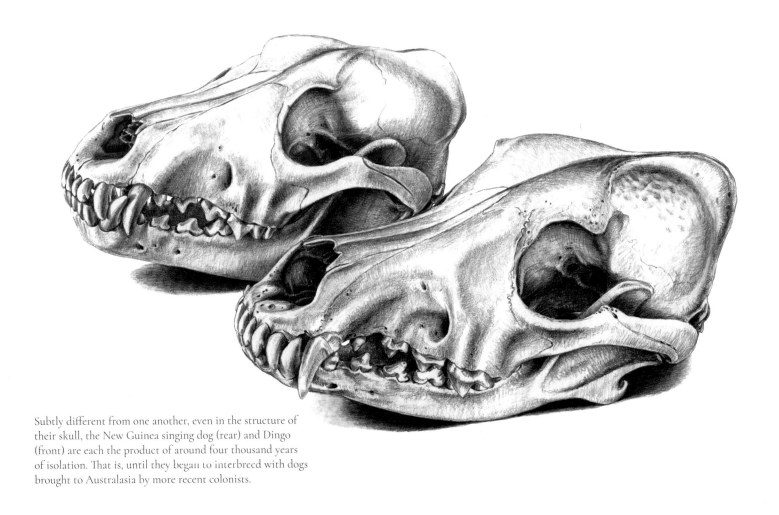

Subtly different from one another, even in the structure of their skull, the New Guinea singing dog (rear) and Dingo (front) are each the product of around four thousand years of isolation. That is, until they began to interbreed with dogs brought to Australasia by more recent colonists.

The practice of keeping studbooks had begun as early as 1791, for racehorses, solely as a means of identifying individual animals as a safeguard against cheating. It was first used as a means of recording lineage in shorthorn cattle in 1822, and from there to dogs and other animals. Pedigree registers were intended as a breeding tool, but they inadvertently became a means of identifying the purest strains untainted with outside blood. The idea caught on like sparks in a hayrick. Inbreeding became synonymous with all that was pure and good, and purity was a fanatical, international obsession. The fault lay, not just with breeders, but with the general tide of opinion. Don't forget that

this was a time when people believed that inheritance was a blend of parental characters, so outcrossing would have been seen as a dilution of these precious traits.

Among the most sought-after animals were the closely inbred shorthorns of the famous Duchess line, bred by Thomas Bates. Because their value was so high they were bought as a commercial investment for export and favored over equally good animals at lower prices. Bates had adopted Bakewell's practice of "breeding in and in" but without the necessary removal of inferior animals, and breeders who had paid high prices for purebred stock from Bates were likewise reluctant to dilute the bloodlines, blind to their diminishing fitness and fertility. And at the prices Duchess shorthorns fetched, who could blame them. The last pure *Duchess* cow, the pregnant *8th Duchess of Geneva*, was sold at New York Mills in 1873 for an astounding $40,600—a high price for a cow even by today's standards and over eighty times the average annual income in America at that time. A few days later she gave birth to a stillborn calf and died shortly after.

However, sometimes, even without culling, there are no apparent ill effects of inbreeding at all. Domesticated Golden hamsters are probably the most famous example. In fact the story seems so unlikely that many people assume that it's a myth. It isn't. All Golden hamsters in captivity are the descendants of a single pregnant female, collected in Syria in 1930 for a laboratory in Jerusalem. From there, hamsters were distributed to London, and ultimately to the rest of the world. They breed prolifically—*really* prolifically—and aren't prone to any known genetic diseases.

The small finch-like birds that arrived by accident on the Galapagos did more than just establish different island populations. They reduced competition within their populations by inhabiting the niches that would normally be filled by other bird species, evolving a wide range of specialized bill types and feeding behaviors. The exact same process occurred within bird groups on other islands too—in the vangas of Madagascar and the (now mostly extinct) honeycreepers of Hawaii. And, in islands of a different kind—water bodies enclosed by land on all sides—the cichlid fishes in Lake Victoria, and Lake Malawi, have similarly radiated into many diverse forms.

As well as specializing in their feeding behavior, closely related populations inhabiting the same geographical areas rapidly evolve different courtship behavior too, preventing interbreeding. Reducing competition isn't an act of kindness, and it isn't deliberate. It begins with the process of utilizing slight variations to gain a reproductive advantage, and ends . . . well, in fact it doesn't end at all. It results in a continued process of speciation and divergence, building yet more branches on the evolutionary tree.

The first part of the process might be for a small percentage of variant individuals to increase their reproductive success by taking advantage of an overwhelming trend. We've seen this with the snails that coil in the opposite direction, with the male ruffs that look like females, and with the small-horned St. Kilda sheep. The strategies are most successful when the "rebels" are in the minority. As their ratio within the population increases, their competitive advantage decreases until, ultimately, they have no reproductive advantage at all and the field is open for a new variant minority to gain a foothold.

Once again, the same process has its equivalent in artificial selection, particularly where the level of competition is at its highest and, again, new alleles can infiltrate a population fastest when the original gene pool is small and isolated.

As every athlete knows, someone who can win a race in a sprint over a short distance would almost certainly not perform as well in a marathon. The same applies to horses, and the reason is that, in horses at least, optimum performance over short and long distances is controlled by two opposing alleles on the same locus. Horses are fast, but they're best adapted to endurance running over long distances. This suited the horse races of the seventeenth and eighteenth centuries, which were between only two competitors over a course two to four miles long, and repeated until one animal had either won twice or out-distanced its opponent. By the 1950s the trend had changed to considerably shorter distances and at this time a horse, named Nearctic, emerged, that outstripped every competitor. Genomic studies have recently shown Nearctic to be the first horse that was homozygous for the "sprint" allele, which had been present in single doses for roughly three hundred years (it's recessive, which is why it had never been expressed in heterozygous combinations). But the advantage was short-lived. The son of Nearctic, Northern

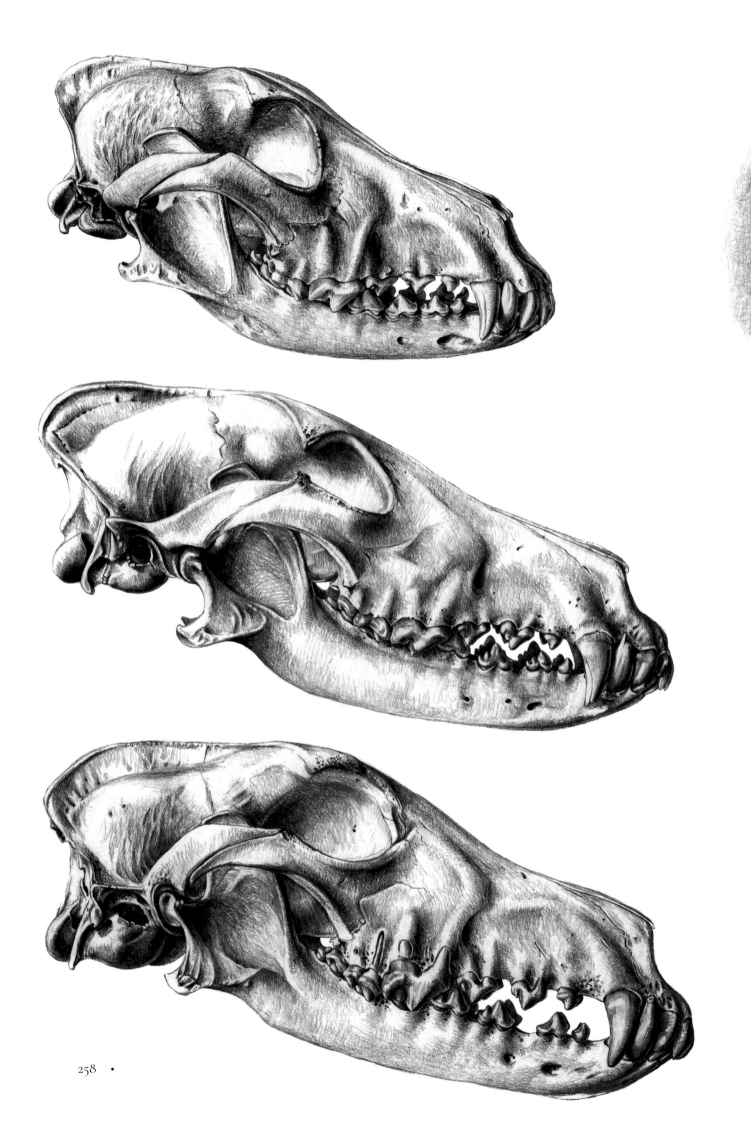

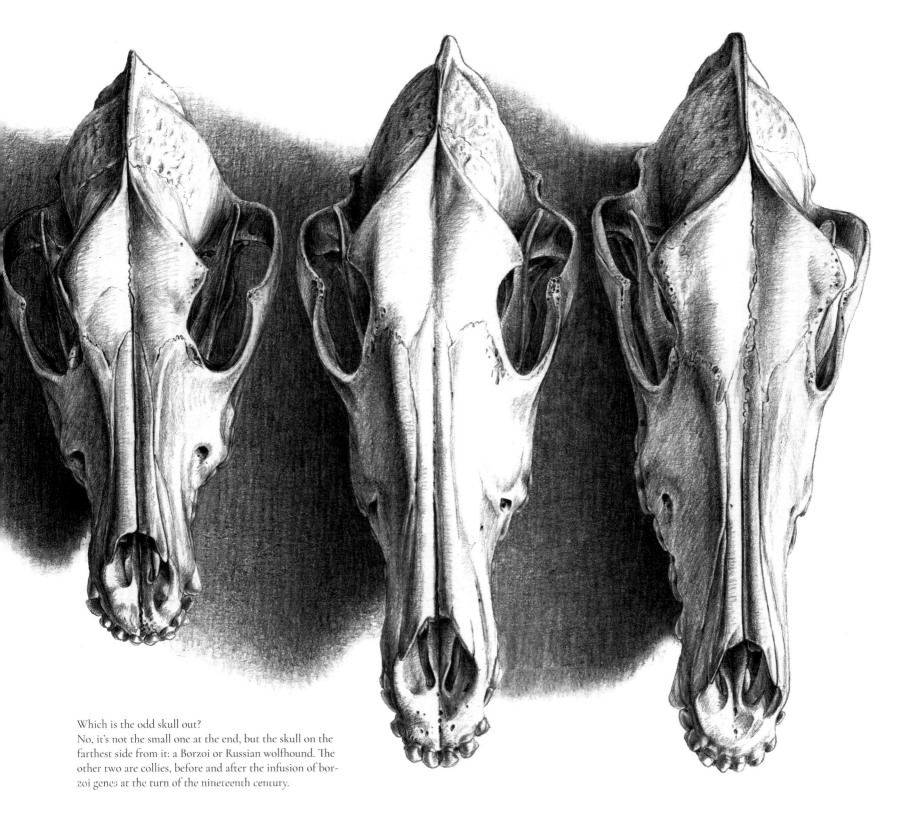

Which is the odd skull out?
No, it's not the small one at the end, but the skull on the farthest side from it: a Borzoi or Russian wolfhound. The other two are collies, before and after the infusion of borzoi genes at the turn of the nineteenth century.

Dancer, reached such popularity as a stud horse that now virtually every thoroughbred racehorse in the world is homozygous for this allele.

It's surprising how quickly a new trait exerts its influence over an entire population. If you look at the three dog skulls pictured, you'll notice that one is significantly different from the other two. As you can probably guess, this isn't the odd one out. This is the skull of a typical pre-1900s collie dog. The modern collie skull is virtually indistinguishable from the Borzoi skull next to it. I'm talking about the breed nowadays known as the Rough collie in Britain, the sort made famous in *Lassie* movies. Just like the shorthorn cattle just mentioned, collies underwent a meteoric rise in popularity, and a radical transformation in appearance.

• 259

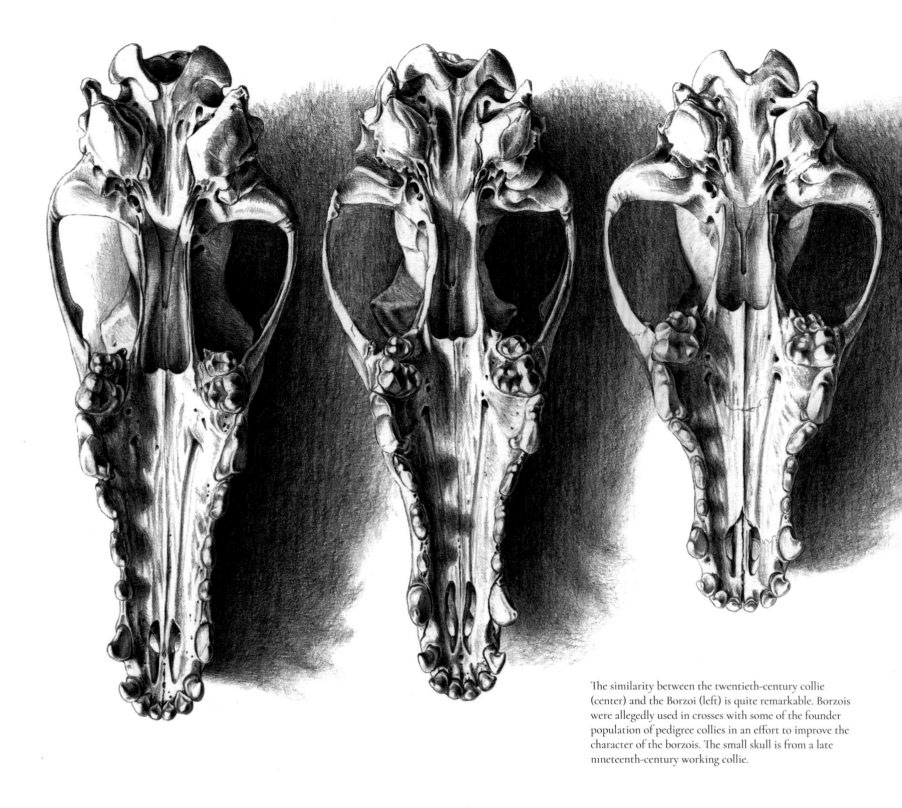

The similarity between the twentieth-century collie (center) and the Borzoi (left) is quite remarkable. Borzois were allegedly used in crosses with some of the founder population of pedigree collies in an effort to improve the character of the borzois. The small skull is from a late nineteenth-century working collie.

Originally they were thick-set farm dogs, usually tricolored, with a broad head and a definite stop between forehead and muzzle. The beautiful golden and white color of Lassie, known as "sable," was the result of a single color mutation in a dog named Trefoil, whose genes lie in the ancestry of every pedigree collie alive today. Similarly, the changes in collie head shape didn't happen gradually. The substantial collection of skulls at the Albert Heim Institute in Bern shows a clear division around the turn of the century. The influence came from the Borzoi—the Russian wolfhound. This has been discredited by some as a myth, and underplayed by others as an occasional bad practice adopted much later in collie genealogy to lengthen the head, but the evidence of the skulls was certainly enough to convince me.

It's likely that collies were initially used to improve the character of borzois, rather than borzois being used to improve the appearance of collies. According to an account given by the former kennelman at the Royal estate at Sandringham, Russian diplomats gave several of these beautiful but aloof dogs to Queen Victoria with the advice that they should be occasionally outcrossed with collies to produce more responsive offspring. Queen Victoria was passionate about dogs and had a particular fondness for collies. Just a few crosses, at just the right time between the collies' career as working dogs and their rise to pedigree stardom, would have been enough to transform the appearance of all future generations.

There's little difference between the giant tortoises, finches, and mockingbirds endemic to individual islands within the Galapagos archipelago, and the countless varieties of domesticated pigeon, canary, working terrier, and many more that evolved in the isolation of industrial cities and mining communities, where contact with animals provided a blissful respite from the harsh reality of working life. Likewise, the local landraces of rural livestock and the dogs kept to work them. Similarly, there's the bewilderingly diverse array of cattle varieties, each with a distinctive color or horn shape, that have evolved as an integral part of their individual tribal cultures—the Fulani, the Maasai, Angoni, and many more—throughout Africa. Populations of domesticated animals haven't been isolated for long enough to achieve true speciation yet, but their similarity at every level, with the fauna of islands of every kind, makes them, as Darwin well knew, a perfect analogy for evolution.

Single-step mutations of the sorts that Darwin would have referred to as "sports" or even "monstrosities"—things like taillessness in cats or in chickens, or color or feather mutations—are as likely to find their optimum environment on an island with niches to spare as with a breeder eager for novelty—especially if it's a semi-protected island, free from predators, where a wider range of variant forms might be supported. Remember that mutations are random, and occur as frequently in wild as in domesticated animals. Darwin, insisting always on gradual change, maintained that such varieties wouldn't survive in a wild state but, as we've already seen, there's plenty of evidence to the contrary.

Several times already in this book I've mentioned the various silkie mutations in birds that prevent the development of the barbules—the tiny hooks that zip the feather barbs together. There are many different types with slightly different effects occurring across a range of species. Silkie pigeons have poor waterproofing, but we came to hear of a Common moorhen—an aquatic gallinule—with a similar mutation that lived wild for several years at a bird reserve in England. Although that individual hasn't been seen for a while now, it's likely that its silkie genes are still swimming around the pool at the Slimbridge Wildfowl and Wetlands Trust reserve just waiting for a chance to reappear. In fact the mutation has occurred in moorhens several times in the past.

Poor waterproofing doesn't necessarily imply poor insulation. In one of Husband's moments of genius, he used Barbary doves with the allele for "pointing" discussed in chapter 9, in experimental crosses with birds of silkie plumage (with normal plumaged birds as "controls") to see if a lower body temperature would be revealed by the comparative density of feather color. There was no difference between them. This is significant in that it indicates that barbules, which are thought to have appeared at a later stage in feather evolution, were not necessary for thermoregulation. They would, however, have been necessary for flight.

Flying is one thing silkie birds can't do. This is obviously a problem for most wild birds, but on predator-free islands it may be one of many energy-saving steps toward flightlessness. Many birds accidentally find their way to oceanic islands and quite rapidly become flightless; their wings diminish in size and their breastbone flattens in the absence of flight muscles. It's not just a result of a lack of selection for flight, but active selection against it. Flight—in fact everything it involves, from the development of muscle to the growth of feathers—is expensive. There's actually a very high incidence of flightlessness in island rails and gallinules, and several of them are known to have a silkie-like feather

The silkie mutation affects the microstructure of feathers, preventing the barbules from knitting together to form a continuous vane and rendering the bird flightless. This is obviously a disadvantage in most wild birds, but in isolated predator-free environments—for example, on oceanic islands or in captivity—birds with silkie plumage might thrive.

structure. Kiwis and ratites, too, have feathers unsuitable for flight. In a contained population derived from a handful of founders, a single feather mutation could easily take off. Who knows—perhaps even dodos, from which no intact feather sample exists anywhere, were large, flightless, silkie pigeons!

One group of mutations—definitely of the sort that most people would assign to the "monster" category—prevents chickens from developing wings. There have even been people, possibly inspired by Seth Wight and his ancon sheep, who thought that this presented lucrative commercial possibilities. In the 1940s Peter Baumann, a traveling salesman of veterinary goods in Des Moines, Iowa, acquired a small collection of chicks with reduced or absent wings from the farms he visited on his rounds, and gradually, through selective breeding, he built up a flock of over four hundred wingless chickens. Baumann didn't like chicken wings, and assumed that no one else did either. He also, like Seth Wight, thought that winglessness meant saving money on fences (forgetting that the main reason for poultry fencing is to keep predators out, rather than to keep the birds in). But he was a salesman after all and was obviously fairly persuasive because thirty-five eggs were sent all the way to the Harper Adams Agricultural College in Shropshire, England. The six birds that were successfully reared to maturity were proudly shown off in a funny little black-and-white British Pathé film, which you can still find on the Internet.

I was determined to find a specimen, and contacted the college in Shropshire, every experimental-breeding center I could think of, and every likely museum on both sides of the Atlantic; my search yielded nothing. As far as I'm aware there are no living wingless chickens in existence, and no museum specimens have been preserved either, which is a sad loss to science. I was particularly intrigued to discover how the lack of flight muscle insertion points on the non-existent wings affected the appearance of the breast and the formation of the keel bone. But it seems I shall never know—at least, not until the mutation crops up again, and is hopefully this time preserved.

Before you dismiss wingless chickens as freaks that shouldn't be permitted to reproduce, imagine an island with its own really ancient bird population evolved in complete isolation from mammalian influence—an island where, for millions of years, birds established supreme rule. Such an island exists, although its endemic avian inhabitants are all but wiped out. The extinct moas of New Zealand were entirely wingless. Their skeleton lacks even any articulation points for wing bones to attach. Moas may well have gradually lost their wings as a result of multiple tiny steps. Or maybe a mutation for winglessness arose spontaneously in their common ancestor and was able to thrive. The answer will have to wait until fossil evidence reveals vestigial wings on a moa. With innumerable specimens representing over thirty species of moa found to date, none of which reveals the slightest evidence of any wing bone, it might be a long wait.

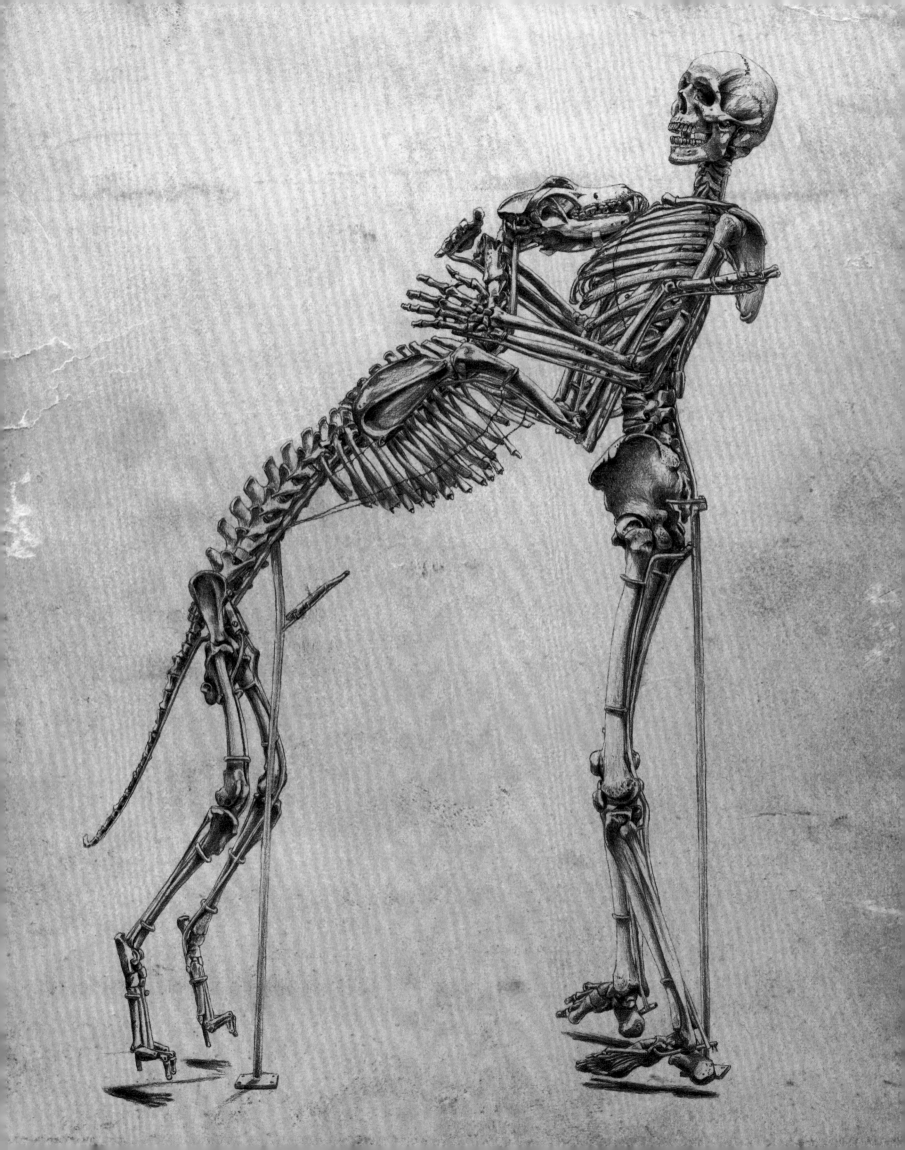

IV
Selection

12. Between Dog & Wolf

12 ~ Between Dog & Wolf

I'd had a grand plan about how to begin my final chapter. It was perfect—the ultimate, triumphant fanfare of an ending for a book about evolution and selective breeding, and simply nothing else would do. It would be written, I'd decided, during the two-day journey from Moscow to Novosibirsk on the Trans-Siberian Railway. The reason for this particular journey will become apparent shortly, though I'm sure some of you have already guessed. I'd saved up the money and was even looking at timetables. Unfortunately it wasn't to be.

My chapter begins, not in the romantic setting of a post-war railway carriage snaking its way through a snowy landscape, but in a dark alley, wet with rain and lined on either side with overflowing dustbins.

If I could trade, however, I would still choose the alley.

The alleyway in question is three doors from my home, in a terraced row of tiny Victorian houses close to the center of a large town. I'd just left the house and was rushing to get to the supermarket before it closed when, glancing into the shadows, my eyes met those of a fully grown fox, just standing, watching me. There are lots of urban foxes in my neighborhood, but they're usually seen scuttling off, or ignoring humans completely. This one met my gaze and held it. It's one thing to *see* the eyes of a wild animal and know that it sees you too, but sharing prolonged eye contact is another thing entirely.

I knelt down to show that I wasn't a threat and the fox walked up to me and nibbled the fingers of my extended hand. (Okay, it was perhaps a tad irresponsible to offer my hand to a wild fox, but it seemed the polite thing to do at the time.) Realizing that it probably thought I was offering food, I dashed home and back, my pockets filled with meaty dog treats, and proceeded to feed the fox, from my hand, until they were all gone. Every so often the headlights of a passing car would illuminate its beautiful russet fur and amber eyes. I could see every detail, even down to a tiny bald patch near the tip of its tail and almost held my breath from the overwhelming sense of awe and privilege to be permitted so close and for so long.

I instantly knew I'd found my opening paragraphs.

You may have noticed—especially if, like me, you've been around for quite a few decades—that the world is rather more full of people than it used to be. I'm sure you've mourned the loss of your childhood meadows as they disappear under housing estates, and noticed the distances between towns getting shorter and shorter. It's no exaggeration to say that this human population explosion is bringing the planet to the verge of its next great extinction event. It's been through many in the past, and will probably go through more in the future. While a large proportion of the world's animal and plant species will definitely disappear within the next century or so, those likely to succeed will be the ones able to tolerate the increasingly close proximity of people.

Lots of animal populations appear to have realized that overcoming fear of humans is a gateway to unlimited food. Any trip to a city park is rewarded with sparrows, squirrels, gulls, ducks, and swans all crowding around in the hope of being fed. There are populations of wild animals living harmoniously in human environments the world over that will eat out of your hand: monkeys in Asian temples, and even, in Harar in Ethiopia—hyenas! Just like my furry friend in the alley, wild animals that are able to suppress their natural instinct to run or fly away from humans

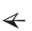

A moving testimony to the bond between man and dog: the skeletons of anthropologist Grover Krantz and his beloved Irish wolfhound, Clyde; on permanent display at the Smithsonian Museum of Natural History.

Domestication isn't a one-way process; it's not "something we do to animals" but something animals can evolve for themselves. Domesticated species have entered into a symbiotic relationship with mankind and, whatever your opinion on the products of artificial selection, that relationship is mutually beneficial. Modern dogs, like this Toy poodle, are an evolutionary success.

The Rock dove is the wild ancestor of all domesticated pigeons. To its feral descendants, the many ledges provided by city-center architecture are a perfect substitute for the rugged sea cliffs of their ancestral home.

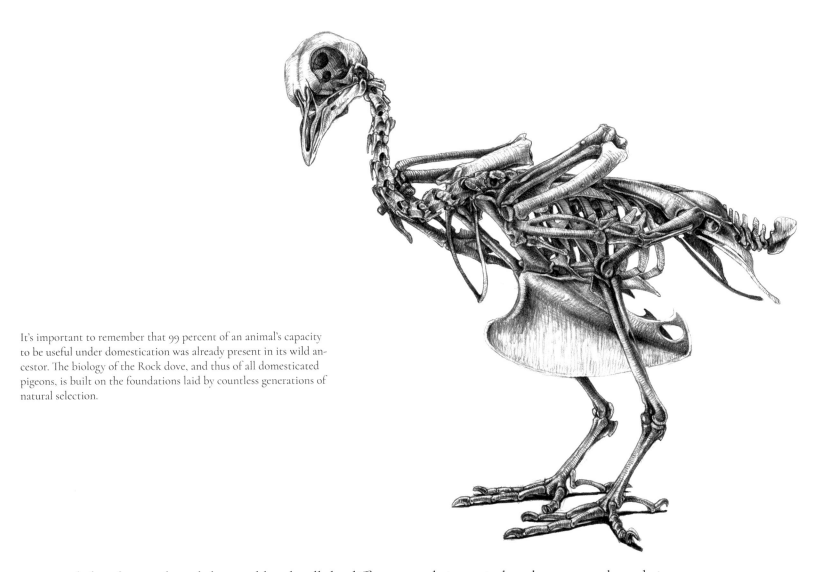

It's important to remember that 99 percent of an animal's capacity to be useful under domestication was already present in its wild ancestor. The biology of the Rock dove, and thus of all domesticated pigeons, is built on the foundations laid by countless generations of natural selection.

are rewarded with a good meal that could make all the difference to their survival, and consequently to their reproductive success. The question is whether this is the result of cultural or genetic evolution. Can any animal learn to behave like this, or just those with sufficiently low stress responses to tolerate human presence? Are these just individual animals conditioned to approach people for food, or the result of many generations of natural selection for living in an overpopulated human environment?

For some animals, the urban environment provides comparable niches to those they and their ancestors have already inhabited for many thousands of years. House sparrows nested in cavities in rocks long before human agricultural settlements provided them with plentiful food and man-made nest sites in the eaves of houses. Similarly, it makes no difference to Rock doves or peregrines whether they're nesting on cliff ledges or skyscrapers. The two species share exactly the same predator/prey relationship in either setting. They didn't move into towns independently of each other; the peregrines followed the pigeons.

Town pigeons are feral. That means that they're the wild-living descendants of domesticated birds, which in turn were descendants of the wild Rock dove (the peregrines' original main food source). Like the mongrel dogs mentioned in the last chapter, the pigeons in our city centers come from a generalized and very ancient "soup" of pigeons with a diverse genome and are not the crossbred progeny of escapees from pigeon lofts. Their apparent tameness is the result of their former domestication, plus thousands of years of evolution for human tolerance, gained in the streets and skies of human habitations, just as they are now. Without town pigeons, there would be no town peregrines.

Red foxes began to colonize towns in the 1930s, a phenomenon that gained worldwide momentum throughout the twentieth century. Although people like to associate foxes with disease and dustbins, they began by colonizing only the most well-to-do suburban areas, moving into city centers when the suburbs were occupied. Although they'll scavenge when necessary, much of their food is deliberately provided by intelligent, open-minded people like me, with an appreciation of nature. In fact, the best way to avoid having your dustbin raided is to feed the foxes

Skull of a Grey wolf: the wild ancestor of all dogs. Dogs were domesticated so long ago that wolves may have been, behaviorally at least, rather different animals then from how they are now. There's a running debate over whether wolves became domesticated by gradually making themselves at home around human habitations, or whether they were taken as wild cubs and hand-reared. I favor the former explanation.

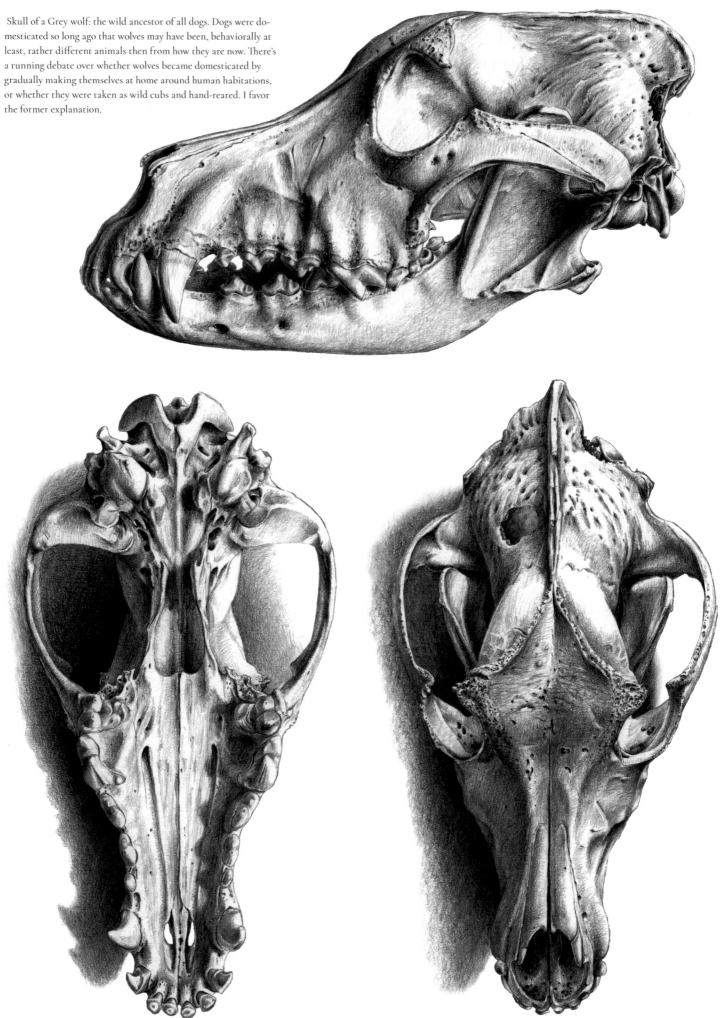

yourself. Calling in the exterminators will just open up new territories for other foxes to move in. While rural animals have remained shy, their urban counterparts treat humans with blatant indifference. Human attitudes, meanwhile, are anything but. People either love them or hate them. In certain company, admitting that you feed foxes in your garden is comparable with admitting to drunk driving or selling drugs to children.

One of the many emotions that surged through me during my fox encounter was the realization that what I was feeling was something very, very old—a sort of primal thrill that must have been experienced by humans gaining the unexpected trust of animals for thousands of years. In their behavior, town foxes are probably not so dissimilar from the wolf-like ancestors of our domesticated dogs. (Wolves then were probably very different in behavior from now—less wary and more enterprising—so it's possibly more accurate to think of them as wolf-like rather than the same animals we know as wolves today.) A small percentage of the population of wild wolves may have had a greater tolerance for living in close proximity to humans, just as our urban foxes have. They may have fed from rubbish heaps or followed hunting parties to feast on spilled blood and entrails; they may even have taken advantage of the worms and grubs exposed in freshly dug soil. They would have kept their distance initially—only gradually earning the acceptance and even affection of their human community. Doubtless some people tossed them scraps, and others complained about it. Perhaps the first person who fed an "urban" wolf by hand felt very much as I did.

There's a running debate over whether wolves became domesticated in this way—by gradually making themselves at home around human habitations—or whether they were taken as wild cubs and hand-reared. Certainly hand-reared animals are far more trusting and comfortable with handling than those gradually acclimatized to the presence of people; particularly animals that are taken early enough to imprint on their human owners. Imprinting is best known in precocial birds that are able to leave the nest and feed independently shortly after hatching, and was popularized by Konrad Lorenz in his work on Greylag geese. In this case the chicks have an instinctive pre-conditioned faculty to form a bond with the first moving object they see within a critical time period after hatching. In ideal situations this is the animal's parent, but they'll readily bond with humans, and even objects. All animals, however, will form at least a temporary bond with the individual that rears them.

I favor the former explanation, though I'm certain that our distant ancestors made many attempts to raise wolf cubs by hand. The appeal of baby animals is universal; many tribal cultures deliberately take them from their nest to hand-rear them, even suckling them along with their own babies, purely as pets. Once they reach sexual maturity, however, they inevitably become problematic. This brand of tameness is not so much a familiarization with humans as an inherent confusion about their own identity, particularly when reared without the company of other animals of the same species. As hand-reared wild animals mature, their stress levels become accentuated rather than relaxed. Most importantly, the descendants of hand-raised wild animals will have no genetic disposition to tameness. At each generation you'd have to start all over again.

There's also the expectation, which I personally find very hard to believe, that wolves were domesticated for a purpose, for example, that their company on hunting excursions was deemed useful in some way. If you've ever hunted with dogs you'll know that the level of adrenalin generated would be impossible to control in a semi-domesticated animal. They'd be more of a dangerous liability—at best, a nuisance—than an asset. It's far more likely that the wolf ancestors of domesticated dogs just hung around humans for hundreds, maybe thousands, of years before they were ever deliberately taken to fulfill a useful purpose—exactly as village pariah dogs have done since time immemorial, and just as town foxes are beginning to do now. Their "usefulness" needed to be only as non-human companions, perhaps raising the alarm if intruders approached. In a sense you can say that they domesticated themselves.

Even for animals familiar with human company, some individuals clearly have different levels of tolerance than others. Take pigeons, for example. In his misspent youth, Husband was not above stealing young woodpigeon squabs from the nest, hand-rearing them, and selling them to bird breeders. He observed that some individuals remained completely tame throughout their life, while others, reared from the same age and under identical conditions, suddenly switched, once the initial period of juvenile dependence was over, to being as wild and nervous as birds caught as adults. All the birds fell into either of these extremes, with no intermediates.

Likewise, certain species are more tractable than others—some resisting all attempts at domestication or even captive breeding. Eurasian collared doves rely on human expansion for their success but, although they breed readily in captivity, they seldom ever become tame and have never been domesticated. The very similar African collared dove

on the other hand is easily tamed even as a wild-caught adult, and has been domesticated as the ultra-placid Ring-necked or Barbary dove. Barbary doves and Collared doves readily hybridize in captivity, producing offspring with the shy temperament of Collared doves—not uncommon behavior for hybrids involving undomesticated species.

Husband recalls the notoriously aggressive behavior of male Australian crested pigeons during the 1980s, which invariably killed any female put in the same aviary. The few successful breeders distributed their progeny among other fanciers who were, in turn, able to raise young. Now, many generations later, Australian crested pigeons are easy to breed in captivity. Improved knowledge and husbandry may have had some influence, but equally likely is that the pigeons have *selected themselves* for more passive behavior, because only the least aggressive individuals would be passing on their genes to future generations.

It was exactly the same with the Socorro dove formerly endemic to Socorro Island in the volcanic Revillagigedo Archipelago off the coast of Mexico. Socorro doves are now extinct in the wild, so their reluctance to breed in captivity was cutting things fine to say the least. Finally a pair in the London Zoo produced a single chick. It was named Arnie, in the hope that its descendants would indeed "be back" someday on Socorro Island! If captive-bred birds are ever re-introduced, having squeezed through this genetic bottleneck, they will probably be very different in temperament from the original population.

These observations suggest that all captive-bred populations may end up being genetically different from their wild counterparts simply because their situation selects against aggressive individuals with a low stress threshold. In other words, the capacity to be tame is a heritable evolutionary trait, completely independent of learned behavior.

This is certainly what Russian geneticist Dmitry Belyaev thought too. The price of saying so, however, was high. Dmitry was inspired to pursue a career in genetics by his elder brother Nikolai at a time when the modern synthesis between Darwinian natural selection and Mendelian genetics was finally opening up new and exciting paths for evolutionary biology. Russian scientists would doubtless have been at the vanguard had it not been for Stalin's political campaign to promote the pseudo-scientific agricultural policies of Trofim Lysenko.

Lysenkoism not only promoted bizarre, untested allegations about almost magical transformations in productivity. It rejected a hundred years of scientific advancement—particularly in the fields of genetics and evolution—falling back on the heritability of acquired characteristics disproven by Weismann several decades earlier. This was no mere poster campaign; the lives of over three thousand biologists and their families were destroyed. The fortunate ones were stripped of their academic positions, while those who dared to speak out against Lysenko's "science" were arrested and thrown into labor camps. Few came out again. Among the victims was Nikolai Belyaev, Dmitry's brother.

Dmitry Belyaev continued his genetic work for some years under the guise of animal physiology at the Department of Fur Animal Breeding in Moscow before retreating to the relative safety of Siberia, where he eventually became Director of the Institute of Cytology and Genetics in Novsibirsk.

He was interested in the origins of domestication, principally in the characteristics differentiating domesticated dogs from their wild ancestors, and was convinced that the answers lay in selection for a single heritable trait—tameness. He chose for his experiment Silver foxes, the melanistic form of the Red fox—the same species as my friend in the alley. None of his experimental animals was deliberately tamed, and they received only the briefest contact with humans. During simple test interactions the young foxes' responses were monitored and only those that displayed no aggression were selected to breed the next generation. (Belyaev also had the foresight to run a control experiment selecting the most aggressive foxes.) Within only two generations some of the animals had begun to greet their human visitors with positive enthusiasm, wagging their tail, licking their handler's hand, and squirming about like puppies. With each generation the percentage of these animals increased until now almost all the foxes selected for tameness fall into this category.

While this experiment proved Belyaev's suspicion about tameness being genetically heritable, there were also some wholly unexpected revelations. Many foxes retained the juvenile features of floppy ears and curled tails for an extended period. There was also an alleged reduction in skull width and length. These features are consistent with the principle of neoteny—the slowed rate of behavioral and physiological development resulting in prolonged expression of juvenile traits. (The submissive or affectionate behavior of many adult domesticated animals has been explained in this way—think of your dog rolling over to show its belly). In addition, a surprisingly high percentage of the cubs were leucistic, with white patches occurring particularly on the tips of their paws and in the white blaze

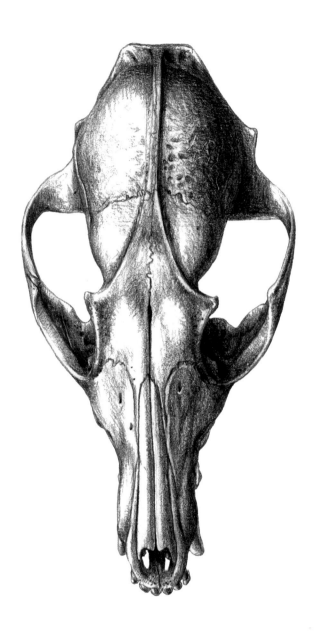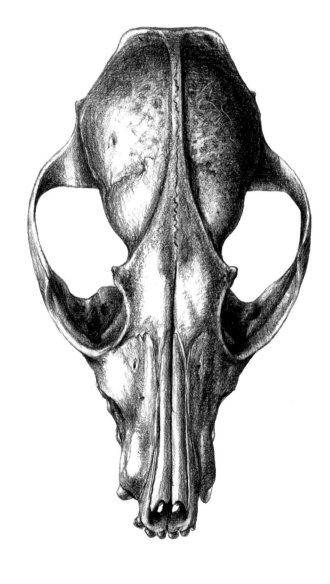

Skulls of an undomesticated (left) and a domesticated (right) Silver fox. After several generations, newly domesticated animals are believed to exhibit a variety of physical changes, including shortening and broadening of the skull. These features, along with a suite of other, seemingly unconnected traits, are collectively known as the "domestication syndrome."

marking of their muzzle and forehead common to many domesticated animals. The genetic trait of tameness, it appeared, was associated with the package deal of additional effects discussed in chapter 5.

While tameness can be explained by a reduced function of the adrenal glands responsible for responses to fear and stress, the processes responsible for these additional by-products—collectively known as the "domestication syndrome" or "domestication phenotype"—however, remained a mystery. Several explanations have been put forward.

One is the expression of mutations under artificial selection that may be present in wild animals without showing themselves. I mentioned elsewhere that existing developmental processes stabilize the expression of certain gene mutations; the machinery for their activation simply isn't switched on. They can't be selected for, or against, because natural selection works only on the phenotype. So these mutations accumulate in the genome until something changes.

Another explanation rests on the high incidence of effects in traits that share a common developmental pathway. Although the adrenal glands don't directly influence things like ear cartilage and pigment, all these features originate in the neural crest of the developing embryo before migrating ventrally to differentiate into distinct and specialized cell types. (If you remember, I mentioned this in relation to leucism in chapter 8.) The reason why white patches occur on the feet, nose, and tail tip of animals is because leucism prevents migrating pigment cells from reaching these extremities. The same principle can be applied to the cartilage of the ears and tail.

I confess to being not entirely convinced by domestication phenotype theories. Although it's easy to spot these traits when you're deliberately looking for them (domesticated pigs, for example, share the floppy ears

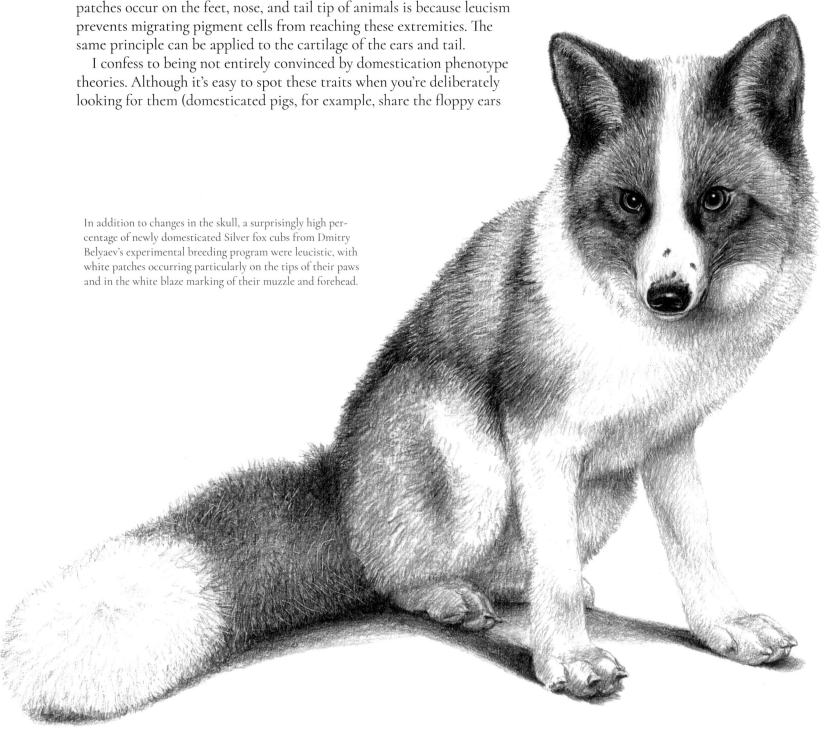

In addition to changes in the skull, a surprisingly high percentage of newly domesticated Silver fox cubs from Dmitry Belyaev's experimental breeding program were leucistic, with white patches occurring particularly on the tips of their paws and in the white blaze marking of their muzzle and forehead.

and curly tail of many dog breeds), there are plenty of exceptions. Curly tails and floppy ears are normal traits in both fox and wolf cubs; the Novosibirsk foxes merely retained them for a slightly prolonged period. Also, as I've mentioned earlier, color aberrations occur very frequently in wild animals. I'd be interested to see evidence of these features in other animals too—those that are unintentionally also selected for tractability and ease of handling, like zoo and laboratory animals. No research has been done on anatomical changes as a result of captive breeding in the latter, and while significant changes, particularly in skull shape, have been recorded in zoo animals, all of these can be attributed to artificial diets and feeding behavior rather than heritable tameness.

Belyaev died in 1985, succeeded by his long-term co-worker Lyudmila Trut, who devoted her life to continuing her mentor's work and helping it achieve the worldwide recognition it deserves. Lyudmila corresponded with me for a while and kindly suggested contacts to approach to ask official permission for my planned visit. None of my e-mails was answered.

Domesticated foxes have been described as combining the loyalty of dogs with the independence of cats. For $7,000 you too can own a fully inoculated domesticated fox cub, shipped all the way from Siberia and delivered to your door. Alternatively, just keep feeding your backyard foxes and see what happens.

For some of our questions about the domestication process, particularly of large, herd-living animals, we can find clues in a modern-day example in the early stages of domestication—Reindeer. The first characteristic to be acquired by a newly domesticated species is tameness (tameness too is the last feature to be lost when domesticated animals become feral), and it can be measured in herd animals by flight distance, that is, how close you can get before the animal runs away. The second is usually a reduction in size, followed by an increase in the expression of color mutations. There are a number of possible explanations for this: the domestication syndrome just discussed; unconscious selection for attractive individuals; the high percentage of variant alleles in a limited gene pool; or increased predation of color variants in the wild populations. (In birds, predation of aberrantly colored individuals isn't as common as you might think, and there's no reason to suppose that in mammals, which rely more on scent and less on sight, it would be any higher.) Domesticated animals also have a smaller brain than do their wild ancestors. This doesn't mean that they're less intelligent but that their sensory areas for eyesight, smell, hearing, and motor control have become reduced from lack of selection. Feral populations never regain these faculties.

Both sexes in Reindeer possess antlers, but they're larger in males. Sexual characteristics, like larger antlers in deer, or tusks in pigs, are only diminished under artificial selection when mate choice is exclusively dictated by human owners, that is, when sexual selection ceases to function. In feral populations they quickly return. Reindeer probably still interbreed with their wild counterparts and it's only when captive herds are taken to areas outside their natural range, when they're fenced in, or when the wild population becomes extinct, that radical changes really start to happen. As long as they select their own partners, males and females will continue to be sexually dimorphic. Reindeer still have a long way to go.

The reduced hormonal stress responses that allow opportunistic animals like foxes to be more tolerant of human presence also affect relationships between and within animal communities. While diminished aggression might not be an evolutionary advantage where territories need to be defended, less competitive environments might positively favor a more passive social structure.

When it comes to social passiveness, the first prize goes to . . . Bonobos (formerly known as Pygmy chimpanzees)—the hippies of the animal world. It's thought that the common ancestor of Bonobos and the very similar Chimpanzee may have been separated into two populations around two million years ago by the formation of the Congo River—animals on the northern side facing competition from other ape species, with those on the southern side enjoying a more relaxed existence. In contrast with the highly volatile Chimpanzee, the Bonobos of today are peaceful creatures that delight in games, sex, social grooming, sex, friendly communication, and . . . sex. The gulf in the level of stress and aggression between the two sister-species has been compared with that of a domesticated animal and its wild counterpart—the difference between dog and wolf.

Bonobos developed their harmonious, stress-free society entirely independently of human influence, in a process that's been termed "self-domestication," and there's nothing to say they were the first.

Domestication, then, isn't a one-way process; it's not "something we do to animals" but something animals can evolve for themselves. Domesticated species have entered into a symbiotic relationship with mankind and, whatever

On the left, Neanderthal skulls (from two different specimens), and on the right, a cranium of *Homo sapiens* excavated from a Bronze Age burial mound in southern England. Are the human flattened face and large cranium signs of retained juvenile features? And if so, is this evidence that we've undergone "self-domestication"?

your opinion on the products of artificial selection, that relationship is mutually beneficial. (We're evolving in accordance with our animals, too. For example, our ability to digest the lactose in milk is entirely due to the practice of dairy farming.) Modern dogs—even the ones with short noses—are an evolutionary success. So are cattle, horses, and camels, all of whose wild ancestors are extinct. Whatever happens to the Grey wolf or Red junglefowl, there will always be dogs and chickens.

There's a lot of gray area about what defines a domesticated animal, especially considering the increasing trend for exotic pets. What about reptiles and aquarium fishes; birds kept for falconry; parrots and foreign finches, with all their color variations? And if these don't qualify, why should budgerigars and canaries?

Throughout this book I've concentrated on the "high end" of selective breeding—on exhibition and commercial animals already domesticated for thousands of years and not on the process of domestication itself. This was quite deliberate and I make no apology for it. Darwin, too, was primarily concerned with what he called "conscious" artificial selection and he used this, as I have, as a metaphor for evolution, to compare the mechanisms by which animals can change. Domestication has recently become something of a hot topic in evolutionary biology, but despite this—although every publication gives an obligatory nod in Darwin's direction—few authors show any appreciation for the processes and products of selective breeding that so interested him. Darwin was passionate about the furthest extremes to which selection could go, the paths taken to get there, whether they were straight paths or branching ones, and the number of steps, big and small. He would, I'm sure, have felt very content in Husband's pigeon loft discussing breeding experiments in feather length and color. He'd have been excited to see how frilly Frillbacks have become in the past hundred or so years, and would have been fascinated by neck-feather loss in Naked-neck tumblers. I hope he would have approved of this book.

Artificial selection is an excellent analogy for natural selection; even more so than Darwin had realized, but the similarity is more than just metaphorical. There are not "domesticated animals," "wild animals," and "humans." There are only animals. There's not a "natural environment" and a "man-made environment"; there's just the environment. Artificial selection is not merely analogous with evolution. It is evolution. And the process of domestication is just one of countless adaptations to changing environments, irrespective of the existence of man.

Although human society is hardly a shining example of harmonious co-operation, the question has been raised about whether we too, like the bonobos, are "self-domesticated"—whether our flat face and rounded head—much more like a baby chimp than an adult one—compared with the elongate skulls of Neanderthals, is a result of neoteny. Although there's little hard evidence of the domestication phenotype in human anatomy, it's nevertheless an interesting idea.

Although I'd made use of international museum collections for many of the other illustrations in this book, I made a point of producing the drawings of a skull of our own species, *Homo sapiens*, from a specimen at the Buckinghamshire County Museum in my home town of Aylesbury—to pay a personal tribute to the museum where I spent all my school holidays as a child as a volunteer in the natural history section.

After finishing the drawing I took my regular walk with my dog, Feather, past the foot of a Bronze Age burial mound circled with a crown of ancient linden trees, through meadows gently undulating down to the banks of a small river. I've known that landscape my entire life. Under that late September sky, painted with tumultuous copper clouds and overhung by a pervading stillness, I suddenly recalled, from the words on the museum label, that the skull was excavated from that very mound. I couldn't help thinking about the man whose skull I'd just drawn, who'd lived and died there four thousand years before. What would he have thought, had he known? Books and writing would have meant nothing to him. Communication with people in countries separated by vast oceans would have been beyond his imagination. Even my brand of representational art may have escaped his understanding. Everything in my world would have been alien to him. Except one thing.

He would probably have had a dog.

I produced this tiny drypoint etching thirty years ago. It's of the very same Bronze Age burial mound where the human skull, pictured on the preceding page, was excavated in 1906—a favorite place for my walks with my dogs over the last half century.

~ Selected Reading ~

Part I: Origin

Barber, Lynn. *The Heyday of Natural History*. Doubleday, 1984.

Blunt, Wilfrid. *The Compleat Naturalist: A Life of Linnaeus*. Frances Lincoln, 2004.

Darwin, Charles. *The Annotated Origin*. A facsimile of the first edition of *On the Origin of Species* with annotations by James T. Costa. Harvard University Press, 2009.

———. *The Autobiography of Charles Darwin: 1809–1882*. Rev. ed. Ed. Nora Barlow. W. W. Norton, 1993.

———. Darwin Correspondence Project, University of Cambridge. www.darwinproject.ac.uk.

———. *The Voyage of the "Beagle."* 1909. Reprint, Borgo Press, 2008.

Dennett, Daniel C. *Darwin's Dangerous Idea: Evolution and the Meanings of Life*. Penguin Books, 1995.

Dennis-Bryan, Kim, and Juliet Clutton-Brock. *Dogs of the Last Hundred Years at the British Museum (Natural History)*. British Museum (Natural History), 1988.

Desmond, Adrian, and James Moore. *Darwin*. Penguin Books, 2009.

Grande, Lance. *Curators: Behind the Scenes of Natural History Museums*. University of Chicago Press, 2017.

Grant, Peter R., and B. Rosemary Grant. *How and Why Species Multiply: The Radiation of Darwin's Finches*. Princeton University Press, 2011.

Homes, Tina, and Dennis Homes. *The Cavalier King Charles Spaniel: The Origin and Founding of the Breed*. Cavalier Club, 2010.

Levi, Wendell M. *Encyclopaedia of Pigeon Breeds*. Levi Publishing, 1996.

Porter, Valerie. *Pigs: A Handbook to the Breeds of the World*. Cornell University, 1993.

Reedman, Ray. *Lapwings, Loons and Lousy Jacks: The How and Why of Bird Names*. Pelagic Publishing, 2016.

Ruse, Michael, and Robert J. Richards, eds. *The Cambridge Companion to "The Origin of Species."* Cambridge University Press, 2009.

Schafberg, Renate, and Arila-Maria Perl. *Zucht und Ordnung: Historische Fotoglasplatten aus dem Ehemaligen* (a book of historical photographs documenting livestock at the Julius Kühn agricultural institute at Halle, Germany). Haustiergarten der Martin-Luther-Universität Halle-Wittenberg, 2014.

Townshend, Emma. *Darwin's Dogs: How Darwin's Pets Helped Form a World-Changing Theory of Evolution*. Frances Lincoln Ltd., 2009.

Weiner, Jonathan. *The Beak of the Finch: A Story of Evolution in our Time*. Alfred A. Knopf, 1994.

Wilkins, John. *Species: A History of the Idea*. University of California Press, 2011.

Part II: Inheritance

Bateson, William. *Mendel's Principles of Heredity: A Defence, with a Translation of Mendel's Original Papers on Hybridisation*. Cambridge Library Collection. Cambridge University Press, 2009.

Crawford, R. D., ed. *Poultry Breeding and Genetics*. Elsevier Science Publishers, 1990.

Darwin, Charles. *The Variation of Animals and Plants under Domestication*. Originally published 1868. 2nd rev. ed., 1883. Johns Hopkins University Press, 1998.

Dawkins, Richard. *Climbing Mount Improbable*. W. W. Norton, 1996.

Henig, Robin Marantz. *The Monk in the Garden: The Lost and Found Genius of Gregor Mendel, the Father of Genetics*. Houghton Mifflin, 2000.

Levi, Wendell M. *The Pigeon*. Levi Publishing, 1986.

Mayr, Ernst. *What Evolution Is: From Theory to Fact*. W. & N., 2002.

Moore, John. *Columbarium or the Pigeon House: Being an Introduction to a Natural History of Tame Pigeons*. 1735. Gale ECCO, 2012.
Robinson, Roy. *Colour Inheritance in Small Livestock*. Fur and Feather, 1978.
Whitney, Leon F. *How to Breed Dogs*. Rev. ed. Howell Book House, 1986.
Wood, Roger J., and Vitézslav Orel. *Genetic Prehistory in Selective Breeding: A Prelude to Mendel*. Oxford University Press, 2001.

Part III: Variation

Bateson, William. *Materials for the Study of Variation*. 1894. Forgotten Books, 2015.
Birkhead, Tim. *The Red Canary: The Story of the First Genetically Engineered Animal*. Bloomsbury Publishing, 2003.
Carroll, Sean B. *Endless Forms Most Beautiful: The New Science of Evo Devo and the Making of the Animal Kingdom*. Quercus, 2005.
Dodwell, G. T. *The Lizard Canary and Other Rare Breeds*. Saiga Publishing, 1982.
Goldschmidt, Richard. *The Material Basis of Evolution*. Silliman Memorial Lecture Series. Yale University Press, 2009.
Hanson, Thor. *Feathers: The Evolution of a Natural Miracle*. Basic Books, 2012.
Held, Lewis I., Jr. *How the Snake Lost Its Legs: Curious Tales from the Frontier of Evo-Devo*. Cambridge University Press, 2014.
Hill, Geoffrey, and Kevin J. Mcgraw. *Bird Coloration*. 2 vols. Harvard University Press, 2006.
Naish, Darren, and Paul Barrett. *Dinosaurs: How They Lived and Evolved*. Natural History Museum, London, 2016.
Owen, Richard. *On the Nature of Limbs: A Discourse*. 1849. Ed. Aron Amundson. With supplementary essays. University of Chicago Press, 2007.
Zimmer, Carl. *At the Water's Edge*. Touchstone, 1999.

Part IV: Selection

Bondeson, Jan. *Amazing Dogs: A Cabinet of Canine Curiosities*. Amberley Publishing, 2011.
Clutton-Brock, Juliet. *A Natural History of Domesticated Animals*. Heinemann, 1981.
Coppinger, Raymond, and Lorna Coppinger. *Dogs: A New Understanding of Canine Origin, Behavior and Evolution*. University of Chicago Press, 2001.
Cronin, Helena. *The Ant and the Peacock: Altruism and Sexual Selection from Darwin to Today*. Cambridge University Press, 1991.
Derry, Margaret E. *Bred for Perfection: Shorthorn Cattle, Collies, and Arabian Horses since 1800*. Johns Hopkins University Press, 2003.
Diamond, Jared. *Guns, Germs and Steel: The Fates of Human Societies*. W. W. Norton, 1999.
Dugatkin, Lee Alan, and Lyudmila Trut. *How to Tame a Fox (and Build a Dog): Visionary Scientists and a Siberian Tale of Jump-started Evolution*. University of Chicago Press, 2017.
Francis, Richard C. *Domesticated: Evolution in a Man-made World*. W. W. Norton, 2015.
Hall, Stephen, and Juliet Clutton-Brock. *Two Hundred Years of British Farm Livestock*. TSO, 1989.
Macgregor, Arthur. *Animal Encounters: Human and Animal Interaction in Britain from the Norman Conquest to World War One*. Reaktion Books, 2012.
Porter, Valerie. *Cattle: A Handbook to the Breeds of the World*. Christopher Helm, 1991.
Ritvo, Harriet. *The Animal Estate: The English and Other Creatures in the Victorian Age*. Harvard University Press, 1987.

~ Index ~

Page numbers in bold refer to illustrations.

achondroplasia. *See* disproportionate dwarfism
acquired characteristics: inheritance of, 67, 82, 84, 85, 103, 244, 272
adaptive radiation, 257
African goose, 8, **169**, 173
age of the earth, 62, 65, 114, 128
agouti pattern, **164–65**, 166, 172
albinism. *See* color variants/aberrations
almond pattern in pigeons. *See* English short-faced tumbler
analogous traits. *See* convergent evolution
ancon sheep, 106, **107**, **108–9**, 114. *See also* disproportionate dwarfism
Arabian horse: female line ancestry, 84
Aracauna, 152–53, **158**. *See also* rumpless fowl
Aurochs, **10–11**, 13, 95
Aylesbury duck, 202, 205

Bakewell, Robert, 101, 235, 254
Barbary dove: grizzle mutation, 113; occurrence of pointing 202, **206**; temperament 272
Bateson, William, 118–20, 124, 138
belted cattle, 142
Belyaev, Dmitry, 53, 272, 275. *See also* tameness: heritable
Bengal cat, 8, 13. *See also* hybridization
Blackface sheep: adaptation to environment, 201; horn spiraling, 130–31. *See also* logarithmic spiraling: degree of spiraling
blending vs. particulate inheritance, 75, 77, 79, 85, 95
Bokhara trumpeter, **194**
Border Leicester: ancon, **108–9**; polled trait in sheep and goats, 167, 173 (*see also* hornlessness)
brachycephaly. *See* shortened skull
branching phylogeny, 39; Cavalier/King Charles spaniel head shape, 44, **45**, **46**, **47**, **48**, 49; Budgerigar size, 44, 49, **52**
Breda fowl: comb shape genetics, 121, **123**; sexual dimorphism in vault size, 147, **152**
breed standards, 26, 229–30
Broiler chickens: selection for traits in non-breeding animals, **68**; double-muscling, **170–71**, 173
Budgerigar, **24**; color, **73**, 77; feathered feet, 113; size, 44, 49, **52**
Bull terrier: skull shape, 26, **28**, **29**, 144, 173
Bulldog/English bulldog, **8–9**, 13, 173, **221**, **222–23**, 224; Leavitt bulldog, **225**, 22.

canary: posture, 116, 118, **120–21**; color, 172–73, 202; progressive graying, 214, **217**
Carrier (pigeon), **22**, 23
Cavalier/King Charles spaniel: head shape, 44, **45**, **46**, **47**, **48**, 49 (*see also* branching phylogeny); thumb spot, 84 (*see also* acquired characteristics: inheritance of)

Chabo, **92**, 98–99, 106. *See also* disproportionate dwarfism; lethal genes
Chambers, Robert, 43–44. *See also* parallel lineages: hypothetical ancestry
Chihuahua, **12**, **31**, **32–33**
Chinese crested, **97**, **98**, 99. *See also* co-dominance/incomplete dominance, pleiotropic effects; lethal genes
Chinese goose, **5**, **6**, 8
co-dominance/incomplete dominance, **74**, 77, 79, **90–91**, 96, **97**, 153, 173, 205
Collie, 259; color, 260; skull shape, **258**, **259**, 260, 260, 261
color variants/aberrations, **70**, **73**, 77, 124, 142, 153, 162, **163**, **164–65**, 166, 172–73, 272, **274**, 275
comb shape in chickens, 118–21, **122–23**
conscious/unconscious artificial selection, 234
convergent evolution, 178
Crested duck, **146**; crest feathers, 144, 147, **149**; skull abnormalities, 147, 150, 152, **153**, **154–55**
crested goose, 144, **147**
crossbreeding: to create or enhance breeds, 38, 39, **78–79**, 80
Cuénot, Lucien. *See* lethal genes

Dachshund: achondroplasia, **156–57**; formation of sagittal crest, **199**
Darwin, Charles: analogy between natural and artificial selection, xiii, 53, 56, 66, 234, 261, 278; associates and correspondents 60–62, 69; *Beagle* voyage, 53, 60, 251; efforts to understand inheritance, 69, 75, 77, 79–80, 85, 103; pamphlet to breeders, 79–80; publication of *On the Origin of Species*, 69; purpose of *Variation under Domestication*, xiii, 69, 75, 85, 103
Darwin, Erasmus. *See* natural selection: evolution of idea
Darwin's Bulldog. *See* Huxley, Thomas Henry dietary color, 202
Dingo/New Guinea singing dog, 253, **256**
disproportionate dwarfism, 159; in cats 173, **174–75**, 178; in chickens **92**, **94**, 99; in dogs, **156–57**; in sheep, 106, **107**, **108–9**
DNA copying errors, 138–39
domestication phenotype/syndrome, 272, **273**, 274, **274**, 275, **276–77**, 278
Dong tao, **139**, 142
double muscling, 173; in cattle, **238–39**, 241; in chickens, **170–71**, 173 (*see also* Broiler chickens)

Eldridge, Roswell. *See* Cavalier/King Charles spaniel
embryonic development, 99, 101, 172, 179–80, 188, 198, 274
English lop rabbit, **61**, 254
English short-faced tumbler, **xiv**, **86**; almond pattern (stipper gene), 101, **102**; brachycephaly, 173

evo-devo, 179–80. *See also* embryonic development

Fantail, 26, 31, **34**, **36**, **37**, 49, **100**, 101, 116
farm fox experiment. *See* tameness: heritable
feather development, 214, 216
feathered feet, 188, 195; in chickens, 153, **189**, 195; in pigeons, 110–11, **190**, **191**, **192–93**, **194**, 195
fighting breeds: dogs, **8–9**, 13, 221, **222–23**, 224, **225**, 229; game fowl, **226**, **227**, 228, 229; geese, 229, **231**
Figurita, 49, **110**
fitness for purpose, 13, 80, **81**, 224, **228**, 229
fly tying feathers, 205, 207, **209**
Frillback, **111**, 112, **112**, **113**

Galapagos archipelago, 251; finches, 53, 60, 251, 257; goats, 252
Galton, Francis: experiment to test pangenesis, 103; interest in domestication, 60
game fowl, 229; Modern English, **226**, **227**, 229; Old English **228**, 229.
gemmules. *See* pangenesis
gene frequency: genetic drift, 253; in isolated populations, 93, 249
genomic imprinting: Callipyge sheep, 200
German beauty homer, 80, **81**
Girgentana goat, **125**, 127. *See also* logarithmic spiraling: direction of spiraling
goldfish: Bristol shubunkin, **240**, 241; Tosakin 240, 241, 254; viewing, 241
Goldschmidt, Richard. *See* hopeful monsters
Gould, John, 44, 60, 166, 251
Grey wolf, 15, **270**; early domestication, 271
Greylag goose: ancestry in fighting breeds, 229; hybridization, 5, 7, 8; occurrence of crested form, 144

Haeckel, Ernst: recapitulation theory, 179
Heck cattle, 13. *See also* Aurochs
henny feathering, **83**, 208; Sebright bantam, 207, **210–11**
Himalayan guinea pig, 201, **204**. *See also* pointing
Hollecropper, 116, **118**, **119**
hominin skull shape. *See* phenotype/syndrome
homologous traits, 178
Hookbill duck, 142, 144, **145**, 173, 254
hopeful monsters, 138, 159
hornlessness, **89**, 93, 95, **167**, 173
horns, multiple, **140–41**, 142, **142–43**
Huxley, Thomas Henry, 114
hybridization, 8, 19, 88; Bengal cat, 8, 13; doves, 272; geese, **5**, **6–7**, 8; Quagga × horse, 85 (*see also* telegony)

imprinting (behavioral), 271
improved livestock, 43, 101, 106, 254, 256
inbreeding, 95, 254; associations with purity, 256; genetic bottleneck, 253–54; Golden hamster, 257; shorthorn cattle, 256–257
Indian game fowl, **94**, 122. *See also* lethal genes
Irish wolfhound, 30, **264**

Jacobin, **21**, 49, 80, 111
Japanese bantam. *See* Chabo
Jenkin, Fleeming, 75, 77

King Charles spaniel. *See* Cavalier/King Charles spaniel
Ko shamo, **114**, **115**, 116
Kumru (Laugher), 235–36

Lamarck, Jean-Baptiste. *See* natural selection: evolution of idea
Large white pig, 38, 40, 41. *See also* skull shape diversity
lethal genes, 98, 99
leucism. *See* color variants/aberrations
Linnaean classification, 4–5, 8
logarithmic spiraling: degree of spiraling, 127–28, **126–27**, **128–29**, **130–31**; direction of spiraling, 124, **125**, 126–27
longtail, **196**, 205
Lyell, Charles. *See* age of the earth
Lysenkoism, 272

Malayan fowl, **93**; comb shape, 121, **122**; "*Gallus giganteus*," **16**, 17, 19; skull shape, 200, **200**
Maltese (pigeon), **176**, **177**, 184
Malthus, Thomas, 62
Mangalitza, **40**, **41**. *See also* skull shape diversity
Manx cat, 82, **84**, 244, 245, **246–47**
Matthew, Patrick, 69
melanins/melanism, 153, 162, **163**, **164–65**, 166, 172, 173, 188. *See also* color variants/aberrations
Mendel, Gregor: his life and legacy, 72, 75; his methods, 72, 95, 96, 98, 118; rediscovery of his work, 103, 121, 124
Mendelian inheritance: explanation of, 72, 92, 95; Mendelian ratios, 95, 98, 120, 153
Merino sheep: adaptation to environment, 201
Middle white pig, **42**, 43. *See also* skull shape diversity
Modena, 236, **237**
modern synthesis, 124, 131, 272
molt, timing of, 205, 214, 216, 217
monstrosities, **132**, 134, **135**, **136**, **137**, 138
Mookee, 31, **35**
Mulefoot, 245, **248**
Munchkin: in crosses, 80; dwarfism 173, **175**, 178. *See also* disproportionate dwarfism
museum collections, importance of, 23, 38–39, 128

Naked-neck fowl: biology of naked neck, 208, 212, **213**; in crosses, 80; genetics of, 96
Naked-neck tumbler pigeon, 208, 212, **215**
natural selection: evolution of idea, 67, 69; explanation of, 65–66, 134, 139, 230, 234, 253
neoteny, 272, **273**, **276–77**, 278. *See also* phenotype/syndrome
Niata cow, **57**, 60, 173. *See also* brachycephaly
nomenclature: laws of, 5, 13–14; problems with domesticated animals, 15, 18–19
Norwich cropper. *See* pouter/cropper pigeons
Nubian goat, **167**. *See also* hornlessness

Onagadori. *See* longtail
Owen, Richard, 179. *See also* homology

pangenesis, 85, 103
parallel lineages, hypothetical ancestry, 15, **16**, **17**, **18**, 19, 23, 44, 60
pedigree register, 256; closed-book system, 250, 254, 256
Persian cat, **160**, **172**, 173 *See also* brachycephaly
pigeon flying, 236
pleiotropic effects, 99, 101, 121, 147; in domestication phenotype, 272, 274
pointing, 201–2, **204**, **206**; in experimental crosses, 261
Polish/Paduan fowl: comb shape genetics, 121; crest feathers 144, **148**; vaulted skull, 147, **150**, **151**
polydactyly, 185; in cats, 249, **252**; in chickens, **184**, **185**, **186–87**, 188; in dogs, 245, **251**
polymorphism, 96, 162, 250–51. *See also* color variants/aberrations
pouter/cropper pigeons, **20**, 80, 114, 116, **116**, **117**
progressive graying, 214, **216**, 251
proportionate dwarfism, 252; Netherland dwarf rabbit, 252, **255**

racing pigeon, **76**, 80, 231; exhibition varieties, **78–79**, 80, **81**
Racka sheep, 127, **126–27**. *See also* logarithmic spiraling: degree of spiraling
Ragdoll cat, 82. *See also* acquired characteristics: inheritance of rare breeds preservation, 142, 144, 152, 159, 249, 254
Red junglefowl, **14**, **15**, **16**, 19
Rock dove: adaptability to man-made environment, **268**, **269**, **269**; ancestry of domesticated pigeon, 23, 49, **50–51**, 54
rumpless fowl, **18**, 19, 23, 114, 152, **158**. *See also* Aracauna; parallel lineages: hypothetical ancestry
runaway/sexual selection, 66, 202 230, 231, 234, 235, 275
Runner duck, ii–iii, 116, 234–35, **235**

saltationist/gradualist debate, 103, 114, 124, 128, 138, 159
Scandaroon, 49, **63**; embryonic causes of bill shape, 144, 173; use in crosses, 80
seaweed diet in sheep, 201, 249
Sebastopol goose, **90**, **91**, 96
Sebright, John, 67, 101, 116, 134; Sebright bantam, 207, 208, **210–11**
self-domestication, 275, **276–77**, 278
Serama: posture, 82, **82**, **83**, 116; size reduction, 200, **200**
sex change in birds, 207–8
sex-linked genes, 101, 103
sexual reproduction, 88; and its importance in generating variation, 80, 85, 92, 134
shortened skull, 173; in cats, **160**, **172**; in cattle, **57**, 60; in dogs, 13, 44, **45**, **46**, **222–23**; in pigs, **42**, 43

short-spine syndrome, 249
silkie feather mutation, 19, 31, **37**, 49, **83**, 96, 153, 261, 262, **262**
Silkie fowl: comb shape, 120–21, **123**; combination of traits, 153; in crosses, 80; polydactyly, **184**, **185**, **186–87**, 188
Silkmoth, 2, 15
Silver fox, 272, **273**, 274, **274**, 275. *See also* tameness: heritable skull shape diversity: in dogs **12**, **26**; in pigeons, **50–51**; in pigs **38–39**, **40–41**, **42**, 43
Soay sheep: horn type ratios within population, 93, 249. *See also* hornlessness
St Bernard: skull shape, 26, **27**
Stargard shaker, **178**, **179**, 184
Steinbacher goose: fighting origin, 229; hybrid ancestry, 8, 13
stipper gene, 101, **102**, 214. *See also* English short-faced tumbler
studbook. *See* pedigree register
supernumerary vertebrae, 180, 184, 185; in pigeons, **176**, **177**, **178**, **179**, 184; pigs, **180–81**, **182–83**, 185
Swan goose, **5**, **6**, 8. *See also* hybridization

tameness, heritable, 271, 272, 275
telegony, 84–85
Temminck, Coenraad. *See* parallel lineages: hypothetical ancestry
thief pigeons, 236. *See also* Modena
Thoroughbred: evolutionary limits, 230, **232–33**; sprint gene 257, 259
tortoiseshell pattern in cats. *See* sex-linked genes
Toulouse goose, **168**, 173
Toy poodle, **267**
toy spaniel 44, **48**. *See also* Cavalier/King Charles spaniel
Tula goose, 229, **231**
turnspit dog, **218**, 220

urban foxes, 266, 269, 271

Vienna long-faced tumbler, **64**

Wallace, Alfred Russel, 60, 69
webbed digits, in dogs, 245, **250**
Weismann, August. *See* inheritance of acquired characteristics
White leghorn: comb shape, 122 (*see also* comb shape in chickens); floppy comb, 208, **212**
Wild boar **38**, **39**, 43, **70**, 77, **180–81**, 185
winglessness, 263

Zebu, 201, **203**
Zigaja sheep, **128–29**. *See also* logarithmic spiraling: degree of spiraling